THE INTANGIBILITIES
OF FORM

THE INTANGIBILITIES
OF FORM

Skill and Deskilling in Art After the Readymade

JOHN ROBERTS

VERSO

London • New York

First published by Verso 2007
© John Roberts 2007
All rights reserved

1 3 5 7 9 10 8 6 4 2

Verso
UK: 6 Meard Street, London W1F 0EG
USA: 180 Varick Street, New York, NY 10014–4606
www.versobooks.com

Verso is the imprint of New Left Books

ISBN: 978-1-84467-167-0 (pbk)
ISBN: 978-1-84467-163-2 (hbk)

British Library Cataloguing in Publication Data
A catalogue record for this book is available from the British Library

Library of Congress Cataloging-in-Publication Data
A catalog record for this book is available from the Library of Congress

Typeset in Garamond by Hewer Text UK Ltd, Edinburgh
Printed and bound in the USA by Courier Stoughton Inc.

CONTENTS

PREFACE

This book elaborates a labour theory of culture as a model for explaining the dynamics of avant-garde art and the modern expansion of the circuits of artistic authorship. In this the writing involves less a discussion about specific artworks (or their interpretation), than an analysis of the kinds of labour contained *in* artworks, as a reflection on a wider debate about artistic labour and productive and non-productive labour and the limits and possibilities of authorship. Why is it that artistic labour is taken to be an exemplary form of human activity and, as such, is judged by some writers to be the basis for the emancipation of all labour? How have productive labour and non-productive labour impacted on the production of avant-garde art challenging traditional accounts of aesthetic value and expression? Adorno's critique of aesthetic theory charted a similar philosophical terrain in the 1960s, but in *Aesthetic Theory* (1970) specific categories of labour were never made expressly visible in relation to the visual artwork, just as the relations between productive labour and artistic labour were kept at a distance. In *The Intangibilities of Form*, I have made these relations explicit, by insisting that it is impossible to explain the ideals of the early avant-garde without stressing the overwhelming importance artists have placed on *how* they have laboured, in contradistinction to, or identification with, how they perceived others (non-artists) labouring.

For the early avant-garde – as much as for the post-Second World War neo-avant-gardes down to the present – the identification or disidentification with various forms of productive and non-productive labour has determined what kind of function and use-values art might best possess

in order to secure its critical identity or autonomy. This process is reflected from the 1920s onwards, of course, in the increasing withdrawal of the notion of artistic value from the mimetic capacity of the expressive hand in painting and sculpture. With the rise of the readymade there emerged an irreconcilable displacement of the link between handcraft and skill. This initiated a huge explosion in revolutionary thinking about the social form of art beyond the artisanal production of the conventional studio. As the artisanal became dissociated from the category of art, authorship came more and more to incorporate both the *non-artistic hands of others* and the development of mechanical/technical and executive artistic skills. Indeed, the use of non-artistic labour in the form of delegated work or the incorporation of productive labour in the form of the readymade defines the broader political horizons of the early avant-garde: the dissolution of the division between intellectual labour and manual labour as the basis for the future dissolution of art into social praxis. For example, Productivism emphasized the assimilation of the worker into the artist and the artist into the worker in order to transform the alienated character of both, just as Constructivism stressed the importance of the need for the artist to incorporate the technical results of productive labour into artistic practice if art was to find a place beyond its own alienated aestheticism.

This displacement or dispersal of the artist's hand into forms of heteronomous labour is the radical disjunction at the heart of modern practice after the readymade, and, as such, is what distinguishes the modern from the pre-modern: the fact that at the point of the dissolution of its traditional forms art invites both productive and non-productive labour into its realm as a means of reflecting on the conditions of both art *and* labour under capitalist relations. The introduction of the readymade into art, in this respect, represents the impact of a more fundamental set of cultural changes: the increasing interaction between artistic skills and the social relations and material forms of technology (artistic *technik*) under the increasing incorporation of technology and science into production (general social technique). This raises an important methodological question: what kind of theory of authorship do we want after the displacement of the author from the centre of his or her artisanal labours in the twentieth century? One in which the decentred author is returned to art history merely 'intertextualised' within a history of artistic styles, or, one in which artistic authorship as an 'open ensemble of competences and skills' is

grounded in the division of labour and the *dialectic of skill–deskilling–reskilling?* This distinction is crucial because, despite the general cultural assimilation of the avant-garde and acceptance of the readymade in contemporary practice, there is much intellectual confusion about what constitutes skill in art after the readymade and the critique of productive labour and art in the early avant-garde. If today there is a notional acceptance that the readymade, and later Conceptual art, have irreversibly changed the value of what artists do, there is little understanding about why – on the basis of the alignment between artistic technique and general social technique – this is the case, and therefore, a limited understanding of why deskilling in art after the readymade does not represent an *absolute* loss of artistic sensuousness.

General social technique – as the dominant framework of art's technological reproducibility and distribution – subordinates handcraft to technique; in this it follows the law of the real subsumption of labour. Yet, because art is not wholly subject to the law of value (to the discipline of the technical division of labour and necessary labour time), the subordination of handcraft to technique does not result in the stripping out of skill from art in the same way sensuous artisanal skills have been stripped out of productive labour since the nineteenth century. The absence or presence of skill in art, therefore, is not derivable from a model of handcraft *as such*, because art does not experience an incremental process of deskilling which leaves producers at a lower level of capability than previously attained, otherwise we would only be able to designate certain kinds of handcrafted objects as art. Deskilling in art, rather, is the name we might give to the *equalization of artistic technique after art enters the realm of general social technique.* In other words, deskilling is what happens when the expressive unity of hand and eye is *overridden* by the conditions of social and technological reproducibility; it is not a value judgement about what is or what is not skilful according to normative criteria about art as painterly or sculptural craft. Accordingly, the split between artistic labour and the conventional craft-based signs of authorship which follows from this split, necessarily links artistic skill in late capitalist culture to a conception of artistic labour as immaterial production. *Artistic skills find their application in the demonstration of conceptual acuity, not in the execution of forms of expressive mimeticism.*

However, this immaterial definition of artistic labour is not reducible to a practice of speculative 'thinking' as if art was simply cognate *with* scientific

and philosophical discourse or the Beauty of Spontaneous Ideas – the mistake made by some early advocates of Conceptual art and the mistake made by much digital and telematic art theory today. The readymade may have stripped art of its artisanal content, but this does not mean that art is now a practice without the hands of the artist and without craft. On the contrary, art's emancipatory possibilities lie in how the hand is put to work *within*, and by, general social technique (and therefore in relation to the techniques of copying and reproducibility), and not through the subordination of the hand to such techniques. This is because the hand still remains key to the 'aesthetic re-education' and emancipation of productive and non-productive labour. This is why I stress the importance of the emergent totipotentiality or multifunctionality of the hand in artistic labour in contrast to the operative hand in productive and non-productive labour. As the mediator of *best practice*, the emergent totipotentiality of the hand remains central to the social destruction of the real subsumption of labour and the technical division of labour in any post-capitalist system. Without the qualitative transformation of the relations of production the hands of productive and non-productive labourers will continue to be subordinate to the machine, even when machines are taken into collective ownership – as the history of Stalinism amply demonstrates.

This argument seems to me to be in keeping with the central emancipatory thrust of Marx's *Capital* and the anti-technist wing of the Marxist tradition: the necessity for an aesthetic critique of the value-form. But the agency of the emancipatory content of emergent totipotentiality is not another name for the 'aesthetic'. That is, the agency of this emancipation is not secured simply through an imposition of aesthetic labour onto heteronomous, productive labour. This is a form of art-led idealism, inherent to many kinds of aestheticized politics, on both the left and right. Autonomy, rather, has to enter the realm of heteronomous labour through heteronomous labour's (workers') own collective agency. It is only when productive and non-productive labourers refuse to labour – and, as a result, the value-form is dissolved, thereby opening up a self-reflective space for 'aesthetic-thinking' – that the emergent totipotentiality of artistic labour will truly be able to enter productive relations and be able to transform the heteronomous conditions of labour and everyday praxis. In this way, by emphasizing the production of art within a dialectic of skill and deskilling the defence of artistic value is divested of its common confusion with traditional forms of painterly and sculptural sensuousness. Indeed, the

virtue of the dialectic of skill and deskilling in thinking about art after the readymade and Conceptual art is that the problems of making and talking about art are grounded in the indivisibilty of technical issues and social questions. This is why there is such a general air of melancholia in much contemporary art criticism and art history, radical or otherwise (Benjamin Buchloh, T.J. Clark, Thierry de Duve, Hal Foster), because there is an overwhelming attachment in this writing to loss of affect in front of the artwork at the expense of any deeper understanding of the technical conditions of modern and contemporary practice. This book refuses this melancholia – at the same time as refusing any of its plaintive or affirmative 'others' – by insisting on the interrelationality of skill and deskilling (or what I call the craft of reproducibility as opposed to say, craft *and* reproducibility), before we can embark on a discussion of value. This distinction is the difference between seeing art history and cultural theory as disciplines where artistic practice is theorized primarily in relation to the social histories of 'expression' and 'style', with all the concomitant problems of historicism, and seeing artistic form in relation to the social and intellectual division of labour. Consequently, this book establishes another topology for modern and contemporary art: one in which artworks, after the readymade and the craft of reproducibility, become focal-points for the redefinition of skill within a socially expanded understanding of the circuits of authorship. My primary concern in the *The Intangibilities of Form*, therefore, is with the process of deskilling and reskilling as it bears on the exchange and collaboration between artistic labour and non-artistic labour, artistic hands and non-artistic hands.

In the introduction, I explore artistic technique and general social technique in relation to the issues of reproduction, reproducibility and copying. I then expand on this in a discussion of Duchamp, the readymade and the commodity, Duchamp's work providing an important range of reflections on artistic labour and authorship. On the basis of Duchamp's reading of his early unassisted or stand-alone readymades as sites of 'rendezvous' between conflictual or opposed concepts (such as complex labour and simple labour, artistic labour and productive labour), we are able to examine how his work opened up new circuits of authorship to the artist. This reading of Duchamp as a theorist of artistic labour differentiates my position from much of the new Duchampian scholarship, with its emphasis on Duchamp as an artist of consumption. In my reading Duchamp is always an artist of production.

The second half of the book examines the expansion of art's circuits of authorship after the readymade has been internalized, so to speak, as 'first practice' in art after the 1960s and the rise of Conceptual art. In this respect this half of the book offers a more generalized picture of where artistic labour and non-artistic labour are conjoined in post-Conceptual and contemporary practice, and what distinguishes the labour of the contemporary neo-avant-garde artwork from the early avant-garde artwork. What function does the dialectic of deskilling and reskilling perform in art after the immaterial transformations of productive and non-productive labour and the expansion of intellectual labour in art? What are the dynamics between art and general social technique today in conditions of the age of the hyper-museum? Is there an actual convergence between the immaterial skills of post-Conceptual art practice and the immaterial labour of some sectors of the new economy? And, if so, how does this form of the skilling–deskilling dialectic equate with the circuits of authorship developed in the early avant-garde? These are substantive questions, particularly as classical notions of autonomy in art have come under further scrutiny in the epoch of art's digital temporalization and post-visual transformation into social technique.

In short *The Intangibilities of Form* reinstates the dialectic of deskilling–reskilling in art as a way of explaining why the question of authorship has been so fundamental to avant-garde art and neo-avant-garde in the twentieth century. For, without addressing this dialectic the avant-garde remains incomprehensible as a revolutionary critique of both art and productive labour. The first part of this revolutionary critique is, no doubt, more believable today than the latter part, given the present utopianism of the aesthetic critique of productive labour. But, nevertheless, the emancipatory horizons of this critique continue to assert themselves in both political philosophy and artistic practice. This makes my claims for the centrality of the deskilling–reskilling dialectic less obdurate than might first appear. For even in a period of extraordinary corporate control of culture, and the heightened efflorescence of the capitalist sensorium, the effects of this critique continue to form the political horizons of artistic practice in all kinds of public and subterranean ways. Art's critique of political economy shapes the content of practices in many surprising directions and in many surprising places. As such, *The Intangibilities of Form* is not only concerned with recovering a history of the hidden labours of the artwork, but also with setting this history in the context of the critical demands of the moment.

Thanks to Stewart Martin for his close and instructive reading of the text and to David Hopkins and Dave Beech for their comments. Thanks also to The Fine Art Research Department at the University of Wolverhampton, Euripides Altintizoglou, Matthew Cornford, and as always, Michelle, for their support.

Introduction

REPLICANTS AND CARTESIANS

In the 1980s the debate on simulacra, copying, surrogacy and authenticity dominated Anglo-American art discourse. There was a widespread assumption that claims to subjective expression and aesthetic originality on the part of the artist were a myth, a delusional hangover from the Cartesian fantasy of the 'inner self' as an authentic expressive self. Since the 1920s and the social claims of the early avant-garde the continual expansion of technology into art's relations of production made it increasingly difficult to equate normative value in art with such claims. Touch and manual dexterity had lost their place as markers of artistic taste and authority. As such, the artist was no longer seen as a self-confirming 'creator', but as a synthesizer and manipulator of extant signs and objects. What largely united these earlier anti-Cartesian moves was a theory of montage as social praxis. Sergei Eisenstein, Dziga Vertov, Alexander Rodchenko, El Lissitzky, John Heartfield, Hannah Höch, Raoul Hausmann, all saw themselves, essentially, as artistic *constructors* and *fabricators*. As Hausmann declared: 'We call this process photomontage because it embodied our refusal to play the role of artist. We regarded ourselves as engineers, and our work as construction: we *assembled* [in French: *monteur*] our work, like a fitter.'[1] In the 1960s and 1970s, this, in turn, was taken to be part of a deeper historical shift in the subjectivity of the artist: the dissolution of the creative *singularity* of the (male) artist. The post-gendered monteur was now merely an ensemble of techniques, functions and competences. In the 1980s much critical art and much art theory under the banners of postmodernism and post-structuralism was produced within this framework.

Today this sense of a 'paradigm shift' is the commonplace stuff of postmodern history and theories of the 'end of modernism', taught in art schools and art history and cultural studies departments in Europe and North America. Where once the expressive skills of the (male) artist were existentially inflated, now they are deconstructively deflated. Indeed, the critique of authorship is now the template of contemporary neo-Conceptual art and post-object aesthetics from Glasgow to Manila. Yet, despite this would-be theoretical displacement of the artist from the privileged scene of his or her production, the issues of simulacra, copying, surrogacy, virtuality and the readymade remain largely one-dimensional in art theory and contemporary cultural theory. This is because the theoretical moment of the debate on authorship in the 1980s has come down to us through a discourse of apocalyptic anti-humanism, unnuanced anti-aestheticism and undialectical social categories. The effect is to reduce the critique of authorship either to the 'end-game' reproduction of preexisting artistic moments or styles, or to an eclecticized intertextuality. As a consequence the critical agency of the artist's labour has become diminished or flattened out, as if the critique of authorship was equivalent to the *end* of representation, the *end* of art, the *end* of meaning, and the *end* of subjectivity. But, unfortunately, this simplistic historical elision is what has usually stood for thinking in art schools and cultural studies departments in the 1980s and 1990s, dominated as they were by versions of post-structuralist simulation theory and deconstructionism.

Yet, at the beginning of the twenty-first century, strong claims for the 'post-expressive' artist as a kind of art-replicant (exemplified, in particular, by the hyper-simulationist Sherrie Levine) have largely subsided. The end of artistic subjectivity and authenticity, once associated with simulationist kinds of art, no longer seems so radical or meaningful as the crisis over uniqueness has become quiescent in the wake of the increasing acceptance of a 'soft' intertextual model of creativity within many leading teaching institutions and museums.[2] Moreover, there is a broad realization amongst a new generation of artists confronted with the realities of the studio and beyond – rather than the comforts of the seminar room – that the tasks of representation and artistic form don't end simply because they are assumed, theoretically, to have ended. As such, hyper-simulationism has come to be seen less as the ideological impeachment of all other art, than an end-game *style* akin to 1970s monochrome painting, which is why Levine herself soon retreated from the extreme implications of her work. In many

respects the problems facing the hyper-simulationists and 'extreme appro-
priationists' were no different from those experienced by certain Con-
ceptual artists in the early 1970s hooked on the nomination of non-artistic
entities and realia as art: by transforming a contingent critical move into a
grand repetitive strategy the critique of authorship became dogmatic and
naturalized.

Nevertheless, questions of appropriation, copying, replication, simula-
tion, and so on, have become the necessary terrain on which art after
Conceptual art continues to pursue its sceptical skills. There is no value (or
critique of value) in art without these forms of scrutiny. Indeed, since the
high point of 'appropriationist art' in the early 1980s, a generation of artists
have taken this as a 'given' and have largely internalized some notion of the
artist as technician, monteur, ideas-manager, constructor, etc. This is why,
despite the recurrence of various defences of 'aesthetics', the humanist
exaltation of 'self-expression' continues to be theoretically marginalized –
at least in the leading academic and cultural institutions, to the rancour of
cultural conservatives and leftist philosophers of aesthetics alike. Further-
more, the notion of the artist as a monteur in the broad sense is now one of
the key moves identifiable with the dissolution of the boundaries between
fashion, style and art in our consumerist-led culture. Many younger artists
see their identity as linked to the execution of tasks across formal, cultural
and spatial boundaries. Commitment to one method of production or form
of distribution, one set of cognitive materials, one outlook, is decried. One
of the consequences of this is the emergence of a historically novel tension
between a received (and depoliticized) older notion of the avant-garde
critique of authorship, and the reinvention of the artist as creative
entrepreneur (under the increased glare of celebrity culture).[3] This pro-
duces an intense conflict of ideologies: the artist's identity may be
deconstructed under the impact of the social relations of advanced art,
but it is simultaneously *reconstructed* as an enchanted image under the reified
forms of the mass media. The idea of the artist as an ensemble of
functions, becomes a set of multitasking *career opportunities*.[4]

But of, course, at the level of political economy, this novel situation for
the artist is not so novel as to be historically anomalous. Rather, it is further
evidence of how the laws of exchange operate on art in the epoch of its
technological expansion and diversification. The acceptance of some
aspects of the critique of authorship in early avant-garde art and Con-
ceptual art in current art has become the means whereby the new

administration of art has *reinvented* itself in order to secure its access to the new, entrepeneurial, technologically driven culture and to new areas of cultural capital. In the absence of the pressures of the traditional artistic and cultural hierarchies, artists are freed up – indeed encouraged – to become curators and critics, and curators are freed up to be artists and critics, in ways that benefit the multiple commercial ventures of the mass distribution of art. Just as workers involved in immaterial labour are encouraged – or forced – to be multitasking, modern artists are encouraged to think of themselves as active as artists beyond the 'limited' point of production, because, it is claimed, artists need to think of themselves as directly engaged in the mediation of the meanings of their work.

But if this multitasking defines the shift of the social identity of the artist from someone who 'externalizes' his or her self from a position of repressed marginalization, to someone who works openly within a complex division of labour (in the way a designer might for example), it is not the darker side of the critique of authorship, or an understanding of the place of artistic labour within the social totality, that is emphasized. As a model of the artist-as-entrepeneur the notion of the artist as an ensemble of functions turns largely on the pursuit of market opportunities. The militant, destabilizing, uncomfortable aspects of the critique of authorship have been written out of the reckoning, or treated in a cursory and peripheral fashion. This is because, by identifying 'appropriation' and artistic 'hybridity' with the end of the avant-garde, and by linking multitasking with a benign pluralism of forms, the effects of cultural and social division that precede and shape the labour of signification – the materiality of signification – are comfortably disavowed. The allegorical complexities of the intentions and competences that underwrite the critique of authorship – in fact sustain its logic of negation – have been dissolved into a cultural studies model of semiotic consanguinity. Hence we have a situation in which the informal aspects of Conceptual art are now being replicated as a neo-avant-garde, but with little sense of the troubling negation of the social world that shaped the early avant-garde's and early Conceptual art's critique of the category of art. This has led, overwhelmingly, to a critique of authorship without the discomforts of ideology critique and the critique of the capitalist value-form, as if attacking the myth of self-expression was in and of itself a critical strategy. Indeed, the deconstructionist attack on authorship as an intertextual version of *bricolage*, is perfectly compatible with

the most conservative views on what artists should now do to define themselves as modern.

Nevertheless, the critique of this benign pluralism is not an argument for the revocation of the original avant-garde or the recovery of a 'lost' Conceptual art. To critique contemporary neo-avant-gardism is not to think of the 'neo' as an inevitable falling away of art from the achievements and commitments of the past. On the contrary, the 'neo' is the necessary space in which the afterlives of art and theory continue to be *reinscribèd* with new and living content. As such we need to examine just what the 'neo' of contemporary neo-avant-garde actually comprises, before we can make a judgement about its criticality.

What I am proposing in this book is a model of the 'post-expressivist' artist which actually takes on the challenges of expression and representation that now confront the artist of the new millennium. This means retheorizing what we mean by the artist as critic and representor in a world of proliferating doubles, proxies, simulations, etc. For what is increasingly clear (beyond the recent moments of the radical negation of authorship in Conceptual art and critical postmodernism) is the need for a model of the artist which is *unambiguously* post-Cartesian, that is, a model of artistic subjectivity which refuses the bipolar model of interiority and exteriority on which modernist and anti-modernist models of the artist are usually based.

In the 1960s the opposition between interiority and exteriority in art took the form of the familiar conflict between modernism (as an expanded sense of art's expressiveness and affectivity) and social realism (as an expanded sense of art's claims on ethical witness and social truth). In the 1980s, this reemerged in the form of a conflict between neo-expressionism and a photographically expanded neo-Conceptual art practice. Today, however, the taking up of a position on either side of the 'interiority' or 'exteriority' debate is inert, if not dead; there is no 'expressiveness' to be won through painting-*as*-painting, just as there is no social truth to be secured through photography (or even photography and text) *as* photography. This is why the weak pluralist intertextuality of contemporary neo-Conceptual art and theory has become so hegemonic: it takes the very real crisis of the exterior/interior dualism as a point of exit from 'interiority' and 'exteriority' altogether and not as the point through which their boundaries might be reformulated. In dissolving the reified identities of 'inside' and 'outside' pluralist intertextuality comes to dissolve 'expression' and the 'self' and the 'real' *tout court*. The crucial question, then, is how the self-evident collapse of older models of expression

and critique in art might allow us to continue to discuss questions of criticality, expression and representation in the twenty-first century. How is it possible to think critique and critical difference in an extended world of neo-artefactuality and neo-visualization?

To answer this we need a model of the modern avant-garde artist that is *already* beyond the binary opposition of interior and exterior. Not in order to lay claim to the artist's privileged place in some theoretical discussion about the 'world as text', but in order to inscribe the artist without remainder into the preprogrammed chains of meaning itself. This model of semiosis is not exactly news. It can be described as materialist semiosis, which has a long and venerable history.[5] But so much of this critical programme has been lost or become toothless in recent art theory that we need to remind ourselves of what the critique of authorship was set up to provide in the transformed world of post-1960s art.

Essentially, since the 1960s the self-identity of the artist has become detached from the traditional hierarchies of artistic media. Artists may continue to work as painters, photographers and sculptors, but painting, photography and sculpture are not in themselves privileged sites of expression and meaning for the artist. Rather, specific media are staging areas for the warping and weaving of the process of semiosis across forms, genres and non-artistic disciplines. In this way the artist's skills as a maker of self-conscious artistic signs is indistinguishable from the artist's competence as a theoretical manipulator of 'stand-ins', performative strategies and prosthetic devices. Yet, in most accounts of the critique of authorship, from the readymade to digital technology, there is an unreconstructed tendency to adopt the Cartesian model of the artist as the self-bound manipulator *of* such devices, props and strategies. The artist's creativity is never implicated *in* these processes; that is, strategies of repetition, re-presentation, reinscription and replication are rarely seen as extending the identity and competences of the artist. Technique, technology and artistic subjectivity – art and social *technik* – are separated. This is because simulacra, copying, surrogacy and replication are not seen as the super-structural conditions of art under advanced capitalism, but as simply modes or devices of artistic audaciousness. In other words, if art is always and already embedded in the technological relations of its time, then the technologies of copying, simulacra and surrogacy are the material basis of art's modern semiosis and not mere stylistic options. Second-order is first-order. Consequently, the early and late twentieth-century critiques of

authorship is the site where the dissolved category of art and the reconstituted content of artistic technique meet, the gateway through which new artistic identities and relations might be formed and the critique of ideology and the value-form sustained. It is not where the identity of the artist is lost or to be mourned.

From this perspective artistic subjectivity *is* the use and manipulation of 'stand-ins'. There is no point, no place, where the artistic self is free of the constraints of prosthetic devices (be it paintbrush or digital camera), the demands of copying (identification and reclamation), and as such the performative voice or persona (recognition of the split between work and authentic self). In this sense we need to distinguish a fundamental set of conditions for art in the twenty-first century.

Under the capitalist value-form social reproduction – the unceasing production and reproduction of the commodity – and technical reproducibility (general social technique) are conjoined, one driving the other. That is, just as general social technique is subject to the law of value, the law of value is subject to the technical transformations of general social technique. Hence in a system where the continuity of production is based on technological forms of replication and duplication, the technical conditions of social and cultural life will necessarily be based on forms of iteration (the neo-effect). Social reproduction and technical reproducibility become indivisible. The result is that the production of art is no less subordinate to the fundamental logic-of-repetition of commodity-production than other non-cultural commodities. In order for art to secure its 'newness' it must, like other commodities, reiterate itself, otherwise it becomes the thing it once was, abandoning itself to the past and the same. But, if the artwork is subject to the drive-to-repetition of the commodity, the artwork's escape from its own heteronomous conditions of production is not like other commodities. Because artworks are invariably distinct singularities, rather than repeated prototypes, their emergence from heteronomy and their inauguration of the 'new' represents a qualitative break in the *subsumptive* repetition of the commodity form. That is, although artworks seek to reiterate themselves, as all commodities must, this reiteration is determined by the autonomy of artistic subjectivity (as opposed to the heteronomy of productive labour). In other words, in contrast to productive labour's repetition of the 'new' as the 'same', the 'new' is transformed into the 'new' as different, as other to its immediate conditions of production. This event of 'newness', as such, is precisely

non-heteronomous, and therefore opposed to the very logic of subsump-
tive repetition that brings it into being. The important point here is that as a
system of commodity production art is both formed by, and is in resistance
to, the iterative logic of commodity form; or, rather, the resistance to
iteration and the production of iteration are the same thing. The conditions
of autonomy and heteronomy are interwoven.

This has a direct bearing on the basis of iterative technique: copying.
Copying or replication in art is not an inert practice, the repetition of the
protoype, but the very means by which art provides a *new successor* to its
chosen antecedent. Thus, the reworking or incorporation of extant materials
is as much a means of sustaining what is thought to be authentic and critical,
as it is a way of trying to replicate or 'steal' what is felt to be the aura of the
image or object in question. In this respect copying clearly needs to be
distinguished from plagiarism or pastiche proper given their associations
with traditional craft, and of passing one thing off in the style or manner of
another. Whereas the latter replicates the admired precedent as an act of
indebtedness, the former takes the likeness of thing in order to inscribe it, or
reinscribe it, in a critical tradition or novel context. Copying in this sense,
therefore, is never strictly copying, never flat mimesis, because it is able to
reanimate the thing replicated.[6] Or, as Kant puts it, mimesis can be divided
into two modes: *nachahmen*, which is merely a form of reproduction, and
nachfolgen, which is transformative and creative.[7] This is why the act of
selecting and presenting a readymade – what I call, in Chapter 2, copying
without copying – is always a productive act. Reproduction becomes a form
of creative re-presentation, or reenactment, insofar as it brings the thing
reproduced to life, or rather, releases it from its previous identity.

In this regard many theorists since the 1960s have argued that there has
been a qualitative technical transformation in how images are produced in
art and in mass culture in the late capitalist world. With the expansion of
the commodity form a corresponding expansion of the conditions of
reproducibility has occurred, bringing with it an unprecedented freedom
from the myths of authenticity and originality. Some of this writing
embraces this condition[8] and some of it decries its would-be detrimental
social and cultural consequences: the loss of a sense of 'tradition', 'artistic
skills', and 'stable social identities'.[9] Less prevalent is thinking of the copy
from *inside* the conditions of social reproduction and technical reprodu-
cibility. By either celebrating or denigrating replication and copying the
nachfolgen function of the copy is divorced from its constitutive place

within the commodity's dialectic of autonomy and heteronomy. One of the results of this is that artistic technique and the various technical conditions of social reproducibility across scientific and technological domains are divorced. If this means thinking of the copy in cultural production from inside general social technique, it also means thinking of general social technique, more broadly, in relation to the sciences of replication: for example, genetic engineering, the new cosmology, theories of Artificial Intelligence and so on. For, it is the impact of these new sciences on general social technique – on the conditions of the technical reproduction of social and cultural forms – that gives us further insight into the material realities of iteration and the copy in late capitalism, and therefore, also defines those points where 'replicant-thinking' in art and 'replicant-theory' in science come into possible creative alignment. In these sciences the copy is the constitutive means by which the reproduction of difference in any given system is produced and reproduced. The upshot being that the copy is not that which fails the status of novelty, or that which lacks authenticity, but the thing *out of which* claims for novelty – what drifts or mutates the identity of the antecedent – is produced.[10]

Since the 1930s when Walter Benjamin was the first to theorize the conditions of technological reproduction in its modern cultural forms, the supersession of the artisanal in modern life defined the expectations for new forms of art and marked out the new forms of experience emergent from this art. If Benjamin was highly optimistic about these forms and experiences, we at least understand from his work an important historical truth: *art and general social technique does not stand still.* Indeed, Benjamin's writing presaged a vast transformation in the content of artistic and social *technik* in the second half of the twentieth century. Since the 1930s the realities of image reproduction and artistic surrogacy or authorship-at-distance have represented the high ground upon which debates on value in art have been fought out. In fact seventy years on we can now see that the debates on the readymade, on photography, on post-object aesthetics have been the phenomenal forms of a much deeper and more profound response to art's place in the social division of labour. Not only does capitalism strip the artisan of his or her means of production and status, it also strips the artist of his or her traditional 'all round' skills. Under advanced capitalism, therefore, debates on modernism, the avant-garde and postmodernism have been principally about rethinking and reinscribing the skills of the artist into these transformed conditions. The contemporary critique of authorship is no

more nor less the theoretical expression of these long-term changes. But today the remnants of any nostalgia for the artisanal which once hung over the early twentieth-century debate have long vanished, as consciousness of the copy in our daily technological practices has dismantled notions of expressive and formal uniqueness. The implications for art from this are indisputable. Art is not just a series of unique inheritable objects produced by diligent individualized handcraft, but also the outcome of a set of shared iterative skills, temporal forms and collective relations. In this its forms are dispersible, expandable and endlessly reproducible. Yet discussions of skill, deskilling and reskilling in art are barely broached in contemporary art theory.[11] Too much theory and history, in fact, filters its sense of art's futurity from a narcissistic mourning of art's would-be lost affective qualities and possibilities. As a result the interpretative disciplines can hardly keep up with the social, cognitive and cultural forces that are now bearing down on the category of art. But, if mourning for the the lost object has become a substitute for its dialectical appropriation, this does not mean that dialectics itself should lose sight of what is empty, repressive or diminished in the iterative culture of our time. To reposition artistic technique in relation to replicant thinking and general social technique is not an attempt to provide art with a set of functional use-values borrowed unmediated from science, as if the solution to the alienated social form of art was art's greater openness to scientific method and technology *per se*. This is the fundamental problem with complexity theory, and cultural theory influenced by it, which map, in an enfeebled way, a bioscientific model of mutation on to cultural practice and social agency, as if art was a *self-replicating* intellectual system free of cultural and social division.[12] Rather, the fundamental issue remains: how might the autonomy of artistic technique be a condition *of* general social technique, and of use-values external to the realm of art?

This book, consequently, is an attempt to draw a different kind of map of the culture of art at the beginning of the twenty-first century: one that treats artistic technique as subordinate to, but also reflective on, general social technique as a consequence of the contraditions and divisions internal to both artistic labour and technology. In this the categories of deskilling and reskilling, as I have stressed in the Preface, play a major part in the book's analysis of art's relationship to *technik*. For the production of value in modern art is inconceivable without the idea of the critique and the reworking of notions of skill and technical competence. The very inter-relationship between artistic technique and general social technique is

predicated upon this. Indeed, it is on the basis of this relationship that the complex labours of art – its 'intangibilities of form' – have been constituted and reconstituted during the twentieth century.

I want to begin, therefore, by looking at what is the founding event of the critique of value and the modern dialectic of skill and deskilling in twentieth century art: the readymade. For it is the readymade, above all else, that is key to understanding the development of the modern conditions of reproducibility in art and art's relationship to general social technique. With the readymade we are, at once, in the realm of artistic labour and productive labour, art's autonomy and post-autonomy, novelty and the copy.

NOTES

1 Raoul Hausmann, quoted in Hans Richter, *Dada: Art and Anti-Art*, Thames and Hudson, London, 1997, p.118.
2 See for example, Peter Noever, ed., *The Discursive Museum*, MAK and Hatje Cantz Publishers, Vienna, 2001; Gavin Wade, ed., *Curating in the 21st Century*, The New Art Gallery Walsall and the University of Wolverhampton, 2000; and Sarah Cook, Beryl Graham and Sarah Martin, eds, *Curating New Media*, Baltic, Newcastle-upon-Tyne, 2002.
3 This also works in the opposite direction. The dispersal of 'artistic technique' across disciplinary boundaries has clearly been appropriated as a model of 'good practice' and 'open' management in some of the creative and new services industries. For a discussion of the impact of 'artistic critique' on capital accumulation and the new workplace see Luc Boltanski and Eve Chiapello, *The New Spirit of Capitalism*, Verso, London and New York, 2005, and Eve Chiapello, 'The "Artistic Critique" of Management and Capitalism: Evolution and Co-optation', in John Roberts and Stephen Wright, eds, *Third Text*, special issue on 'Collaboration', No. 71, Vol. 18, Issue No. 6, Nov–Dec 2004 (see Chapter 6).
4 Tracey Emin's career is a perfect example of this: from neo-Conceptual marginalia to designer of smart bags for the luxury luggage maker Longchamp.
5 See in particular Valentin Voloshinov, *Marxism and the Philosophy of Language*, Harvard University Press, Cambridge, Mass. and London, 1986.
6 See Hillel Schwartz, *The Culture of the Copy: Striking Likenesses, Unreasonable Fascimiles*, Zone Books, New York, 1996.
7 Immanuel Kant, *Kritik der Urteilskraft*, Reclam, Stuttgart, 2004, pp.194–7.
8 See Jean Baudrillard, *In the Shadow of the Silent Majorities . . . or The End of the Social*, trans. Paul Foss, Paul Patton and John Johnston, Semiotext(e), New York, 1983.
9 See Paul Virilio, *The Aesthetics of Disappearance*, trans. Philip Beitchman, Semiotext(e), New York, 1991.
10 Genetic engineering instates this process clearly. Cloning – Cell Nuclear Replacement – is the infinite reproduction of the same as the 'new'. That is, cloning is not the *exact* reproduction of the prototype in physiology or consciousness (just as twins born within seconds of each other are not exactly identical). The genome may be reproducible but the behaviour and individual characteristics of human beings are not. As John Harris

puts it: 'Autonomy, as we know from monozygotic twins, is unaffected by close similarity of bodily form and matching genome. The "indeterminability of the individual with respect to external human will" will remain unaffected by cloning.' (*On Cloning*, Routledge, London and New York, 2004, p.49). In other words clones are *unique* copies: although a series of cloned sheep have the same somatic form as their prototype, they each will develop internally differentiated neural pathways on the basis of their separate and individuated experience of the world, just like non-cloned sheep.

11 Where it has, it has borrowed its models from the biological, neurological and other physical sciences. One such model is the neurocomputational account of consciousness in the new neurobiology, for example, Paul M. Churchland's work. As he argues in *The Engine of Reason, the Seat of the Soul: A Philosophical Journey into the Brain* (MIT, Cambridge, Mass. and London, 1995), his aim is to bring a 'broad range of human artistic endeavour comfortably into the fold of a neurocomputational account of human cognition' (p.298). He calls this the creative deployment and development or 'recurrent manipulation' (p.279) of prototypes. Creativity resides in those people who are skilful at recurrent manipulation, that is, those who are sufficiently learned that they are able to build up a large repertoire of prototypes. When this repertoire is in place humans are in a position to produce new and novel applications of these prototypes by virtue of 'our built-in capacity for *vector completion* or filling in the gaps' (p.280).

12 On complexity theory, see, for example, Fritjof Capra, *The Hidden Connections: A Science for Sustainable Living*, Flamingo, London, 2003. See also, Niklas Luhmann, *Art as a Social System*, Stanford University Press, Stanford, California, 2000.

ONE

THE COMMODITY, THE READYMADE AND THE VALUE-FORM

Almost all articles of consumption can re-enter the production process as excrements of consumption, as for example worn-out and half-rotten rags of linen in the manufacture of paper. But no one produces linen in order that it should become, as rags, the raw material for paper. It only gets this form after the linen weaver's product as such has entered consumption. Only as excrement of this consumption, as residuum and product of the consumption process, can it then go into a new production sphere as means of production.

<div align="right">Karl Marx[1]</div>

The nomination of found objects and prefabricated materials as 'readymade' components of art is the crucial transformative event of early twentieth-century art. This much is self-evident and is reflected in the extensive literature on the readymade in art criticism, art history and philosophy since the 1960s. Indeed, the readymade looms vast over twentieth-century art carrying all before it, invoking both feelings of horror (at the supposed loss of artistic value), and of sanguine relief (of having the burden of academic naturalism finally lifted). But in a sense we can only see this now. It was only with the theorization of the importance of Duchamp's works from 1910–40 in the 1950s and 1960s, coupled with the recovery of the revolutionary content of Constructivism, Productivism and Surrealism in the 1960s and 1970s, that the readymade has been able to work its retrospective and prospective power on the development of twentieth-century art. In other words, the occluded but dominant tendencies of twentieth-century art had to be brought into practice again for their criticality to become visible. The European New Objectivism and

New Realism of the early 1960s played their (minor) part in this, just as the Johns–Cage–Warhol version of the *objet trouvé* helped to reestablish Duchamp's reputation in the US and Europe; but it was Conceptual art that proved to be the real historically transformative moment in this process of recovery and continuity in the 1960s. Conceptual art is not a theory of the readymade *per se*. A number of conceptual artists were vehemently opposed to the Duchampian tradition because of its perceived literalism and anti-intellectualism. Art & Language, for example, saw the return to the stand-alone or 'unassisted' readymade as an enfeebled anti-art gesturalism.[2] However by installing the readymade within an unfolding theoretical reflection on practice, Conceptual art was also the point where the *function* of the readymade was reopened to a new set of historical demands and conditions. Hence, there is a way of seeing Conceptual art as a 'vanishing mediator' for the original readymade. By stressing art's indivisibility from the theoretical claims of language, Conceptual art reconstituted the terms of the avant-garde's original critique of the category of art: the necessary disjunction between art as a set of nominated objects and art as an *aesthetic* experience. Through this gap between art and aesthetics rushed the readymade-ideology which has underwritten art since the late 1960s.

Yet, despite the extensive literature on the readymade, there has been little substantive writing on what this transformation means at the level of *artistic labour* and the *cultural form* of art. Too often discussion of the readymade languishes in the realm of stylistic analysis, the philosophical discussion of art and anti-art, or, more recently, the Institutional Theory of Art (an artwork is no more nor less an object or event nominated by artists and their representatives and presented to an artworld public).[3] This is because the analysis of artistic value in these discourses is rarely broached in relation to a discussion of actual labour *in* the modernist work of art. The readymade's break with certain artisanal functions of art is treated simply as a formal option or as a reflection on the interpretative powers of the artist, and not as a *technical* category and demand. It is the technical status of the readymade, however, that defines the moment of Conceptual art's reading of the early avant-garde. After Duchamp and Surrealism the readymade becomes not so much a formal choice as an operative process for artists, something that defines the limits of artisanal skill. In this regard the prevalent approaches fail to bring the transformative use-values of the readymade into correspondence with technical

transformations in the relations of production. The result is that the readymade is divorced from any intelligible evaluation of skill, deskilling and reskilling. There are a few significant exceptions to this rule, but we have to look outside of art history and before the 1960s for them: Walter Benjamin's writing, for example.

Art for Benjamin is itself a form of production, and as such, establishes new modes of interaction between humans and technology.[4] This is why for Benjamin the readymade is constitutive of the interrelationship between art and technology. Yet today Benjaminian discourse on the readymade is largely divorced from the labour theory of culture. His primary debt to Constructivism and Productivism is exchanged for a production-free textual hermeneutics.[5] Similarly, the best of the new Duchampian scholarship may emphasize the readymade as an *intentional category*,[6] but, like the Benjamin scholarship of the moment, it is distinguished by its indifference to the relationship between the readymade and labour theory. Thus, the issue here is not just that the 'deskilling' imposed by the readymade on the artwork dissolves the residual artisanal content of modernist painting and sculpture, or that the dissolution of the category of art is not, in simplistic terms, an act of nihilism. (In these terms the new scholarship is certainly correct: the post-war critical discourse on the readymade has been crude and reductive.) But rather, more affirmatively, that the abandonment of painterly skills is a *productive process* in which the nomination and transformation of found objects and prefabricated materials represents a technical and cognitive readjustment on the part of the artist to the increasing socialization of labour. By presenting a discrete commodity, or a constellation of fragments of commodities, in the form of a montage as a meaningful artistic act, the modernist artist insists on a point of mimetic identification between artistic production and social production. Art and social production (mechanization, reproducibility) become conjoined. The technical and cognitive demands of the readymade, then, derive from the perceived phenomenological inadequacy of painting. The dabbing, pushing and smoothing of paint across a surface is held to be utterly residual, a process that can no longer be made to seem homologous with the experience of modernity, of living in a world of hard, reified things. Consequently, what these cognitive and mimetic demands introduce into art in this period is a very different relationship between the eye and hand of the artist. By *not* painting (and also by not modelling or carving) the artist's hand is able to act on intellectual decisions in a qualitatively

different kind of way. The hand moves not in response to sensuous representation of an external (or internal) object, but in response to the execution and elaboration of a conceptual schema, in the way a designer, architect or engineer might solve a set of intellectual or formal problems. The hand and eye become linked through the selection, arrangement, superimposition and juxtaposition of materials, enforcing a shift in art's technical base from covering and moulding to the organization and manipulation of preexistent objects. The notion, therefore, that the ready-made, in its very act of presentation, deskills the artwork is a misnomer. Traditional artistic skills are certainly challenged by the process of deskilling of the readymade – violently so – but this deskilling is also the point where the artwork is opened out to other skills and therefore to other use-values. But it is this image of art's absolute dissolution – its would-be disappearance into mere conceptual form – that has held the critical high ground, even amongst the avant-garde itself. Thus, in Joseph Kosuth's 'Art After Philosophy' (1969),[7] one of the founding texts of Conceptual art, the Duchampian introduction of the readymade is the point where traditional skills in art are seen as finally being stripped of their continuity with the past. In this way Kosuth identifies the Duchampian readymade ambitiously with the subsumption of Conceptual art under the regulative notion of art-as-Idea. The art object – the readymade – is merely the bearer of an idea, and, as such, is indifferent to aesthetic judgements about how the work is actually made. As an operative process the value of the readymade lies in the quality of its propositional content. This is no less undialectical than the numerous conservative critics of the Duchampian legacy. For here questions of skill and deskilling are not presented under the logic of the commodity form as *co-extensive* categories, but as opposed categories, bringing the notion of skill in art to its very knees.

THE METAMORPHOSIS OF VALUE

The readymade sits at the centre of an epochal shift in the relations of art's production, as art opens itself up to the technological and technical transformations of the first decades of the twentieth century. In this the readymade's technical invasion of the heavily protected realm of artistic skill is at the heart of a discourse on labour. For the readymade not only questions what constitutes the labour of the artist, but brings the labour of others – ideally at least – into view. Or, to be more precise, non-alienated

and alienated labour are brought into view *simultaneously*. There is no theory of the readymade, therefore, without an understanding of the commodity form.

Simply put, the readymade is a commodity which is transposed from one productive sphere (the realm of circulation or non-circulation) to another productive sphere (the studio or other workplace). But, whether it is bought from a store, or found in the street, whether it is old or new, once it moves from studio on to the market the readymade is transformed into a *new* commodity and, therefore potentially into a sale, into money. In this respect as it enters the gallery the commodity form of the readymade undergoes a three-part transformation: 1) *alienated commodity*; 2) *alienated commodity in non-alienated form*; and 3) *alienated commodity in alienated form*. Of course, the production of paintings and sculptures for the market assumes a similar logic: the transformation of alienated commodities (paint, canvas, prepared metal, wood and stone) into non-alienated form (the completed painting or sculpture) for sale (alienated form). But, in the case of what we might call the non-customary art commodity – the *functional non-artistic object* – this passage of the alienated commodity into another alienated commodity is made particularly explicit. Indeed, the hidden labour embedded in the commodities consumed in the production of the artwork is deliberately not concealed. This is why the passage of the readymade into an artwork constituted such a shock for the traditional defenders of artistic creativity: this process of revelation dared to expose the necessary labour which makes artistic labour possible. In doing so, therefore, the mimetic identification between the artistic act and productive labour was more than a proletarian gesture on the part of the artist. By incorporating evidence of the productive labour of others into the artwork the labour of the artwork was stripped of its self-authenticating mystique, leaving the artist de-autonomized and bereft of his or her traditional self-composure as the possessor of a transcendental craft.

In this sense Duchamp's early unassisted readymades exposed the artist and the artwork to a different kind of scrutiny: the scrutiny of those whose labour is invariably judged as repetitive, and subordinate to the 'mysteries' of creation: workers. In the gallery the unassisted readymade produces a destabilizing exchange across this divide between artistic labour and productive labour. The spectator sees – simultaneously – an absence of palpable artistic labour, the presence of the palpable labour of others, and the presence of immaterial or intellectual labour (the reflection, that as a

spectator I am being called on to recognize the object in front of me as a work of art). However, this is not to say that Duchamp had a fully elaborated theory *of* labour and art, or that the early readymades spoke from the left or to the left (although it has been argued that Duchamp was a follower of the anarchist Max Stirner[8]), just as it is mistaken to assume that Duchamp saw himself in a utilitarian vein in the early works as a kind productive labourer. In fact the opposite is implied here. It is the power of non-alienated labour (in this instance immaterial labour) to transform the inert, alienated matter of the commodity which represents the liberatory content of his art and that drives his use of the readymade. But, nevertheless, in their obvious deflation of artistic labour, Duchamp's readymades are able to concretize the real crisis of artistic skill and puncture the retarded technical base of art in this period, and, in doing so, offer a view of artists as thinkers and constructors, rather than as the makers of fictive illusions. Thus, although Picasso's and Braque's *papier colles* of 1912 predate Duchamp's first use of the readymade (1917), and inhabit the same terrain and set of historical problems, their superimposition of appropriated newspaper titles over painted forms is unable to produce the same disruptive and long-range historical effects. For the readymade had to leave the painterly frame in order to draw attention to painting's fictive boundaries; inside it could only disturb and revivify these boundaries. And this is why, because of their marked singularity and austerity as objects, Duchamp's unassisted readymades, remain, to borrow Duchamp's own words, a striking point of 'rendezvous' for ideas 'inside' and 'outside' of art.[9] Duchamp's unassisted readymades expose more than the mystique of artistic skill: they expose the very metamorphoses of labour itself; and this is why we are never very far away from the question of value and the value-form when we look at Duchamp's readymades.

Metamorphosis is one of Marx's favourite words in the opening sections of *Capital*. For what defines Marx's entire approach to the commodity and the question of value in *Capital* is the fact that as soon as goods step forth as commodities into a network of social relations 'entirely beyond the control of their authors'[10] (i.e. the market), the goods experience a constant mutation of their identity. Marx talks about the 'social interchange of matter' and the 'rapidity with which commodities change their forms' under market relations.[11] Commodities undergo a 'rapid disappearance' and a 'rapid substitution'.[12] Indeed, the commodity represents a 'continued interlacing of one series of metamorphoses with another'.[13] In this sense

the commodity exists under multiple descriptions leaving it with an indeterminate and relational identity. The commodity is a 'transient apparition' Marx says, using the language of ghosts and spectres.[14] This spectrality of the commodity, its constant production and consumption, transmutation into capital and then transformation back into the production of commodities, is nevertheless underwritten and secured by one thing: labour, and specifically labour-power. It is only waged labour exchanged for capital that produces commodities. It is therefore only waged labour exchanged for capital that constitutes productive labour. Unproductive labour is labour exchanged directly with revenue (profits); where wage labour pays itself, no capital and wage labour exists. Marx devotes much space in *Capital* and the *Theories of Surplus Value*, to establishing this distinction, because it is the confusion around the specific character of productive labour that produces so much theoretical misunderstanding and sophistry. In Marx a definition of productive labour is not derived from its material characteristics (its duration, harshness or intensity), but from the *definite social relations of production* within which labour is realized. Hence a clown or an actor is a productive labourer if he or she works in the service of capital (that is if he or she returns more labour to their employer than he or she receives from the employer in wages), whilst a self-employed plumber who regularly fixes the wash basins and toilets of capitalists, produces only use-values and is therefore an unproductive labourer. 'The former's labour produces a surplus-value; in the latter revenue is consumed.'[15] Accordingly an artist is a productive labourer if he or she enriches a gallery or publisher and not because he or she is a hard-working fount of creative ideas. In this respect labourers whose labour is exchanged directly against revenue perform only personal services, and only a small quantity of this total will actually produce use-values (plumbing, tailoring, cooking, etc.). As a result only a small number of unproductive labourers play a part in material production once capitalism is developed, for the services unproductive labour provides do not again become money.[16] On this basis Marx challenges Adam Smith's distinction between productive and unproductive labour. For Smith *all* labour is counted as productive which manifests use-values. For Marx, however, it is expressly labour that produces commodities, or 'directly produces, trains, develops, maintains or reproduces labour-power itself', that is productive.[17] Thus productive labour is labour whose contribution to production involves a definite quantity of labour-time. And consequently this form of labour will cover

both factory workers *and* artists working for capital. This is an important distinction because it reveals that the production of value by productive labour is not confined simply to material production; concrete labour can also take an immaterial form and still be productive. Productive labour can take the form of labour which is not embodied in material objects. Contrary, then, to the popular notion of Marx as a theorist solely of industrial and manual labour-power, Marx does not propose any significant productive difference between physical labour and immaterial or intellectual labour. Immaterial labour is productive labour if it falls under the law of value.

But does this mean then that Marx sees the production of art as falling under the law of value (the socially necessary conditions for the production of a commodity)? Is art subject to the law of value? Well, when Marx talks about artists being productive labourers he is only talking about a small number of particular artists. It is only those artists who are responsible for mass-produced artistic goods that count as productive labourers and therefore fall under the law of value. As Marx says: 'Milton, who wrote *Paradise Lost* for five pounds was an *unproductive labourer*. On the other hand, the writer who turns out stuff for his publisher in factory style, is a *productive labourer*. Milton produced *Paradise Lost* for the same reason that a silkworm produces silk. It was an activity of *his* nature.'[18] Milton, nevertheless, as the author of *Paradise Lost* was the author of a reproducible artistic commodity, and therefore potentially subject like all *published* authors to the discipline of competition. The law of value is only truly inoperable once the commodity-form of the artwork becomes unreproducible in the form of a discrete and autonomous object, a distinction Marx implies in the example of Milton, but doesn't explore in any great detail. This kind of unreproducible object falls outside of the law of value precisely because under the law of value the value of a unit of production (an advertising poster for example) is derived by dividing the value of the entire production of poster-producers by the number of similar products produced under the given system of (poster) production. With unreproducible objects such as paintings and other discrete works of art, however, this price calculation is not possible. I.I. Rubin addresses this problem in *Essays on Marx's Theory of Value* (1928):

> The fact the wasted expenditure of labour of thousands of painters who failed is compensated in the price of a painting by Raphael, or that the wasted expenditure

of labor of hundreds of unsuccessful painters is compensated in the price of a painting by Salvador Rosa, cannot be in any way derived from the fact that the *average* value of the product of one hour of labor of a painter is equal to the value of the product of five hours of simple labor (to each hour of the painter's labor is added one hour of labor spent by the painter for his training and three hours of labor expended on the training of three painters who failed). L. Lyubimov is completely right when he subsumes the value of a product of a highly qualified laborer under the law of value. But he cannot deny the fact of monopoly in relation to the individual price of unreproducible objects.[19]

In other words, in Rubin's view, Marx did not subsume the price of unreproducible objects under the law of value precisely because the law of value has to explain the laws of human *production*. Marx, therefore, excludes those forms of creative activity that cannot be reproduced by socialized labour.

UNREPRODUCIBILITY/REPRODUCIBILITY

This distinction between the reproducible art-commodity and the unreproducible art-commodity is at the centre of the important and familiar debate that took place in the 1930s on art and technology between Benjamin and Adorno, and which is concretized in Adorno's mature work on aesthetic theory in the 1960s.

In Adorno the concepts of reproducibility and unreproducibility have no absolute value across artistic forms. He is no defender of one against the other as a matter of aesthetic virtue, for, following Benjamin, reproducibility is what brings modern artistic forms into being, such as the novel and the cinema, and what defines the common spectator and reader in the era of monopoly capitalism. However this does not mean Adorno does not have a critique of reproducibility, particularly in relation to music and the visual arts. In fact it is because the visual arts have an anomalous and exemplary relationship to unreproducibility that Adorno is led to treat the labour immanent to the work of art as a special case. That is, because the artwork is not subject to the law of reproducibility in an absolute fashion, because the unreproducible work of art escapes the law of value, the labour in the artwork is able to define the potential critical and liberatory content of art's labour. Yet, this is not because the unreproducible artwork enables a particular kind of autonomous non-productive labour to be enacted in

the artwork. The novel and the symphony also enable this. 'Works of art are plenipotentiaries of things beyond the mutilating sway of exchange, profit and false human needs . . . Marx's denunciation of productive labour is the strongest defence of art against its functionalization in bourgeois society.'[20] The 'social deviance of art is the determinate negation of a determinate society.'[21] But, rather, in contrast to the reproducible artwork – the artwork that is potentially exposed to the law of value – the unreproducible artwork allows *all* moments of its production to be determined by the artist's subjectivity. At no point in the work's production is the rationalization of labour determinate of the work's outcome. For Adorno, then, the unreproducible work of art encapsulates or concretizes a particular *kind* of artistic autonomy, *freely sensuous* artistic subjectivity. Freely sensuous labour may appropriate the materials and techniques of determinate, heteronomous labour, but the making of the work is secured solely through the autonomous actions of the producer. Yet, if the freely sensuous unreproducible artwork secures an image of liberated labour, this does not mean that unreproducible artworks are not commodities, and therefore, beyond the sway of fetishism. Indeed, the very opposite applies. Because unreproducible artworks are not subsumable under the law of value, paradoxically, they transcend their own status as commodity fetishes by becoming, in a sense, bloated and *absolute* kinds of fetish, absolute commodities. That is, their fetishistic status as unique things in a world of reproducible things produces a qualitative transformation in their character as fetishes. By refusing to descend to the level of productive labour their non-identity in the world of socially useful things is heightened and made socially distinctive and disjunctive. Hence it is the non-instrumental character of the unreproducible artwork that distinguishes its artefactuality from that of productive labour, throwing into relief the dominative relations in which productive labour is embedded. By heightening its status as a thing-apart, the sensuous artefactuality of the unreproducible artwork is able to recall for productive labour the sensuous immediacy of labour freed from the hierarchies of capitalist production, making the unreproducible artwork both the living embodiment of spontaneous labour and the site of its historical (pre-capitalist) memory. In this respect the unreproducible artwork is the place where the capitalist value-form is contested, *all the way down*.

But does the sensuous immediacy of the unreproducible artwork actually contest the value-form all the way down? Adorno's identification

between the spontaneous artefactuality of the artwork and the critique of the value-form is certainly the central emancipatory terrain on which political economy is to be contested. Like Marx, Adorno is a defender of the liberatory agency of art's sensuousness developed in Romanticism and German Idealism; as such *Aesthetic Theory* might be read, in this spirit, as one of the concluding volumes of *Capital*. Marx, it has to be said, was not a left-Ricardian or a theorist of 'Marxian' economics;[22] *Capital* is a work written against the bourgeois category of 'economics'. But in identifying the unreproducible artwork as the sole site of art's resistance to the value-form, the unreproducible work's artefactuality is subject to an incipient normative understanding of what is non-dominative. Adorno is always on the lookout for those practices that open the door to productive labour: such as the readymade, photomontage, assemblage. He doesn't actually condemn these practices, but he doesn't defend them as productive, technical resources either. This leads to a confinement of art's use-values to unreproducibility, severely narrowing what the artefactuality of the work of art might be. This was the basis of Benjamin's disagreement with Adorno. Adorno's writing on art, he argued, lacked a theory of *technik*, of the interrelations between technology, technique and artistic artefactuality. Benjamin, however, is both right and wrong. Adorno's writing did not lack a theory of *technik* at the level of the *artwork*. His defence of modernism was based precisely on the fact that it opened itself up to the advanced technical relations of production, but what his defence of the advanced technical relations of production in art itself lacked was an understanding of the interrelations between technology, technicality and artefactuality as a *cultural* form – hence his ambivalence about the readymade and photo-montage and assemblage. Adorno's defence of the advanced technical relations of art was never translated into a discussion of the distributive, sociable and interventionist potential of such practices, for fear that such things would reintroduce the heteronomous forces of productive labour back into the artwork. Unreproducibility and reproducibility, then, may not be absolutized in Adorno's writing, but the distinctive challenge of unreproducibility is certainly opposed to reproducibility, on the basis that the systematic pursuit of the latter could only destroy the expressive artefactuality of the unreproducible artwork. In one sense Adorno's premonitions have been borne out: the expressive artefactuality of art, in its traditional and modernist forms, has been destroyed. The suprafe-tishistic notion of the unreproducible modernist artwork as the site of non-

dominative labour has been completely swallowed up by the culture industry. But this destruction of the suprafetishistic identity of the modernist artwork has not delimited or destroyed art or the possibility of art's critique of the value-form. On the contrary it has opened out art to new use-values and new modes of expression. The further embedding of art into advanced technical relations has made it possible for new, reproducible forms of artefactuality to be developed, as in digital and other reproductive practices, for instance. Defending art, therefore, as a site of struggle against the value-form cannot be based solely on the artefactual *integrity* of the unreproducible artwork. But neither can it be based simply on a defence of the reproducible artwork as a political critique of the value-form as well, as Adorno correctly observed. Reproducible forms must embody, or at least recognize the transformative subjectivity of the artist *all the way down*, for otherwise such artefacts become congealed with the heteronomous effects of productive labour. What needs to be explored, therefore, is how unreproducibility and reproducibility intersect with each other, transforming the conditions of autonomy in art as a consequence. For if autonomy cannot be secured solely through unre-producible forms of artefactuality the struggle for autonomy is not excludable from reproducible forms.

The general argument I am proposing here is that, just as we need a new theory of autonomy which reopens the categories of labour for art, we also need a reading of *Capital* which recaptures its categories of labour for cultural and aesthetic theory. Marx is not a left-Ricardian precisely because *Capital*'s critique of the capitalist value-form, in the end, is not a discourse on the emancipation of labour, but the emancipation from productive labour. Marx does not just analyze the material and technical aspects of capitalism, but its *social form* – the totality of capitalism's production relations. In this sense *Capital* proposes that there is no such thing as production in general, there is only production in its variable and historical forms. This means that for value to be understood in its proper and full dimension it must be distinguished from its specific form under capitalism: the *value-form*. The value-form is the form value takes when one commodity (labour-power) is exchanged for another under the conditions of general-ized commodity production, producing what Marx calls abstract labour, or socially equalized labour (in the process of exchange individual differences in kinds of labour are eliminated).[23] If some form of abstract labour exists prior to capitalism proper, nevertheless it is only abstract labour that creates

value under capitalism. And herein lies the key theoretical point of Marx's distinction between unproductive labour and productive labour: *labour and value are not identical*. Labour is only the substance of value, it does not in itself produce value, only labour in a determinate social form (productive labour) achieves this. In this sense by carrying through a fundamental distinction between human labour in general and the specific forms in which it is in embedded in the commodity, Marx opens what had hitherto remained the accumulation of capital's dirty secret: the suppression of the social form of wealth. This is why, as a discourse on economics-as-social-form rather than a discourse on 'economics', *Capital*'s critique of the value-form is intimately bound up with struggle over the social dynamics and content of the liberation of labour. As Diane Elson has argued, the theory of the value-form builds into itself a 'potential for political action',[24] and therefore, as David Harvey has insisted, the political project is to liberate labour as ' "living form-giving fire" from the iron discipline of capitalism'.[25] But this action and liberation is meaningless without the potential for the aesthetic transformation of the future social forms of labour – hence the importance of the readymade in any discussion of *technik* and art's cultural form. For, as a technical category, the readymade brings into view the crucial categorial distinctions of the labour theory of value as a matter of aesthetic debate and cultural engagement. One of the immediate tasks, therefore, in developing a theory of critical autonomy in art and a new aesthetic reading of *Capital*, is exactly the task that Marx sets himself at the beginning of *Capital*: to analyse the commodity-as-readymade as the conflictual form of a more fundamental set of conflicts.[26]

As a commodity which has passed out of one circuit of consumption into another circuit, the readymade extends the life of the commodity's metamorphosis. So, just as the commodity in the process of exchange changes its substance, the commodity-as-readymade takes on a new identity. In this Duchamp's unassisted readymades extend the commodity's process of circulation. But, with the passage of the readymade-commodity into art another and 'miraculous' metamorphosis takes place: the readymade brings forth the commodity's *own function*. The commodity's metamorphic function is made transparent by the act of artistic transmutation which occurs. By transforming a reproducible non-art object into an unreproducible art object in the form of a reproducible art object, the logical relations of artistic labour and productive labour are exposed and inverted. A kind of commodity-madness is installed. In this way Duch-

amp's ostensibly 'non-art' and indolent gesture performs something that is deceptively profound. One inauspicious commodity has been turned into another – and auspicious – commodity without any physical manipulation of its form. Consequently through their unwillingness to present themselves as traditional kinds of artistic labour, Duchamp's readymades enact the conditions of transformation under which artworks become commodities, commodities become other kinds of commodities, and labour becomes a commodity under generalized commodity production. As such the immateriality of Duchamp's artistic gesture operates in three directions simultaneously. First, the readymade obviously deflates the privileged place of the artisanal in artistic production; second, it reveals the place of productive labour in artistic labour; and third, it discloses the capacity of commodities to change their identity through the process of exchange. The point here is that Duchamp's use of the readymade does not derive simply from a discourse on the magical capacity of art to turn 'rubbish' into 'gold'.[27] Although they are formally simple, Duchamp's readymades bring into view the complexities of exchange-value, use-value and the value-form. Yet what is profound about this is that this content is inscribed in the very act of non-artistic presentation. By failing to present palpable evidence of artistic labour Duchamp's readymades are thereby able to show the apparitional identity of the commodity *in its very audaciousness and madness*.

Duchamp's choice of the notion of the readymade as a place of 'rendezvous', therefore, is wisely chosen. For the readymades exist in a resonant constellation of forces and relations. This is why the early unassisted readymades continue to hold such fascination for artists and writers, because their withdrawal of conventional artistic labour confronts a series of opposed categories: unproductive labour and productive labour, the unreproducible and reproducible object, manual labour and intellectual or immaterial labour. But, beyond the intricacies of my argument here, it is the latter that is Duchamp's great theme in the early unassisted readymades, and this is what continues to make them so exceptionally resonant in the twenty-first century. Duchamp's unassisted readymades are not merely a defence of the conceptual over and above the retinal, as is common art historical currency, but of the place of intellectual labour in artistic production. The 'anti-art' gesturalism, therefore, hides a utopian moment of reflection. By presenting an anti-art gesture in the form of productive labour the homogeneity of productive labour is marked and transfigured by the autonomy of artistic labour. Necessary labour and

artistic labour, manual labour and intellectual labour, are brought together into suggestive, albeit uneven, alignment. This marks out Duchamp's practice at this point as embedded quite unambiguously in the reflection on art's place in the division of labour. Like many other artists, including some who would go on to form Berlin Dada and develop theories of art's production during the Russian revolution, Duchamp confronted the division between intellectual labour and manual labour head on. By attaching his intellectual creativity to the results and consequences of productive labour he was clearly not only divesting artistic labour of its evident idealisms, but confronting productive labour's internal coercions. But what Duchamp was interested in was something that most other artists of the period were not: the impact of the time (of utilization) in and on the form of the artwork under the capitalist value-form.

THE POLITICS OF 'DELAY'

Capitalism demands full and permanent use of plant and machinery. As Marx puts it, 'continuity, uniformity, regularity, order, and even intensity'[28] become the norm in the factory. As such this full and permanent capacity ensures the implementation of a ruthless economy of time. This drives the logic of the value-form. Under the pressure to fall in line with socially necessary conditions for the production of a commodity, the efficiency and speed of producers (and consumers) are the only factors the value-form recognizes. These conditions 'forcibly' assert themselves on production like 'an over-riding law of Nature'.[29] Consequently, for Marx, the emancipation of labour is indivisible from the emancipation of time. And by this he means not simply emancipation from necessary labour, but from the conditions of 'continuity, uniformity [and] regularity' which drive the logic of productive labour. Accordingly, for Marx, the emancipation of labour is bound up with the transformation of the use-values of labour. There can be no emancipation of labour without the transformation of how and under what conditions labour comes into being. For labour to be emancipatory, rather than simply emancipated, the abstract socialization of labour must be dissolved. This distinction between an understanding of the time-of-the-commodity and the time of emancipated labour was explored in the 1960s and 1970s by, amongst others, Guy Debord and Alfred Sohn-Rethel. Echoing Debord's critique of the time-of-the-commodity from the late 1950s,[30] Sohn-Rethel argued

that under generalized commodity production exchange always rules out use for collective use and extended utilization. Indeed, this system of exchange 'impels solipsism' on the part of its productive agents.[31] Commodity production performs its socializing function – its social synthesis – through its abstractness from conscious collective use, creating a naturalization of abstract labour. 'With a technology dependent on the knowledge of the workers the capitalist mode of production would be an impossibility.'[32] Capitalism is able to reproduce itself, therefore, precisely because abstraction is a *real* abstraction: market relations appear to cohere with the real. Under a system of commodity production control-over-use, then, requires an interim kind of strategy: the stopping or hindering of exchange-value. Unlike the Situationists or the Italian autonomists of the 1970s, however, Sohn-Rethel does not transform this into an actual practice of sabotage amongst advanced workers. His critique of the value-form does not take an explicit political form – as suggested above, for example by Diane Elson – and as such, points to substantive problems with his position.[33] But he does recognize the importance of the 'delay' in any practical and imaginary confrontation with the effects of the value-form. For it is in the space of delay – the space where use-values assert themselves against exchange-value – that the naturalization of the abstract socialization of labour can be confronted, and the division between intellectual labour and manual labour be opened up to reflection. 'Use here is not forbidden by social command or necessity.'[34] In other words the act of 'delay' becomes the measure by which humans regain control over socialized labour and the freeing of the intellect of productive labourers.[35] As such 'delay' has a universal aesthetic significance. For it recovers not just a space of social negation for the subject, but a space in which dissociation and imagination prevail. In this regard Sohn-Rethel shares a clear affinity with Adorno. Adorno similarly accredits the power of delay (of refusing to consume, of resistance to immediacy and rapid utilization) with the powers of reflection and emancipation, but for Adorno such practices are to be found primarily in the production and experience of the autonomous artwork itself, rather than the aesthetic transformation of general social technique. As a consequence it is the possibility of the artwork's resistance to dominant forces of abstraction that drives his defence of the unreproducible artwork. Although the unreproducible artwork and resistance to immediacy are not co-extensive – far from it –

the mimetic attention given to the unreproducible artefact on the part of the spectator, provide, for Adorno, a better means of securing these powers of reflection.

In these terms Duchamp is undoubtedly an artist of the 'delay'; he sees 'delay' as constitutive of serious artistic labour and judgement. In this he values the artwork as a source of dissent against art's rapid and instrumental utilization. 'Use "delay" instead of picture or painting', he says in the notes to *The Green Box*.[36] But unlike Adorno, Duchamp puts no faith in the unreproducible artwork securing the use-value or utilization of the artwork. Indeed, as I have argued, the opposite in fact applies: there is nothing inherent to the unreproducible artwork that might secure this utilization. This makes his intervention on behalf of the concept of the 'delayed' artwork, in the second decade of the twentieth century and thereafter throughout his career, a complex and disjunctive process. In the next chapter I will explore the historical intricacies of this process. Now I want to concentrate on what this concept of 'delay' meant for Duchamp at the time.

To all intents and purposes, Duchamp's *Fountain* fails the most basic understanding of what 'delay' might mean as an aesthetic 'resistance' to the value-form. The famous urinal is unmanipulated by the artist's hand, it has a weak or undistinguished set of internal relations as an object, and, most strikingly of all, it is directly recognizable as an object of productive labour. The notion of 'delay' here, therefore, is not one an aesthetic theorization of art's complexity would recognise. Duchamp's 'delay', in *Fountain*, is essentially a transmutation of the notion of aesthetic delay into a cognitive and conceptual framework whose complexity lies *outside* the temporality of aesthetic judgement. The spectator's attention is not held by the internal relations or surface of the object but by the object's conceptual identity. In this sense *Fountain* is based on an extreme form of 'delay': the artwork that purposefully defies all its audience's expectations, resulting in its disappearance as an object of contemplation, and (hopeful) reappearance at a later point as an object of reflection. Accordingly there is a broader sense of 'delay' at stake for Duchamp: the replacement of the object's immediate audience at the New York Society of Independent Artists exhibition, with the possibility of an appreciative audience in the future. Consequently, the presentation of *Fountain*, under the pseudonym R. Mutt, involved a gamble on Duchamp's part: that the 'aesthetically disinterested' unassisted ready-made would *not* find its audience, and therefore would be rendered

immediately passé. And he wasn't mistaken. In 1917 *Fountain* was rejected by the directors of the exhibition.[37] The work's 'delay', then, derives from its incorrigible opacity as art; its claims to being art are unable to fit into any known categories of artisticness. Thus, after courting and securing this exclusion, Duchamp's primary occupation was to bring the *Fountain* back into view in order to establish its lost status. This is why initially he went to inordinate lengths to put the work back into circulation and thereby claim a place for it within an emergent avant-garde, and within his own history as an artist. When *Fountain* was rejected Duchamp resigned from the board of the Independents on the grounds that the rule of open submission had been flouted, and mounted a campaign of support for the mysterious R. Mutt. This involved persuading Alfred Stieglitz to photograph the urinal. At the time Stieglitz represented the 'official' avant-garde opposition in New York, and was considered by Duchamp and his circle to have become insufferably parochial and self-satisfied, although like Stieglitz they were equally interested in producing a distinctive, non-Europeanized American modernism.[38] They just had no time for his artisanal metaphysics and anti-machine aesthetic. Yet his judgement and his photographs still counted for something, so getting his imprimatur on Mutt's work represented a significant step forward in establishing the work's institutional legitimation, as well as allowing Duchamp a joke at the expense of Stieglitz's new-found conservatism. Stieglitz, reputedly, saw through and enjoyed the Mutt deception, hated the bigotry of the directors' decision to pull the work and suspected – or even knew – that Duchamp was behind it. Anyway, he went to great lengths to produce a convincing and sympathetic photograph of the object, which in its play of shadows, emphasized the implicit sexual ambiguity of the inverted urinal. Duchamp was impressed and the photograph appeared in the second issue of Duchamp's jointly edited avant-garde magazine *The Blind Man* in May 1917. In the same issue Duchamp also published an anonymous letter of support for Mr Mutt, most likely written by Duchamp and one of the other editors, the Dadaist Beatrice Wood. The letter was supposedly sent in by a blind reader, who, despite being unable to see the urinal, authenticated the existence of the artist by referring to his first name, Richard. In a gesture of 'blind solidarity' the blind spectator embodied the absent, spectral artist.[39]

Although the *The Blind Man* campaign shifted the focus of discussion about *Fountain*, on to the New York avant-garde and away from the idea that the work was a capricious joke, the process of readjustment and

recovery, however, was highly attenuated for Duchamp. *Fountain* remained a distant memory for the New York avant-garde for most of the 1920s and 1930s until Surrealism's reception in the late 1930s. This was partly to do with the urinal being exhibited only once after submission (supposedly for a week at Stieglitz's 291 Gallery),[40] then soon being lost or stolen – thereby robbing exhibitors of reprieving the 'scandal' of the Independents; but also due to the fact that, until Surrealism, the unassisted readymade really had no intellectual home. The work may have had a certain status as a notorious artworld event, but it only had a half-life as a work of art, and, therefore, was able to be retrieved from deathly blindness into *productive* blindness, so to speak, until the cultural and intellectual tendencies that produced and shaped it had become historically embedded in post–1920s avant-garde discourses.

Now, of course, all significant works with the advent of modernism have experienced a process of 'delay' in their reception. This is exactly how modernism has defined its hard-won autonomy in the face of the instrumentalization of art's meaning and reception. Duchamp's unassisted readymades are the direct descendants of this logic. But what marks out Duchamp's understanding of 'delay' here is that it refuses the relations of distance and nearness on which the painterly avant-garde's understanding of 'delay' is conventionally based. If Cubism introduced the readymade into painting in order to destabilize the fictive autonomy of painting, thereby aestheticizing the readymade as a resource for painting, and, as such, bringing the sensuous particulars of painting into alignment with the real empirical object, Duchamp's unassisted readymades bring the readymade-as-commodity directly into the realm of judgement. The perception of painterly autonomy is substituted for the heteronomy of productive labour. The anticipated 'delay' of the work, then, is embodied in a form of judgement which painterly modernism was at pains to reject: *the immediacy and transparency of the commodity*. This reveals something perverse and contrariwise about Duchamp's notion of 'delay'. Avant-garde 'delay' is presented in a form which is identifiable with the experience of mass production and mass culture, and not simply with the processual integrity of aesthetic judgement. I would argue, therefore, that Duchamp invites the readymade-as-commodity without ambiguity into art not only to deflate painterly artisanal labour, but also in order to bring the artwork into full alignment with the modes of attention of modern mass production. And this is what makes these early unassisted readymades' dialectic of distance

and nearness so complex and disjunctive. For, as a number of Duchamp scholars have pointed out recently, it is the shop window – the place obviously where commodities are displayed – which becomes a determinate framework for Duchamp in the early years. As Duchamp writes in 1913:

> The question of shop windows ∴
> To undergo the interrogation of shop windows ∴
> The exigency of the shop window ∴
> The shop window proof of the existence of the outside world ∴
> When one undergoes the examination of the shop window, one also pronounces one's own sentence. In fact, one's choice is "round trip". From the demands of the shop windows, from the inevitable response to the shop windows, my choice is determined . . .[41]

In other words, if the modernist work of art is to be interrogated by the shop window, mass consumption is to be interrogated by modernism. The readymade returns the gaze of the consumer to the spectator of art. But for all the suasiveness of this as a model of interpretation Duchamp is not an artist *of* consumption. This, essentially, is the weakness of the new Duchampian scholarship which reads Duchamp's politics of delay from within this model of the 'shop window'.[42]

According to David Joselit the Duchampian readymade represents the modern self as a 'subject constituted in relation to its desire for an identification with commodities that surround them'.[43] As such Duchamp is one of the first artists to address the 'desire-value' of the commodity, as opposed to the commodity's use-value. Desire-value is predicated on deferral. The commodity is now a thing that is produced in order to produce desire and therefore something to be waited for (in various stages of frustration and anticipation). For Molly Nesbit 'Duchamp seized control of the dialogue dictated by the shop-window: the model is taken out of circulation, often given an absurd title, hung in a limbo, and effectively silenced.'[44] Now, 'desire-value' – if we can call it that – is not something that is directly applicable to the early readymades. Many of the early readymades, such as the urinal, snow-shovel (*In Advance of the Broken Arm*, 1915) and commercial bottle rack (*Bottle Rack*, 1914), are far from being luxury goods or objects of impatient consumer desire. Indeed, their everyday functionality marks them out as 'social goods' rather than as

objects of personal consumption. Urinal, snow-shovel and bottle rack are all collectively used, but more significantly, in contrast to a 'desire-economy', they all possess long-term utilization. This, I believe, is significant, because it points beyond the shop window, or through the shop window, to what kind of artist of the commodity Duchamp is. As much as contemporary scholarship would like to find in Duchamp's address to the shop window an artist of the 'spectacle', Duchamp's relationship to mass consumption was one of a *producer*. That is, at all times Duchamp's early unassisted readymades invoke or mediate the signs of labour and utilization; or, more precisely, a new utilization or extended utilization of the artwork is given form through the utility of objects produced by productive labour. The notion that the early unassisted readymades are objects which possess extended utilization in their pre-art state is rarely commented on, if at all. This is because the readymade is invariably slotted into the generic and unexamined category of 'found objects'. As I have suggested, this emphasis on utilization is not to turn Duchamp into a revolutionary productivist by another name. His subsequent career obviously belies this. But, rather, it is an attempt to acknowledge how much Duchamp is an artist in which artistic labour and productive labour, the conditions of autonomy and heteronomy, infect each other. His readymades, therefore, are far from being deracinated objects of the spectacle or free-floating cyphers of consumer desire. On the contrary, they are congeries of two kinds of labour (artistic labour and productive labour) made homely and unhomely by their proximate relationship to each other. Hence it is the long-term utilization of the urinal as an object that is crucial to evaluating *Fountain*'s initial failure as an artwork. The courted 'delay' of the urinal's acceptance as an artwork is co-extensive in time with the long-term utilization of the urinal as a functional object. In other words the use-value of the art object (its desire to escape exchange-value) and the object of productive labour as an object of utilization coalesce. This points to what, I believe, preoccupied Duchamp in these early unassisted readymades: the production of an object in which productive labour and artistic labour are conjoined in a state of critical tension and suspension. The meaning of 'delay' in Duchamp's work, then, is attached to something more profound and far-reaching than reflection on the exigencies of consumer desire. It is attached to the future transformative possibilities of *aesthetic praxis on social praxis*. This is why the period of the unassisted readymade didn't last very long. For its reliance on the 'literalism' of the

object of productive labour was too open to confusion as a form of artistic nihilism. And this is why Duchamp spent so much intellectual and creative energy in recovering the unassisted readymade's place in his practice. To 'let the unassisted readymade go' would have confirmed its nihilistic status to those who counted, and therefore it would have appeared as if he *did not care*. All Duchamp's subsequent important work (*The Large Glass* and *The Green Box*) is taken up with showing that as an artist of the readymade, he *does care*. So, as unassisted readymade passes into assisted readymade and assisted readymade passes into numerous other sub-categories, the readymade becomes a rendezvous for various kinds of intellectual labour, leaving the idea of the early 'unassists' as mere tokens to those who would wish they had never happened.

At this juncture it is well to return to Marx and his dialectical insistence that, just as there is no significant difference between physical and intellectual labour under the law of value, the law of value strips intellectual labour from productive labour *tout court*.[45] Indeed both processes feed on each other. Marx referred to these aspects as the equalization of labour, the tendency inherent in abstract labour to reduce complex labour to simple labour. The result, he insists, is a general process of deskilling in which qualified labour is subject to a general separation of intellect from manual skills. This prevails because the distribution of knowledge amongst productive workers becomes a positive barrier to the extraction of surplus-value. The time-consuming processes of intellection are taken up by the development of machinery, stripping the productive worker of his or her accumulated skills. Deskilling, therefore, is the general expression of the abstract socialization of productive labour, irrespective of counter-tendencies across different sectors of production. And without this process of stripping complex labour back to simple labour, capitalism would not exist – to reiterate Sohn-Rethel – it would simply collapse back into forms of artisanal co-operation.

Duchamp is not so much an artist of an emergent 'consumer economy' as an artist of this transition from complex labour to simple labour. For not only do we encounter an explicit convergence between physical and intellectual labour in his art, but, in the unassisted readymades we are confronted with an object that, although it claims artistic status, clearly takes a form of labour which is stripped of subjectivity. The unmanipulated object of productive labour stands as a stark reminder of the subjectless content of abstract labour. But this does not mean that the technical

deskilling of art can be mapped unilaterally on to the deskilling of productive labour (see Chapter 3). The fact that art does not fall under the law of value obviously precludes the *loss* of skill in any absolute sense: the introduction of technical elements and technological processes into the work of art is always subject to the autonomous control of the artist. Yet, in a world of deskilled productive labour there is perhaps a more compelling way of reading Duchamp's notion of the readymade as a 'rendezvous', or a rendezvous with *technik*: as an intrusion of artistic subjectivity *into* simple labour. In other words in the unassisted readymades simple labour is repossessed or contaminated by a substitute form of complex labour, just as in the later works the readymade becomes part of a series of complex narratives and theoretical frameworks. All of his artistic decisions, after he gives up painting, point to a reflection on the reality of this convergence between complex labour and simple labour, intellectual labour and manual labour. However, does this mean that Duchamp was a theorist of artistic labour before he was an artist who broke with painting? No, rather, he allowed his own aesthetic dissatisfactions with painting to find what he saw as the most audacious counter-intuitive form available to the avant-garde artist at the time: a commodity *without* ostensible artistic content. This means we should not make him out to be an artist who had strenuously prepared the grounds for his own intervention. Rather, his skill and acumen lay in his willingness to open himself to the technical forces that were about to pass through art like a whirlwind in the first three decades of the twentieth century, without fear of consequence. Duchamp, therefore, was an artist whose hunch about the readymade as a technical category paid off. The readymade became more than a discrete intrusion into painting, it became the source of material practice.

NOTES

1 Karl Marx, *Theories of Surplus-Value*, Part 1, Lawrence and Wishart, London, 1969, p.236.
2 Terry Atkinson (Art & Language), 'From an Art & Language Point of View', *Art-Language*, Vol. 1, No. 2, February 1970, pp.25–60.
3 See Arthur C. Danto, *The Transfiguration of the Commonplace: A Philosophy of Art*, Harvard University Press, Cambridge Mass. and London, 1981; and George Dickie, *Art and Value*, Blackwell, Oxford, 2001. On the question of anti-art and the readymade, see Héléne Parmelin, *Art Anti-Art: Anartism Explored*, Marion Boyars, London, 1977; and for a wholly aestheticized (and psychoanalytically driven) reading of the readymade, see Margaret Iversen, 'Readymade, Found Object, Photograph', *Art Journal*, Vol. 63, No. 2, 2004.

4 See, most famously of course, Walter Benjamin, 'The Work of Art in the Age of Mechanical Reproduction', in *Illuminations*, Fontana, London, 1973, pp.219–53.

5 See Gary Smith, ed., *Benjamin: Philosophy, History, Aesthetics*, University of Chicago Press, Chicago, 1989.

6 For example, Thierry de Duve, *Kant After Duchamp*, MIT, Cambridge, Mass. and London, 1996; David Joselit, *Infinite Regress: Marcel Duchamp 1910–1941*, MIT, Cambridge, Mass. and London, 1998.

7 Joseph Kosuth, 'Art After Philosophy', in *Art after Philosophy and After: Collected Writings, 1966–1990*, ed., Gabriele Guerico, MIT Press, Cambridge, Mass. and London, 1991.

8 A claim made, with some plausibility, by Allan Antliff. Stirner's condemnation of the ego's subservience to metaphysical concepts and to normative social conventions (*The Ego and Its Own* [1845]) and defence of the 'decentred' 'I', certainly has convincing affinities with Duchamp's espousal of the protean self and the 'underdetermined', contingent artwork. Moreover, Stirner's writing on the proletariat and 'free labour' were subject to extensive discussion in avant-garde circles in New York in which Duchamp participated. See Allan Antliff, *Anarchist Modernism: Art, Politics and the First American Avant-Garde*, University of Chicago Press, Chicago and London, 2001. Yet it would be wrong to assume that the debate on artistic labour and productive labour internal to Duchamp's work was derivable from this political position. On the contrary, my argument is that the reflection on artistic labour and productive labour in Duchamp's art is part of a general debate taking place in the avant-garde in Europe on the nature of labour, art and value which was far wider than a commitment to Stirnerism or any other political position; and that Marx's categories are best placed to understand this. Stirner's politics, then, may be useful in filling out the historical agency of the moment of the early avant-garde in the US, but they don't explain the generalized commitment to the debate on labour and art in the period, or why Duchamp's work is so significant as a series of reflections on labour.

9 'It is a kind of rendezvous.' Marcel Duchamp, *The Essential Writings of Marcel Duchamp*, eds Michael Sanouillet and Elmer Peterson, Thames and Hudson, London, 1975, p.32.

10 Karl Marx, *Capital*, Vol. 1, Lawrence and Wishart, London, 1970, p.112.

11 Ibid., p.121.

12 Ibid.

13 Ibid.

14 Ibid, p.129.

15 Marx, *Theories of Surplus-Value*, Part 1, p.157.

16 Since Marx's day unproductive labour has declined outside the remit of capital as capital needs more workers to realize surplus-value. A new mass of unproductive labour, therefore, has emerged which shares the oppressive and routinized conditions of productive workers, although these workers do not actually produce surplus-value, their wages continuing to be paid out of the commodity values produced by productive workers. See Harry Braverman, *Labor and Monopoly Capital: The Degradation of Work in the Twentieth Century*, Monthly Review Press, New York, 1998.

17 Marx, *Theories of Surplus-Value*, Part 1, p.172.

18 Ibid., p.401.

19 I.I Rubin, *Ocherki poteoril stoimosti marksa*, Moskva: Gosdarstvennoe Izdatel 'stvo, 3rd Edition, 1928; translated as *Essays on Marx's Theory of Value*, Black & Red, Detroit, 1972, p.166.

20 Theodor Adorno, *Aesthetic Theory*, Routledge and Kegan Paul, London, 1984, p.323.

21 Ibid., p.321.

22 There is no theory of 'economics' in Marx, only the relentless exposure of the delimited conception of human autonomy in the categories of political economy. Concomitantly, this is why *Capital* is an underused theoretical resource *for* 'aesthetic thinking', separate from its older and more familiar use as a foundational text for (post-capitalist) ethics. The distinctive qualities of the labour of the non-determinate artwork shapes Marx's theory of value, bringing the alienated forms of productive and non-productive labour into sharp relief – hence the importance of the memory of 'complex' labour in all its historical variegation in underwriting Marx's analysis of deskilling and the drive towards simple labour at the point of production. Capitalism's socialization of labour, for all its expansion and development of human needs, diminishes the aesthetic embodiment and transmission of human skills in production.

23 Patrick Murray has recently qualified Marx's category of 'abstract labour' by introducing a distinction between 'abstract labour' and 'practically abstract labour' on the grounds that the latter makes a better fist of abstract labour's capitalist form. Hence he argues that although the concept of value-producing labour depends on abstract labour, it is not the same concept. Labour can only produce value if it is abstract, but not every sort of labour produces value if it is abstract. Abstract labour is a general category of labour in the 'physiological sense'. Only under capitalism is labour *practically* abstract. That is, labour is value-producing only when it is systematically divorced from its sensuous, definite aims. See 'Marx's "Truly Social" Labour Theory of Value, Part 1, Abstract Labour in Marxian Value Theory', *Historical Materialism*, No. 6, Summer 2000. See also, Patrick Murray, 'Reply to Geert Reuten', *Historical Materialism*, Vol. 10, Issue 1, Spring 2002. 'Practically abstract labour involves a social practice, the market, "that validates individual labours as human labours in the abstract".' (Murray, 2002, p.171).

24 Diane Elson, 'The Value Theory of Labour' in Diane Elson, ed., *Value: The Representations of Labour in Capitalism*, CSE Books, London and Humanities Press, Atlantic Highlands, New Jersey, 1979, p.173.

25 David Harvey, *The Limits To Capital*, Blackwell, Oxford, 1982, p.37.

26 There is also a way, of course, of reading the readymade as involved in a *veiling* of productive labour. The readymade's decontextualization of productive labour enacts the process of commodity fetishism in pure or absolute form: the commodity is presented solely for contemplation. But this weakens what I believe to be the more convincing notion: that the very presentation of productive labour as artistic labour carries with it a shock effect that cannot be routinely 'aestheticized'. The disruptive presence of productive labour in the sphere of artistic judgement militates against the aesthetizing effects of commodity fetishism.

27 Michael Thompson's post-Duchampian discussion of the passage of 'rubbish' into art, (*Rubbish Theory: the Creation and Distribution of Value*, Oxford University Press, Oxford, 1979) suffers from this. Like Marx he talks about the 'social malleability' (p.50) of commodities, but his understanding of the metamorphosis of the commodity is pursued separate from the theory of labour, turning the commodity into an anthropological category. Thus he assigns cultural objects into two major categories: 'transient' and 'durable'. 'Transient' objects are commodities which are used up in consumption and 'rubbish' (what is left over from consumption). These are objects which decrease in value in time. Durable objects are permanent objects (buildings, precious objects and certain artworks). These are objects which tend to increase in value in time. However, what is peculiar about 'rubbish' is that it can pass over into the category of the durable through the category of art. Furthermore, once it is has attained this status, like other durable objects (not made out of 'rubbish') it is hard for it to pass back into the category

of rubbish. Rubbish-to-durable is common therefore; productive-labour-to-durable-object uncommon; and durable-object-to-rubbish uncommon – although it was said that seventeenth-century Anabaptists in Münster reputedly turned pictures of the Virgin Mary into toilet lids, just as high-alters were used as latrines in defiance of the sacredness of Church property (see Dario Gamboni, *The Destruction of Art: Iconoclasms and Vandalism since The French Revolution*, Reaktion, London, 1997). For Thompson, then, 'rubbish' becomes a post-Duchampian catch-all for the function of the readymade as a source of 'wild value' at the expense of the readymade as a technical category. See also Peter Hacks, *Schöne Wirtschaft. Ästhetisch-ökonommische Fragmente*, Nautilus, Hamburg, 1996.

28 Marx, *Capital*, Vol. 1, p.345.

29 Ibid., p.75.

30 Guy Debord, *The Society of the Spectacle*, Black and Red, Detroit, 1977.

31 Alfred Sohn-Rethel, *Intellectual and Manual Labour: A Critique of Epistemology*, Macmillan, London, 1978, p.42.

32 Ibid., p.123.

33 Sohn-Rethel's critique of the value-form is limited by his acceptance of the notion that the 'scientification' (*Verwissenschaftlichung*) of production under capitalism makes possible a new form of the socialization of labour under socialism. For Sohn-Rethel capitalist rationalization has already accomplished the main work of this socialization. In this respect his critique of value only goes so far. Under socialism the value-form is not abolished, but consciously *applied* by workers. This is a critique of the value-form under *market* socialist conditions. On this basis Sohn-Rethel reveals a technist indifference to the social form of technology. For a further discussion of this issue, see Chapter 7.

34 Ibid., p.24.

35 See also, Istvan Mészáros, *Beyond Capital: Towards a Theory of Transition*, Merlin Press, London, 1995. Like Sohn-Rethel Mészáros is preoccupied with the concept of utilization and the use-values of labour. Wealth is not to be equated with surplus-value (the production of wealth) but with self-realization through the *wealth of production* (the creative application of disposable time). Unlike Sohn-Rethel, however, he is unambiguous about the social form this will take: the capitalist factory 'cannot be simply transplanted to the social soil of the "new historic form"'' (p.544). Only with the supersession of the value-form will a 'qualitative reorientation of [the] social metabolic reproduction' (p.546) of capitalism occur. Only then will human practice be reoriented towards the wealth of production (the universality of individual needs, capacities and pleasures).

36 Duchamp, 'The Green Box', in *The Essential Writings of Marcel Duchamp*, p.26.

37 In March 1912 Duchamp's *Nude Descending a Staircase* (1912) was rejected by the hanging committee of the Paris Indépendents, which included Duchamp's own brothers, betraying the committee's very *raison d'être*: 'Ni récompense ne jury' (which had been introduced in 1884). The New York Society of Independent Artists borrowed this slogan from the Paris Indépendents – largely through the efforts of Duchamp, who was one of the directors of the Society. When he submitted the urinal in 1917 and it was rejected there was, therefore, a recent history of disappointment and failed expectation underlying his brinkmanship. Rather than submit something that the selectors expected him to submit – a post-cubist collage or painting or a mechanoid image – he failed to submit altogether, that is, he submitted something quite different – a vulgar toilet – under a pseudonym. For a discussion of the submission procedure and the aftermath, see Thierry de Duve, *Kant After Duchamp*, pp.89–143.

38 For a lengthy discussion of the national context of Duchamp's early work see, Wanda

M. Corn, *The Great American Thing: Modern Art and National Identity 1915–1935*, University of California Press, Berkeley, Los Angeles and London, 1999. Corn reads Duchamp and his circle as being in competition with Steiglitz's 'second circle' (the largely nationalist post–1917 post-Camerawork grouping, which included for a while William Carlos Williams) for the mantle of a de-Europeanized – that is non-*Parisian* – American avant-garde. As such, Duchamp (and Picabia) tended to recognize 'only those elements of life in America that were different from those of Europe and exaggerated their character and incidence' (p.55).

39 This notion of the 'blind' seeing the readymade as against the seeing being blinded by the readymade's refusal to return the spectator's gaze (their pleasure in the art object) is constitutive of the campaign. *Fountain*, which does not want to be seen by the seeing – because they see blindly – is given a new life by the blind who can see beyond the letter of the law and the blind who want to see in good faith (the easily led Stieglitz). Here in all its clarity is the apparitional condition of Duchamp's courting of 'delay'. The readymade blinded at birth gradually makes its way into the light. But of course, the reemergence of *Fountain* is not the rebirth of the original object, but its spectral reinvention: there is no object to recall to vision, only Stieglitz's photograph. In this respect what *is* made visible here in these transactions is the very immateriality of the meaning of art: the fact that a work of art can be made out of a series of transferences from real object to imaginary object without experiencing loss of vision, so to speak. 'Delay' is a form of productive blindness in Duchamp. Some writers have allied these constitutive relations of 'blindness' and vision in Duchamp's work to a narrative of 'lost and found', given that many of the readymades come down to us as replicas and photographic stand-ins. (See, on this point, Martha Buskirk, 'Thoroughly Modern Marcel', in *The Duchamp Effect*, Martha Buskirk and Mignon Nixon, eds, MIT, Cambridge, Mass. and London, 1996) Many of the early readymades were lost or were deliberately 'disappeared'. Moreover the failure to see the readymade as a corollary of 'refusing to see it', seemed to be deliberately courted by Duchamp. In 1916 he showed two readymades, *In Advance of the Broken Arm* and *Traveller's Folding Item*, at the Bourgeois Gallery in New York. These were exhibited in the entrance and were taken for ordinary objects. Furthermore, if the readymade, at its birth, is unseen in its visibility, many of Duchamp's later composite works 'fail' vision. In *The Large Glass* the would-be primary conditions of aesthetic experience – the sensuously visible – are suspended by the transparent conditions of viewing.

40 Sarah Greenough, ed., *Modern Art and America: Alfred Stieglitz and his New York Galleries*, Bullfinch, Boston, 2001, p.222.

41 Duchamp, *The Essential Writings of Marcel Duchamp*, p.74.

42 See for example, David Joselit, *Infinite Regress: Marcel Duchamp 1910–1941*, and Molly Nesbit's 'Ready-Made Originals: The Duchamp Model', *October*, No. 37, Summer 1986, pp.53–64.

43 David Joselit, *Infinite Regress*, p.196.

44 Nesbit, 'Ready-Made Originals', p.62.

45 Marx, *Theories of Surplus Value*, Vol. 1, pp.152–304 and pp.389–413.

TWO

MODERNISM, REPETITION AND THE READYMADE

As a technical category the readymade draws on a key number of formal processes: superimposition, juxtaposition and, most importantly, reproduction or repetition. It is the latter I want to discuss in this chapter as a further exploration of Duchamp, *technik*, artistic skill and labour theory. For it is the interdependent notions of reproduction and repetition that characterize Duchamp's shift away from the *primary* emphasis on the handcraft in his use of the readymade, and that determine the relations between skill, deskilling and reskilling in art generally.

By placing an object of productive labour (the urinal) in front of an art audience, Duchamp produced a kind of mimetic short-circuit. The actual object of perception now stood in for the object of representation. Braque and Picasso also realized how vivid this kind of play between perception and representation was. But they cast it as a kind of *trompe l'oeil* detail in their paintings: is this an actual masthead of a newspaper, or is it a painted masthead of a newspaper? Duchamp had no interest in such *trompe l'oeil* effects. On the contrary, what was so striking about the readymade released from the confines of the frame of the painting was that it didn't need to persuade you it was something else. It was exactly what it appeared to be: an object of productive labour transposed into the category of art. Yet Duchamp and Braque and Picasso do at least share one thing: the readymade relieves the artist of the burden of *mere representation*. Why replicate an object, sign, notice, when you can place such things directly before an audience? This is also reflected in the incursions of the linguistic readymade into modernist fiction. The publication of James Joyce's *Ulysses* in 1922 inaugurated a profound reassessment of the mimetic structures of

the classical, high-bourgeois novel. Joyce's loss of confidence in linearity, peripatetic adventure and psychological description as a means of moving the narrative forward was a consequence of two related claims: the belief that montage approximated the discontinuities of reality more closely than classical narratives, and an insistence that the direct 'documentary' incorporation of readymade texts, quotes, titles and slogans increased the textual verisimilitude of the work. These devices are also evident three years later in John Dos Passos's *Manhattan Transfer* (1925). Lines or verses from songs of the time, store signs, newspaper headlines and adverts (invariably in capitals) punctuate the narrative. Similarly this docu-montage conjunction of narrative form and readymade form is also evident in German literature of the period, in particular Alfred Döblin's *Berlin, Alexanderplatz* (1929). Duchamp's early readymades do not prefigure docu-montage in any simplistic sense. But, as in the later moment of photodocu-montage, in which we could also include both John Heartfield and Hannah Höch, his work does insist on the power of the presentation of the actual to do the work of representation itself. This is something, therefore, that seems constitutive of the technical transformations of early modernism, and not something that is specific to one artist or a group of artists. In other words the modernist use of the readymade makes a strong claim on a form of mimesis that is qualitatively different from its classical understanding. The object of perception is not transcribed or fabricated into an imitative form, but is delivered *intact* to the beholder. And it is this 'intactness' or repleteness that signifies its modernity and link to general social technique. But, of course, there are limitations to this repleteness across art forms. The readymade in literature is a very different matter from the readymade in art. The readymade in literature is never other than a *sign* of readymadeness: the original signifiers do not themselves appear in the text, even when they are reproduced, and therefore, their function is merely quotational.[1] This is due to the simple fact that literature is an art of reproduction and therefore its material signifiers are subordinate to the process of reproducibility. No novelist would dream of sticking different found images or objects in each of the published copies of his or her book, nor would they be encouraged to.[2] In art, however, and in Duchamp's art in particular, repleteness is actual and transparent. The readymade is *co-extensive* with the form of the work. This is because the art object is, as I have outlined, not necessarily subordinate to reproducibility (and the value-form). This means that the mimetic content of the readymade in art is quite

unlike any other creative practice that underwent the mimetic revolution of the readymade in the first two decades of the twentieth century. The readymade may undergo some form of manipulation in art, it may even be transformed into a sign of readymadeness (as in the rephotographing of a photomontage or, for example, Stieglitz's photographing of Duchamp's *Fountain*), but nevertheless it is able to retain its formal repleteness, or some part of this repleteness. This means that the mimetic content of the readymade in such instances establishes a quite specific relationship between reproduction and representation. The repleteness of the ready-made in art derives from the fact that the presentation of the readymade is an act of repetition *without copying*. The readymade is not made to stand in as a replica or imitation of itself; artistic-form and material-form are identical. As such the readymade is not the result of any effort on the part of the artist to reproduce an approximate representation of some object, or some part of the world. No handcrafted or mechanical process of replication is involved in the realization of the object. Yet, if no process of replication takes place, the readymade is without ambiguity a form of representation. For in entering the category of art the readymade enters the intentional space of authorship, and therefore enters the space of signification, insofar as the act of presentation is bound by nominal conditions of authorship (choice and judgement). The act of presentation or nomination is itself a claim to representation and meaning. And this is what Duchamp implies by the readymade as a place of 'rendezvous'. By submitting itself to aesthetic judgement (and thereby losing its *objective* status as productive labour) the readymade's original sign-value is made subordinate to other sign-values. Original sign-value and other sign-values establish a hermeneutic bond; or, to be more precise, a hermeneutic *triangulation*. The readymade's empirical form as a particular kind of common object is conjoined with its con-ceptual identity as a form of productive and alienated labour, and with its subjective identity as a sign of non-alienated and immaterial artistic labour.

Repetition without copying, therefore, is the very means by which this process of autonomization takes place. By technically separating work and author, a semantic exchange is able to take place between opposed or conflicting categories: art and non-art, alienated labour and non-alienated labour, simple labour and complex labour. It is because the readymade fails to fulfil the conventional criteria of art that this exchange is produced. Without this negation there would be no tangible evidence of conflict between these categories, and therefore no possibility of 'rendezvous'

between their meanings. Indeed 'rendezvous' needs to be seen as the semantic and critical outcome of the readymade's technical separation of work and authorship, much like Eisenstein's 'third meaning', and not as a kind of 'poetic' corollary of the readymade. 'Rendezvous' is, in short, what occurs when a non-art object is nominated as, or as part of, an art object.

The use of the readymade, consequently, is not just about the artist replicating the phenomenological appearances of modern, industrial society, as if all the readymade signified was a desire on the part of artist to bring art and life closer together. This is the readymade as mimetic fallacy. Rather, the importance of the readymade lies in the way it assimilates the technical and technological processes of capitalist production in order to reflect on the possibilities and limitations of those processes of production for art. Without *repetition without copying* art would still be fixated by the idea that the manipulation of the materials of art were incontrovertibly bound to the expressive movement of the hand. *With* repetition without copying art is freed to expand the materials of art beyond artisanship and therefore beyond mimesis as replication by hand or machine: the prefabricated materials of the world become the primary representational materials of art. '[W]hat is making?' Duchamp asked bluntly in 1961. 'Making something is choosing a tube of blue, a tube of red, putting some of it on a palette and always choosing the quality of the blue, the quality of the red . . . So in order to choose, you can also use a ready-made thing, made either mechanically or by the hand of another man, if you want, and appropriate it, since it's you who chose it.'[3] Or, as he was to say in a similar vein in the following year: 'So man can never expect to start from scratch; he must start from ready-made things.'[4] These quotes couldn't be clearer as to the technical content of the readymade. The readymade's expansion of the materials of art is not just a formal extension of the artist's repertoire, but a point of reflection on art's place within the division of labour. This means that, for Duchamp, the readymade can encompass the materiality of painting itself under industrial capitalism. The unassisted readymade may constitute a qualitative break in the *technik* of art, but nevertheless it is continuous with the modern artist's reliance on the necessary labour of others. In other words the readymade is seen by Duchamp to be co-extensive with the history of painting under capitalism, even if it breaks, qualitatively, with the formal contents of this legacy.

This sense of continuity between painting and the unassisted readymade is important in understanding Duchamp's subsequent career after the

unassisted readymades. For it is clear that at no point does Duchamp see the readymade in absolute terms as the *end of craft* in art as such; but, rather, that notions of craft must be severed from the pre-industrial logic of the High-Renaissance paradigm that still holds art, and certain modernists too, in its thrall (see Chapter 5). This is why in a counter-move to the absolutist logic of the anti-art defenders of the readymade, in later statements he incorporates the history of painting into the readymade. 'Since the tubes of paint used by the artist are manufactured and readymade products we must conclude that all the paintings in the world are "readymades aided" and also works of assemblage.'[5] All the paintings in the world, including those by Cimabue and Giotto? Well, in a loose and highly attenuated sense – it is hard to think of the colours and materials prepared by Giotto's and Cimabue's studio apprentices as exactly 'readymades' – but the point is well taken. The history of painting is a history of the artist's reliance on what has been made and touched by other hands ('readymade aided'); and as such, also a history of collective and collaborative labour. But if Duchamp is willing to overgeneralize the historical definition of the readymade, pushing the industrialization of art back to the very origins of capitalism itself, he, nevertheless, is keen to emphasize the singularity of the unassisted readymade as part of this process. For it is the unassisted readymade, under the determinate conditions of advanced capitalism, that brings the link between artistic technique and general social technique in the modern period into inescapable view. On this basis, if we are to strengthen our understanding of Duchamp's work within the labour theory of culture, then Duchamp's art might be best described as a practice formulated against artistic *do-it-yourselvers*.

Just as even fanatical do-it-yourselvers wouldn't smelt the iron and carbon to make the steel to fabricate the nails they need to put up a shelf, artists wouldn't fabricate all the materials they might need for fear that that they were not being authentic and true to their professional status and 'inner creativity'. By the second decade of the twentieth century the transmission of specialist knowledge amongst painters about the preparation of paint and canvas was long in decline. Prepared paints and canvases were widely available, enabling amateur and professional alike access to high-quality artistic goods and resources. In this way, we might talk about the readymade as essentially a discourse on the diffusion of authorship through the social division of labour. This is a labour theory of culture in which art is *produced production*: art is always and already work on that which

is fabricated.[6] Daniel Dennett in his writing on Artificial Intelligence touches on a similar question: how much traffic must humans have with the world, how much must agents 'do-it-themselves', before they can become producers of meaning? In a striking echo of Duchamp, he disagrees that you have to 'learn it all', 'prepare it all', 'make something in its entirety', before signification and agency follow.[7] On the contrary as 'syntactic machines' humans take advantage of understanding that is already built into our bio-historical development. The call for technologically untainted, 'pure', or 'highly crafted' forms of artistic production, for example, is therefore crudely counter-intuitive, insofar as it negates what defines the cognitive and material achievements of human beings. The distinguishing feature of humans is their capacity for 'swift, sensitive self-design'[8] revealing the superiority of human cognitive attributes over all other living beings.

COPYING WITHOUT COPYING

In this light, repetition without copying is a technical advance on repetition *as* copying, because it allows the artist to develop and elaborate other skills on the basis of general or shared social technique. But, if the readymade is not produced as a copy by the artist – copied from an original or another copy – it is nonetheless a copy: a mass produced object. And it is this paradox which sits at the heart of Duchamp's practice. Duchamp presents a copy (a mass produced commodity) without having copied the object himself. The 'copying' has taken place somewhere else – in the manufacturing process. Repetition without copying, then, is another way of saying that the copying has been done by other hands (or other hands at a machine) and not that copying has not taken place at all. This leads to what we might call the *copying without copying* theory of the nomination process of the readymade. No actual replication of an object takes place in the presentation of the object, yet in nominating the object for artistic judgement the object is copied, so to speak, because it is no longer the object it once was, an object of productive labour. The object still retains its material and phenomenological form, but because it is no longer just an object of productive labour, it exists as other to itself, and therefore could be said to be a replication of its original form. And this is where the technical profundity or legerdemain of the unassisted readymade lies: the object is reproduced or copied *in* the act of nomination.

There is much evidence in Duchamp's writing that he was aware of the creativity of copying, and copying without copying, early on in his career. But it is only with the perceived nihilism of the unassisted readymade in the wake of the Independents debacle, that Duchamp began to think through the wider creative implications of this kind of practice. This is reflected in the massive investment Duchamp makes, from the end of the First World War, in the idea of nomination as a complex form of labour, as in the notes for *The Bride Stripped Bare by Her Bachelors, Even (The Large Glass)* (1915–23). Increasingly Duchamp moves from the unassisted readymade as a reflection on the crisis of the artisanal and handcraft to an understanding of the readymade as the source of a different kind of handcraft, in which copying, nomination and mark-making are interwoven. Taking as making, copying without copying as processes of intellection and sensuous apprehension become constitutive of the work. This leads to a greater emphasis upon artistic labour as the interrelationality of technology, technique and artistic subjectivity. Hence, there is an extraordinary commitment on Duchamp's part in the 1920s and 1930s to the reintroduction of notions of craft *into* the readymade.

In Chapter 1 I talked about the utopian inflections in the unassisted readymades; the fact that forms of complex labour in the form of the immaterial labour of the act of nomination inscribed themselves on forms of simple labour (productive labour). Well, in the later work this process of contamination reorientates itself. The readymade is no longer the singular site of artistic labour's transformative content, but the material basis for various kinds of artistic reinscription. This certainly aligns Duchamp's art in the 1920s and 1930s with the dominant model of the readymade of the period: montage. Montage collates disparate photographic-readymade elements as the basis for new unities of meaning. But Duchamp's reinscription of the readymade is not simply montage in these terms, because, for all his reliance on the congregation of discrete elements in *The Large Glass*, Duchamp had no interest in the pictorial (Heartfield, Höch) or linear (El Lissitzky) resolution of such elements, or the subjection of the readymade to the heteronomous functions of an art of copying (propaganda, design, advertising). On the contrary the readymade is folded back into a reflection on the hand and craft. This is revealed, most strikingly, in *The Green Box* (1934), Duchamp's repository and archive of his early works.[9] The box contains not only photographic reproductions of the early readymades, such as

Fountain, but also hand-altered photo-reproductions. Sarat Maharaj describes the contents in detail: In *The Green Box*

> touched-up photographs as assisted or rectified readymades, take on the status of originals. More surprisingly, photoreproductions, colored by hand from memory of the original, for use as color models, "coloriages orgineaux," are inserted in the deluxe series as originals. These are replicas made from reproductions of replicas and readymades and the like. With each inflection of the original/reproduction divide, [Duchamp] produces some sort of curious in-between item – hybrids that belong neither to one side nor the other but seem to be made up of elements of both.[10]

These 'curious hybrids' are no more nor less the result of Duchamp's continuing exchange between artistic labour and productive labour, non-alienated labour and alienated labour, simple labour and complex labour. Yet, what distinguishes these hybrids of artistic labour and productive labour from the unassisted readymades is that the unreproducible and reproducible identity of the artwork converge. Hand and machine become partners in the conflict between alienated and non-alienated labour. Handcrafted reproducible images (elaborately coloured prints) share the same space as reproductions of handcrafted reproducible images (collotypes interrupted by cut-outs and stencils); reproducibility is subject to the intervention of the hand, and therefore to artistic subjectivity. In line with Duchamp's view of tubes of paint as readymades, reproducibility is shown to possess the materiality of craft. Original and copy change positions. But this is not a free exchange. Reproducible object and non-reproducible object remain of necessity caught up in an asymmetrical relationship. Craft is not that which *transcends* reproducibility, but, on the contrary, that which is *subordinate* to it and, therefore, *inscribed* in it. I have argued that Duchamp's drive to reclaim the unassisted readymade for his practice was an attempt to recover the readymade from its perceived nihilism. It seems increasingly the case that in the 1920s and 1930s this process takes on the reconstitution of the notion of craft. Through the assisted readymades, such as *With Hidden Noise* (1916), to *The Green Box*, Duchamp transforms the readymade into the *craft of reproducibility*. *The Green Box*, then, is a way of Duchamp showing off this range of techniques. His early contempt for the hand, *la patte*,[11] has been exchanged for a realization that it is the hand, touch, sensuous manipulation that secures reproducibility from the forces of

heteronomy. But this is not an argument *for* handcraft. *The Green Box* is, rather, a demonstration of the interchange of immaterial or intellectual labour and craft. Handmade and readymade, manufactured object and crafted object, writing and printing, language and image, visualization and conceptualisation infect and 'correct' each other.

This leads us to one of the central questions of the new Duchampian scholarship and the issue of the readymade's relationship to craft: how much does the principle of copying without copying, and the craft of reproducibility, translate back into painting? In the light of Duchamp's readiness to incorporate painting into the readymade, how close does the craft of reproducibility remain linked to the history of painting?

What is forthright about the new Duchampian scholarship is the notion that the craft of reproducibility demonstrated in works such as *The Green Box* is evidence of Duchamp secretly maintaining his career as a painter by other means. Painting as craft is remade as painting as *idea as craft*. By drawing the readymade into a system of complex allegorical reflections on authorship Duchamp disabuses those who read the readymade as instituting an absolute division between authorship and the *work* of the artwork. That is, the internal complexity of Duchamp's art doesn't just derive from an intellectual reflection on the 'condition of painting', but from a material engagement – albeit displaced – with the manifold cognitive demands of post-Cubist painting itself. Hence, far from being the very antithesis of painterly form and therefore separate from the horizon of modern painting's achievements, the unassisted readymades and later readymades are treated first and foremost by the new scholarship as an ideational translation and transfiguration of what is central to Cubism: the withdrawal from painting of the figurative body. The metonymic bodily elements of Picasso and Braque's *papier collés* become the metonymic bodily *stand-in* of *Fountain* and *Bottle Rack*. This is very much David Joselit's position in *Infinite Regress* (1998). Like Rosalind Krauss he defines the importance of Cubism in the first two decades of the twentieth century as lying in its occlusion of the figurative, carnal body to vision.[12] The female body and male body are made incorporeal, separated from sensuous anatomy, delivered to the strictures of anti-naturalism. In Picasso's *Demoiselles d'Avignon* (1907), for example, the figures (prostitutes) are clearly naked, but their nakedness is

subordinate to the inchoateness of the composition, diminishing the sexual import of the scene. Picasso and other modernists didn't stop painting the body, or stop trying to find correlates for the representation of sexual identity, but under the demands of anti-naturalism the carnal body was no longer the focus of a palpable eroticism, for fear of reintroducing the 'nude' as a retrograde kind of studio practice: the naked body as a muse or source of anatomical study. Indeed such eroticism could only oppose the analytic logic of Cubism: its identification of the carnal body as an artistic pleonasm, the thing that seeks florid (but unearned) attention for itself. This deidealisation of the carnal body is even evident by the 1860s, as evinced by Manet's ironic deflation of the classical nude in *Dejeuner sur l'herbe* (1863). Duchamp's bodily stand-ins in the unassisted readymades, therefore, are a direct translation of this deidealizing Cubist 'script' into a post-painting painterly space; 'carnality is established not by the nude but in the material bodies of commodities like a snow shovel or a urinal'.[13] Carnality is reintroduced *as* sign, and furthermore, as a 'troubled' sign: these are bodies caught up in linguistic, social and scientific mensuration. For Joselit, then, in early Duchamp there is no 'irreversible move from painting to [the stand-alone] commodity'.[14] The readymade is lodged at every turn within the problem of painterly figuration.

DE DUVE'S DUCHAMP

This is plainly an attack on those, such as Peter Bürger, who read Duchamp as a nihilist and without any nuanced understanding of the work's debt to the problem of the body in Cubism.[15] In *Kant After Duchamp* (1996), Thierry de Duve is also dismissive of those who remove the dialectical penetration of painting into the readymade in order to read Duchamp against the history of modernism. If Duchamp had given up every artistic ambition associated with painting when he gave up painting 'no one would speak of him today', de Duve says.[16] In this respect the readymade 'ought to be reinterpreted today in connection with paint-ing';[17] and Duchamp should be seen as an artist who found a way of 'painting' after painting. As with Joselit, in de Duve it is *The Large Glass* that encapsulates this non-painting-into-painting practice. The bride (painting) in *The Large Glass* is inaccessible to vision (and to penetration) because it requires another way of seeing her, beyond the painterly, mensuration of the bachelors' (painter's) stare. 'If painting was a *bride*,

rs. Separation between the lovers had to be
ndition of *eroticism*, humorously understood as a
if de Duve, like Joselit, is interested in locking
)gy of modernist painting, his claims for doing
han Joselit's, bringing the new Duchampian
hilosophical focus. Because Duchamp's under-
is always a matter of judgement and choice, for
the fact that the readymade has no special
s an object: it is submitted to the judgement
he way, and under the same conditions, as any
art' Duchamp is not thereby saying that 'this is
art' and that this non-readymade 'is not art', but, that this readymade,
here, is necessarily subject to a judgement of taste (of approval or
rejection) on the part of the spectator, and therefore, open to evaluation
as a *good* work of art. The revolution of the readymade, for de Duve, then,
is based on a Kantian imperative: the readymade is submitted, without
favour for universal aesthetic judgement. And key to this is what de Duve
calls the 'enunciative' function of the readymade.[19] The fact that as an
object of conscious choice and intellectual nomination the readymade is a
statement, and as such redescribable as a complex and meaningfully
authored act. De Duve recognizes, then, that the readymade has trans-
formed the conditions under which artists labour and spectators fashion
judgements. And he refers to this as a shift to a generic practice of art.
The artist can now be an 'artist at large', rather than just a painter, sculptor
or composer, etc.[20]

However, these changes are not presented as a technical liberation by de
Duve, but as a historical *fait accompli*, which the artist is compelled to
address. Duchamp is a significant artist because he was one of the first to
acknowledge the actuality of this historical situation in a rigorous and
ambitious fashion. Hence what de Duve is keen to emphasize is that
Duchamp is *much more* than an artist of the readymade. And this is why,
despite de Duve's recognition of the 'generic' artist, he is keen to bring
Duchamp squarely back into the painterly fold. De Duve's reading of
Duchamp's painterly turn to the readymade, therefore, carries with it a big
stick to beat the revolutionary avant-garde: what makes Duchamp a better
artist, than say, Tatlin, Rodchenko and El Lissitsky, he suggests, is that he
didn't invest in the anti-aesthetic ethos of the readymade. Quality in art
cannot be defined except by pointing at particular works and judging them

to be of quality – as exemplars of quality in *all* art. In this sense, argues de Duve, only conservatives have been faithful to anti-tradition because they stubbornly see that the avant-garde is tradition. So, Duchamp is the exemplary traditional anti-traditional artist for placing the negation of painting – the readymade – so securely into the place of aesthetic judgement.

There is some truth in de Duve's and Joselit's painterly model of attention: the giving up of painting and the crisis of the 'retinal' are inscribed in the very materials of *The Large Glass* and the *The Green Box*; just as the deflated Cubist body is present as a metonymic absence in the early readymades. Duchamp's relationship to painting is unmistakable. Similarly, a defence of the readymade as a place of authorial intention, rather than as a cipher of anti-art or the end-of-art, seems utterly indisputable. But if the painterly carnal body disappears in Picasso, it doesn't just reappear in Duchamp as a form of displaced painterly labour. The loss of the body in Cubist painting may be inflected in Duchamp's early readymades, but the body is not 'painted in' by the readymade. The readymades also importantly *displace* painting from the seat of authorship. As I have insisted, just as the readymade is subject to aesthetic judgement, aesthetic judgement in turn is subject to the use-value (utilization) of productive labour. This is why it is important to think of the readymade not just as an enunciative category characterized by painterly ambition, but as a productive category characterized by objective technical demands. De Duve, however, doesn't do this. This leaves his enunciative model of the readymade without any discernible link to the debate on labour that underlies Duchamp's resistance to conservative defences of *la patte*. Indeed, the separation of artistic technique from general social technique in de Duve locks his writing into an antinomial Kantian logic, leaving his commitment to aesthetic judgement limping behind art's technical transformations. This is reflected expressly in his very narrow understanding of art in the wake of the technical and cognitive revolution of the readymade. He talks constantly about the crisis of the avant-garde, and of its 'disappointed hopes',[21] listing post-war art movements and manifestations (Conceptual art, body art, land art) as if they had failed some indisputable test of political, social and cultural judgement. 'None of [the] ideals of [the avant-garde] has kept its promises.'[22]

The idea that art fails the test of judgement because it fails to materialize its ideals is sheer idealism; art's ideals are tested in social circumstances not

of their own making, and, therefore, art's claims to 'transform' the world in non-revolutionary periods are neither here nor there. But the more pertinent point here is that de Duve divorces the revolution of generic art from the deeper and longer process of transformation that links Duchamp and the artists of the Russian revolution and Weimar to art of the 1960s and beyond: the (attenuated) convergence of art with general social technique. De Duve may accept that art is now 'generic', but it is accepted with some resistance and with a melancholic Greenbergian incomprehension as to 'how did things get so bad?' In this way de Duve proudly proffers his Foucauldian genealogical method as a way of stepping beyond what he sees as the false hopes of the old avant-garde. But what we get in its place is a theory of milksop-negation. Because art – as de Duve contests – is cut off from an emancipatory project; art must now turn 'utopian critique into the critique of utopias'.[23] Art must 'no longer anticipate'.[24] Even if this was hermeneutically possible – as Adorno admirably demonstrates it is not[25] – it is a strange thing to say for someone who is ostensibly committed to 'reflexive' practice.[26] But this is what happens when 'aesthetics' as an experiential category is separated from the craft of reproducibility and copying without copying: the links between technique, technology and art and social transformation become incomprehensible. Hence antinomic logic can appear in formulations that appear to be progressive. For example de Duve declares in all sincerity: 'It is not true that artistic freedom derives from political freedom, nor conversely that artistic liberation or revolution necessarily announces, prepares, provokes, or accompanies political liberation or revolution.'[27] This might seem reasonable, but, I would insist, it is exactly the opposite of the truth. On accepting the assumption that art's autonomy cannot be secured by instrumental ends, a familiar slippage tends to occur in the views of those who see art and social determination as antipathetic: art's autonomy is made to float free of technique and technology as social transformative categories. In this way the general separation of artistic technique from general social technique, which runs through de Duve's writing, actually contradicts what is significant about Duchamp as an artist of the readymade. Duchamp is not just a non-painter in the guise of a painter, even if painting does haunt his life's work. He is a critic of the *separation of artistic labour and productive labour*, which places his use of the readymade not just on the side of aesthetics and the enunciative. The readymade is also a *rebuke* to 'aesthetics' understood as a category of experience separate from the realm

of productive labour. Thus the 'generic' is not something his commitment to painting-beyond-painting subverts and whittles down to size, but that which the work passes through and whose contours it reshapes. This makes the interface between the reproducible and non-reproducible in *The Green Box* crucial to understanding Duchamp's relationship to the legacy of painting and to questions of artistic skill. For what the *The Green Box* presents is the placing of the artist's body in a position of purposeful *non-alienated intimacy* with the machine. Hand and reproducible process impose themselves on each other *all the way down*. This releases a very different sense of authorship than that constructed in the new Duchampian scholarship. What Duchamp is prepared to give to aesthetic judgement he is also prepared to take away with his antipathy to *la patte* as the sign of authenticity. For Duchamp's enunciative use of the readymade is always qualified by the actuality of where the readymade has come from: *the realm of alienated labour.* Hence, we might say – particularly in the early unassisted readymades – it is precisely this which is enunciated.

This leaves us with an important question: what kind of Duchamp do we want, and concomitantly what kind of theory of the readymade do we want? If the theory of the readymade in Duchamp in post-1960s avant-garde theory has become largely otiose because of its misreading of the readymade simply as a critique of commodity fetishism,[28] in the new scholarship a less absolutist reading of the readymade has nonetheless produced a mirror image of this closure. In looking past each other both positions fail to address the complex relations of Duchamp's use of the readymade. As a consequence these positions fail to register the way in which the readymade in Duchamp participates in an emergent debate on, and struggle over, definitions of labour in cultural production in modernism. This culture of labour in modernism is thoroughly generalized in Europe in the 1920s and 1930s and is very familiar, stretching from Alexander Rodchenko, Sergei Tretyakov and Boris Arvatov, to Brecht and Moholy-Nagy (see Chapter 4), and represents a long line of theoretical and artistic achievement. In America, distanced from the broader ideological terrain of this tradition and subject to a pragmatist rather than a revolutionary model of culture on the left in the 1920s and 1930s, modernism was never as multifunctional and capacious. Yet Duchamp preempted some of the interests of this tradition, and reframed some of its questions in pursuit of his own critical predilections. Duchamp's commitment to *copying without copying* and the *craft of reproducibility* shares a common

ground with the European avant-garde. As such, despite the political gulf between Europe and the American avant-garde, Duchamp and the critical high-ground of European modernism are linked by a certain perception and expectation: that making art was perhaps closer to the making of other, non-artistic things than aesthetic discourse allowed, and that the making of other things might be transformed in the light of how artists made things.

In these terms I want now to focus not on the labour theory of culture in Europe in the 1930s as it impacts on Duchamp and American modernism (which I will take up again later in my discussion of Moholy-Nagy), but on a discussion of labour and art where it seems most appropriate and continuous with Duchamp's actual practice: American modernist poetry, in particular Objectivist poetry, perhaps the most significant modernist achievement in the US after Duchamp's interventions during this period. This is not to prove that the ideology of the readymade made its way far further than we might imagine, although this is surely true; or, to widen Duchamp's cultural profile beyond the narrow confines of the New York art world. But, rather, to insist that the impact of the readymade produced a perceptible transformation of notions of labour in the artwork across disciplines, broadly coeval with what was occurring in Europe. I have already mentioned Joyce and Dos Passos. Well, these transformations were no less acute for American modernist poetry. Indeed, American modernist poetry reveals continuities with Duchamp that warrant close attention. For there is a clear convergence between American Objectivist poetry and Duchamp on the question of *how* the artist labours, and as such, how notions of technique and skill shape the subjectivity of the producer.

In the late teens and early 1920s Duchamp, Francis Picabia and William Carlos Williams were part of Walter Arensberg's artists' colony at Grant-wood. When Williams joined the group he was producing a conventional Poundian Imagism. After being exposed to the thinking of Duchamp, Picabia, Albert Gleizes and others – a frequent topic of discussion was the readymade – his poetry shifted focus.[29] The rhythms and pictorial metaphors of Imagism were renounced in favour of the 'words themselves beyond the mere thought expressed',[30] laying the ground for the Objectivist dissolution of syntax. This is not to say that Duchamp and the later Objectivism share an identical cultural space – there is certainly a 'delay' in reception of the visual arts in American modernist poetry – or, for that matter, that they define the crisis of labour in the artwork in the same way. But, rather, that they share a similar sense that artistic labour and other

forms of labour define each other, and in defining each other challenge the very content of labour and the content of art.

<div style="text-align:center">

THE MODERNIST OBJECT:
OBJECTIVISM AND THE LABOUR THEORY OF POETICS

</div>

At the point where the presence of the hand in art is being occluded and reshaped in Duchamp and later avant-garde art, Objectivist poetry looked to identify the labour of the poem with that of the artisan. This would seem, superficially, to pull Objectivist poetry in another direction to that of Duchamp and the readymade. It is the craft of the poem that repays the attention of the poet and reader. But the Objectivist notion of craft is one that has little to do with conservative notions of aesthetic totality. Artisanship here, is identified, rather, with those forms of complex labour that continue to find expression within a capitalist economy against all odds, and, therefore, share with art some residual resistance to dominant forms of productive and heteronomous labour. The complex labour of the poem – the intellectual working of recalcitrant linguistic materials – is a metaphor for the unity of intellectual and manual labour.

In the late 1920s and 1930s this position received its most advanced expression in the poetry and theoretical writings of Louis Zukofsky. For Zukofsky the modernist poet is the poet who replicates the craft of the artisan through an ego-diminished attentiveness to the object of thought. Accordingly, modernist artist and pre-industrial artisan achieve a comparable kind of intense effacement: their subjectivity disappears into the labour process itself. This is the regulative idea in Zukofsky's poetry in the 1930s: in labouring on poetic form, the poet labours both in solidarity with the object of thought and with the labours of others. Yet, if the production of poetic form is associated with forms of complex labour this is not to be mistaken for any identification between modernist poetry and folk art. Although the craft of the artisan and the craft of poesis share an assiduous attention to the materials of production, for the poet this attentiveness is more than simply a matter of phenomenological sensitivity to form and subjective investment in these materials. On the contrary, the diminishment of the poet's ego in the process of making results in something quite different to that of the pre-capitalist artisan: out of an attention to materials is produced an intellectualization of perception. In producing the object as an object of poetic perception the object is given an 'objective' identity in

social relations. Modernist poesis is a process in which the word exists in a world of external, socially bounded objects and theoretical categories, and not in the realms of the ineffable and metaphysical, or for that matter in the singular, interior voice of the poet as bard. The materials of poetry lie 'outside' the poem and the poet.[31] This grounds the craft of poesis – its autonomy as words and sounds – in historical and theoretical learning, and therefore in a constellational form of production. As Zukofsky said famously in his 'Program: Objectivists' in 1931, emphasizing the importance of intellectual citation and historical knowledge for poetry, Objectivism is embedded in 'historic and contemporary particulars'.[32] In this way Zukofsky insists on a refusal of extraneous metaphor and paraphrastic detail. He talks of the 'isolation of each noun so that in itself it is an image' and the need for the 'grouping of nouns so that they partake of the quality of things being together without violence to their individual intact nature'.[33] This puts him in proximity to the factography of the Russian and European avant-garde rather than the high-modernism of Pound and Eliot, although Pound was one of his most ardent supporters and a major influence on his understanding of the 'ego-less' constellational poem.[34]

In the late 1930s Zukofsky began working for a Works Progress Administration (WPA)-sponsored programme, the Index of American Design.[35] The Index was an attempt to produce a comprehensive archive of images and descriptions of American design stretching back to the seventeenth century. In the 1930s knowledge about local craft traditions was only just coming into being, largely initiated by the WPA. In 1932, Holger Cahill, who instigated the Index of American Design curated *American Folk Art: The Art of the Common Man* at the Museum of Modern Art in New York. Under the influence of Cahill, Zukofsky and his co-workers sought to produce a social poetics of the object, indebted, on the one hand, to Marx's labour theory of value and, on the other, to a native American pastoralism, perhaps the most powerful and dominant counter-hegemonic (anti-corporate) ideological force on the left in America during this period. Some parts of this tradition were clearly anti-urban and conservatively pre-capitalist in orientation, drawing on forms of rural populism,[36] but the progressive wing of this pastoralism was focused more generally on defending an urban, anti-monopoly capitalist communalism. This found one of its marked expressions in the WPA, as these indigenous forms of populism across the country came into contact with Marxism (invariably that of the American Communist Party (CPUSA),

although Zukofsky had no interest in left populism) and European socialist traditions. Zukofsky's work on US artisanal design is a product of this conjunction, generating what is an unprecedented poetics of labour and labour theory of poetics in the US.

The immediate impact of this work on Zukofsky's poetry and Objectivism, generally, was a shoring up of Zukofsky's commitment to 'historic and contemporary particulars'. Which, in turn, became a more direct defence of the possibility of a viable modernist poetry *within* the American context, and not just a defence of American poetry. By focusing on a long and indigenous tradition of American craft, the making of an American poetry from American particulars for Zukofsky seemed less in need of a Europeanized (that is Poundian) revision.[37] The research on design both dissolved the idea that American culture was historically thin (once the artist was prepared to look over the parapet of New York high-culture) and that the object-world of American culture needed 'lifting' by employing classicizing and Europeanized references. Zukofsky, of course, was not alone in this process of US modernist reassertion. However, he is the only major practitioner in the 1930s to think this localized problem of form precisely in relation to a labour theory of culture. This concern with the labour of the artist doesn't actually result in a theory of the readymade in Objectivist poetics. Zukofsky's isolation of the noun as an image is not strictly a theory of the linguistic sign as readymade, as if the noun was a kind of 'unassisted' linguistic element of the poem. Yet, the constellational model of the poem that follows from his theory of the poetic particular – expressed in its most ambitious form in Zukofsky's extraordinary life-long poem '*A*'[38] – is clearly indebted to the prevailing model of intellectual-montage and to a 'rendezvous' theory of the object of poetic perception. Admittedly Zukofsky may not actually use the term 'rendezvous', but he certainly talks about the object speaking back out of its empirical inertness, as part of a poem that thinks *relationally* rather than discretely. And this is where his work for the WPA impacts directly on his labour theory of poesis, and brings his work directly into alignment with Duchamp. In his essays, and radio scripts for station WYNC in New York, Zukofsky stresses the power of the craft object to speak back from its historical slumbers.[39] Like Duchamp, Zukofsky treats the object of labour as capable of realizing certain powers of historical recall through the reader or spectator. The reader or spectator becomes a kind of ventriloquist of labour, in which the object's conditions of production are 'reanimated'

against the object's fetishization as a commodity and its aestheticization as an *objet d'art*. That is, the non-alienated identity of the object, and the object's embedded historical meanings, speak across the centuries to the hand and eye of the modern alienated producer. As in Duchamp, here the object of labour de-aestheticizes judgement, forcing the spectator do some non-emotivist, intellectual work. In one section of '*A*', labour actually speaks through the commodity:

> So that were the things words they would say: Light is
> Like light is like us when we meet our mentors
> Use hardly enters into their exchanges,
> Bought to be sold things, our value arranges;
> We flee people who made us as a right is
> Whose sight is quick to choose us as frequenters,
> But see our centers do not show the changes
> Of human labor our values estranges.[40]

This notion of the reanimated object (and reanimated spectator) is crucial to Zukofsky's poetry. As the ideal reader and spectator the poet metamorphosizes the world of things, brings them into imaginative focus. The intellectual labour of the poem affirms the poet's capacity to shape a thing in consciousness and language.[41] This is compellingly in evidence in one of the best poems of his early career: 'To My Wash-stand' (1932). In this poem Zukofsky addresses his washstand, not in mock bathos as if he were substituting the banal for Romanticism's urns, daffodils and nightingales, but as something prosaic which is worthy of the utmost attention.

> To my wash-stand
> whose wash-bowl
> is an oval
> in a square
> To my wash-stand
> whose square is marble
> and inscribes two
> smaller ovals to left and right for soap[42]

A miscegenation of poet and the actuality of the object occurs. As the poet washes his hands he also composes a poem in his head about the wash-

stand, meditating on its individual parts. However, this 'reanimation' of the ordinary (of squares and ovals) is not to be confused with the residual bardism of William Carlos Williams's experience of the numinous in all things. Zukofsky doesn't want to illuminate the wash-stand with evidence of its hidden beauty, but to mark it out as something whose utility compels respect: 'its marble completed my getting up each morning'. In this there is a clear parodic revisitation of the notion, subscribed to in particular by Duchamp and other immigrant European modernists, that America's greatest contribution to modernity and modern culture is its plumbing.[43] Such a poetics rejects the idea of the poet as a lyrical Cartesian surveyor of a metaphorically 'full' or plumped out stable reality. What is 'reanimated' is the living 'actuality' of the thing. Hence Zukofsky's emphasis on the isolation of the noun into an image is a way of situating the object without the metaphysical intrusions of the poet. If this results, specifically in this poem, in a poem which enacts the making of a poem as the poet goes about his diurnal activities, it issues more generally at the level of the poem's organization – particularly in '*A*' and the later poetry – as a kind of scattering effect in which ordinary nouns 'poke' out from a predication-less syntax. Indeed, it is this 'poking out' of the object that both distinguishes Zukofsky's later work and Objectivism as a whole. In George Oppen, for instance, an Objectivist poet who shared Zukofsky's politics but was less driven by his ambitions of constellationality, nouns hang unattended to. 'I have not and never did have any motive of poetry / But to achieve clarity.'[44]

> Civil war photo:
> Grass near the lens;
> Man in the field
> In silk hat. Daylight.
> The cannon of that day
> In our parks.[45]

Oppen's and Zukofsky's rejection of syntactic disclosure is key to my argument here. As I have stressed, it is hard to talk about the noun as readymade in any strict sense in Objectivism: nouns are not 'found elements' arbitrarily connected as in a 'cut-up' poem, just as they are not simply an enactment of the 'mechanization' of art under the commodity-form. Yet the sense of the noun 'poking out' or through the poem,

thereby denaturing the integrated voice of the poet is clearly indebted to the post-Duchampian mimetic shift of the readymade. Objectivism derives much of its compositional force from the declarative function of the unassisted readymades. The poem presents its objects without metaphoric adornment and syntactical resolution.[46] For Pound and Eliot, and earlier for Manet, the solution to the problem of the fragmentation of tradition lay in the accumulation and reembedding of the signs of modernity in a new classicized space. Duchamp rejected this classicizing by striving, as many of his generation did, for a kind of composition that plunged art into the contingencies of modernity itself. The objects of modernity were not to be pictorialized or aestheticized as part of a narrative of decline but as a site of *productive contradictions*. And, as such, these contradictions (hand and machine, art and anti-art, simple labour and complex labour) were to drive the art, and significantly, transform the self-identity of the artist into a master of miscegenation. Indeed, the origins of the readymade begin in this respect as an attack on the peaceable identity of objects. In the second issue of *The Blind Man*, the campaign in support of R. Mutt gets under way with an article written by Louise Norton (and most probably Duchamp) entitled 'The Buddha of the Bathroom'.[47] This derides the monogamous relationship, not just between people, but between objects themselves, suggesting that what is important about Mr Mutt is that his readymade is prepared to undermine the lawful marriage of object and function. A deliberate clue to this is to be found in R. Mutt's name itself. In Franglais R. Mutt becomes *ars mutt* – a compound of 'art' in French and 'mongrel dog' in American-English – the implication being that the readymade is at base a mongrel art. Moreover Richard ('ri-chard'), French slang for 'moneybags' or 'fat cat', reinforces this, by identifying the monolinguistic (American) spectator with a failure to read the artwork across cultural boundaries and signs.[48]

The miscegenating or mongrelizing artist is crucial to Duchamp's move against Cubist painting and to his convergence of hand and machine, reproducible and unreproducible art object. By nominating the object of productive labour as an artwork and therefore of intellectual interest and curiosity, the artist frees himself from the inhibitory painterly limits to artistic intelligence. Artistic intelligence is no longer governed by the conflation of making with the traditions of mark-making, but rather, with conceptual *acuity*. This idea that painterly intelligence is a limited intelligence shapes Duchamp's thinking before he leaves for New York. For, the overwhelming local artistic context for Duchamp's early readymades

before The First World War is the vast overproduction of painting in the Paris salon and its congealed, prolix justifications. As he was to say in an interview with Jacques Rivière in 1912 at the very height of this glut of paint and words: '[painters] pretend to think.'[49] And it is this pretence to thinking, most dutifully inscribed in Gleizes and Jean Metzinger's *Du Cubisme* (1912) with its waffly Cubist exhortations to beauty, that the readymade 'poked' through, releasing the labour of the artist into a world outside of art. Hence this is what is so liberatory (in the long run) about Duchamp's supposed 'anti-intellectual' gestures: in their suspension of aesthetic process they renew the artist and spectator in an intellectual dialogue. This setting free of the commodity's function in the readymade is analogous to the setting free of the noun in Objectivism. The release of the noun from metaphoric pictorialism allows the voice or voices of the poem to divest themselves of debased lyrical convention and open themselves up to extra-poetic and extra-artistic language. It is no coincidence, then, that Zukofsky's '*A*' should present the poet's voice as a collective voice, a voice which brings the voices of the many (labourers, bourgeoisie, artists, intellectuals) into constellational form. Just as Duchamp decentred the Cubist painter from his insistence on his privileged painterly intelligence, opening the artist to what he does not know or want to know, in opening the poem up to the labour theory of poetics Zukofsky's Objectivism aligns the poet's labour with the conceptual reconstruction and relationality of things.

What, therefore, is at stake in this moment of reflection on the labour of the artist? No more nor less a determination to be rid of the cloying mystifications of traditional notions of artistic craft: in art, the genius of the hand, in poetry the bardic, spiritualized eye. Both Duchamp and Zukofsky make open mockery of certain kinds of deliberative, metaphysical, artistic labour, in favour of a craft of the intellectual, the craft of reproducibility. In turn the terms 'craft' and 'artistic labour' are transfigured, transforming the conventional attributes and character of artisticness. Both artist and poet identify their artistic activity as 'mere' labour – that is, as an ordinary craft, rather than as a form of pure creative autonomy; but if this represents an identification with the figure of the artisan or productive labourer, it is not an identification with the specific content of their labours. On the contrary, 'mere' labour here is something prefigurative – *intellectual labour made commonplace*. Intellectual labour becomes the ordinary content of the artist's/writer's craft, inverting the traditional attributes of the artist as

'critic of reason', and defying the separation of craft and intellectual labour of the labour process.

THE LABOUR OF DEFLATION/DEFLATION OF LABOUR

One of the abiding themes of much Duchampian scholarship on this question of art's relationship to intellectual labour is that the unassisted readymades were not much more than a joke, or more precisely a grim joke at the expense of handcraft. The unassisted readymades' refusal to offer any sensuous rewards and evidence of palpable artistic labour were judged to be a flippant jest, bizarre and adventitious. In *The Popular Culture of Modern Art* (1994), Jeffrey Weiss extends the logic of this argument, but, in a far more sophisticated and critical direction. He believes Duchamp's rejection of the craft of Cubist painting is indebted, overwhelmingly, to two main critical forces which shaped much of late nineteenth and early twentieth-century popular French culture's mediation of high-culture: the *blagueur* (the hoaxer) and the *raté* (the embittered bohemian artist *manqué*, who strives for the immortal 'put down'). Both have the origins in the Second Empire, when modern art was beginning to be subject to various kinds of anxious scepticism within popular culture and amongst artists themselves. Was modern art to be trusted when it appeared so ironic and even infantile in tone? Indeed, the pranks of the *blagueur*, and his cohort the *mystificateur*, who derived humour from the mournful and 'official' delivery of absurd information, and the cynicism of the *raté*, became an established part of Second Empire culture and after, generating a large cast of humorists, chancers and deadpan deflators of modern art and modernism. But *blague* was not unidirectional, a conservative one-way street, it also infected the avant-garde itself. In fact, the *blagueur*, *mystificateur* and *raté* become key parts of the avant-garde armoury in its war of attrition with the forces of bourgeois culture: positivism and propriety; and, perhaps more pertinently, with the official guardians of modern art. For what unites conservative and radical *blague* alike is the pleasure of resisting what is judged to be well thought of, 'of feeling oneself superior by proving that one is not a dupe', as the critic Francisque Sarcey put it.[50] The outcome in pre-First World War France, is a complex array of positions of cultural anxiety on the modern in which popular writers try to outdo the modernists themselves in fabricating avant-garde outrages (in 1877, for example, playwrights Meilhac and Halévy invented an artist Marignan who produced a blank grey canvas

to which was attached a knife); and modernist writers, such as Alfred Jarry, successfully fabricated an absurdist exaggeration of bourgeois efficiency and industry. As Weiss says: 'to the extent that [the *blague*] constitutes a popular experience of modern art, prewar esthetic disorientation can be identified as branch of popular culture, a kind of collective consciousness of sensibility of ambivalence.'[51] This ambivalence is Duchamp's early *metier*, making his unassisted readymades utterly believable as interventions, rather than simply the febrile obsessions of a real and witless *raté*. In fact the word *blague* was soon on the lips of his amanuensis Louise Norton after the debacle of the Independents. In 'The Buddha of the Bathroom' she declares: 'And there is among us today a spirit of "blague" arising out of the artist's bitter vision of an over-institutionalized world of stagnant statistics and antique axioms.'[52] Against the aesthetic redeemers of Duchamp, therefore (and de Duve might creep under the wire here), Weiss rightly treats Duchamp's manoeuvres within the pre-war Cubist milieu as fundamentally disaffirmative and disruptive of prevailing notions of craft. The *blague* is disreputable and noisome, it is not the first move of a shiny 'new industrial aesthetic'. In this respect Weiss's emphasis on the context of the *blague* and the *mystificateur* is important in retaining the notion of the readymade as a rebuke to the aesthetic. Weiss certainly is not a recruit to the new painterly paradigm of Duchampian scholarship. Yet, if Weiss sees *Fountain* first and foremost as a mockery of Cubist labour (all that huffing and puffing for meaning), in the form of the *mystifacateur* deadpan gesture, the general absence of any systematic understanding of the reflection on labour in Duchamp's work leaves the concept of the *blague* as a mere joke, as bereft from the wider and deeper changes the 'hoax' mediates. As I have argued the unassisted readymades are congeries of simple labour and complex labour, artistic labour and productive labour, alienated labour and non-alienated labour. As such they are not 'mere functional'[53] things, content with their own deadpan implacability. On the contrary they are sites of conflict, meaning that their irony, humour and *blague* are weakened, and even mystified, when divorced from the broader context of labour which underpins the Duchampian culture of anxiety. This leads us to ask: how do humour and the *blague* come to find their voice in Duchamp's reflections on labour and artistic skill?

Henri Bergson notes that we tend to laugh when we see an inappropriate or unconscious rigidity of movement or thought. What is humorous is an experience of the mechanical and inelastic where we expect to find the

fluidity and litheness of a human life. In this respect it is the various effects
of the automaton that are primary causes of laughter, for what we see is
inertness where we expect pliability. Inflexibility produces unease, which is
dissipated by laughter. 'Rigidity is the comic, and laughter its corrective.'[54]
Consequently, laughter is a purgative response to the threat of rigidity and
unselfconsciousness (the humour of Charlie Chaplin and Jacques Tati are
perfect examples of this). This is why, as the result of preening self-esteem,
or as an expression of unthinking high ideals, physical obstinacy and rigidity
are so humorous. Inattentiveness to bodily posture tends to produce a
betrayal of such self-esteem and ideals. Accordingly, this is why the comic
always derives from repetition, inflexibility and stasis, and why we laugh
when the body becomes a machine in the pursuit of order, efficiency or
good sense (as in John Cleese's 'Ministry of Silly Walks'). Concomitantly,
this is the reason that fluidity of response, sensitivity to detail and to others,
and dialectical judiciousness are not funny, or rather, are only funny if they
fail to remain fluid and non-programmatic. Once they become program-
matic or obsessive they become equally rigid, and, in turn, become as
potentially humorous as the mechanistic and unconsciously repetitive. To
draw laughter, then, is to imitate those rigid and inflexible aspects of
someone who remains unaware of their own physical and intellectual
inflexibility. Duchamp's unassisted readymades exist in this world of inert,
comedic things: the transformation of the 'living' artwork – of artistic
labour – into a thing without ostensible artistic qualities, produces the
automaton-comedic effect. By copying without copying, and thereby
producing something dead in the name of something living, the producer
of *Fountain* takes on the appearance of someone who is so unaware as to
what counts as artistic labour that they can unselfconsciously pass off an
object of productive labour as art. This creates the impression that the
artist, in an attempt to be 'avant-garde', has fallen in an unthinking way into
the very antithesis of what constitutes a work of art as art: *mere* repetition.
In stretching for effect the artist bamboozles himself. Bergson talks about
this falling into the automatic as an actual fall into the readymade. 'It is
comic to fall into a ready-made category. And what is most comic of all is
to become a category oneself into which others will fall, as into a ready-
made frame.'[55] It is not clear whether Duchamp borrowed the concept of
the readymade from this comedic context, but as master of miscegenation
and the *blague*, he must surely have been aware of its comedic associations.
Duchamp's withdrawal from art into the 'inertia' of the readymade,

therefore, results in an avant-garde gesture, but in a reversal of this ambition in the form of the *blague*, it reveals the stupidity of the avant-gardist who made it.

This gap between desired outcome and actual outcome generates a comedic-effect that is central to Duchamp's reflections on artistic skill: *misjudgements* of labour undertaken. Something is funny when we recognise that there is a disproportion between the result and the labours undertaken to achieve it, for then we notice a lack of awareness or sensitivity on the part of the person who produced or completed the work. For instance the person who spends an inordinate amount of dedicated time on something that fails to produce the desired effect, or any worthwhile effect, yet who professes its magnificence, or charming or sterling qualities. This might be the novice eco-warrior who makes a house out of leaves and straw and proudly shows it off, which then gets blown away with the first gust of wind; or the worker who spends all day dutifully pulling a series of levers, that unbeknownst to her are not connected to anything and therefore her labour does not produce any effect or outcome. Conversely a disproportionate gap between final outcome and process results from the person who, in blithe indifference to their own lack of the required skills and patience, passes off some speedy and incurious activity as skilful. This latter outcome – as a perfect kind of *blague* – is close in spirit to the copying without copying of the unassisted readymade. An object without discernible artistic merit is meretriciously passed off as art in conscious opposition to the blustery labour of the *fine artiste*. But, of course, what distinguishes this kind of *blague* is that it hides a secret: where you look for effort you won't find it; the trick, in the act of judgement, is to *rethink* the object, reanimate it conceptually, in Zukovsky's language, and the efforts of the artist will then reveal themselves. The unassisted readymade performs a perfect transformation of productive labour into artistic labour: what appears effortless becomes effortful. The significance of copying without copying, therefore, is not to eradicate skill from art, but to eradicate *purposeless* skill from art. But, although Duchamp's readymades exist in the world of comedic-automaton effects in the pursuit of these ends, they do not exist in the world of laughter. Duchamp was a *blagueur* without an immediate audience. Because *Fountain* remained on the whole unexhibited, it never had an audience to laugh *at it*. As such *Fountain* was unable to experience that moment of release in an audience that Bergson insists the comic necessarily produces.

Duchamp's early work is clearly indebted to the inversions and sub-terfuges of the *blague*, as a way of clearing out the congestion of Cubist in-fighting. But it is also clear that the *blague* is only a provisional way into his work. Despite his overdetermination of the joke in Duchamp's practice, Weiss admits as much. Although the spirit of *blague* is unmissable, it is 'only an underlying disposition over which the elaboration of other philosophi-cal, literary or scientific resources are then introduced'.[56] Indeed, the process of 'rendezvous' immanent to the readymade is a process of theoretical exchange across different forms of labour. The *blague*, then, is not an invitation to the dissolution of meaning, but the means by which contraries can be performed and made visible.

NOTES

1 See, for example, the threatening postcards sent from the con-man Ernest Ralph Gorse to Ryan and Esther in Patrick Hamilton's *The West Pier* (Constable, London, 1953). Hamilton reproduces the postcard, with its cut-out letters from newspapers and magazines, one-third of its original size. In a work that is largely conventional in its narrative structure, these interruptions have the visual character of Futurist poems.

2 Of course this argument is undermined by the artist/author who produces a small run of books incorporating readymades. But these are essentially art objects in the form of books, and not books subject to a process of reproduction. The artistic/writerly dematerialization of the book, then, faces insuperable problems: at the point where it introduces external reproducible elements into its form it stops being a book, that is, something to be widely disseminated and read. One author who courted this dematerialization of the book as a writer, rather than as a producer of *artists'* books, was B.S. Johnson. In *The Unfortunates* (Panther Books in Association with Secker and Warburg, 1969) Johnson incorporated the logic of the readymade into the structure of the novel. *The Unfortunates* was published as a box which contained separate sections of a narrative which were to be read in no particular order. Although the box did not contain any extrinsic readymade elements, by breaking down the text into discrete parts, the readymade components of the novel's material form (its printed pages) became intrinsic to the book's content. In a Duchampian invocation of the play between the reproducible and the unreproducible, the reader recasts the reproducible form of the book into an unreproducible (discontinuous) experience. The problem with *The Unfortunates*, though, is that this discontinuity didn't go far enough. The shuffling of the pages only produced a limited number of permutations.

3 Marcel Duchamp, radio interview with Georges Charbonnier, RTF, 1961, quoted in Thierry de Duve, *Kant After Duchamp*, p.162.

4 Marcel Duchamp, interviewed by Katherine Kuh, *The Artist's Voice: Talks with Seventeen Artists*, Harper and Row, London, 1962, p.90.

5 Duchamp, 'Apropos of "Readymades"' (1961), *The Essential Writings of Marcel Duchamp*, p.142.

6 I borrow 'produced production' from Roy Bhaskar, or rather, Bhaskar's early Marxian phase. See *The Possibility of Naturalism: A Philosophical Critique of the Contemporary Human Sciences*, Harvester Press, Brighton, 1979.

7 See Daniel Dennett, *Brain Children: Essays on Designing Minds*, MIT, Cambridge, Mass. and London, 1998.

8 Ibid., p.77. Dennett's position owes a great deal to the labour theory of culture and to the notion of creativity as prosthetics. Human agency and labour are not biologically preordained. They are an accident of biology that resulted from mutually reinforcing developments: tool-use and language.

9 The idea of the repository or inventory of reproducible and non-reproducible techniques, of course, precedes *The Green Box*. In 1918 Duchamp completed his last painting *Tum'*, a long narrow frieze-like painting consisting of a series of images of projected and distorted readymades. Attached to the surface itself are a number of actual readymades: a bottle brush, three safety pins and a bolt. The depicted readymades were projected on to the canvas and the cast shadows were traced in pencil. The traced forms, therefore, bear an indexical relationship to the shadows of the readymades. This puts in place an apparitional circuit similar to the earlier unassisted readymades. The commodity, occluded as art, is projected as a shadow which is then traced and made visible as an artistic sign. Corporeality dissolves into incorporeality to be reconstituted as a sign of corporeality (echoing Marx's formulation of C-M-C). Moreover, in the middle of the canvas is a painted image of a detached hand which is pointing at the shadows. This appears to be an indexical sign of Duchamp's authorship – 'these traced signs are evidence of my authorship' it might be saying – yet it is known that he did not paint the hand himself. These accumulated signs of detachment, then, do more than stage a break with the expressive craft of art. Rather authorship is both detached from and reattached to craft – as in *The Green Box*. That is, at no point in looking at the picture is handcraft ever identified with the maker of the picture, but neither is the hand ever absent from the picture's making.

10 Sarat Maharaj, '"A Master of Veracity, a Crystalline Transubstantiation": Typotranslating the Green Box', in Buskirk and Nixon, eds, *The Duchamp Effect*, p.66.

11 As Duchamp was to say about the early work years later: 'I wanted to get away from *la patte* and from all that retinal painting.' Quoted in Calvin Tomkins, *The Bride and the Bachelors: Five Masters of the Avant-Garde*, Viking Press, New York, 1968, p.24.

12 See Rosalind Krauss, 'The Motivation of the Sign', in William Rubin, ed., *Picasso and Braque: A Symposium*, Museum of Modern Art, New York, 1992.

13 Joselit, *Infinite Regress*, p.72.

14 Ibid., p.72.

15 See Peter Bürger, *The Theory of the Avant-Garde* (1974), University of Minnesota Press, Minneapolis, 1984.

16 de Duve, *Kant After Duchamp*, p.150.

17 Ibid.

18 Ibid., p.161.

19 Ibid., p.388.

20 Ibid., p.154.

21 Ibid., p.353.

22 Ibid., p.353.

23 Ibid., p.435.

24 Ibid., p.435.

25 Adorno, *Aesthetic Theory*.

26 de Duve, *Kant After Duchamp*, p.447.

27 Ibid., p.446.

28 See for example, Bürger, *The Theory of the Avant-Garde*.

29 See Bram Dijkstra, *Cubism, Stieglitz, and the Early Poetry of William Carlos Williams: The Hieroglyphics of a New Speech*, Princeton University Press, Princeton, New Jersey, 1969.

30 William Carlos Williams, *Autobiography*, Random House, New York, 1951, p. 380.

31 Louis Zukofsky, 'An Objective' (1930/31), in *Prepositions +: The Collected Critical Essays*, Wesleyan University Press, Hanover, New England, 2000, p.15.

32 Ibid., p.12.

33 Ibid., p.13.

34 Zukofsky's poetry stands somewhere between the factographic inclinations of the 1930s – the poetry of report – and the high modernism of Eliot, Pound and importantly Hart Crane. Crane's sub-Eliotic *The Bridge* (1930) (Liveright, New York and London, 1992, commentaries by Waldo Fran and Thomas A. Volger) is a key transitional poem. Like Eliot, Crane relies on a mythic structure – in this instance the epic journey – to frame the poet's immersion in, and revulsion at, the new shock experiences of urban capitalism. But for Crane this journey – across Brooklyn Bridge and through the Hades of monopoly capitalism and Fordist factories – is a new object world which demands the complete attention of the poet. 'Dream cancels dream in the new world of facts'. 'Under a world of whistles, wires and steam'. It is the pressure of this 'new world of facts' that Objectivism and the generation of the 1930s inherited. The classicism, with its melancholic attachment to the object of lost desire, could only occlude the intensity of this new object world.

35 He began working for the Index in 1936. The earliest written piece on design is from 1938.

36 For example, William Carlos Williams's influential *In the American Grain* (1925) (W.W. Norton and Company, Norfolk, Conn., 1956), which champions the integrity of the small rural community and is expressly anti-urban in its sentiments.

37 A two-way passage of the 'quotidian object' could be said to present itself in Duchamp and Zukofsky during this period: Duchamp arrives to discover the American urban on the basis of his exposure to French 'contemporary particulars', and Zukofsky realizes a meaningful modernism of 'contemporary particulars' at his fingertips and not in Paris. As John Taggart says: 'Zukofsky got there by staying there.' John Taggart, 'Afterword', in Louis Zukofsky, *A Useful Art: Essays and Radio Scripts on American Design*, ed. Kenneth Sherwood, Wesleyan University Press, Hanover, 2003, p.230.

38 Louis Zukovsky, '*A*', John Hopkins University Press, Baltimore and London, 1978.

39 These were broadcast in 1939 and 1940, and covered a variety of craft-subjects including: American ironwork (1585–1856), The Henry Clay Figurehead (a carved figurehead which may have been at the prow of a steamboat when it crashed in the Hudson in July 1852), American tinsmiths, a pair of New York made pitchers circa 1817 depicting the unshackling of a slave boy, a handbill representing a seaman holding a ship's binnacle, a 'Wide Awake Lantern' carried by abolitionists on processions in the 1860s, the furniture of Duncan Phyfe, carpenters from New Amsterdam, Remmey and Crolius stoneware, the Caswell carpet, Friendship Quilts, and cotton historical prints.

40 Zukofsky, '*A*', p.106.

41 See Mark Scroggins, *Louis Zukofsky and the Poetry of Knowledge*, University of Alabama Press, Tuscaloosa and London, 1998.

42 Zukofsky, 'To My Wash-stand' (1932), in *55 Poems*, Press of J.A. Decker, Prairie City, 1941.

43 Of course this hardly needs spelling out, but in these terms, Duchamp's *Fountain* is a clever form of chiasmus. The selection and presentation of a urinal constitutes the very *best* of American culture, and as such the highest values of modernism.

44 George Oppen, from collected papers, quoted in Michael Davidson, 'a man of the Thirties', in George Oppen, *New Collected Poems*, ed. Michael Davidson, Carcanet, Manchester, 2003, p.xxiii.

45 George Oppen, 'Party on Shipboard', from *Discrete Series* (1934), in *New Collected Poems*, p.21.

46 This is generalized across much Objectivist writing in the 1930s. Lorine Niedecker, though, is to my knowledge the only American poet of this generation who incorporated an actual readymade into the form of the poem. In 1935 she wrote 'Next Year I Fly My Rounds Tempestuous' which consisted of 27 poetic entries written on sheets from a calendar (a 'Favourite', Sunlit Road Calendar). Each poem is written on a sheet pasted over the central space, which contains a sentimental/religious verse or poem just visible underneath, forming a kind of détournement of the printed verse or poem. On page 15, July 1935 the printed verse reads:

> As the fountain
> from the hidden
> spring so issues man's
> life from the secret
> recesses of his heart.
> All that he is and
> does is generated
> there

Over which is written:

> I talk at the top
> of my white
> resignment

See, Lorine Niedecker, *Collected Works*, edited by Jenny Penberthy, University of California Press, Berkeley, Los Angeles and London 2002, pp.41–67.

47 *The Blind Man*, Issue No. 1, 10 April, 1917, reprinted in Joseph Masbeck, ed., *Marcel Duchamp in Perspective*, Prentice Hall, New Jersey, 1975. Also in this issue was a reproduction of a nude by Louis Eilshemius entitled *Supplication*, which unlike *Fountain*, had been selected for the Independents. Eilshemius was a blustery faux-naif painter who proclaimed his genius around New York while being roundly ignored by most of the New York art world. In this issue of *The Blind Man* he was interviewed by the poet Mina Loy on his favourite subject: himself and the pure unmediated vision of the 'true artist'. This juxtaposition of highly mediated but rejected art, with would-be spontaneous, authentic, legitimated art made a deliberate and sardonic point: egoist expression is no less blind than the blindness of art's official legislators. For extensive discussion of *The Blind Man* and Eilshemius, see de Duve, *Kant After Duchamp*, pp.89–143.

48 For a discussion of the punning interface between French and English in Duchamp's work and its critical relations to the debate between European modernism and the nascent force of American modernism, see Wanda M. Corn, *The Great American Thing: Modern Art and National Identity 1915–1935*.

49 Jacques Rivière, 'Le Salon des Indépendants', *La Nouvelle Revue française*, 1 May, 1912, quoted in Jeffrey Weiss, *The Popular Culture of Modern Art: Picasso, Duchamp, and Avant-Gardism*, Yale University Press, New Haven and London, 1994, p.158.

50 Francisque Sarcey, quoted in DuBled, *La Société Française du XVI siècle au XX siècle* (Paris 1913), Jeffrey Weiss, *The Popular Culture of Modern Art*, p.120.

51 Jeffrey Weiss, ' "Marcel Duchamp Qui Est Inquiétant": Avant-Gardism and the Culture of Mystification and *Blague*', in *The Popular Culture of Modern Art*, p.109.

52 Louise Norton 'The Buddha in the Bathroom', *The Blind Man*, No. 2, May 1917, reprinted in Masbeck, *Marcel Duchamp in Perspective*, p.71.

53 Weiss, *The Popular Culture of Modern* Art, p.125.

54 Henri Bergson, *Laughter: An Essay on the Meaning of the Comic* (1900), trans. Cloudesly Brereton and Fred Rothwell, Green Integer Books, Copenhagen, 1999, p.24. Bergson's book was published at the height of the culture of *blague* in France (although the humour of deceit is not discussed in the text).

55 Ibid., p.134.

56 Weiss, *The Popular Culture of Modern Art*, p.136.

THREE

DESKILLING, RESKILLING AND ARTISTIC LABOUR

Duchamp's importance lies in his separation of artistic work from the conventional signs of artistic authorship. In copying without copying and disinvesting artistic labour of 'purposeless' effort he eradicates the normative distinction between skill and deskilling in pre-modernist art. The result is that Duchamp's work opened itself up to general social technique without seeking to aestheticize this process. This is his great historical achievement. But if he opened the artwork up to the results of heteronomous labour, he did not thereby identify art with heteronomous labour. All his efforts, from the unassisted readymades onwards, point towards the critical appropriation and articulation of the heteronomous content of labour. He positions complex forms of artistic labour in relation to, and as a transformation of, simple forms of productive labour; artistic subjectivity and general social technique are conjoined as a site of productive tension and exchange. Duchamp's relationship to the denigration of labour skills under capitalism, therefore, is more demanding than many of his defenders are willing to see or accept. Duchamp does not embrace heteronomous labour in order to dissolve art into social technique, but in order to re-pose what artistic skills might be in the light of their transformation by heteronomous labour. He is an artist, therefore, whose work willingly opens itself up to the generalized deskilling of productive labour under capitalism, but whose work, at all times, is a challenge to this general tendency under the exigencies of art's complex labour. In this chapter I want to develop my discussion of skill and deskilling by embedding the implications of the readymade in a broader discussion of art and general social technique. This means

reconnecting our discussion of skill and deskilling with the value-form and the labour process.

DESKILLING AND GENERAL SOCIAL TECHNIQUE

The impact and reality of the deskilling of productive labour is at the very heart of Marx's *Capital*. According to Marx there is a systematic tendency of capitalism to produce work which is repetitive and unsatisfying. As he outlines in Volume 1 of *Capital*, the development of the early manufacturing system is accompanied by the simplification and interchangeability of jobs amongst workers.[1] In 1832, in *On the Economy of Machinery and Manufacture*, Charles Babbage had codified this development for the new capitalist class in terms of the need for maximum control over the labour process.[2] Capitalists should always resist workers' extensive on-job training as far as possible in order to undermine the accumulation of specialist knowledge on the shop-floor. Marx talks about this tendency in terms of the real subsumption of labour under the value-form. When the labourer sells his or her labour-power he or she gives up his control over the labour process. Which is to say that the pressures that the value-form brings to bear on production and consumption are inseparable from the fragmentation and deskilling of labour. One implies the other. In other words, this is what *happens* to labour-power under conditions of generalized commodity production, it is not something that distorts or impedes the production process as a result of external 'interference' or bad management. This is clear from the famous studies of the labour process conducted by Frederick Taylor at the end of the nineteenth century, who is candid enough to articulate the reality of the imperatives of the value-form from within an emergent managerial discourse of 'efficiency'.[3] However, the question of management 'efficiency' is easily misunderstood as the source of deskilling. Management 'efficiency' imposes and shapes the value-form, but this does not mean the level of skills *on average* within production decline as a result of its effects. On the contrary, as the history of capitalism reveals, with the development of technology and the application of science in production, higher levels of technical and scientific knowledge have been incorporated into the production process overall. Skill levels across production are now greater than they were at the beginning of the twentieth century. And management theory loves to affirm this. Yet what is invariably omitted from this account is that the general increase in skills are subject to an increasing

polarization between workers and management. Skills become accumulated and refined in various technical, supervisory and administrative sectors; the mass of workers do not, however, benefit from these changes. Indeed, they suffer from its consequences as their labour is consistently stripped of its autonomy and sensuous form. Marx refers to this process of decomposition as the technical division of labour (within the factory, office and workshop) in order to distinguish it from the social division of labour (the different tasks performed by workers across different sectors). The technical division of labour destroys and re-routinizes labour in order to create new sub-categories of labour. The social division of labour is evident in all modes of production; but it is the technical division of labour which prevails under capitalism. By breaking down and recomposing labour processes, the technical division of labour is enforced ruthlessly at the expense of the social division of labour. What are the benefits of this process for the capitalist? Principally, that through the decomposition of the labour process capital is able to purchase the dissociated elements of production more cheaply. It costs less to employ many workers engaged on one dedicated task, than on a number of tasks which involve change-over times and different work rhythms. Consequently, there is a competing conception of needs at stake between labour and capital confronted by the effects of the value-form. Workers seek to defend the conception or possibility of all-round skills, or what's left of such skills, and management needs to subject such autonomy to constant restriction. This results in a general principle of the technical division of labour: when labourers control − or attempt to control − the labour process, the law of value cannot prevail. This means that control of the technical division of labour is absolutely crucial for the capitalist mode of production. In stripping the worker of both manual craft skills and accumulated knowledge and intellect, management forces a split between conception and execution at the point of production. The labourer's knowledge is 'taken up' into the development of machinery and technological processes leaving the worker with an attenuated grasp of the technical processes that he or she now simply monitors or adjusts.[4] The outcome is that today workers in industry are less able to operate the industry in which they labour than at the beginning of the manufacturing process in the middle of the nineteenth century.

In his important study of the labour process *Labor and Monopoly Capital* (1974), Harry Braverman argues that this represents the long-term secular trend within capitalism: the continuous 'lowering of the working class as a

whole below its previous conditions of skill and labor'.[5] 'Each advance in productivity shrinks the number of truly productive workers.'[6] Under automation the skill of the mass of workers falls in an absolute sense (they lose their traditional craft abilities without receiving any comparable skills in return) and a relative sense (the more scientific knowledge enters the labour process the less able workers are to comprehend the total labour process). Accordingly the multiplicity of technical specialities is the pre-condition for removing workers from general scientific understanding. This means that the number of workers connected to scientifically and technologically advanced sectors of industry diminishes. This is reflected in the vast changes in the Western economy since the 1960s. The contraction of heavy manual labour and the rise in non-productive labour with the development of automated production, far from introducing new skills into the labour process has, on the contrary, created a huge pool of routinized and unskilled clerical and service labour. What 'new skills' have developed tend to be in the expansion of management operations with the institutionalization of capital (advertising, sales analysis, promotion, or-ders). For Braverman, then, the entire concept of 'up-skilling' so beloved of management theory as applied to immaterial labour is largely delusory. Under advanced capitalism the expansion of labour tends to occur in those industrial sectors *least* affected by technological and scientific advance. Indeed, a general misapprehension prevails: what the management social scientists call skill in describing the tasks performed by the new branches of clerical and service work is simply a form of dexterity. 'With the devel-opment of the capitalist mode of production, the very concept of skill becomes degraded along with the degradation of labor.'[7] This leads Braverman to a stark conclusion: that the occupational and craft heritage of the worker has been systematically stripped and re-stripped under capitalism.

On this basis Braverman has been subject to a consistent stream of criticism on the left on the grounds that his reading of Marx's notion of the real subsumption of labour is too pessimistic and one-dimensional. As Paul Thompson argues: 'Braverman is surprisingly deterministic concerning the shaping of work by technological change.'[8] In this Thompson asserts that Braverman ignores the primary role played by class struggle in determining the outcome of technological change and the discipline of the technical division of labour. By wholly emphasizing deskilling Braverman fails to acknowledge the complexities of workers' resistance. For instance, de-

skilling can at times confer bargaining power through an extension on workplace organization, thereby challenging management's implementation of new work practices. Skills can be won back from the drive to efficiency. 'The lesson is that no amount of deskilling or mechanisation can lead to the *complete* domination of capital over labour.'[9] This, of course, is true, however the issue is not that pockets of artisanal skill do not exist in production, or that skills cannot be won back from management, but what happens, *systematically*, to labour-power under generalized commodity production. What is the content of deskilling and what are its effects across all sectors of production? This is where Braverman's work remains invaluable. Braverman's concern is not simply with worker's control or lack of control of the labour process at the point of production, but with the processes that shape these struggles over control.[10] Indeed, Thompson admits as much: 'deskilling remains the major *tendential* presence within the development of the capitalist process.'[11]

Deskilling takes two main forms: 1) the incorporation of science and technology into the labour process, and 2) the managerial organization of workers. These two forms, in turn, can be divided into three aspects: 1) the replacement of skilled workers by machines or machine-operatives; 2) the division and subdivision of jobs, with any residual skills allocated to a few specialized workers, and 3) the fragmentation of the remaining tasks. In this light Braverman's absolute insistence on deskilling as the driving force of the technical division of labour recognizes a structural feature of labour under capitalism that lies beyond workers' resistance and, consequently, defines the very form of workers' emancipation: the fact that capitalism is unable to *secure* the unity of intellect and manual labour for the majority of those who labour. To insist on the degradation of labour under capitalism, therefore, is not a concession to management, or a critique of technology *tout court*, but a critique of technology as an expression of the value-form. 'I was always a modernizer',[12] Braverman insists, meaning that he was no defender of a normative model of labour practice or a fetishist of 'lost skills'. In this respect he is a closer follower of Marx than his critics: the real subsumption of labour certainly limits the development of all-round skills at the point of production, but it also enables a process of objective socialization to take place. In this way capital creates the possibility of a fully co-operative labour process. Without this process of socialization labour would still serve very meagre needs indeed. The problem is not how this process of socialization might be dissolved back into multifarious

artisanal practices, but what kind of emancipatory content might be given to this process of objective socialization on the basis of the development of all-round skills. Braverman's revival of Marx's critique of the value-form, then, is not an extension of a nineteenth-century Morrisonian critique of capitalism's debasement of craft *per se*, it is a contribution to the debate on labour, *technik* and technology. His model of labour is one of *best possible practice*. The significance of his intervention lies not in the area of 'economics' (and in the ideology of job satisfaction and dissatisfaction, so beloved of bourgeois economists), but in a theory of value beyond production as production. As Braverman says: 'the critique of the capitalist mode of production, originally, the trenchant weapon in Marxism, gradually lost its cutting edge as the Marxist analysis of the class structure of society failed to keep pace with the rapid process of change.'[13] Hence, Braverman's reflections on the technical division of labour under capitalism reestablish the fundamental distance between Marx's critique of the value-form and those who defend – both on the left and the right – technology's essential neutrality. Technology does not simply *produce* social relations, it is itself *produced by* the social relations of capital. The relations of production, designed and shaped as they are by the technical division of labour, cannot, therefore, be taken over wholesale by socialist forms of organization. They have themselves to be transformed by non-heteronomous forms and practices. This is why art's place within a political critique of the value-form (not as Schillerian play, but in terms of the richly expanded manual and intellectual content of the relations of production and the 'everyday') has an important contribution to make to the critique of production. But contrary to the Schillerian and Romantic aesthetic tradition this promise of non-heteronomous labour cannot begin and end with the 'aesthetic'. That is, the aesthetic remains meaningless so long as it is theorized solely as a capacity for sensuous feeling or a particular kind of affective experience in front of discrete works of art. Rather, for the aesthetic to enter into living social relations it has to enter and transform the governing forms of social organization, otherwise it imposes itself *as* an external category of the non-heteronomous. The history of aesthetics is exactly this history of external imposition: 'aesthetics' substituting itself for thinking aesthetically. Thinking aesthetically is not just about turning the practices of art over to the sphere of heteronomous labour, but of transforming heteronomous labour into the realm of the autonomous; and art, precisely because, in the main, it is not subject to the law of value, is

able to contribute decisively to this process. What is purposeful about the labour of art is that it is transformative of its materials in ways that are non-subsumptive and non-heteronomous, thereby allowing the subjectivity of the artist to penetrate the materials of artistic labour *all the way down*. Subject to the law of value productive labour is unable to achieve this because the subjectivity of the producer is 'blocked' off from the materials and machinery of production. This is why deskilling in art is not the same as deskilling in productive labour.

Like productive labour, art has experienced a stripping out of its artisanal base since the late Renaissance (see Chapter 5). Art follows the historical tendency in production towards the general lowering of all-round craft skills. And, as I have explained, this reached its defining moment of self-reflection in Duchamp's readymades. But, unlike productive labour, this stripping of the artisanal is not subject to the technical division of labour. Rather, deskilling in art is *aligned* to general social technique which, in turn, is shaped and controlled in production by the technical division of labour. General social technique (the various technical conditions of social reproducibility), therefore, identifies the technical horizons of art at any given historical moment, but it is not able to impose itself as a *disciplinary* apparatus on art. This is reflected in the dialectic between deskilling and reskilling in art. In productive labour, as Braverman makes clear, general levels of skill in production are irrecoverable because of the systematic lowering of skill across sectors under the technical division of labour. Certain skills in certain sectors might be able to be clawed back, and indeed certain skills might be created out of a process of deskilling, but productive labour as a whole is subject to the effects of degradation. There is therefore little evidence of a dialectic of deskilling and reskilling across the various sectors of production, when reskilling in these instances invariably means non-productive forms of dexterity. In art, however, the reskilling immanent to general social technique is *emergent from* the post-artisanal conditions of deskilling. But how is this so, given that after Duchamp there is general separation of artistic work from artistic authorship? Isn't art after Duchamp – and certainly Conceptual art – the apotheosis of deskilling? Haven't artists cut themselves off from all craft skills? Reskilling is emergent from deskilling precisely because as non-heteronomous labour the deskilling of art is open to autonomous forms of transformation, and these forms of transformation will of necessity find their expression in other skills than

craft-based skills: namely, immaterial skills.[14] This difference in scope can be traced out in the position and place of the hand in productive labour and in artistic labour.

There is no place for substantive reskilling in productive labour because there is no place for the independent action of the hand in productive labour. The hand in productive and non-productive labour is *operative* rather than constructive; it is the fixed point through which the extraction of surplus-value occurs. The hand in productive and non-productive labour is 'unfree', that is, it is limited in its actions and subjective investment in the transformation of materials. In artistic labour art may be subject to the exigencies of general social technique, but this does not imply the diminishment of the autonomy of the hand and therefore the eradication of craft skills *as such*. On the contrary with the development of immaterial forms of production the place and function of the hand changes its role in art.

What the readymade introduces into art in the first decade of the twentieth century is precisely a new set of *cognitive relations* between eye and hand. In early Cubism the artist's reliance on the painting-hand as a continuous process of pushing, dabbing and pulling of paint across the surface, is arrested by the placing of the readymade element (*papier collé*) on the painterly surface. The sense of the painting as an aesthetic totality, driven by the fluid movement of the hand, is broken by the introduction of an interruptive, alien content. Accordingly the hand reaches *into* the picture space. This is the point at which the hand in art shifts its motor function from expressive manipulation in painting, and moulding and carving in sculpture, to the demands of conjunction and superimposition. This small, discreet disturbance of the painterly integrity of the modernist painting, represents a profound transformation, therefore, in notions of artistic value, setting the dialectic of deskilling and reskilling on its modern Duchampian course. It may have taken Duchamp to frame the readymade as a problem *for* painting, and not just in painting, but this does not alter the prescient character of the Picasso and Braque *papier colles*. This is because their collages reveal a glimpse of what was to shape the function of the hand of the artist after the technical assimilation of the readymade: placing, ordering and selecting.[15]

These new cognitive relations reveal how after the introduction of the readymade the movement of the hand in art is subject to general social technique. But this divergence between skill and expressive movement does not thereby mean a loss of artistic autonomy. The theory of deskilling in productive labour is essentially a theory of the hand's displacement from a conception of labour as sensuous, totalizing practice. In art the hand suffers a similar displacement, but, importantly, unlike productive labour artistic labour does not suffer a diminishment of sensuousness and value. Rather, the sensuousness of artistic labour is transmuted and deflected into immaterial forms of labour. The traditional eye-hand relations of craft-based artistic skills are subject to a new intellectual and technical base. Calling on traditional craft skills and the integrity of the hand to ward off what is perceived as the craft-less decadence of contemporary art, therefore, not only defies the inexorable force of general social technique, but severely limits our understanding of craft. The place and function of the hand in art needs to be reembedded in an analysis of the relations between deskilling and skilling as part of a wider analysis of craft's relations to general social technique. Yet, before we embark on an analysis of this we first need a more detailed physiological and anthropological understanding of the hand.

HUMAN AND HIGHER-PRIMATE TOOL-USE

What sets humans apart from other animals is that the human hand is an organ of manipulation and communication in ways that far outstrip the dexterity of the hands or paws of anthropoids, or non-human primates. Indeed it is the opposable thumb which accounts for this exceptionalism. Only human beings have an opposable thumb which is able to fully touch the tip of the index finger. This means that the hand has multi-manoeuvr-ability and powers of delicacy and precision not possessed by non-human primates. In this respect as a guide to action and knowledge the human hand is unique. This is why humans are capable of sustained labour and non-human primates are not. Humans are *primary* tool-users. They use tools to mediate their interaction with other human beings and the world. Non-human primates certainly use found materials as tools in order to pick, gather and swipe, but importantly they are incapable of using these tools in a predirected or socially conscious way. Consequently they are unable to use tools to plan the production or gathering of food and

determine their environment. Moreover, and significantly, they cannot use tools to make other tools, the key means by which humans have transformed themselves and the world. As Charles Woolfson says: in humans the use of a tool to make a tool demonstrates a 'reallocation of social energies from immediate episodic subsistence to general preparation for future subsistence activity'.[16] In short, tool-use in humans is directed towards planned social production, and not a form of species behaviour such as nest building.

There is, therefore, a profound connection between the manipulative capacity of the hand and the development of human language and cognition. It is commonly assumed among anthropologists and palaeontologists that hominid tool-use predates the development of human language in the region of two million years. As a system of symbolic exchange designed for judgement and control, language did not emerge until between 50,000 and 100,000 years ago. It is extraordinary then that in the two million years that spanned the development of cutting tools from pebble choppers to hand-axes humans were unable to build a composite tool, whereas over the last 50,000–100,000 years since the emergence of language, the development of tool-use has been multifarious and rapid. There are two questions, therefore, that stem from this discrepancy. What is it about the long and 'uneventful' period of tool-use that provided the conditions for the emergence of language? And what is it about the relationship between tool-use and language that has driven the development of human labour? The development of the prehistorical conditions of language derive from what anthropologists see as the slow incubation of hominid powers of external discrimination through the attempt to gain mastery over nature. Tool-use plays a determining part in this as a result of the indicative and social function of tools. In the attempt to gain mastery over nature there emerge in early hominids forms of internally directed reference.[17] Labour reshapes not only nature but the conditions under which this reshaping takes place. In other words, the use of tools, in a long and highly attenuated way, opens out hominid consciousness to a greater internally differentiated psychological environment. This would no doubt have passed through various stages of generalization – fragmented grunts with gestures, structured grunts with gestures, modulated sounds, and so on – as a result of the increasing need on the part of early hominids to organize their immediate environment and discriminate between things in it. Labouring on the world drives the need for better internal representa-

tions of the world, that can then be shared and established as knowledge of the world. The development of internally directed reference in early humans, therefore, is not just the outcome of improved cognition, but of an emergent dialectic of hand and sound.[18] Language emerges when the socialization of this feedback mechanism between labour and sound reaches a qualitatively transformative point, expressed in physiological change, particularly the development of larynx and the increase in brain size. This neural development in turn further opens up the window of consciousness and the development of hand-to-object skills, driving tool-use forward. It is known from the palaeontological record that tools were held in collective ownership. The emergent forms of socialization achieved through labour and sound, then, would have also benefited and directed the development of primitive forms of language as social exchange, thereby reinforcing the feedback mechanism between labour and sound.

The importance of the hand and human tool-use in the development of human language and culture has played a large part in both Marxist and non-Marxist anthropology and accounts of the palaeontological record. In recent developments in evolutionary psychology and cognitive science, however, the tradition of anthropological human exceptionalism has come under criticism in an attack on human hubris.[19] The similarity between the neural pathways of consciousness in humans and non-human primates and other animals is taken as evidence of the somatic continuity between humans and animals.[20] (see Chapter 4). The result is a downplaying of the dialectic of tool-use and sound/speech in the emergence of human culture, and the emphasis on an abstract (socially delimited) model of physiological and cognitive human development. The impact of cognition on labour, rather than of labour on cognition (through a feedback mechanism), becomes the preferred model. This has an underlying political and social agenda: humans are seen, essentially, as thinking animals, or rather, animals which are better at certain kinds of thinking than other animals. Human genius lies above all, therefore, in its power of intellection – reflected in the vast increase in reach of scientific knowledge over the last hundred years. Humans are now – with the aid of computers and multidimensional mathematics – able to discern, with the greatest accuracy, the chemical components of the furthest stars and galaxies. Human consciousness is able to penetrate parts of the universe where humans (in their current form at least) will never go! These advances in science provide a rationalization for a post-prosthetic economy and humanity, in which the demanualization

of labour is taken as an emergent model of human evolution and social development. Because the rise of prosthetic technologies allows the precision and dexterity of the hand to be invested outside of the body in unprecedented ways, the human hand is viewed as only minimally attached to the manipulation of sensuous, material form, and is therefore judged to be subordinate to the 'labour of machines'. In the world of digitalization the labouring hand is rendered multidextrous. In this respect, the primary anthropological characteristic of human social development – the progressive emancipation of humans from their own biology – is divorced from the dialectic of tool-use to become evidence of the 'post-human' dissolution of handcraft *into* general social technique.

This 'post-human' scenario might be taken as a radical continuation of Braverman's deskilling thesis if not for two fatal – and interrelated – misunderstandings in this type of thinking: 1) under capitalism machines cannot replace labour-power completely, for to do so would undermine the very conditions of capital accumulation and the value-form; it is humans that produce value, machines do not. Machines cannot add value to the production of a commodity and therefore only produce use-values (efficiency). This is because machines enter the production process as constant rather than variable capital, unlike labour-power;[21] and 2) the labour-power of the hand, despite its removal from the realm of the sensuous totality of labour, remains the motive force of productive and non-productive labour. *Hands* still labour, even if the range of skills is severely limited by deskilling and demanualization. Moreover, as a propor-tion of productive and non-productive labour globally, manual labour remains high. For instance the majority of commodities produced globally are still shipped around the world by *sea*. Indeed, the so-called production-on-time digital economy would not exist without the 'slow' time of the maritime economy, and its capacity to move large quantities of commod-ities safely and securely across large distances. In these terms the place and function of the hand in the new digital or immaterial economy is subject to a basic confusion. Machines may be able to reproduce the complex and detailed skills of humans and therefore dramatically reduce labour's reliance on tool-based handcraft, but this does not diminish the place and function of the hand as the creator of value. The containment of the hand in labour is not the same as the removal of the hand *from* labour.

In *The Hand: A Philosophical Inquiry Into Human Being*,[22] Raymond Tallis attacks the 'post-human' theory of the hand in an extended consideration

of its physiology and anthropology, dismissing the contemporary dissocia-
tion of the hand from what makes humans human. He thus defends the
exceptionalism of human labour on familiar grounds: it is how humans
make and manipulate tools to intervene in the world that distinguishes us
from non-human primates. As such he draws on the labour theory of
culture to elaborate on the fundamental place of the hand in the devel-
opment of human evolution. Key to this development are two distinguish-
ing sensorimotor features of the human hand: protension and
proprioception. Protension is the act of reaching, the fact that the hand
and arm are able to extend beyond the body to make contact with the
world. By reaching out to touch and grip, the arm and hand involve
themselves in a process of choice and deliberation. Of course non-human
primates reach out and make contact with the world – they may also be
engaged in a process of choice and deliberation – but they do not reach out
in the same way humans do. This is because the manoeuvrability and grip
of the human hand are precise enough in humans to allow for the most
complex forms of manipulation of materials and objects. Unlike non-
human primates the human thumb can move in many more directions than
the other fingers, just as the human thumb and index finger meet with
power and accuracy (as in threading a needle). In apes 24 per cent of the
muscles of the hand control the thumb; in humans it is 39 per cent. In the
hominid's struggle for the rudimentary mastery of nature it is this slight
difference in hand-to-object capacity (that is, itself, an evolutionary
response to the demands of labour) that generates the long drawn out
emergence of language and, importantly, creates the conditions for the
separation of animal consciousness from human self-consciousness. For
with the precision and adaptability of the hand come humans' capacity to
think of themselves as separate from the nature they inhabit and transform.
This awakening of the body out of nature through the manipulative power
of the hand is also reflected in the extraordinary capacity of humans for
proprioception – an awareness of parts of the body as opposed to an
awareness of the outside world. In contrast to non-human primates and all
other animals, humans are able to self-touch in multifarious and sensitive
ways. In touching ourselves we continually report to our self as self, further
intensifying our separation from nature. In touching ourselves we divide
ourselves into *two* subjects and *two* objects: for instance, the cold hand
(subject) is aware of the warmth of the thigh (object). The thigh (subject) is
aware of the coldness of the hand (object). Such actions, in other words,

contribute to the awakening of agency and self-consciousness out of our bodies. 'It is through our hands that we expropriate our own bodies, get a first-person grip on the organism that we live, and, through this, get a grip on the world.'[23] 'The hand opens up the body to itself as an instrument, awakens the sense of self and of the (cultural) world to which the self relates.'[24] Thus, the opposability of the thumb, the ability to move the fingers independently, and the non-superposability of the hands (the fact that the hands are not identical halves with identical movements), allow the human hand to become a sophisticated means of body to object, body to body, and self to self, interaction. We owe our escape from biology, therefore, to what Tallis calls the *totipotentiality* of the hand.

In this regard Tallis rejects the prevailing sociobiology and cognitive psychology for its brain-led account of human development. Human differences from animals do not arise from anatomical difference as such. Hominid tool development is not linked simply to an increase in brain size. A gorilla has a relatively large brain but has little or no tool-using abilities. This reveals how much the development of anatomical difference provides different social pathways for evolutionary development. The hominid reliance on the free movement of the hand after hominids had descended from tree-dwellings to the plains put in place the beginnings of an agentive relationship between hand and tool, which in the long term utterly transformed hominid *consciousness*. Increase in hominid brain size may, in a feedback mechanism, have reinforced this development, but it did not cause it. The emergence of bodily self-awareness, then, is the result of tool-use and the adaptation of tool-use to the emergence of speech.

Tallis's theory of developed wakefulness through the hand and tool-use is a significant argument against the biological and cognitive deracination of the hand in contemporary digital and informational-society theory. However, his materialism is let down by a bewildering attack on Marx which weakens his adaptation of the labour theory of culture overall. 'He took technology for granted: he did not go far back or deep enough in his thinking.'[25] Marx's work produced a 'denial of the conscious human agent'.[26] One begins to splutter here: there are poor readings, inadmissible readings and downright inane readings. One wonders if Tallis has really understood, in any way, the part Engels and Marx have played in the development of the very labour theory of culture he is indebted to. As Marx says in *Capital*: 'The use and fabrication of instruments of labour, although existing in germ among certain species of animals, is specifically

characteristic of the human labour-process, and Franklin therefore defines man as a toolmaking animal.'[27] But another philosophical agenda emerges from the fog: Tallis is not interested in replacing the hand back into an analysis of productive labour (or artistic labour for that matter), in order to reembed it in a dialectic of skill and deskilling, but, rather, in hypostasizing the hand as a sign of transcendental human will. At this point Tallis's argument descends into a banal technologism undoing all his previous good work. In a paean to the technical ingenuity of liberal democracy he talks about overcoming the self-contempt of those who criticize the technological achievements of capitalism. The hand, in a burst of pro-prioceptive self-love seems to have wandered off into the sunset. In his attempt to release the evolution of hand from biological determinism, he simply hands it back to philosophical abstraction. In this respect Tallis is so busy building a theory of the transcendental agent through the totipotentiality of the hand, that he has no time for the 'unfree' and operative hand. In Tallis's model the sensorimotor activity of the hand is released from the burden of deskilling and heteronomous labour to reclaim its lost sensuousness. The outcome is a theory of the hand which may be anthropologically robust, but is politically reactionary and socially under-determined: the hand surely drives our reason, but the reason which employs the hand has nothing but contempt for the hand as sensuous practice.

LATENT TOTIPOTENTIALITY OF NEGATIVE LABOUR-POWER

It is important, therefore, in stressing the dialectic of skill and deskilling in an account of labour that the hand is neither hypostasized as a source of transcendental agency – even if it is the physiognomic source of agency – nor sidelined simply as a residue of the labour process. If there can be no theory of the hand as such, hands in the post-Fordist labour process are not mere appendages either. Rather, we need to see the totipotentiality of the hand as emergent or constrained according to what kind of labour is being performed. The totipotentiality of the hand is severely restricted in productive labour. It follows predetermined pathways. In artistic labour, in contrast, it is freely determined, even if its powers are no longer reliant on all-round handcraft. (As I have explained, the immaterial production of contemporary art allows for other, non handcraft, hand-to-eye skills; the totipotentiality of the hand therefore finds other ways of being skilful.) But

this does not translate into a simple distinction between the limited or empty totipotentiality of the hand in productive labour and the emergent totipotentiality of the hand in artistic labour. The totipotentiality of the hand in productive labour does not just represent the heteronomous side of this split, and the totipotentiality of the hand in artistic labour the other, autonomous side. This is because the totipotentiality of the hand in productive labour conceals a latent creative agency, in spite of the effects of deskilling and heteronomy: the *negative power* of human labour. The hand in productive labour and non-productive labour may be operative rather than constructive, but labour-power is not a commodity in the way other commodities are. This lies with the fact that it is the capacity of humans to refuse to realize their labour as labour-power that constitutes the value-producing form of labour. It is because labour is not *just* value, identical with itself (as machines are), that workers are able to produce surplus-value, that is, produce something over and above value. This is why capitalists cannot build as many machines as and when they like, in order to reduce wage costs. The result would be the diminishment of the very thing which creates value: living labour.

The latent totipotentiality of the hand in productive labour emerges, paradoxically, therefore, at the point where the hand withdraws from labour, for then the hand opens up the actuality of production to other use-values. And this, precisely, is where Marx's *Capital* is a critique of political economy and not a theory of economics. In denying that labour is reducible to the machine, or that the machine is reducible to living labour, and therefore that labour-power is not identical with itself, Marx makes it possible for there to be a critique of the value-form. Thus, the emergent totipotentiality of the hand in artistic labour may be decisive in realizing this non-identity and the limits of heteronomous labour, but the critique of this heteronomy is not just the province of aesthetic theory. A critique of the heteronomy of productive labour is also embedded in the labour process itself through labour's negative relation to itself – in the labourer's labour over and above value and, consequently, in the labourer's constant refusal or unwillingness to labour. We might talk, therefore, about the negative totipotentiality of the hand as providing a gap *through which* the artistic critique of heteronomous labour enters. The negative totipotentiality of the hand in productive labour opens up the technical division of labour to the emergent totipotentiality of the hand in artistic labour. The general deskilling of labour under capitalism conceals its opposite (emergent

totipotentiality) at the point where all 'skill' is suspended. Because labour-power can be withdrawn from the labour process and the value-form threatened from within, labour, in its very alienated and diminished form, is also the negation of value. At the point where the proletariat's refusal of labour is made generalizable the latent totipotentiality of the hand opens up the blocked subjectivity of productive labour on a universally transformative basis. Artistic labour is able to release its subjectivity into this space.

This is what I mean by thinking aesthetically, rather than thinking as 'aesthetics'. The emergent totipotentiality of the hand in artistic labour remains the mere imposition of non-heteronomous thinking without this negative power of the latent totipotentiality of the hand in productive labour. The creation of the conditions for the autonomy of labour is a form of aesthetic ideology if separated from the dynamics of this negation of labour-power. This is why it will be the hand at the machine in productive labour that, in the final reckoning, will shape the content of the relations between autonomous and heteronomous labour. It is these operative hands that will ultimately determine what we mean by the dissolution of the technical division of labour and the convergence of artistic labour with general social technique.

Where, then, does this leave the hand in art's dialectic of skilling and deskilling? If the cognitive and manual skills available to contemporary art are not in themselves subject to a loss of sensuousness in an absolute sense, how is the diminishment of craft skill to be theorized? Where is the hand, exactly, in the dialectic of skill and deskilling? Duchamp initially thought it was nowhere, or in a limited place that was of little value for art after Cubism. As late as 1964 he was saying: 'There are so many people who make pictures with their hands, that one should end up not using the hand.'[28] But of course, by the late 1920s 'the hand', in a nominal sense, had been 'reintroduced' by Duchamp into his practice. The deracination of the hand in the unassisted readymades had given way to the craft of reproducibility in *The Large Glass* and *The Green Box*, in which the hand multiply transformed the reproducible object. Consequently, out of the original *blague* of the unassisted readymades Duchamp soon realized the limits of any radical displacement of the hand *per se*. Or, to put it another way, there could be no emancipatory modernist practice without the rethinking and replacement of the function of the hand. The hand had to be subject to other kinds of labour and intellectual reflection if art was not to end up as sheer heteronomy – as if all that was left to the artist after

the readymade was simply 'thinking' and the desultory delegation of artistic labour to technicians. The emergent totipotentiality of the hand in artistic labour had to be given other tasks. Duchamp's work after the unassisted readymades is instructive, therefore, in its willingness to let *la patte* do some work again. In operating in the space opened up by the crisis of handcraft, the hand is released from expressive mimeticism to find new forms of dexterity and facility through the manipulation and transformation of the sign-values of extant symbolic materials. In this the 'demanualization' of art links dexterity and facility to conceptual acuity as an expression *of* craft. Skill reemerges *as* the craft of reproducibility and the craft of copying without copying, realigning the emergent totipotentiality of the hand with general social technique. That is, the new forms of dexterity and facility put in place by the 'demanualization' of art open up the totipotentiality of the hand to mechanic and digital forms of general social technique. Thus in artistic practice the relative loss of handcraft has to be placed against the emergence of new skills from out of the general process of deskilling. Deskilling in art is the name given to the equalization of artistic skill after art enters the realm of general social technique. It is what happens, therefore, when the expressive unity of hand and eye is overridden by the conditions of social and technological reproducibility; it is not a value judgement about what is or what is not skilful according to normative criteria about art as painterly or sculptural craft. As such, the split between artistic labour and the conventional craft-based signs of authorship that follows from this process necessarily links the development of artistic skills to the craft of reproducibility. This, in turn, releases the prosthetic and surrogate capabilities of the hand (which I will discuss in the next two chapters). New skills emerge from the precise control by the fingers of processes outside of the body. Facility is downloaded to the manipulation of technology.

NOTES

1 Marx, *Capital*, Vol. 1, pp.336–8.
2 Charles Babbage, *On the Economy of Machinery and Manufacture* (1832), Indypublish, New York, 2002.
3 Frederick Taylor, *The Principles of Scientific Management* (1911), Harper Bros, New York, 1947.
4 See Sohn-Rethel, *Intellectual and Manual Labour*.
5 Braverman, *Labor and Monopoly Capital: The Degradation of Work in the Twentieth Century*, p.89.

6 Ibid, p.142

7 Ibid, p.307

8 Paul Thompson, *The Nature of Work: An Introduction to Debates on the Labour Process*, Macmillan, London, 1983, p.106

9 Ibid., p.108.

10 For a defence of Braverman's return of the exploitation of labour to the dynamics of the value-form, see Sheila Cohen, 'A Labour Process to Nowhere?', *New Left Review*, No. 165, Sept/Oct 1987. As she rightly says, scientific management is not concerned abstractly with the 'control' of workers, but with profitability. Struggles over control in production are invariably economic issues: the rhythms and intensity of surplus-value extraction and the reduction of socially necessary labour-time. Techniques of work organization and discipline are not part of a managerial strategy to subordinate a recalcitrant workforce, but are the outcome of the value process itself. The 'quantitative structuring of production – not what, but how much, not how, but how quickly – is ordained by the dominance of value' (p.39).

11 Thompson, *The Nature of Work*, p.118.

12 Braverman, *Labor and Monopoly Capital*, p.5.

13 Ibid., p.9.

14 As Adorno says in a reference to a degraded notion of craft as visualization in art: 'a widely accepted notion – a bowdlerized theorem of aesthetics . . . [is] that art *per se* ought to be visual. It ought not. Art belongs squarely in the conceptual realm.' Adorno is not referring here to Conceptual art – Conceptual art was in its infancy when Adorno was writing *Aesthetic Theory* (1970) – but to the mystificatory notion of art as a form of doing rather than a form of thinking. 'Doing' for Adorno is always thinking *in* form. Adorno, *Aesthetic Theory*, p.461.

15 In this sense Braque's and Picasso's *papier colles* prefigure the complex labour/simple labour of Duchamp's model. By placing a found printed element (itself the outcome of waged labour) directly into the sensuous realm of a partly painted surface the alienated nature of productive labour is brought into disruptive proximity to non-alienated labour.

16 Charles Woolfson, *The Labour Theory of Culture: Reexamination of Engels' Theory of Human Origins*, Routledge and Kegan Paul, London, 1982, pp.39–40.

17 Ibid., pp.63–6.

18 See ibid.

19 See for example, Stephen Pinker, *How The Mind Works*, Penguin, London, 1997.

20 See Churchland, *The Engine of Reason*. Churchland defends the neurological homologies between humans and animals: 'higher animals are just as conscious as we are, at least when we are awake' (p.268).

21 For a critique of the notion that machines produce value, see C. George Caffentzis, 'Why Machines Cannot Create Value; or Marx's Theory of Machines', in Jim Davis, Thomas Hirsch, Michael Stack, eds, *Cutting Edge: Technology, Information Capitalism and Social Revolution*, Verso, London and New York, 1997.

22 Raymond Tallis, *The Hand: A Philosophical Inquiry Into Human Being*, Edinburgh University Press, Edinburgh, 2003.

23 Ibid., p.130.

24 Ibid., p.286.

25 Ibid., p.259.

26 Ibid., p.260.

27 Marx, *Capital*, Vol. 1, p.179. See also Frederick Engels, *The Dialectics of Nature*, Lawrence and Wishart, London, 1940. For Engels, hominid adoption of the erect posture and

bipedal motion enabled the development of the hand for tool-use, which in turn, led to physiological changes in the hand.

28 Interview with Marcel Duchamp by Otto Hahn, *L'Express*, 23 July, 1964, quoted in Jennifer Gough-Cooper and Jacques Caumont, eds, 'Ephémérides on or about Marcel Duchamp and Rrose Sélavy 1887–1968', in *Marcel Duchamp*, Pontus Hulten, ed., Bompiani, Milan, 1993, entry unpaginated, quoted in Joselit, op. cit., p.157.

FOUR

THE POST-CARTESIAN ARTIST

What kind of artists are produced by the process of deskilling and the craft of reproducibility? It is clear historically what kind of artist Duchamp was – a dissembler of art, a constructor of multiple identities, and the fabricator of ruses – but, is this necessarily what the craft of reproducibility entails? Are all artists who employ the readymade encoded to diminish or even destroy the idea of themselves as unified creators and engage in the dispersal and displacement of their authorship? Does the readymade lead, inevitably, to the dissolution of the artist?

In a significant sense it does. As I have outlined in my discussion of Duchamp, the use of the readymade conceals a nihilism – copying without copying – that destroys the very basis of conventional artistic labour. But, as Duchamp himself realized, this nihilism, in alliance with general social technique, also releases the hand from the tedium and preposterousness of expressive painterly mimeticism, thereby transforming not only what the artist produces, but how he or she sees himself or herself as a maker of meaning. Author and authorship are *re*-made through general social technique. It is the transformation of the identity of the artist, therefore, that is presupposed by the readymade, and that makes the dispersal and displacement of authorship and the readymade indivisible. But does this make the post-readymade artist a post-Cartesian? Are all artists prior to Duchamp labouring as Cartesians – that is, defenders of the notion that all we can be certain of is the content of our own private subjective experiences? 'To all men's minds there are bounds set that they cannot pass', declares Descartes.[1] Put like this, of course, the idea of the post-Cartesian artist is plainly absurd; one day there was darkness and scepticism, and a notion of creativity as self-

enclosed subjectivity, and the next there was post-Cartesian light. In this way post-Cartesianism can seem like the worst kind of empty sociological category, particularly in the wake of its extensive use across disciplines today, and easy conflation with the critique of the self-transparent subject. But an important question does have to be answered: what happens to the artist's identity after the artistic subject can no longer derive its stability and security from a sense of its own expressive unity, from the idealisms of a self-enclosed subjectivity? And, in turn, in what ways does this crisis of subjectivity manifest itself cognitively and culturally? To say, therefore, that such a thing as a post-Cartesian artist exists is not to say that 'deluded' Cartesian artists have now been vanquished and replaced by 'smart' post-Cartesian ones or even that 'smart' post-Cartesian artists are not open to thoroughgoing criticism; but, rather, that the artist is no longer the singular creative unity he or she believed they were before the readymade and the craft of reproducibility. This leaves the identity of the artist in a place where skill – as I have explained – is no longer definable solely by what the craft of the hand does. Thus, the post-Cartesian artist is not the name for a particular *kind* of artist or even a particular kind of artistic virtue, but, rather, convenient shorthand for a number of different social and cultural tendencies which have gathered force since the first two decades of the twentieth century. In this chapter I want to explore these tendencies, as they find their expression in different accounts of artistic authorship after the revolution of the readymade.

From the 1960s to the 1980s these tendencies were largely grouped under the heading of the 'critique of the author'. The traditional notion of the author as a bounded expressive unity was dismantled by a succession of philosophers and literary theorists armed with a theory of the cultural object as intertext. As Roland Barthes said, stamping his thinking on the minds of a generation, texts redistribute other texts, artworks redistribute other artworks. There are always texts before and around the 'primary' text.[2] Here, though, I am less interested in the critique of the author as the theorization of the polysemic production and reception of the artwork, than in what happens to the technical, cognitive and prosthetic extension of authorship *once* the author has been decentred. This means moving the dialectic of deskilling and reskilling in art on to a broader terrain than the artwork as intertext.

The critique of authorship does not just involve the displacement of the author from the centre of his or her creativity in order to reembed the

spectator's understanding of the cultural object outside of its manifest meaning, it also requires aligning the decentred skills and competences of the author with general social technique. The decentred author moves out from a place where authorship is seen to be *displaced* by general social technique, and therefore effectively subordinate to it, to a place where decentred authorship and general social technique, subjectivity and technique, coincide. Accordingly, this demands a very different sense of the artist as subject. Authorship is the result of the use of a given ensemble of techniques (produced and reproduced as a set of skills) which are subject to, and transformative of, an intentional framework and intellectual programme. The producer's creativity is based on how technical procedures are employed in the development and transformation of this framework and programme; intentions and technical procedures are therefore co-emergent. In this way what we mean by creativity does not preexist the ensemble of techniques as skills employed within a given framework and programme. The author is not a stand-alone 'expressive' figure, whose agency is external to the employment of these particular skills, because what is conceived as authorship is determined by the employment and development of these skills. Thus, the notion that only certain kinds of (craft) skills are able to secure authorship is based on the presumption that we know what the content of authorship actually is. But, if authorship is not presupposed by given techniques and practices, there is no necessary connection, for example, between the qualities of 'expressiveness', 'aesthetic repleteness' or 'representational vividness' and conventional skills. Indeed, authorship might find its enunciative conditions through means which are actually opposed to such qualities and, moreover, might be found in subjects who have no obvious cognitive and physiological access to such qualities, such as artists who are blind, or artists who suffer from protanomaly (a decreased response to the colour red) or some other physical deficiency or disability.

This encourages us to think of the artistic subject in two related ways: first, as a social agent separate from the first person singular (even if the artist is constituted as a subject) and thereby co-extensive with the collective intellect. And, second, as a place where the enunciative requirements of authorship can be demonstrated and fulfilled technically in many different kinds of ways. The critique of the author, however, rarely encompasses these two points. This is because its primary hermeneutic function in literary theory is to reveal the intellectual indebtedness of the

first person singular (or, rather, to be more accurate, to expose the very absence of the possibility of the first person singular) and not the links between the 'I' and 'others' of creativity as part of the collective intellect. The sociality of authorship is returned to the author, but on a very limited formal basis. Conversely, then, the critique of authorship must itself be embedded in the dialectic of deskilling and reskilling. For without this process the critique of authorship becomes merely an empty challenge to a Cartesian model of expression, falling into the worst kind of anti-humanism and post-human rhetoric. Deskilling is divorced from reskilling in a nihilistic confrontation with craft. But in linking the critique of authorship to reskilling, decentred artistic authorship is reconnected to the labour theory of culture to become an *emergent* category. And it is the conditions of this emergence – how subjectivity inhabits social technique, and how social technique inhabits subjectivity – that defines the condition and possibilities of authorship after the readymade. But, if this is an issue about expanding artistic subjectivity into the realms of the virtual, immaterial, prosthetic and surrogate – of the expansion of authorship through the development of the hand-at-a-distance – it is not an argument about how artistic subjectivity is *itself* machinic or programmed. Machines mediate and transform artistic subjectivity. It is artists – and their hands – however, who bring use-values to machines and their programmes. Similarly, defending the decentred artistic subject as an emergent category of artistic labour is not a way of claiming that things or beings other than humans might be artists or possess authorship in the same way as humans.[3] Artists are authors (even as decentred, delimited authors) because as humans they possess the kind of attributes and skills we have already discussed. Machines and animals, on the other hand, cannot be artists – even if they fulfil the formal criteria of low-level authorship – because their meaning-creating and learning abilities (under current evolutionary and scientific conditions) are damagingly restricted by their zero – or, in the case of non-human primates, highly limited – access to the totipotentiality functions of the hand.[4] They, therefore, possess zero or limited capacity for labour and as such for self-transformative activity. I believe this distinction between the human and the machinic and the animal to be fundamental to the development of our understanding of skill and deskilling and therefore a good place to clarify what we mean by decentred artistic authorship after the readymade. This is because if the notion of authorship is to be reconstituted through an understanding of how technology and subjectivity are co-emergent, this

does not mean that we can reconstitute what we define as authorship in *any way* whatsoever. We first need, then, to refine our understanding of what we understand by human consciousness and creativity as opposed to machinic and animal consciousness and creativity.

REDUCTIVE AND NON-REDUCTIVE THEORIES OF CONSCIOUSNESS

Debates on consciousness in the philosophy of mind, cognitive science and Artificial Intelligence continually return to the problem of *other* forms of consciousness, and whether these forms of consciousness are equivalent to, or primarily different from, human consciousness. In doing so it is believed that we can establish a clearer picture of why human consciousness takes the form that it does. These debates can be divided into two main camps: the reductionists and the non-reductionists. The reductionists hold that consciousness can be explained solely in physical, neurological terms, and non-reductionists (mainly philosophers) that brain states and mental states are not the same thing, and therefore that mental states need to be treated as a special case of physical phenomena. The reductionists defend an aggressive computational model of the mind, the non-reductionists argue that consciousness, essentially, conceals its interior movements. However, this isn't simply a debate between the hard physical sciences and philosophy, or between epistemology and metaphysics. Non-reductionists do not dismiss the entreaties and advances of science, just as reductionists are not adverse to speculations about the social development of human consciousness. Rather, it is more broadly a debate about the place of human consciousness in the chain of being. This is why non-reductionist positions and reductionist positions occasionally cross over each other, although they derive from different perspectives. This is particularly so in the case of how these positions understand animal consciousness. The non-reductionist argument tends to see the consciousness of animals (as well as human consciousness) ineluctably as opaque entities, and as such unassimilable to human reason; whilst the reductionist argument sees animal consciousness as computationally the same as humans and therefore neurologically equivalent to humans. Both positions have little interest in the notion that humans possess a qualitatively different kind of consciousness (neurologically), which in key ways is superior to other kinds of consciousness. As Paul Churchland, one leading reductionist argues: 'higher animals are just as conscious as we are, at least

when they are awake. For most of those animals have multilayered cortex, viscerally-connected parietal representations, and widespread recurrent connections, between their thalamus and cortex, much as humans do.'[5]

Much of the recent dialogue across these positions is indebted to one author, Thomas Nagel, and one essay in particular, 'What is it like to be a bat?' (1974), which famously addresses how bats 'think' as opposed to how humans think. Underlying his essay is an old philosophical problem: how do we gain access to other minds, when, experientially, we only have access to one mind, our own? Nagel takes a non-reductive line: without an idea of what the subjective character of experience is it is impossible to reconstruct a theory of consciousness. Hence, despite knowing that bats possess an elaborate system of sonar guidance there is no reason to suppose that we can imagine what it is like to be a bat. If I do try to imagine such a thing my understanding is confined to the 'resources of my own mind'.[6] In this respect, for Nagel, we cannot expect to accommodate experiences in our language which are not compatible with our own. We do not have access to the relevant or required experience that will enable us to reconstruct such experiences. Nagel, then, is making a claim about the species-specific limits of human understanding: there may be experiences (indeed many) that will always be denied us because of our neurological make-up. As Colin McGinn argues, in a commentary on Nagel: 'Bats perceive different secondary qualities from us when they employ their echolocation sense; it is not that they perceive precisely the same qualities and embed them in a different (non-representational) medium.'[7] In other words trying to imagine how bats 'think' forces us to recognize that the internality of states of consciousness different from those of humans actual embody qualitatively different perceptual mechanisms. Nagel's position is classically Lockean: there may be domains of knowledge and experience which lie beyond the reach of human concepts because we do not have concepts of the right and adequate kind.[8] However, this is not a defence of the essential privacy of experience. Rather, it is an argument about the limits of reason when applied to beings not like us. In this, Nagel's essay provides the resources for an attack on scientific hubris, which at the time of writing had echoes of early Richard Rorty and Paul Feyerabend, but now certainly dovetails nicely with post-modern theories of the 'other'. Science cannot explain the consciousness of the 'other' because it cannot explain what it is like to be the possessor of that state of consciousness. Or as McGinn puts it (sympathetically): 'one's form of subjectivity restricts one's concepts of subjectivity'.[9]

For the Lockean, then, there are two related epistemological issues. The bat possesses a consciousness that is not accessible to human understanding; and human cognitive powers are limited by the structure of the knowing mind. As McGinn insists: 'Total cognitive openness'[10] is not a guarantee for human beings. But if Nagel is prepared to rely on scientific investigation to reveal that bats have a different kind of consciousness to humans why then isn't he prepared to claim that such knowledge might also be able to furnish us in the future with a more exacting awareness about what it is like to be a bat? Total cognitive openness may not be an option for humans (although the demand for total cognitive openness sounds suspiciously like something that humans cannot possibly fulfil in any circumstances), but this does not mean that the failure to recognize some phenomenon is intractable, it might just reflect our present *inability* to recognize it. It does not follow, therefore, that the structures of 'bat consciousness' are ineffable and as such closed off indefinitely to understanding. Nothing suggests on the basis of the history of science that the sensory states of the bat or any other creature, *ipso facto*, transcends the investigations of the physical sciences. Science will not be able to represent the neurological pathways of the bat in the proprietary ways of the bat – that is clear. It will represent them in the languages of science. But this does not then disqualify the physical representation of such pathways or weaken the notion that on the basis of these physical representations we now have a better picture of 'bat consciousness'.[11]

The reductionist and non-reductionist position do at least share one thing: a scepticism about the idea of human consciousness as a privileged version of consciousness. In reductionist thinking, particularly Churchland's, this is expressed through a critique of the language-model of consciousness, most recently identified with Daniel Dennett, one of the few scientists and philosophers of mind working in the area of Artificial Intelligence committed to some version of the labour theory of culture and human 'exceptionialism'. When humans learn a language they acquire the capacity – absent in nonhuman animals – to represent and process information in sequence. For Dennett this is what makes human consciousness special and, therefore, different from other forms of consciousness. In Churchland, however, this language-model of human consciousness is simply 'human-centric'. It disregards the broad neurological homologies between animal and human consciousness in favour of a tiny-subset of neurological processes which are language-like (syntactical).

Human consciousness, Churchland, insists, also contains 'visual sequences, musical sequences, tactile sequences, motor sequences, visceral sequences, social sequences, and so on'.[12] And these are spread out over a range of non-human consciousnesses. Furthermore, he declares, the cognitive activity of humans and the higher animals display a remarkable symmetry. Both possess 'short-term memory, input independence, steerable attention, plastic interpretation, [the] disappearance [of consciousness] in sleep, [its] reappearance in dreaming, and unity across the sensory modalities'.[13] Dennett would, no doubt, concede that the neurological content of consciousness contains many other qualities than language-use. This is largely uncontentious. He would no doubt concede the *neurological* continuity between humans and the consciousness of certain higher primates. But he would not concede that the 'social institution of language has nothing to do with the genesis of consciousness'.[14] Indeed, Churchland's 'symmetrical' account of animal and human consciousness hides a fundamental asymmetry: the constitutive part labour and the relationship between language and the totipotentiality of the human hand plays in the development of human consciousness. It is the virtue of Dennett's work on consciousness and language that he doesn't disguise this asymmetry, although the specific category of labour is not something that he gives systematic attention to.[15] For Dennett we can only understand human consciousness, ultimately, by how it functions in behaviour and language. Hence, as within the tradition of the labour theory of culture, he stresses the importance of an environmental model of development: for consciousness to emerge certain environmental conditions had to provide the physiological development of the brain. Consciousness is not part of any innate 'hard-wiring' but the result of our long participation in collective culture. Dennett is less interested, therefore, in what is conscious or not conscious, or rather, what we might describe as having consciousness, than the *quality* of our consciousness. This means, inevitably, defending the exceptional conditions of the development and character of human consciousness. This is expressed most forcefully in his work on Artificial Intelligence.

The crucial question for recent robotics has been: how is it possible to produce a robot that can interact within humans in real time, that can take care of itself, and talk about itself to its designers? In this the ambition is to develop a robot at the interface of bio-engineering and mechanics, for instance, a robot with real muscles and with artificial retinas lined with

organic rods. If this is achievable it might follow that a bio-mechanical robot could then be able to embark on a period of infancy and nurturing like any human being, and as such establish the Holy Grail of contemporary AI: the real and sustainable conditions of robot 'world knowledge' (the correlation between praxis and the accumulation and refinement of knowledge through the five senses). By solving real-time problems of self-protection and by developing precise eye-hand coordination the bio-robot will be in a position to develop the sufficient conditions for advanced cognitive interaction with other forms of consciousness and with the world. The quality of the content of consciousness emergent from any conscious machine will depend, therefore, on factors external to the fact of consciousness: quality of movement and quality of social interaction. However, robots still lag some distance behind this ideal horizon. This is because it is extremely hard to achieve genuine embodiment in the real world solely through the electronic manipulation of symbols. Such symbols are invariably installed in robots on the basis of what designers believe intelligence-machines should know or will need to know in the future, and not, as in real human consciousness, as a matrix of possibilities in which the solution to problems of understanding are flexible and context-sensitive. As Dennett puts it in a memorably vivid concept, intelligence-machines suffer from being 'bedridden'.[16] Thus, even if machines can be pro-grammed to learn, their ability to learn as a result of their sensuous involvement in, and transformation of, material reality is virtually non-existent. Machine-consciousness is still principally a number-crunching, computational intelligence, heavily reliant on the top-down direction of programming and subject to limited real movement. The generation of meaningful interaction with the world gets stalled at what is programmed by the designers to be meaningful on the basis of what is assumed by designers to be already meaningful. As a result artificial intelligence is unable to replicate the labour-cognitive feedback mechanisms of genuine creativity in human culture. Machines may be practised at 'learning', but – at present and for the foreseeable future – they have no actual praxis.

Dennett calls this absence the central Framing Problem of Artificial Intelligence: artificial intelligence cannot be produced solely through symbol manipulation within a system of recursively applicable rules. In this he follows Herbert Dreyfus's important work from the early 1970s: computer programmes are not *constitutive* of human consciousness.[17] However, this does not seem to worry Paul Churchland. In contrast to

Dennett, Churchland takes a purely functional line: there is no reason to presuppose that human neural elements cannot be duplicated electronically. Churchland's own objection to classical AI is simply that the science and technology are insufficient. The prospects for classical AI remain poor because the cognitive architecture of classical syntactic machines is presently inadequate to the task of replicating consciousness. Future intelligence-machines will have to replicate the brain as a dynamic and parallel processing system, in which discrimination and recollection and the navigation of complex environments shape the qualitative content of consciousness. But if this might significantly contribute to the Framing Problem Churchland does not believe that it is necessary to insist on the complete electronic replication of human neurological conditions to talk about successful AI. A successful intelligence-machine does not need to have '*all* the causal powers of the brain'.[18] Settling for less, however, in the hope of something better does not solve the problem of the sensuous and material embodiment of artificial intelligence. How less 'bedridden' is an intelligence-machine that possesses only some causal powers of the human brain? This settling-for-less-as-enough, therefore, is revealing. Churchland is not so much interested in what counts as the achievements of human consciousness distinctive from other kinds of consciousness, and its possible replication in machine-intelligences, than in the *minimum* conditions of consciousness shared by humans, animals and machines. He notes six major cognitive properties that are displayed in all living creatures, and that can conceivably be replicated by a Parallel Distributed Processor computer: 1) the capacity for reorganizing features and patterns given only partial visual information; 2) the capacity for seeing complex analogies; 3) the capacity for recalling relevant information as it bears on contingent circumstances; 4) the capacity for focusing attention on different features of sensory input; 5) the capacity for trying a series of different cognitive 'takes' on a situation; and 6) the capacity for recognizing subtle differences in a given environment.[19] But if humans, animals and (future) intelligence-machines share these capabilities, and as a result introduce us to the specific qualities of other kinds of consciousness, none of the above produce agency as a condition of free will, except in humans. This is because we can think about our activities in ways that bats or dogs can't. Bats and dogs exhibit intelligent behaviour (in the ways outlined above), but it is intelligent behaviour which is essentially unthinking.[20] For Dennett this implies that human consciousness is embedded in something quite

different to the behavioural sensitivities of other sentient creatures: namely, a second-order intentional system of beliefs and desires. Such a system produces beliefs and desires about the beliefs and desires of both the self and others. Human consciousness, therefore, functions self-reflectively as part of a constitutive process of reflection on other selves. And this is why human consciousness and labour are intimately connected, because they presuppose self-transformative agency in ways that are not available to animals or machines. Churchland and other reductionists may, of course, have no objections to this even if they dislike language-based theories of consciousness that prop up human 'exceptionalism'. But by emphasizing consciousness solely as a neurological and cognitive problem they flatten out what is immanent to humans as primary labourers and language-users: their capacity for self-reflection as first person and collective expression. Robots – at least currently – do not create, they act as if they do. Chimpanzees do not paint when given a brush and canvas, they act as if they're painting. Being electronically alive or being biologically alive, therefore, is not a sufficient condition of authorship. Indeed, the Turing Test designed in the 1940s by Alan Turing to expose forms of computer consciousness which pose as human consciousness, is exactly that: a test for authorship *all the way down*, a test, in other words, that links authorship to the subject's powers of self-reflection and social interaction.

But if humans are distinctly authors and agents, what kind of authors and agents are humans in the light of developments in cognitive science and the critique of the Cartesian consciousness? This is where, having travelled in opposite directions, Dennett and Churchland eventually meet. Dennett may place language at the centre of human cognition, whereas Churchland may prefer a model of the human brain as a parallel processor, but both insist on the neural reality of consciousness as a dynamic and distributive network. That is, there is no central processing centre in the brain where everything 'happens'. There is no 'Cartesian Theater' of judgement, as Dennett puts it. On the contrary neurological investigation shows us that consciousness is an extended network in which cognition and judgement are distributed moments of what Dennett calls 'micro-taking'.[21] 'The idea that a mind could be a contraption composed of hundreds of thousands of gadgets takes us a big step away from the overly familiar mind presupposed' by Cartesianism.[22] In this sense, the perceived unity of consciousness is an illusion dependent upon the gap between neurological reality and the formation of the subject. We may speak in the

first person singular, but neurologically consciousness is the outcome of a vast distributive network that has no centre to speak of. This leaves consciousness as a function of a number of sub-systems and not a single overarching structure. And this is why Dennett and others are prepared to talk not of one self but about many selves immanent to the various vectors of consciousness. Indeed, the formation of the subject follows the neurological sub-system logic of consciousness. As Dennett and Nicolas Humphrey argue: 'a human being first creates – unconsciously – one or more ideal fictive-selves and then elects the best supported of these into office.'[23] These fictive selves will then emerge out of, and be shaped by, familial and social relations. Self-hood is the result, therefore, of a number of emergent possibilities *for* self-hood; and psychoanalysis, essentially, is the story of this emergence and how difficult it is for human beings to keep these self-symbols under control. When control is lost, as in Multiple Personality Disorder, a radical discontinuity occurs between self-symbols. 'Each self, when present, will claim to have conscious control over the subject's behavior.'[24]

This notion of multiple selves, inherent to all human beings, is easily trivialized, as evinced in its positivistic celebration in some corners of contemporary therapeutic culture. However, heuristically, it possesses an important insight into what we might mean by the post-Cartesian self. In emphasizing the formation of the subject out of multiple possibilities of the self (and their accompanying multiple countervailing repressive and veiling forces) consciousness is given a *radial* structure, in which it is the dynamic properties of neural networks that assumes control of consciousness, rather than some centrally housed 'essence' or 'spirit'. In turn this means that the subject in its 'disorder' and 'dissolution' is already 'decentred', so to speak, as a consequence of its radial structure. But if our brains are complex distributive networks busily building and dismantling self-symbols why do humans rely so much on introspective infallibility? Why do isolationist, Cartesian illusions prevail? This is where non-reductionist thinking on consciousness comes back into play. It seems essential to successful cognitive functioning that introspection does not reveal the full distributive, radial extent of consciousness to the subject, otherwise consciousness would be swamped by overwhelming amounts of non-essential information. (This is why we don't have cognitive access to our own processes of thought.) Similarly when the radical split between self-symbols results in destructive behaviour it is significant that sufferers from Multiple Person-

ality Disorder are *treated*, rather than given Performing Arts grants. This is not to say that they shouldn't, under all circumstances, be given grants, or that sufferers from Multiple Personality Disorder cannot be the harbingers of an extraordinary creativity, but that there is a good reason that consciousness does appear unified to the subject: it helps promote and secure agency.

The critique of authorship and the critique of the subject may be neurologically essential and culturally imperative, yet they are physiologically and socially impeded by the formation of humans *as subjects* (as opposed to the formation of humans as complex 'social vectors', for example). That is, we cannot think and act freely as socially distributed, multiple intelligences, without encountering – contrary to postmodern accounts of the polymorphously perverse subject – the disciplinary flow of the value-form into the Cartesian space of our subjectivity. Work, family relations, manufactured leisure, identify the subject with the 'first person singular' and as such corral and channel the 'first person singular' into socially acceptable forms of desire and belief: advocate of individual self-expression, defender of 'private property', pursuer of 'self-development', etc. This leads, on the basis of the perceived unity of consciousness, to a naturalization of Cartesianism in practice. However this is not to say that Cartesianism is the state ideology of capitalism. Rather, the naturalization of Cartesianism is the form the social relations of capitalism take under the commodity form.[25] This, in turn, leads, under conditions of blocked collective praxis, to the emergence of compensatory forms of multiple intelligence – such as Multiple Personality Disorder and other forms of psychic splitting – which, in their symptomologies, derive their psychic energy from the desire to escape the Cartesian expectations of capitalist consumption and exchange. The cultural and political challenge, therefore, is to expose the disciplinary drive of the value-form/Cartesian ego, but without collapsing identity into non-identity and the psychotic.[26] The challenge is to bring the critique of the ego out of the domain of fantasy and the pathological into the domain of critical reason and, therefore, into the realm of politics and of culture.

How is the critique of authorship and a defence of distributive intelligence, then, to be squared with 'first person' authorship and the anthropological drive to authorship in humans? How is it possible to think in terms of the critique of the author and defend the authorship of the artist?

The advantage of the distributive model of consciousness is that the self is unseated from the 'centre' of the brain. This in turn allows us to build a model of human consciousness in which the human agent is pictured, not as a monadic, bounded, self, but as a convocation of competing forces, and nexus of competences and capacities. In this sense the self is the name we give to the evolutionary and social development of consciousness. Selves, therefore, are not just the predetermined outcome of these evolutionary and social conditions, they are also *self*-forming as a result of their distinctive agency. Human agency is socially *evitable*, on the grounds that human consciousness can never be transparent to itself.[27] Because the subject knows less than it can ever hope to know or encompass, because it cannot be epistemologically omnipotent or infallible, it is able to act on the basis of a subjectively open future. But this open-endedness of the subject is, in fact, what proves the truth of evolutionary science rather than the truth of 'human freedom'. Humans are self-authoring subjects on the basis that their biological, physiological and social formation provides the conditions for this openness. The distinction between determinism and free will, so beloved of the old philosophy of mind and critics of evolutionary theory, does not, then, hold up. Human agency, as the result of the long drawn out development of the labour-cognitive feedback mechanism, is produced out of the physiological and cognitive adaptations and transformations of humans (independent movement of the hands, sociability through language, bipedal movement, etc.).

> The distinction between being a thing with an open future and being a thing with a closed future is strictly independent of determinism. In general, there is no paradox in the observation that certain phenomena are *determined* to be change-able, chaotic, and unpredictable, an obvious and important fact that philosophers have curiously ignored . . . it could very well be one's "fixed" – that is, determined – personal *future* to be blessed with a protean *nature*, highly responsive to the "activity of the self".[28]

And this is why humans are authors and machines and animals are not: they are designed to be authors.

The notion that subjectivity is the work of evolutionary design is not Godly design by another name, so beloved by religious defenders of evolutionary theory at the end of the nineteenth century. On the contrary, it represents the more mundane claim that human free will and agency are

not anthropological givens, but produced out of human skills, competences and capacities which are derived from evolutionary adaptation of humans to their environment. This, I believe, tightens up our understanding of authorship as produced production, as an ensemble of emergent, embedded skills and competences; and, as such, offers a clearer sense of why we might want to defend a notion of decentred, post-Cartesian authorship.

By identifying authorship with an ensemble of emergent embedded skills and competences the artist's voice is separated from the proprietary claim on 'first person' expression. But this displacement of the 'I' as the point from which the artist emerges and speaks, is not a dissolution of first person authorship *into* a preprogrammed intentional framework and intellectual programme. It is not authorship without the first person singular as such. Rather, it is that point where the first person singular is unable to speak with transparency or ease *in the name of* its own artistic authorship. This means it cannot speak from outside of its own intellectual and technical embeddedness without denying the conditions of its own sociality by which it performs its artistic labour. This is why artists today who talk about their 'inner creativity' distinct from an intellectual programme sound so baleful. Now, this understanding of sociality does not need a theory of the readymade in and of itself for this awareness to be put in place. It is possible to imagine a critique of authorship in these terms centred solely on the technical problems of painting (as was the case with pointillism in late nineteenth century France with its turn to a 'mechanistic' application of paint). But it is the readymade and the craft of reproducibility which makes this awareness available as an *intellectual position*, given the way in which the craft of reproducibility *forces* the split between craft skill and expression. This is why, once the dissociation between craft skill and expression is opened up by the craft of reproducibility, it is harder for the first person singularity of the artist to speak so confidently in a unified voice. Once authorship and the craft of reproducibility become identified in practice the artist's voice becomes subordinate to the forces of reproducibility and general social technique. This, in turn, transforms the relationship between the author and artistic and intellectual tradition. The displacement of the first person singular discourages the author to think of himself or herself as a unified subject bounded intellectually and conversationally to art historical precedents (rather than, say, for example, a performer of a set of cognitive/artistic skills indebted to the problems of

philosophy and science and other non-artistic discourses). Consequently, it is here that the sociality of authorship becomes the sociality of authorship beyond singular authorship. At the point where the first person singular becomes subordinate to general social technique, authorship is also expanded to encompass the possibility of the artist possessing a number of voices (as in Duchamp and Moholy-Nagy) and also the dispersal of the author into *collective* practice – the drawing together of different voices in a process of collaboration. This is why during the Russian revolution the systematic critique of artisanal artistic ideologies produced a vast out-pouring of thinking on group practice and art as a manifestation of collective intellect. Similarly, once the conditions for artistic enunciation are dissociated from the expressive unity of craft skills, *who* qualifies as an author is also transformed and extended. Authorship is not just demo-cratized demographically with the equalization of skills, its *points of entry* are multiplied, diversified and transfigured.

In the following section I want to explore these two categories: direct collaborative authorship, and what I shall call, *delimited authorship*. I want to begin by looking at delimited authorship, specifically what it would mean to be a *blind* Conceptual artist. Such a possibility offers insights into the boundaries of the decentred author and, therefore, what we might mean by the different enunciative conditions of post-Cartesian authorship.

THE BLIND CONCEPTUAL ARTIST

In an episode of *The Simpsons*, 'Mom and Pop Art' (1999), Homer tries to build a back-garden barbecue. Clumsily following the enclosed instructions he makes a hideous mess of it. Frustrated, he later places the bricks and twisted metal on a trolley, attaches it to his car and takes it back to the Mart. At the Mart he is refused a refund or exchange and so tries to dump the tangled metal, unsuccessfully, outside the building. On the way back home the trolley and barbecue separate from the car and hit the hood of another car. Homer drives off regardless. The driver of the other car, however, turns out to be Astrid Weller, an art dealer, who then turns up at the Simpsons' house claiming the distorted barbecue set to be a work of art and Homer a great artist in the making. On the basis of this judgement Homer is 'given' the powers of artistic expression. Weller calls him an 'outsider artist', and praises his barbecue sculpture as an 'expression of raw human emotion'. The piece is duly exhibited in 'Inside Outsider Art' and is

a resounding success, being bought at the private view by an admiring Mr Burns. At the opening we also see a distracted and kleptomaniacal Jasper Johns busily pocketing his would-be favourite readymades: light bulbs, and pieces of cake (from the buffet). Homer then gets down to work for a solo show, driven by the need to find his 'creative anger'. The solo show, though, is not a success. He's accused of repeating himself (of relying too easily on familiar readymades) and the new work is rejected by the dealer. The private view crowd turn tail and leave. Barely into his career, his work is now out of fashion. At this point Homer asks self-pityingly: 'why does art hate me?', and questions his future as an artist. Lisa is less pessimistic and suggests he should outdo himself in order to recover the faith of his dealer and his audience. Precociously she encourages him to produce something like Christo. This will require, she says, a rejection of the breast-beating outsider-expressionism he's become identified with. 'You have to do something big and daring.' Homer follows her advice and switches to a full-blown, conceptual, nominative art. After rushing to Springfield Zoo to fix snorkels on to all the animals, as a living-installation he floods the town turning it into a kind of small-town Venice. The art dealer and friends are ectastic: 'you've turned this town into a work of art.' 'It's Conceptual art', says Homer confidently, drifting smugly by in a boat.

The idea that success as an artist can be returned to the artist by extending his or her powers of nomination has become an art-parable of our times. As an artist Homer gets to flood his home and his environs and call it art and have others call it art, without fear of ridicule. This is the nightmare of artistic nomination that many analytic Conceptual artists and other artists critical of the Duchampian legacy reacted against in the early 1970s. The ease with which realia or huge physical and geographical entities were able to be nominated as art, turned the critical function of the readymade into sleek legerdemain and barbarous Wagnerian spectacle. 'It's Conceptual art' became a suasive refrain, but also a manipulative and ugly one. But even at the moment of its hypertrophic absurdity the nominative function of the readymade contains an important truth: *art is not reducible to an expressive model of visualization*. Homer's artist, given the power of authorship by the art institution ('Outsiderism'), realizes this with abandon, giving himself up to the full powers of artistic nomination.

The fear of unearned authorship haunts art after the readymade, for it opens art up to the spectre of the author as a bare simulacrum. Is it possible, therefore, to put in place the equivalent of a Turing Test to

determine what is or what isn't worthy of artistic authorship? What would the minimum criteria for authorship be? Once this is resolved, wouldn't we then be able to designate what is genuine authorship from what is mere dissemblance, or Homer-like hokum?

For all the merits of this approach's directness, however, this is the wrong way of looking at the problem. The Turing Test seeks to register authentic 'authorship' by checking for the signs of reflective consciousness *all the way down*. It is thus very good at what it was designed to do: distinguishing between human authorship and non-human 'authorship'. In evaluating artistic authorship reflective consciousness is *presupposed* from the beginning. Whether we judge the use of readymades to be skilful or not, the presentation of a readymade is no less reflective and authored than is a naturalistic seascape in oils. All authorship is reflective on its materials at some level – even Homer's opportunistic 'Conceptual art'. This means that amongst those who all possess the capacity for authorship we need another way of evaluating what we might mean by artistic authorship. This involves us borrowing some bits of the conceptual criteria of the Turing Test, if not its overall framework.

In looking for authorship all the way down the Turing Test checks for evidence of 'world knowledge' – knowledge gained laboriously in experience, through failure and struggle. In this respect the subject of the Test (a computer posing as a human interlocuter) can be questioned on the veracity of its claims to possess knowledge. The same might apply for claims to artistic authorship. How, and in what ways, is artistic authorship the result of 'world knowledge'? How is 'world knowledge' made manifest in the reflective powers of the author? Indeed, what kind of 'world knowledge' is required for authorship to take place? This means shifting our focus of attention on to something the Turing Test presupposes as the basis for its evaluations, but is unable to check directly: the presence and functioning of the human faculties themselves. It is consideration of the five human senses, therefore, that will tell us whether authorship is present or not; and, furthermore, what we can designate as an author.

To imagine someone who is blind, deaf and mute is to imagine someone who is without the powers of authorship. He or she might be attached to a computer that would allow them to configure random symbols, but this would be a very minimal kind of authorship indeed. For the person who is only deaf, the conditions of authorship are restricted, but certainly not imprisoned in the crippling way they are above. The deaf artist therefore is

not a strange or exotic figure, because their access to sight is able to secure their primary means of signification. The blind artist, however, is a different matter, given that access to this primary means of signification is missing. In what ways might a blind artist be construed as being a *visual* artist? If the artist has no primary access to appearances how is the visual to be made manifest in the work? How is it possible for aesthetic and critical judgements to be made in darkness? Clearly these are severe limitations, leaving the blind artist with a restricted number of options. These options will tend, as such, to be haptic, that is why many blind artists work in sculpture, modelling in clay or constructing in wood. For artists who have become blind later in life ('late blindness') this may offer a mimetic trace of things in the world, for those who have been blind from birth ('congenital blindness') it offers the direct pleasures of being able to manipulate and bring materials under control. But if some powers of reflection are being brought to bear here what do these powers of reflection actually consist of? The work may generate intense haptic pleasure for the artists, but as objects they are cognitively thin. In fact, because of their limited access to 'world knowledge' they are reliant on a highly restricted sense of form. Some conditions of authorship are being met in this instance (the reflection on and manipulation of materials), but is authorship anything other than a narrow and claustrophobic experience here? This puts an enormous strain on the possibility of artistic authorship separate from access to the visual; haptic skills are not sufficient to compensate for what is learnt empirically from visualization. But what about a blind *Conceptual* artist? I do not know whether there are any blind Conceptual artists working, but let us say, hopefully, that there are, and that they are successful. Let us also make our blind Conceptual artist blind from birth, making her awareness of Conceptual art works limited to descriptions and analyses in braille, and from public lectures. Our congenital blind artist, then, has become a Conceptual artist because she knows that she can work in ways that do more than 'compensate' for her lack of visual powers; unmediated hapticness is, she says, for dummies. Thus, she begins to produce works which reflect on her own limited visualization by working with those powers she has access to and which she has developed throughout her life: her highly sensitive hearing.[29] She has familiarized herself with the soundworks of Lawrence Weiner and recently Janet Cardiff, and decides to produce a series of spoken pieces on 'touch' and her life-long frustration at being limited to the 'visualization' of things and surfaces through the use of her hands. She has

read John M. Hull's *Touching the Rock: An Experience of Blindness* (1991) in braille and it confirms for her what she had always realized, that the world apprehended through sound is dynamic, rich and complex. Her sound pieces speak of how her body feels permeated by the world, despite not living *in* the world, and how sensitive the tips of her finger feel when she touches different objects.³⁰ The detail of the surface of objects feels so various. She knows that the power of capturing knowledge is associated with sight and feels locked out from its riches, but, at the same time, she feels that her acute hearing and sensitivity of touch offer other pathways to knowledge. In the sound pieces she registers this by asking the listener to imagine the world as awakened through the powers of touch. The hand becomes the amplifier of objects and surfaces, bringing them out of their inert and disregarded identity. Furthermore she asks the listener to imagine the world as an acoustic landscape, in which introspection and memory are determined by sounds and voices and not by images. How can we imagine a history of sound, she asks? What would an autobiography or diary of sound be like (or an autobiography of touch)? She believes that our sensitivity to our acoustic landscape vividly connects us to our past, and recalls the time, aged four, when her mother would walk her across the living room placing her hand on various objects, calling out their names and asking her what they felt like. Her mother's reassuring touch and voice passes through her every time she moves her hand over a new object or surface.

Does this represent a limited form of authorship compared to sighted artists? Yes undoubtedly. But does it result in cognitively thin or un-demanding work? Clearly not. By reflecting on the visual in non-visual form the work contributes to our understanding of the reification of the visual in our post-oral culture (and its inherent violence), producing insights that no sighted artist could possibly accomplish. The work, therefore, is not compensatory in form, it is actually expansive. How is this possible given that the artist's 'world knowledge' is determined by limited access to braille texts and public lectures, and the fact that the enigmas of sourceless sound, the overwhelming acoustic experience of the blind, is no substitute for empirical verification? It is possible because the enunciative conditions of authorship here are rich and complex in implication and suggestion. Indeed, they are rich and complex in implica-tion and suggestion precisely because they derive *from* would-be limited resources. 'Limited' technique and subjectivity coalesce to produce an

authentic encounter between knowledge and the world. And this is the great lesson of the readymade and Conceptual Art. The fact that she is blind has no detrimental effect on the conceptual rigour or acuity of the work.[31] But this is not to say that limited resources can *in themselves* carry enunciative richness. This is clearly not so in the case of the haptic-centred work of the conventional blind artist. The limited enunciative conditions of authorship are able to transcend their limited conditions by finding ways of connecting and opening themselves up to 'world knowledge'. 'World knowledge' is worked into the art through the available senses in ways that are amenable and appropriate to the artist's restricted comptences.[32] As a result of the artist's cognitive limitations deskilling becomes a form of reskilling, on the basis of the reconceptualization of the resources of 'expression' – in this instance the use of ambient sounds and voices as an expanded acoustic environment.

The blind Conceptual artist, consequently, appears less constrained than we might have initially imagined. But if we can point to the enunciative richness of this work how much of this enunciative richness is determined solely by the blindness of the author? Is the blind Conceptual artist continually compelled to reflect on her own blindness in order to secure the conditions of this enunciative richness? Are her enunciative powers, ultimately, one-dimensional given that her powers of empirical verification are severely limited? As is clear, it is possible to possess the conditions of authorship even if access to 'world knowledge' is not attached to all five senses. The readymade and copying without copying facilitates this by opening up delimited powers of expression to conceptual reflection. This means that being blind is no barrier to producing work which is cognitively rich, because copying without copying and the craft of reproducibility converge with the absence of the blind artist's craft skills.[33] But, in the final analysis, delimited authorship, through limited access to 'world knowledge', cannot be a substitute for full access to 'world knowledge' through the five senses. This is because full access to 'world knowledge' is the means by which artistic authorship is able to move out to meet the world in its all its sensuous detail and complexity. Delimited authorship certainly produces knowledge and use-values, but it also points out how much artistic authorship is reliant on the 'world knowledge' which the five senses brings. This means that the minimum enunciative conditions of blind or deaf artists are certainly far more advanced than the minimum enunciative conditions of machines or chimpanzees. Blind artists are no different from

sighted artists in their ability to reflect on their means of production. As I have suggested, blind artists can be good Conceptual artists – no problem; but this is an authorship whose powers of reflection are confident and expansive principally in the realm of one area, the acoustic. When judgements about the visual are required it is necessary for the blind artist to defer to the judgements of the sighted artist. This, naturally, presupposes another kind of blind artist, the blind artist who uses a sighted artist or assistant as a surrogate. The sighted artist puts into effect the intuitions and hunches of the blind artist. Yet although this promises an expanded authorship on the basis of the sighted surrogate it doesn't actual resolve the problem at hand: how does the blind artist make decisions about matters of empirical verification when she has no experience of such phenomena? How does she know the colour blue, or the translucent form of a rainbow, when she doesn't have a visual sensation of blue or a rainbow? The cognitive confidence of the blind artist may increase as a result of the use of a sighted surrogate, but this does not in itself improve her own individual powers of judgement. The blind Conceptual artist (or non-Conceptual artist for that matter) who uses a surrogate, then, is engaged in a form of *sighted collaboration* in which her authorship becomes subordinate to that of the sighted partner. This means that with the surrogate the blind artist is no different to sighted artists in having access through all five senses to 'world knowledge', even if it is another pair of eyes and ears. As in the sighted artist devolving the production of the artistic object to technicians, the blind artist devolves the execution of the work to the surrogate. This is an enterprising and vivid solution to the empirical problems of blind authorship, but, nevertheless, it takes us away from what is the key question: what are the conditions of authorship once we separate enunciation from the notion of 'visual expressiveness'? The blind-artist-with-surrogate only deflects from this issue.

GROUP LEARNING, WORLD KNOWLEDGE, AND THE SOCIAL FORM OF COLLECTIVE AUTHORSHIP

From the above it is evident that there is a necessary and abiding relationship between access to 'world knowledge' and authorship. Whether authorship is cognitively thin – as in the haptic expression of the blind modeller, or possibly cognitively 'thick' – as in the case of the blind Conceptual artist, the success of the outcome will depend upon this

relationship. Thus even if the author has limited or no access to the visual apprehension of the world, access to (some) 'world knowledge' conceptually can still enable work of high quality to be produced and authorship to be secured.

I now want to look at the inverse of this delimited notion of authorship: open access to 'world knowledge' on the basis of collective practice. This sets up very different problems for understanding the dynamics of authorship given that the skills and competences of the individual are distributed and redirected directly through teamwork, group learning and access to the collective intellect. We might say, then, for simplicity's sake, that this form of authorship is maximal as opposed to the minimum authorship of the blind or deaf author. By maximal I mean that, with the reliance on collective learning, the praxis of authorship becomes intellectually and culturally *expanded*. Group discussion and sharing skills and ideas across disciplines produces a direct and unambiguous enlargement of the powers of authorship. Access to world knowledge is secured in a multiple and collaborative fashion. But, unlike the blind Conceptual artist we don't need to imagine this collective author primarily as a counter-intuitive exercise on the margins of philosophical discourse. The collective author and group practice run parallel with the very critique of the artist from the early avant-garde onwards. Indeed, at a fundamental level, the collective author and the avant-garde presuppose each other. This is reflected in the extraordinary range of positions on collective-authorship in Soviet Productivism and Constructivism, the Bauhaus and Surrealism.

The attack on the artisanal practices of the academy in the early Soviet avant-garde and Bauhaus is predicated on two defining notions of the decentred author which run through advanced art in the twentieth century: the idea of the 'laboratory' artist, in which the production of the art object is subject to group research; and the notion of collective practice as a liquidation of the barrier between artistic technique and general social technique.[34] The former, best represented by Alexander Rodchenko's Constructivist *Metfak* faculty at the VKhUTEMAS, tended to emphasize authorship as a shared studio practice and the basis for speculative social projects and interventions (usually design-oriented and propagandist in nature); the latter, Productivism, made a priority of working directly with industry and social institutions as the basis of a worker/artist and engineer/artist collaborative practice. These two positions were certainly not identical in their critique of the author. Productivism judged Constructivsm

to be too in thrall to the old atelier system of art's organization, despite its democratic and research-based character. Constructivism judged Productivism too close to the instrumental and pragmatic demands of industry and idealist about worker participation. But both represent what happens to artistic authorship during this period as a result of its social critique: art becomes subordinate to a model of the collective intellect in which collaborative artistic practice and socialized labour converge.[35] No distinction is made between revolutionary social praxis and revolutionary artistic praxis – both exist in the same transformative space, the labour of the studio and the labour of the factory and office forming part of the same collective production. This drive to convergence is reflected in the widespread theorization of the artist as a hybrid or composite figure: artist-engineer, artist-designer, artist-educator, artist-constructor, artist-worker.[36] All the leading Soviet avant-garde artists and theorists – Vertov, Arvatov, Gan, El Lissitzky, Rodchenko – offer some version of this. By dispelling the notion of the artist as a specialist in aesthetics these hybrid artistic–non-artistic identities function as a prefiguration of aesthetic *thinking*, and the breakdown between intellectual and manual labour and the reign of non-alienated labour. The theorization and practice of collective authorship, however, lasted briefly in the Soviet Union in the 1920s. Debates on the social production of art soon become subordinate to the dictates of the Taylorization of production as War Communism gave way to the building up of heavy industry and the top-down organization of culture,[37] leaving the revolutionary transformation of the cultural form of art as a pre-Stalinist memory. Even by the early 1920s, the virtues of the scientific organization of work were being extolled. As Alexey Gastev – an influential ex-revolutionary worker-poet, turned epigone of Taylor's – declared, the psychology of the proletariat must be subject to mechanized collectivism. Admittedly Lenin was no unthinking defender of such worker-machinism, but Gastev's ideas were certainly welcome on the Central Committee, along with Taylor's widely-read *The Principles of Scientific Management* (1911).[38] In order to improve labour efficiency Gastev headed up a Time League, with outposts in all cities and towns, which monitored lateness and dilatoriness at work and shop-floor practices.[39]

Yet despite the rapid disappearance of revolutionary conditions, the ideal of collective authorship has held the high-ground of Western avant-garde practice since the 1930s. This is reflected in the repeated return within the neo-avant-garde to the Constructivist model of group learning

and shared research within the confines of the studio, and a Productivist-derived commitment to social functionalism. Artists' groups and collectives, art-as-social-interventionism, have been recurrent features of the neo-avant-garde since the 1960s, just as artists' groups continue to emerge with similar kinds of aims as the early Soviet avant-garde: the convergence of artistic technique with general social technique. This is because, irrespective of the social conditions under which it is formulated, collective authorship represents the displaced *social form* of non-alienated collective labour. It therefore always possesses a utopian content.

Under capitalism the social character of labour – its coordinated and collaborative form – constitutes the social productive power of labour. As Marx puts it, co-operative labour *is* capitalism; co-operative labour is, above all else, that which distinguishes the capitalist mode of production from earlier modes of production. But the co-operation of labourers is 'the act of capital'[40] and not of the labourers themselves. The result is that labourers have 'ceased to belong to themselves'[41] and have become 'incorporated into capital'.[42] Collective authorship in art promises the opposite in that its processes of co-operation and collaboration result in forms of complex labour, rather than simple labour, at the level of the collective intellect. Because art is not subject to the discipline of the technical division of labour its relationship to general social technique becomes a place, therefore, where co-operative skills and collaborative practice can be explored at little or no cost to capital. As a result collective authorship is able to develop the individual skills of participants in ways that strips the ego from both its limited Cartesian Theatre of desires and from its subjection to the discipline of the productive power of labour. In collective authorship group access to 'world knowledge', then, systematically develops and heightens the individual skills and competences of participants, in turn developing and expanding what access to 'world knowledge' in art might actually be. This is why access to 'world knowledge' is made available through collaborative practice as a social universal in collective authorship. Collective authorship represents the promissory social space of the organization of art's ensemble of skills and competences beyond their privativization in 'first person' expression, aesthetics, and the whole panoply of possessive individualism inherent in the Cartesian Theatre. But if collective authorship can heighten the powers of individual authorship this does not mean that collective authorship is any less subject to the division between the reproducible artistic object and the non-reproducible

artistic object as in the work of individual producers. The decision to collaborate, therefore, can just as easily derive from the customary requirements of object production for the market as from a commitment to a post-autonomous social interventionism. Similarly, some post-autonomous practices may in fact be committed to extra-studio group labour on materials, whereas studio-based group practice may involve little actual production at all. There is no strict correlation between actual group labour on the production of objects and studio-based practice. Furthermore, because all artistic production is subject to the division of labour, all art is, in a formal sense, the outcome of collaborative practice. In the conventional atelier production of objects for the market by the singularly named artist, for instance, the collaborative nature of the studio production is largely hidden, diffused into technical support. Jeff Koons's studio is a case in point. In this respect, the critical and promissory content of collective authorship can only be judged *case by case*.

To this end I want to look at two studio practices which represent two very different models of group learning for collective authorship in post-war art: Warhol's Factory and Art & Language's group practice. Warhol uses collective authorship to 'devirilize' the masculine afflatus of the painterly modernist artist in his studio, Art & Language turn the studio into an anti-modernist 'research centre' in which reading, writing and group conversation locate the relations of production of art in discursive activity. In this both practices are representative of the search by artists at the height of the power of official modernism for other ways of thinking and being as artists. But they are also indicative of the problems faced by the neo-avant-garde in the period of modern art's revisionist assimilation as aesthetics, and as such, are particularly instructive for our wider discussion on artistic authorship and autonomy and post-autonomy.

Warhol's Factory in the mid–1960s is a good example of the tensions between collective authorship and the market. In the late 1940s Warhol had been exposed to the new Bauhaus (he had studied at the Carnegie Institute in Chicago) and was keen to bring art into realignment with the newly emergent forms of mass reproduction. As Benjamin Buchloh puts it, Warhol wanted at the time to 'bring the rights of the readymade into painting'.[43] And crucial to this was the very transformation of the conditions of the production of painting in the studio and what a painting might be. With the printed incorporation of the photographic readymade into the painting Warhol soon realized that the painterly mark had no

proprietal relationship over painting, and therefore any number of pairs of hands might contribute to the painting's serial production. As he declared in 1966: 'A factory is where you build things. This is where I make or *build* my work. In my artwork, hand painting would take much too long and anyway that's not the age we live in. Mechanical means are *today*, and using them I can get more art to more people.'[44] The Factory, however, was not a *Metfak* in the making. Warhol's model of 'research' was informal to say the least. Similarly, he may have borrowed the model of the industrial work-shop, and in the early years have been keen to designate his art a form of 'Commonism',[45] but he was not interested in transforming his co-workers into an industrial design co-operative or a cadre of activists. The result at the Factory in the mid-to-late 1960s was a collaborative practice of a different kind: collaboration as *performative flow*, indebted on the one hand to counter-cultural notions of self-activity, and on the other to the idea of the non-unitary author as a critique of identity.[46] The latter owes a primary debt to the Brechtian notion of authorship as a 'community of ideas', a notion introduced into Warhol's circle by the Marxist documentary film-maker Emile de Antonio, who for a while had Warhol's ear and later went on to collaborate with the artist on the film *Painter's Painting* (1973). But it is also a consequence of Warhol's desire to see the dissolution of the heterosexual ego in the studio, identifiable in his eyes with the male hubris of expressionist American modernism and with sturdy notions of craft. In the early days for Warhol a community of ideas also meant the possibility of a studio that allowed for a sociability across the sexes and sexual identities. Although it was the (young) men who did most of the printing and studio labour, it was women, transsexuals and transvestites who contributed extensively to the flow of ideas. Warhol later recanted his radical commitment to the non-unitary author – the attempted assassina-tion in 1968 pulled him back sharply from the sociability of his model – retreating into a more openly managerial position in which 'collaboration' was conducted more along the lines of the old master-atelier system: other hands providing the technical back-up for the valorization of the singular named author. It was now Business, without the early ironic appropriation of the studio as a commercial premises. Nonetheless, during this period Warhol's dissolution of art into industrial processes produced a candid commitment to the non-unitary author. The sociability, discursivity and collectivity of the Factory revitalized the studio as a place of complex social interaction and complex division of labour during a period in which the

solitary, virile and auratic labour of the modernist male artist was widely admired and fetishized.

Warhol's collaborative model in the 1960s, then, is shot through with all the historical constraints and fudges involved in bringing the collective intellect into artistic production for the market. By the 1970s, as Warhol became a stylist to the New York Upper West Side social scene, his commitment to collective authorship was no more than a fig leaf on what had become a very successful atelier-style business run by compliant assistants.

In the late 1960s Conceptual art began to challenge this cynicism by exploring collective authorship in *good faith*. Reattaching the avant-garde 'research model' of practice to notions of art's collective intellect, Conceptual art harnessed the displaced social ideals of Constructivism to a philosophically robust account of the artist-as-thinker. In this not only did Conceptual art subject Warhol's performative flow model of non-unitary authorship to an implicit critique, but it embarked on a wholescale confrontation with the vast logjam of revisionist thinking on authorship and artistic form installed and institutionalized under the aegis of post-Second World War American modernism. The aggressive Cartesianism and asocial aestheticism of modernism that the early Warhol had challenged through his non-unitary staging of the author required more than performative displacement, it required a thorough uprooting. Conceptual art, then, went one step further: a partisan confrontation with all the cherished shibboleths of modernism's liberalism: artistic autonomy, self-expression, and 'visual language'. And, central to this move was the reconstitution of the intellectual claims of authorship as a constitutive part of art's relations of production. Research was not something artists did clandestinely or inconsequently as an aside, or like 'homework', or even as part of the performative flow of studio practice, it was part of the *primary* activity of artists-as-thinkers and the apodictic claims of art. This did not mean that Conceptual artists saw themselves as philosophers or scientists, or treated the truths of art as akin to the deductive truths of philosophy and science. But, rather, in a climate where 'knowledge' was derogated and severed from the 'sensitivities' of the artist, the 'research model' of collaboration was an exemplary way of opening up the space of learning in art. What should artists know? And in what ways, with what means, should knowledge be shared and transmitted between artists and other artists, and between artists and their audience? What kinds of knowledge is art capable

of producing? How might knowledge be represented in art? If art is intertext, can art itself be made of textual materials? If art can be text, what kind of texts?

In certain cases, primarily that of the group Art & Language, this model of learning became more than a commitment to the theorization of art as collaboration, it became an actual commitment to research-based group practice itself, reviving a model of studio practice that had not been seen since the 1920s. More than any other group of artists in the 1960s, Art & Language's project was engaged in a form of collective authorship in which the distinctions between artist and thinker, artist and philosopher, artist and critic were openly flouted. In this their work has the character of an extended (and never-ending) conversation, in which discussion, disputation and shared learning and reading shape the outcome of research interests unfettered by scholastic, aesthetic or academic fealties. Research is the outcome of collaborative learning, with all its attendant conflicts, confusions and misrepresentations.

Much of this labour in the early work was taken up with redefining the place or places from out of which art might be authored. Instead of beginning with the notion of the artist as a picturesque site of expressive drives and native abilities, the author's subjectivity is displaced into the conversational requirements of cross-disciplinary problem-solving. 'I am . . .' or 'I believe . . .' are replaced with: 'Is this meaningful once we subject it to scrutiny?' For Art & Language, individual members might express 'themselves' (view the other members as wrong-headed, or as worryingly preoccupied with the minutiae of an argument), but 'expression' and 'expressiveness' were meaningless once skills and intellectual labour were shared and subject to group critique. The proprietal stakes of authorship were always being broken up and redistributed. However, this is not to say that different subjectivities did not contribute to the character of the group or were not recognized as such by the members. Or, moreover, that the force of argument of certain personalities did not prevail to the cost of other personalities' arguments; but that – in the image of Dennett's unseated consciousness – there was no expressive centre through which the authorship of the group could be defined, without doing violence to the internal relations of the work. Wanting to know who made the work as a means of locating the work within the stable bounds of personal biography is simply incoherent as an interpretative route into the work. This model of resistance to the hermeneutics of interpretation – a method

of interpretation so central to maintaining the conventional division between artists and critics, and between artists-as-thinkers and artists-as-doers – represents the critical core of Art & Language's commitment to collective authorship, and marks it out as one of the theoretical high points of Conceptual art's reflection on collective authorship. In Art & Language collective authorship is not just a would-be democraticization of authorship, it is a defensive operation against the persistent rerouting of the meanings of art, and its internal relations, back into 'first person biography'. In its very non-unitary and decentred structure collective authorship becomes a space of negation and resistance.

In this respect there is a clear overlap with Duchamp's late practice, despite the over-rehearsed antipathy on the part of Art & Language to the Duchampian legacy of the readymade. The collective authorship of Art & Language restages the decentred Duchampian author and Duchampian 'delay' as a displacement of the aestheticized Cartesian spectator. As with the later Duchamp's dispersal of authorship into an enigmatic and non-artistic discursivity, Art & Language's use and misuse of analytic philosophical language and scientific models exhibits a similar disregard for 'retinal pleasure' and notions of intellectual transparency or economy. Theoretical texts and the graphic organization of linguistic materials substitute themselves for sensuous form and expressive surface. But in the 1920s and 1930s Duchamp's non-unitary author was still attached, at least in spirit, to the socially progressive notions of the artist-intellectual. By the late 1960s the artistic model of the collective intellect was facing in another direction completely: confrontation with the power of the post-war institutions of art, after the vast new museum-building programme in the USA and Europe and expansion of the private gallery system. Art & Language's collective authorship may think the artistic self beyond the boundaries of the self-enclosed Cartesian artist and 'expressive mimeticism', but as a defensive reflex against American modernism and the rapacious culture industry its sense of what is made possible by the challenge of collective authorship is also confronted by the internal realities of sustaining a group under these conditions. This is why despite Art & Language's defence of research practice as the best way of securing the openness of art as a category, the group experienced an internal crisis similar to Warhol's Factory. Once Art & Language's reflection on reflection had accomplished its work on modernism, reflection on reflection needed a practice it could call its own. At the point of Conceptual's art's

demise as an international movement in the early 1970s, the group disbanded the collegiate structure of the practice and opted for a model of collective authorship that enabled them to return to the studio as the basis for a reengagement with the art object and the question of artistic autonomy (as against the growing pressure to submit to the post-conceptual alternative: the dissolution of group activity into actual art-political practice). The return was far from unanimous; and today it still represents a moment of extreme contentiousness for ex-members.[47] However, most members and ex-members agree that what drew these arguments to the surface was the final manifestation of the group's high-water-mark engagement with collective authorship: *Index 001*. First shown at Documenta in 1972, the *Index* represents the group's conversations in symbolic logical form typed on index cards stored in a row of file boxes. Vast and impenetrable, this huge compilation of Art & Language material is both the critical and disciplinary outcome of their collective authorship and also the point of its asocial implosion. The capacious and speculative conversation of the group in the studio becomes a highly opaque reference system in the gallery, leaving the imagined 'new spectator' of the early days of Conceptual art adrift and confused.[48]

Warhol's Factory from 1963–8 and Art & Language's 'research-based' practice represent the point where various notions of collective authorship challenge reductive or partial accounts of authorship in modernism generally. In this both offer corrective accounts of the expressivist and Cartesian model of American modernism, during a period when such thinking was being enshrined at the heart of the new museum system. But both studio practices also represent a recurrent problem for collective authorship housed inside the post-war institutions of art: how does group learning transform itself into practice beyond the comforts of the performative flow of ideas or group research itself? Is the social form of collective authorship best served, given the limited access of art to social praxis, by a defence of artistic autonomy? Or is collective authorship, as an expression of the relationship between artistic technique and general social technique and the displaced social form of non-alienated co-operative labour, best served by a *post-autonomous* commitment to research as artistic technique? How, then, might the post-Cartesian artist embed himself or herself in the world without handing over authorship to practices other than those identified with art (a fear that accompanied the split in Art & Language)? Is this, in fact, a genuine fear at all, given the long-term demise of traditional practices?

Since Conceptual art the conflict between the studio-based research model of Constructivism (as in the legacy of the Factory and Art & Language) and the commitment to the social functionalism of the Productivist legacy has sharpened these questions, as numerous artists have adopted post-autonomous approaches to individual and collective authorship. The defence of autonomy as collective labour in the studio, as practised in their respective ways by Warhol and Art & Language, has, in turn, come under a great deal of scrutiny. It is these issues that I want to explore in the rest of the book. How might collective authorship and other non-normative accounts of authorship be put into practice? But, before I answer this I want to expand the discussion of artistic surrogacy and authorship-at-a-distance, and also take a closer historical look at the social division of labour in the studio. For in clarifying what we mean by these things we will be able to offer a sharper understanding of what the question above entails.

CHAPTER 4

1 René Descartes, 'Private Thoughts', in *Philosophical Writings*, trans. and ed. Elizabeth Anscombe and Peter Thomas Geach, Open University Press/Thomas Nelson Publishers, London, 1970, p.3.

2 Roland Barthes, 'Theory of the Text' (1973), trans. Ian McLeod, in *Untying The Text: a Poststructuralist Reader*, Robert Young, ed., Routledge and Kegan Paul, London, 1981.

3 Animals-as-artists experiments are strange concoctions, fuelled by all kinds of fantasies about non-human creativity. The populist social anthropologist Desmond Morris is perhaps most well known for his work with chimpanzees in the 1950s and 1960s on creativity and cognition. He encouraged a number of chimpanzees to 'express' themselves with paint. It was not clear, though, what the results – vaguely 'expressionist' daubs – presupposed: that non-human primates were able to produce fairly convincing Abstract expressionist paintings – more Franz Kline, however, than Mark Rothko or Jackson Pollock – or that Abstract expressionist painting was as cognitively diminished as the painterly efforts of chimpanzees? As a surrealist-manqué of sorts, Morris's position was perhaps closer to the former. But, either way, both presuppositions remain completely underdetermined and repressively counter-intuitive. As a sign of manual dexterity a chimpanzee's ability to move a paint brush back and forth across a bounded space is certainly more impressive than, say, what a mollusc might achieve encouraged to perform the same task with a strap-on brush. But, as a sign of authorship it is as vacuous as if the chimpanzees were asked to 'sort out' squares of coloured paper as the basis for assessing their proto-Constructivist intelligence. This is because authorship requires more than motor dexterity or pattern recognition. As Hilary Putnam has argued, a nominal definition of authorship must include the capacity for specific and *recursive* powers of recognition: an ant may miraculously scratch out a portrait of Churchill, scuttling about on the beach, but because the ant cannot possibly recognize Churchill, and as such lay claim to it as a

portrait *of* Churchill, the ant is not the author of the picture. (Hilary Putnam, 'Brains in a Vat', in *Reason, Truth, and History*, Cambridge University Press, Cambridge, 1981.) Morris's chimpanzees, therefore, were not the authors of their 'expressionist daubs' (even if cognitively it could be proved that there was actually a causal connection between certain patches of colour and various emotional states experienced by the chimpanzees), because there was no retrospective self-assessment of their effects. 'Intelligence' in non-human primates, then, is soon exposed, irrespective of neurological similarities between humans and the higher animals. Tellingly, for example, non-human primates, unlike humans, are unable to recognize a specific number of things, only approximate magnitudes (big or small).

4 The idea that machine-intelligence can substitute for human authorship is a recurring fantasy in late bourgeois culture. What it assumes is the notion that intelligence and creativity can be replicated as computational systems. Knowledge, borne of error, false starts and incompetence, as a result of the vicissitudes of extended social interaction, in short, is discarded.

5 Churchland, *The Engine of Reason*, p.268. See also Capra, *The Hidden Connections*: 'the cognitive and emotional lives of animals and humans differ only by degree' (p.57).

6 Thomas Nagel, 'What is it like to be a bat?' in *Mortal Questions*, Cambridge University Press, Cambridge, 1979, p.169.

7 Colin McGinn, *The Problem of Consciousness: Essays Towards a Resolution*, Blackwell, Oxford, 1991, pp.35–6.

8 John Locke, *An Essay Concerning Human Understanding*, ed. John W. Yolton, Everyman, London and Rutland, Vermont, 1993.

9 McGinn, *The Problem of Consciousness*, p.10.

10 Ibid., p.5.

11 See Churchland, *The Engine of Reason*.

12 Ibid., p.269.

13 Ibid., p.271.

14 Ibid., p.269.

15 See for example, Dennett, *Kinds of Minds: Toward an Understanding of Consciousness*, Basic Books, New York, 1996.

16 Dennett, *Brain Children*, p.21.

17 Herbert Dreyfus, *What Computers (Still) Can't Do*, MIT, Cambridge, Mass. and London, 1972.

18 Paul M. Churchland and Patricia S. Churchland, 'Could a Machine Think?', in *On the Contrary: Critical Essays, 1987–1997*, MIT, Cambridge, Mass. and London, 1998, p.61.

19 Churchland, 'The Puzzle of Consciousness', in *The Engine of Reason*, pp.187–226.

20 See Dennett, *Kinds of Minds*.

21 Dennett, *Brain Children*, p.133.

22 Ibid., p.365–6. In this Dennett is as much a reductionist as Churchland. Mental states do not have intrinsic properties separate from their dispositional properties in the brain. Conscious experience is not something separate from neural processes, it is a succession of states constituted by these processes. Internal states of consciousness, then, do not possess a set of ineffable and private properties. There are processes in the brain that actually *do* correspond to the visual awareness of red, green and blue, etc.

23 Dennett and Humphrey, 'Speaking for Ourselves', *Brain Children*, p.41.

24 Ibid., p.45.

25 See Sohn-Rethel, *Intellectual and Manual Labour*.

26 The blocking of multiplicity, of course, is another name for Lacan's monadic ego. For Lacan the ego also cannot be overcome simply through a post-Cartesian play of identities or selves; however, it can be exposed and challenged through the interplay of identity and non-identity.

27 See Daniel Dennett, *Freedom Evolves*, Allen Lane, London, 2003. See also Slavoj Žižek, *The Ticklish Subject: the Absent Centre of Political Ideology*, Verso, London and New York, 1999, who makes similar arguments via Lacan and a discussion of German Idealism's relational subject.

28 Dennett, *Freedom Evolves*, p.90.

29 Recent work by researchers with the congenitally blind suggests that the blind are capable, through touch and hearing, of generating 'mental images'. Experiments into the visuospatial awareness of both the congenitally blind and 'late blind' reveal that they are able to make perceptual judgements in the absence of any visual sensation. But these cognitive skills tend to be passive ones (the storage of information). Difficulties arise when the congenitally blind, in particular, are required to actively manipulate and transform visuospatial images. For instance congenitally blind people's judgements do not – or very rarely – reflect the laws of perspective. This confirms what I mean by the delimited authorship of the blind. Blind people are perfectly capable of producing mental images as a result of the development of their spatial and auditory skills, but they find great difficulty in updating and transforming this information into cognitively new and novel arrangements, given their absence from full access to 'world knowledge'. Hence, we might say, the congenitally blind artist doesn't simply use the haptic and auditory as compensatory means for the visual, rather, inversely, the auditory and the haptic actively shape a severely restricted access to the production of mental images. For a discussion of blindness and the production of mental imagery, see Cesare Cornoldi and Tomaso Vecchi, 'Mental Imagery in blind people: the role of passive and active visuospatial processes', in Morton A. Heller, ed., *Touch, Representation and Blindness*, Oxford University Press, Oxford, 2000, pp. 143–81.

30 For a discussion of the permeating powers of sound, see Steven Connor, *Dumbstruck: A Cultural History of Ventriloquism*, Oxford University Press, Oxford, 2000. Following the writings of Don Idhe, Connor suggests that the 'value of sound, and of an intensified awareness of it, is to restore us to a sense of being in the middle of the world' (p.15). See also Jonathan Rée's, *I See a Voice: Language, Deafness and the Senses*, HarperCollins, London, 1999, which develops a post-Cartesian account of deafness and sense-diminishment. '[We] do not really perceive the world through our five separate senses, but with our bodies as a whole' (p.11).

31 A number of sighted artists have either affected blindness, or some other disability, to reflect on the enunciative limits and possibilities of authorship. In 1971 Vito Acconci blindfolded himself and 'deafened' himself by blocking his ears in a gallery performance that involved him writing down descriptions and making drawings of visitors to the gallery who came to look at him. He knew people were in the gallery by the movement of air and other physical disturbances in the space. In effect he drew and wrote his notes in response to the vibrations his body experienced. In the late 1970s Dieter Hacker 'painted by mouth', as did Art & Language in the early 1980s, in order to query notions of the necessary connection between 'expressiveness' and the hand. And in the mid–1980s Ian McKeever painted in the dark, producing, as is perhaps to be expected, sombre expressionist looking landscapes that converged towards murky browns and black.

32 This linking of 'world knowledge' to 'limited' or constrained technique is rich in its
 possibilities for teaching practice. We might imagine an ideal art foundation course along
 these lines. In the first week the student is asked to draw a sheep's skull in fine
 naturalistic detail. At the end of the week he or she is then told to tear the drawing up
 into tiny pieces and throw it away. In the second week the student is asked to find a
 discarded washing machine and dismantle it. Once broken down into its constitutive
 elements he or she is then directed to make another machine with moving parts. In week
 three the student is asked to dig a hole precisely three feet deep and three feet square in
 an area of disused land. The contents of the hole are then to be laid out on a plastic sheet
 and sorted through by hand into various object categories: organic material/ non-
 organic material, small things/very small things, brown things/black things. In week
 four the student is asked to make a three foot by three foot drawing of the hole. This
 drawing is kept and to be placed in the student's studio throughout the course. In weeks
 five, six, seven, eight, nine, ten, eleven, the student is required to read only geology
 books, keep a notebook and not produce any art. In weeks twelve, thirteen and
 fourteen, the student is then requested to produce a piece on the concept of
 techtonicity. In week fifteen the student is asked to photograph their house and
 flatmates blind with a digital camera, and then get a friend to transfer them to their
 computer. Without seeing the photographs, he or she is then asked to deliver a
 PowerPoint presentation on them as if they were the work of a sighted artist. In week
 sixteen the student is asked to find themselves an unknown collaborator outside of
 college and begin a friendship. This burgeoning friendship is to be the basis of a diary. In
 week seventeen, the student is asked to read an art-theoretical text of their choice and to
 defend it in written form by only using words contained in the text, and without
 repeating any sentences or extensive phrases in the text. In week eighteen the student is
 told to visit a modern art museum and hover around next to a painting making notes of
 the all conversations or conversational fragments they overhear. The student is then
 asked to write these up into a short script and perform them with fellow students. In
 weeks nineteen and twenty the student is asked to design a tiny model for inside a
 Kinder egg, based on a work of minimalism or Conceptual art. In week twenty-one, the
 student is asked to photograph all their work and defend it in front of the class. Some of
 the content of this imaginary course – or content like it – no doubt exists on actual
 foundation courses. But, broadly, as a model of learning it has little bearing on how art is
 still taught before undergraduate level, and even at undergraduate level. This is because
 the business of art-making still remains divided between hand and intellect: the recidivist
 'craftsfolk' (in all their traditional and modernist guises) standing scowling at the
 conceptualists and digitalists, and the conceptualists and digitalists standing scowling at
 the 'craftsfolk'. With thanks to Mark Harris and our conversation on this topic,
 Newington Green, March 2005.

33 I have already touched on the links between the readymade and blindness (Chapter 1).
 Duchamp's *Fountain* refuses the gaze of the spectator, as if they were blind to aesthetic
 reason. Accordingly, there is a way of reading Duchamp's readymades as an 'art of the
 blind': an art that releases the 'intellectual senses' at the expense of the retinal.

34 For a discussion of Productivism and general social technique, see Boris Arvatov's
 important *Kunst und Produktion*, Karl Hanser Verlag, Munich, 1972. See also, Victor
 Margolin, *The Struggle For Utopia: Rodchenko, Lissitzky, Moholy-Nagy 1917–1946*, University of
 Chicago, Chicago, 1997.

35 See John Roberts and Stephen Wright, eds, 'Art and Collaboration', a special issue of
 Third Text, No. 71 Vol. 18, Issue 6, November 2004.

36 Famously in the 1930s, of course, Walter Benjamin called for the melting of artistic forms and artistic identities across the art/non-art divide. See 'The Author as Producer', in Victor Burgin, ed., *Thinking Photography*, Macmillan, London, 1981, pp.15–31.

37 For a discussion of the effects of this on, and inside, the avant-garde, see Brandon Taylor, *Art and Literature Under The Bolsheviks, Vol. 1: The Crisis of Renewal 1917–1924*, Pluto Press, London, 1991.

38 F.W. Taylor, *The Principles of Scientific Management*, Harper Bros, New York, 1947.

39 For a discussion of Gastev's ideas, see René Fülöp-Miller, *The Mind and Face of Bolshevism: An Examination of Cultural Life in Soviet Russia*, translated by F.S. Flint and D.F. Tait, G.P. Putnam and Sons, London and New York, 1927, pp.185–222, Brandon Taylor, *Art and Literature*, pp.120–1, and Thomas F. Remington, *Building Socialism in Bolshevik Russia: Ideology and Industrial Organization 1917–1921*, University of Pittsburgh Press, Pittsburgh and London, 1984.

40 Marx, *Capital*, Vol. 1, p.331.

41 Ibid., p.333.

42 Ibid.

43 Benjamin H. Buchloh, 'One-Dimensional Art: 1956–1966', in Annette Michaelson, ed., *October Files 2: Andy Warhol*, MIT, Cambridge, Mass. and London, 2001, p.9.

44 Andy Warhol, interviewed by Douglas Arango, 'Underground Films: Art or Naughty Movies', *Movie TV Secrets*, June 1966, quoted in Buchloh, ibid., p.5.

45 Interestingly the site of the old Factory at East 47th Street housed the American Communist Party on the eighth floor. The prospect of Gus Hall, the then party leader and perhaps the most unimaginative and unthinkingly pro-Moscow of the CPUSA's leaders, exchanging pleasantries with Warhol on the stairs of the building is rich in bathos. The building was condemned in 1968. For a discussion of Warhol's notion of Commonism, see Caroline A. Jones's important *Machine in the Studio: Constructing the Postwar American Artist*, University of Chicago, Chicago, 1996.

46 Emmett Grogan's 'never-ask-or-protest-for-anything-rule' perhaps comes closer to the truth of Warhol's reticence. See Emmett Grogan, *Ringolevio*, Rebel Inc. Press, Edinburgh, 1999, p.587.

47 Terry Atkinson, for example, who left the group in 1974, regards the *Index* as the point where Art & Language's apodictic model of research collapsed back into the realms of artistic reference. By allowing the open conversation of the studio to take the synthetic form of a reflection on its own conditions of production, the truth conditions of the internal relations of group learning were submitted to a formalist (rather than dialectical) account of their dynamic. This made the 'return to the object', as an engagement with artistic autonomy out of the ruins of Conceptual art, appear the right and appropriate thing to do, rather than a messy and internally conflicted decision. There is some truth in this. The return to the issue of autonomy in Art & Language was not accompanied (initially that is) by any real theorization of the expanded possibilities of the social content of autonomy. Back in the studio with the painted object Art & Language took a dim view of socially collaborative practice, by identifying all such moves with the distributive fantasies of post-conceptualism. However, not all socially collaborative work endorsed such fantasies at the time (and subsequently). On the contrary, there was still a debate to be had about the autonomy of socially engaged practice. In the 1990s Atkinson wrote a number of unpublished papers ('Hobbes Leviathan', 'Tarrying Art After Philosophy: Wittgenstein is smarter than Duchamp', etc.) chronicling his years in the group, and critiquing what he sees as the limitations of the model of collective learning subscribed to by the group in these years and after. Underwriting this project

has been Atkinson's own critique of the Cartesian subject, borrowed from debates in neuroscience and the philosophy of mind. His relentless dissection of the occult mentalism of the Cartesian illusion enabled work in the 1990s on non-standard theories of enunciation in art to go forward.

48 After the production of the *Index*, the extended NY–UK membership of the group finally dissolved, leaving the group with three remaining members (Michael Baldwin, Mel Ramsden and Charles Harrison).

FIVE

SURROGATES, PROSTHETES
AND AMATEURS

The idea of collective authorship is, of course, not particular to the modern division of labour in art. The old workshop system from the Renaissance to its demise at the beginning of modernism at the end of the nineteenth century allowed artists to hire apprentices to work under their tutelage in order to contribute to the completion of the work in the studio. From the Renaissance to Romanticism the life of the studio is essentially collective. Artists learnt to be artists in close proximity to the work of the master and other apprentices. But, if the emergence of the artist is shaped by the division of labour, importantly, the co-operative function of the studio is also a history of the separation of the apprentice system from the *purely* artisanal. The collective life of the artist, in its modern form, really only begins in the High Renaissance after the subordination of the workshop to the intellectual demands of the atelier or studiolo. In the early Renaissance the co-operative function of the workshop was geared not to the production of independent artists in the image of the master, but craftsmen – and invariably men – capable of working collectively under the guidance of the master on a variety of decorative/devotional objects and in a variety of materials.[1] The primary emphasis, therefore, was on interdependent craft labour and the honing of diverse craft skills. As the fifteenth-century Florentine workshop manual, *The Craftsman's Handbook*, by Cennino de'Andrea Cennini puts it – one of the few complete workshop manuals that have come down to us – the apprentice was expected to be proficient in, amongst other things: drawing on paper with charcoal, making brushes, painting beards and hair in fresco, painting trees, plants and foliage in fresco, painting faces, dead bodies, and wounds in tempera on panels,

making goat's glue, making cement for mending stones, making gesso, gilding a panel, grinding pigments for colours, grinding gold and silver for use in colours, tinting papers in indigo and peach, working delicately on silk and velvet, modelling crests and helmets, constructing caskets and chests, drawing on gilded glass, casting a full-length sculpture of one's own body, and casting medals.[2] In short, artists/craftsmen had the same status as a shoemaker or a tailor, even if the skill-base was considerably wider. This is reflected in Cennini's concern with the steadfastness of the hand; wayward and shaky hands held up the interdependent character of the labour in the workshop; abstemious hands enabled production to flow smoothly. 'There is another cause which, if you indulge it, can make your hand so unsteady that it will waver more, and flutter far more, than leaves in the wind, and this is indulging too much in the company of women.'[3] The early workshop system then does not characterize the interdependent labour of the workshop as that *of* the master's; the apprentices may work in the manner of the master, learn his tricks and mimic his qualities, but they are not the surrogates of his autonomous authorship. This changes with the mercentile and ecclesiastical rise of Florence and Rome in the sixteenth century. Changes in the system of patronage (from communal and small-scale private commissions to large-scale private and ecclesiastical commissions), in concordance with the rise of natural philosophy as the bearer of *individual* perception, brings pressure to bear on the co-operative character of the workshop, as patrons begin to define artistic quality in terms of prestigious, independent authorship. The distinct craft skills of workshop masters and apprentices alike begin to be valued as evidence of 'revealed creation'. A crucial aspect of this development is the refinement of the concept of *disegno* (principally by writers outside of the workshop system, such as Vasari), which begins to link the model of natural philosophy to the intellectual discipline of drawing from life. In the workshop system *disegno*, or more precisely *disegniare*, meant simply 'to draw' in a preparatory fashion, and had no particular importance attached to it; or rather, as Cennini demonstrates, was one skill amongst many. With the rise of natural philosophy in the mid-1500s, however, it divests itself of its manual functions to come to serve as a specific and exemplary model of intellectual achievement and distinction.[4] In other words *disegno* was part of the general Aristotelianization and ennobilization of art during this period, exemplified first and foremost by Vasari's hagiographic *Lives* (1568). Drawing from life was held to be part of a cognitive continuum in which the artist moves,

constantly, from perception to intellection, from sensuous particular to concept. Consequently, unlike the interdependent labour of the workshop craftsman, the artist of 'revealed creation' needed, it was argued, a universal knowledge of the forms and objects of the world, that could only be supplied by close attention to the particulars of nature. This is why Bernedetto Verchi, Vasari and others cast Michaelangelo as the great examplar of *disegno* and the 'new artist'.

In 1563 the new concept of *disegno* and the intellectual ennobilization of the artist is codified in the foundation of the first academy of art in Europe, the Accademia del Disegno in Florence.[5] Inaugurated by Cosimo 1 de'Medici, the academy was consciously set up across workshop and guild lines, laying down the intellectual and artistic guidelines for all future academies of art in the early modern period. Craft skill was reformalized within an educational context that emphasized anatomical studies, mathematics and philosophical reflection. In Florence and Rome and elsewhere traditional workshop production continued unabated; but what was released historically from this system was a new kind of master–apprentice relationship. Workshops became studios in which the master-artist employed apprentices according to a given set of requirements. Hired labour was no longer interdependent in the production of objects in any systematic way, but was now discrete and occasional, that is, put to work on the job at hand. Indeed, when hired hands were employed (to prepare materials and complete basic preparatory tasks) they were thoroughly subordinate to the authorship of the master. The studio-as-workshop, therefore, introduces a radical new conception of co-operative labour into the production of art: when and where directed, apprentices and assistants, labour for the greater glory of the artist. Where this changes – and weakens – in the seventeenth and eighteenth centuries is when the authority of the master's authorship is subject to an increasing executive role under the commerical demands of the fledgling commercial art market. Here the master redevelops the apprentice-workshop system to *share* the effort of completing certain works on time in a way that encourages the contribution of each apprentice. For example, Rembrandt employed a number of apprentices and assistants who worked closely with him on the preparation of his paintings – reputedly over fifty apprentices and assistants passed through his studio during his career – and, in some cases actually copied or completed work in his name, such as some of the late portraits. The character of this co-operation, then, is derived neither from that of the early

Renaissance nor the High Renaissance, but from a kind of 'hybridization' of both; the master's authorship is channelled *through* the apprenticeship system. Not surprisingly our increasing awareness of this kind of co-operation in Rembrandt's studio has been at the centre of an extraordinary critical deflation of his studio practice. In its analysis of Rembrandt's apprentice system since the late 1960s The Rembrandt Research Project in Amsterdam has disattributed many works by the artist, severely disrupting our understanding of Rembrandt's singularity as a painter.[6] Because he had no compunction about letting assistants finish his work or student-artists copy his work *in his name*, the conventional view of Rembrandt as isolated and superhumanly prolific – and a figure thereby generally indebted to the (mythic) High Renaissance model of the studio – is irredeemably transformed. We now see him as an artist reliant on a complex division of labour. Nevertheless, this nascent commercial model of the painter's studio never becomes fully operative for painters until Warhol, because of the limited scope of the painter's studio for industrialization (for copying and the rationalization of painterly, material process). When the industrialization of art does enter the studio in the latter half of the nineteenth century, it is sculpture which is best placed to adapt to its demands, and, as such, is able to radically extend Rembrandt's pragmatism about how artists control their signature style. This is perhaps best exemplified by the rise of the commercial sculpture-atelier in France in the 1860s with the work of Jean-Baptiste Carpeaux, and later with Auguste Rodin. Both their studio practices are at the centre of the extension of the studio-master as executive producer, given their respective commitments to the *reproduction* of their work and to the systematic use of assistants on mutiple commissions. By 1890 Rodin was running *six* studios, with innumerable assistants fashioning clay moulds for Parisian founders. In the 1860s and early 1870s, Carpeaux was less 'corporate' but no less ambitious to see his work translated into reproducible form, setting up a commercial studio run by his brother. By 1875, the year of his death, he was employing twenty-five people.[7] In her biography of Rodin, Ruth Butler explains the nature of this new executive role very well, and is worth quoting in full:

> The creative idea, the core of every sculpture that came from Rodin's studio, began as a clay form modeled in Rodin's own hand. Usually he tried the same idea out in several versions; only when he felt it was right did he have studio assistants make plaster casts. First they made a negative mold from the clay. From this a plaster

figure face, or group could be made. Rodin often had single figures broken into pieces and rearranged, though he usually kept at least one cast intact. When he considered the idea right, assistants established a metal armature – the interior structure that held a figure upright; then they packed on fresh clay before Rodin brought the work to its final form. Again a negative mold and a plaster were fashioned. The negative would be used by the foundry in making bronze casts, the positive by the carvers transferring the image into marble. *Rodin did not fashion unique works; rather he was chief of an atelier* [my emphasis]. The decisions and the governing imagination were his; he provided models and clear explanations of what he wanted to his assistants. On any given day in one of Rodin's studios, someone was roughing out a clay, while others were constructing an armature, using a machine to enlarge or reduce a clay or plaster, sawing a block of marble, or using a pointing machine to transfer the plaster onto the marble block.[8]

In this light Rodin's and Carpeaux's studios present the expansion of the executive role of the master-sculptor, who, in directing his assistants on numerous commissions, and largely authoring his work at a distance, generally weakens the idea of the studio-master as pedagogue. Carpeaux's and Rodin's assistants were not hired as *pupils*, they were hired as wage labourers, although in Rodin's case he did develop a close collaborative relationship with two of his assistants who were artists in their own right. This points to the growing separation, in the late nineteenth century, between the apprentice system as a source of cheap studio labour and the apprentice system as a transmission belt for hands-on learning; and, as a consequence, points the way to the rise of the autonomous modernist artist free from the teaching responsibilities of the *maitre*.[9]

The complex division of labour of the studio, then, takes on various forms in the pre-modernist production of art. From the fourteenth century to the end of the sixteenth century the *collective workshop* prevails, although increasingly subject to the new market for freely creative objects by *independent artists of distinction*. From the seventeenth to the mid-nineteenth century the artisanal workshop is eventually replaced by the *master-run atelier*, heavily or loosely reliant on apprentices as wage labourers *and* pupils. By the end of nineteenth century, however, the apprentice has increasingly become an assistant and wage labourer, allowing the master-sculptor to focus on his executive role, and the painter-master to draw on a network of assistants to provide the necessary material, if not painterly, support. Of course some artists fall outside of these divisions, but nevertheless, by the

late nineteenth century and the advent of modernism and the expanded market for originality, all artists are beginning to be subject to the increasing divorce of the artist from his traditional supervisory artisanal role within the division of labour. The modernist painter, then, is the advance figure of the contraction of the division of labour in the studio. But, if the modernist *painter* establishes this process of contraction, with the readymade, copying without copying, and the craft of reproducibility, something *qualitatively* different occurs to the division of labour in the studio: *the extended division of labour internal to the collective workshop in its early and late forms and to the master-atelier tends to disappear.* Neither reliant on the hands of interdependent labour in the workshop, nor on the waged labour of studio assistants, the artist of the readymade and mechanical reproducibility embraces the social division of labour – manufacturing and commodity production – outside of the studio. In other words, the early modern executive function of the artist is transferred out of artistic hands to non-artistic hands, in an identification between artistic labour and productive labour. Thus the artist of reproducibility may share with the modernist painter a distaste for the master-atelier system, but, in direct conflict with the modernist painter, this is based on the formulation of a new kind of collective (studio and extra-studio) practice.

SUBJECTIVE OMNIPOTENCE

In short, with the expansion of the commercial and executive role of the artist after Romanticism the Rembrandt-like atelier-workshop system goes into decline. This is compounded by the weakening of state and religious patronage of the arts and the emergence of a new professional class of artist-teachers attached to the older academies, who in certain instances take over the the role of the studio *maitre*. But, during the latter part of the nineteenth century these changes undergo a further acceleration in response to the social and cultural crisis of the academies themselves. By 1914 no academy has escaped its designation as a bastion of *bourgeois* culture and source of ideological constraint. This is why Rodin is a key transitional figure.[10] His work may be reliant on some version of the apprentice system, and the dispersal of his talent and labour through the labour and talent of others, but in releasing the 'conceptual' role of the sculptor from the labour of making, he is utterly intolerant of the demands of academic learning (for Rodin it is precisely the academy that has held back sculpture in France).

French Modernist painters in the latter part of the nineteenth century take this even further. For Impressionism and post-Impressionism the break with the academic constitutes a break with the division of labour in the studio itself, given how it is embedded in a traditional chain of artistic command. Modernist painters, then, committed to defining the singularity of painting against academic, naturalistic models, have no material investment in *allowing others to complete or share work already undertaken*. What counts above all else under the new market conditions (specifically the rise of the small private gallery) is the uncertain and potentially novel execution of the painting, in *all its imagined purity*. If the authenticity of the act of painting is not to be forfeited, the making and execution of the work by the artist have to be seen to be indivisible; each mark has to be accounted for, so to speak. Thus paradoxically, at the point where the modern social division of labour enters the studio through the introduction of new industrially produced paints and other materials the artist resists the presence of the social division in the fabrication of the work itself. The act of being modern is identified with the singular subjective investment of the artist in the production of the painting. Artistic struggle, consequently, is defined by the level of artistic control exhibited by the artist over both the means and ends of art's production. This is why painting under modernism becomes the site of a renewed engagement with the conditions of expressiveness, in a way that would have been bewildering to Rembrandt and Caravaggio. However, this is not to say that Rembrandt and Caravaggio did not take an intellectual pride from completing their own work according to their own dictates and beliefs (and not the dictates and beliefs of their patrons). Or that Rembrandt, for instance, failed to prize the materiality of the act of painting above all else. But, rather, that their understanding of authorship was not expressed *through* the intense and necessary subjectivity of the act of painting. Hence although Rembrandt's rough painterliness is unprecedented, and his decision to work directly from the model in the studio clearly distinguishes him from the neo-classicism of many of his peers, he is not a proto-modernist. This is because painting for Rembrandt was also a matter of dextrous endeavour, and therefore such labour could be given to assistants and other artists to be completed without loss of quality and the loss of his professional status.[11] Modernist painting, on the other hand, is a theory of authorship as *subjective omnipotence*. The painting must carry evidence of the author's hand throughout all of its production. Artist's hand and artist's materials must converge *at all times* (something that the

leading artists of the High Renaissance were never quite able to fulfil, despite their commitment to 'revealed creation').

It is little surprise, therefore, that modernism, as it became inscribed in European and American painting from 1860–1960, reifies the subjective act of the artist in defiance of the social division of labour and co-operative labour in the studio, because the division of labour in the studio is taken to represent a subservience of material process and artistic judgements to the dictates of patron-requirements. It is also understandable that this produced an intense asocial conception of artistic labour: the artist alone in his studio confronting himself in the process of confronting the weight of artistic tradition and the bare canvas. The early avant-garde attack on this model was based precisely, therefore, on attacking the modernist confusion between artistic subjectivity and the unitary identification between the artist and his or her materials. (Like Daniel Dennett's do-it-yourselfers, this modernist account of authorship is a neurotic compensation for the decentred self as it experiences its own relationality within the social division of labour.) In the late 1960s Warhol and Conceptual art extended this critique, in a period when the identification between artistic value and subjective omnipotence had overwhelmed studio practice. Allowing the readymade back into practice during this period allowed artists to put a break on the technical retardation of modernist painting by again separating artistic subjectivity from the complete manual execution of the work. But if this period of work reintroduces the social division of labour into the day-to-day practice of the studio this move was not simply a recovery of the old master-atelier system. The readymade and the craft of reproducibility do not seek to reposition the artist at the head of a team of assistants in the studio (even if this is exactly what happened to Warhol's Factory after 1968). On the contrary, the function of the artist is repositioned in the social division of labour outside of the studio, even if he or she does or doesn't remain a studio artist with assistants. This, essentially, is the challenge of Productivism, Constructivism and Duchamp: the labour of the artist is not extended (solely) to others in the studio, but to those labouring in various technical and non-artistic domains. (The use of the readymade is in a sense one embodiment of this extra-studio labour.) This means that in displacing authorship to the social division of labour outside of the studio, the studio is neither a place where assistants are taught in the style of the master, nor the primary place where the subjectivity of the artist is performed in a confrontation with his materials. Rather, it is place where

plans are executed, research pursued, conversations conducted, decisions and connections made, and materials sorted and assembled.

This model of the studio really only emerges with Duchamp and during the Russian revolution; and by the late 1930s, with the crisis of first-generation Surrealism, it is in decline. But irrespective of its demise through post-war modernism and beyond, it represents a fundamental transformation in the position of the artist in the social division of labour that is comparable in its effects to the 'revealed creativity' of the High Renaissance studio. By transferring the labour of the artwork to technical domains outside of the studio, and therefore to unknown hands, the relations between authorial intention and control and the reliance on the labour of others undergoes a radical transformation. The artist's hands are now in explicit co-operation with the hands of the *non-artist*. Artist assistants may help in the process of assembly and fabrication, but the fundamental relationship is with the anonymous hands that have laboured on these materials. In this sense general social technique imposes itself on the intentions of the author, further displacing the requirement of the master-artist to produce his work co-operatively by 'showing and telling' at the immediate point of production. In other words, the transmission of skills from the master to the student in the execution and copying of exemplary works no longer becomes a priority in the formation of artistic identity. Essentially, the readymade, copying without copying, and the craft of reproducibility introduces the anonymous hand into the production of the art in such a way as to shatter the fetishization of artistic subjectivity in both the master's atelier, and in its independent, modernist forms. Duchamp is one of the first artists to recognize this as a problem and a resource for practice and treat it as a constitutive theme of art. Another artist is Laszlo Moholy-Nagy. Moholy-Nagy, however, differs from Duchamp in directly addressing the non-unitary author, artistic-authorship-at-a-distance and artistic surrogacy in relation to technology and technique.

MOHOLY-NAGY AND THE SURROGATE HAND

Moholy-Nagy was working in Berlin around the same time Duchamp was working in New York, but unlike Duchamp, Moholy-Nagy's 'training' in the readymade and the craft of reproducibility, was done in close colla-boration with European Constructivism and in critical alliance with Soviet Constructivism and Productivism. This makes the context for his reflec-

tions on artistic surrogacy, authorship-at-a-distance, and the anonymous hand of authorship, more theoretically engaged than Duchamp's writing of the period, who had no fraternal links to Constructivism.[12] Thus he is one of the few European avant-gardists committed to the critique of the author who talks directly about *technik* and art, in the way Rodchenko, El Lissitzky and Boris Arvatov did – even if his revolutionary politics largely fell away by the mid-1930s. For Moholy-Nagy artistic authorship reflects a permanent state of destabilization, allowing for all kinds of surrogacy and blurring and deflation of artistic identity. Like Duchamp, Moholy-Nagy begins from a basic anti-Cartesian premise: all extant signs, objects, symbols are available for reinscription by the artist, allowing the artist to refunction artistic subjectivity as a kind of ego-less 'writing machine'. As in Duchamp, the sense of the artist as an insatiable 'machine for reinscription' is a technical move made by the artist inside the realm of general social technique. But for Moholy-Nagy this has broader epistemological implications: in the world of reinscriptions and copies, the author is unable to narrate his own creativity as a fixed name. That is, the artist is never willingly the owner of his or her means of expression. As Louis Kaplan puts it: 'Moholy repeatedly employs strategies to efface, erase, or deface himself.'[13] For instance, throughout his career Moholy-Nagy produced a series of photogram non-portraits or anti-portraits in which there is no explicit correlation between physiognomy and referent. The portraits are certainly *of* Moholy-Nagy – on the basis that they are indexical traces of the artist – but because of the abstraction of form we cannot verify this on the basis of resemblance. (For example, *Photogram: Self-Portrait Profile* [1922] and *Self-Portrait, Photogram with Torn Paper* [1924].) Similarly, at various points in his early work as a painter he either fails to sign his work, or changes his name and signature. But perhaps of singular importance here are his infamous 'telephone paintings' of 1922. In this year Moholy-Nagy ordered over the phone from a factory five steel paintings covered in porcelain enamel. In their way these telephone paintings are as significant as Duchamp's *Fountain* in confronting the hubris of modernist subjectivism. In a move that directly echoes Duchamp, Moholy-Nagy incorporates evidence of the production of non-artistic labour outside of the studio into the finished work. But unlike Duchamp, Moholy-Nagy makes direct contact with the anonymous hands which perform his labour. By communicating his intentions down the phone to the factory supervisor the work finds its social form in an actual exchange with productive labour.

This puts Moholy-Nagy's work firmly within the sphere of Constructivist practice: the work is essentially a collaboration *with* non-artistic labour, albeit of a very simplistic (non-revolutionary) and executive kind. But, even so, the point is well made: the immaterial labour of the artist's hand – in this instance the dialling of the number of the factory and the reading out of the specifications of the order – constitutes an authentic, meaningful act given its material outcome: five steel paintings covered in porcelain enamel. Both Hans Arp, and Moholy-Nagy's early collaborator, Alfred Kemeny, were quick to question Moholy-Nagy's presumptions here. Kemeny dismisses him for his 'non-creative aesthetics',[14] and Arp (and El Lissitzky, ironically) called him a 'common [house] painter'.[15] But that is exactly how Moholy-Nagy would have wanted it: like many avant-garde artists of his generation he could think of no better description of himself than that of a so-called 'mere' labourer.

The telephone paintings, then, carry all before them in the 1920s. For they register the initial trauma of the readymade brought into actual conjunction with general social technique. No doubt in 1922 in the Soviet Union, the idea of 'telephone paintings' as a conceptual challenge would have seemed rather effete and after the fact; telephoning in your orders to the factory would have constituted a commonplace and *unselfconscious praxis* rather than an artistic *geste*. But in Berlin it presented a radical alignment of artistic labour with non-artistic labour, and as such it took on a programmatic character in exactly the same way as Duchamp's unassisted readymades did: artistic surrogacy – the reliance on the labour of others outside the studio – is not inhospitable to artistic authorship. In fact surrogacy expands the content of authorship by opening out its technical domain. Duchamp had, of course, implied this in his unassisted readymades, but had not actually performed it as an artistic act in solidarity with productive labour in quite the same kind of way. This is why the metaphorization of the hand as something active but not present – similar in effect to the present but absent face in the photogram portraits – is so important in Moholy-Nagy's art. Indeed, it is the force of the absent hand that circulates through Moholy-Nagy's work, and that identifies his art as one of the first systematic explorations of the surrogate and prosthetic capabilities of authorship. As he was to declare in *Painting, Photography, Film*: 'With the aid of machine production, with the aid of exact mechanical and technical instruments and processes (spray-guns, enamelled metal, stencilling) we can today free ourselves from the domination of the individual hand-made

piece and its market value.'[16] In this way authorship becomes a kind of medium-like state through which various technological apparatuses pass. It is understandable, therefore, that in his later career he should take the apparitional status of authorship as a model for a temporal, disembodied practice. 'I dreamed of light-apparatus, which might be controlled either by hand or by an automatic mechanism by means of which it would be possible to produce visions of light, in the air, in large rooms, on screens of unusual nature, in fog, vapor and clouds.'[17]

As in Duchamp's early work Moholy-Nagy was desperate to give up authorial control, or at least put it on hold to see what happened in its place. The telephone paintings are a perfect example of this form of surrogacy as it came to be defined in the early avant-garde: surrogacy as the *autonomization of art*.[18] For, along with this telephone art, each of his engagements with various technological apparatuses – photogrammatology, photomontage, and light-projection – courts the disappearance of the hand into the machinic. In fact, if Moholy-Nagy could have built a convincing art-machine in the early 1920s, he would surely have used it with relish. But, as in early Duchamp this fantasy of autonomization met its limits as soon as Moholy-Nagy possessed and inhabited each of his technological apparatuses. Where it was necessary to remove the expressive hand in the name of the non-unitary author, the hand of authorial control reasserted itself. This is why it is possible to see Moholy-Nagy as following Duchamp down the same route: the readymade, copying without copying, the craft of reproducibility, are sites where authorship is remade, and the hand repositioned, and not the places where its expressive functions are finally dissolved. For all his efforts to autonomize the means of art's production in his early work, the subjectivity and technology are later brought into alliance. This produces a comparable shift to that in Duchamp in how the critique of authorship is theorized once the nihilism of autonomization is worked through: non-unitary authorship becomes, in the image of Constructivism's and Productivism's author-hybrids and Zukofsky's relationality and miscegenation, a composite activity. Surrogacy is the name we might give, therefore, to the technical extension of authorship, rather than its deferment or eradication. This is why photography, of course, is the greatest surrogate practice of all: it autonomizes the act of producing an image whilst at the same time allowing for the intrusion of intentionality in the act of taking the photograph.

The hand returns, then, to haunt copying without copying and the craft of reproducibility. And it haunts the craft of reproducibility precisely

because of our definition of human authorship as an expression of consciousness *all the way down*. This is why the avant-garde critique of modernist subjectivity is not as clear-cut as we might imagine. What modernism's defence of the totality of expression recognizes is that the experiential transformation of the materials of art is a condition of art remaining open as a category. Once art becomes subordinate to the dictates of a professional craft and to academic precedent (as salon art had become prior to modernism), *to* repetitive labour in a sense, then hearsay substitutes itself for knowledge and practice. Modernism's insistence on 'doing-it-yourself' was, therefore, a defence of the possible knowledge immanent to the development of painting. This was an extraordinary challenge to neo-classicism and the academy, because it insisted that knowledge might be contained in error, failure, abstruseness and the grotesque. The problem, however, is that modernism believed that access to these forms of knowledge was only sustainable through painting, and the necessarily isolated condition of authorship.

Moholy-Nagy's drive to authorial anonymity is certainly a significant rebuke to the hubris of modernist subjectivism, but, at the same time, it is not an invitation to treat the new studio as a place where the subjective investment in materials is superfluous or erroneous. Indeed, this is the singularly determining problem that faced his art and his generation of Constructivists as they confronted modernist subjectivity: how is a defence of artistic authorship as a critique of repetitive, heteronomous labour, *all the way down*, to be squared with the necessary separation of subjective expression from the execution of the artwork? This conflict is also reflected in the work of El Lissitzky. El Lissitzky trained as a technical draftsman at the Technische Hochschule in Darmstadt and the Riga Polytechnical Institute, and subjected his theory of 'art beyond art' to all the customary Constructivist proscriptions. Yet, his art remained open to the artisanal in a way that openly distinguished him from orthodox Constructivism (in particular Aleksei Gan, Varvara Stepanova and David Arkin). An indication of this is given in his photogram self-portrait *The Constructor* (1924), in which the interplay of symbols – art (hand), technology (compass) and science (intellect) – reveals how much Lissitzky continued to invoke the determinate function of the hand within the orbit of general social technique. As he was to say in 'Suprematism of World Construction': 'in expressing our creative ability, paint brush and ruler and compasses and machine are only extensions of the finger which

points the way'.[19] The determinate function of the hand in El Lissitzky and Constructivism, therefore, is less residual than we might first presume. All the keys works of revolutionary Soviet Constructivism – Tatlin's *Model for a Monument to the Third International* (1920), Rodchenko's workers' club built for the 'Exposition Internationale des Arts Décoratifs et Industriels Modernes' in Paris (1925), and Lissitzky's chairs for the Internationale Pelz-ausstellung in Leipzig (1930) – were *handmade in wood*.[20] This of course reflects, on one level, the underdeveloped industrial conditions under which Constructivists laboured in the early years of the revolution. But, it also reveals, on another level, how the reorganization of artistic subjectivity in Constructivism was never simply, and never could be, an instrumental matter.

In this way Moholy-Nagy's 'research projects' into photogrammatology, photomontage, art by telephone and projected lightworks are attempts to invest the transformative content of artistic subjectivity into general social technique in ways that might transform what we might mean by artistic subjectivity. By distributing artistic labour outside the bounds of the studio, authorship is dissolved into the social division of labour. But, at the point where the labour of others is returned to the artist in the studio the artist is also confronted by the demands of this labour: how do I make this anonymous productive labour 'my own', how do I bring it into my powers of authorship? In what ways can my signatory hand and the anonymous labour of the non-artist converge in authorship? Surrogacy, therefore, is not an answer to modernist subjectivism in the ways that Duchamp and Moholy-Nagy first believed. Surrogacy is, in fact, soon revealed to be a circuitous path back to authorship and artistic subjectivity. This is why Duchamp has no theory of the readymade as a readymade beyond the early 1920s, and why Moholy-Nagy, despite his more ardent commitment to the Constructivist line, eventually sees the displacement of the hand as an invitation to resignify the readymade and copy.

The dialectical form of surrogacy as a return to authorship out of an exit from authorship is allegorized in one of Duchamp's later collaborative works, 'Compensation Portraits', which he produced with André Breton. The 'Compensation Portraits' consist of a group of passport-like found photographs of anonymous and some well-known men and women with the name of a Surrealist written under each photograph, and was first published in the catalogue 'First Papers of Surrealism' to accompany an exhibition in New York in 1942. Each photograph, then, acts as a

surrogate; and one of the most interesting of these surrogates is Duchamp's photograph. Duchamp's portrait is of a women taken from Ben Shahn's photograph *Untitled (Rehabilitation Clients, Boone County, Arkansas) October 1935*, shot while the photographer was working for the Farm Security Administration. Remarkably the prematurely aged female sharecropper in the photograph looks like Duchamp himself. As David Hopkins suggests in an essay on the portraits, 'The Politics of Equivocation: Sherrie Levine, Duchamp's "Compensation Portrait" and Surrealism in the USA 1942– 1945',[21] this work, and particularly Duchamp's portrait, is largely concerned with entries and exits, ingress and egress. First, the complete work summons up the idea of the 'Surrealists entering America under assumed identities with *false* papers (Duchamp had in fact assumed the identity of a wholesale cheese merchant in order to transport materials for *Bôites-en-Valise* through the German-occupied zones of France in 1941)'.[22] Second, Duchamp's actual involvement in the production of the work suggests the return to an intellectual terrain (the Surrealist international) that he had long severed his connections to. And thirdly the portrait offers a kind of return to his own earlier appropriation of a female identity, his alter-ego Rrose Sélavy. During a continued period of exile then, for Duchamp and for the remaining members of the surrealists these portraits read very much as displaced persons. But why choose the Shahn portrait? What other displaced identities does this image hide? Hopkins argues that the sharecropper surrogate is not just an entry back into Duchamp's own past but into the recent past of Surrealism itself, expressly the long-standing struggle in the group in the late 1920s and early 1930s over the meaning of the real and realism. That is, there is a metonymic echo of Duchamp's own place within this dispute: the fact that the original photographer of Duchamp as Rrose Sélavy was Man Ray, who in the late 1920s had been at loggerheads with Surrealism's most famous apostate, Louis Aragon, in the dispute about realism. By placing his own Ben Shahn portrait-as-female-sharecropper in a Surrealist line-up he reverses this polarity. Whereas in the early Man Ray photograph Duchamp is seen impersonating a glamorous woman (the avant-garde in all its multiaccentuality), here a poor women is seen impersonating Duchamp (realism in all its resoluteness). Moreover, in this instance the person who has taken the photograph is one of the leading documentary photographers of the moment, a defender of realism, and, pointedly, a former CPUSA fellow traveller to boot. In this sense, as a simulated passport photo, Duchamp reenters the US not only impersonat-

ing/being impersonated by a woman, but reenters as a working-class woman whose identity is marshalled under the auspices of the Communist party and realist aesthetics. Is this an attempt, as Hopkins argues, to reinstate the leftist credentials of the Surrealists during a period of Popular Front cultural retreat, an ironic revisitation of the conflict between modernism and realism during the 1930s? It is impossible to say. But, even given Duchamp's history of subterfuge, his open identification with this proletarian woman as an image of entry into the USA does suggest a self-conscious and direct expression of political sympathies. In this respect is Duchamp using the form of the surrogate to reveal the limitations of his own practice of deferral? Or is the portrait, more likely, a question posed to the nature of political commitment itself within and beyond documentary practice and realism? Even though the proletarian woman stands in for him and therefore he and the woman might be said to be the same person, as the artist he retains control over the process of representation. As an artist he is able to 'find' himself and his political convictions in the 'other'; the other is unable to reciprocate, remaining the 'other'. It is unclear, therefore, whether Duchamp's work on this basis slips back into a model of melancholic deferral, or whether, in fact, the very identification with the proletarian woman is presented in order to defy this. The claim to political transparency of course is the very *raison d'être* of documentary practice during this period. However, what Duchamp reveals is that both moments can exist dialectically in the same image. In other words this surrogate portrait is a lesson in avant-garde cultural politics at a time when avant-garde culture was being dispersed or in ideological retreat: Duchamp shows that the taking on and refusal of identity are co-extensive. Which in turn leads us to the issue of surrogacy proper. The surrogate portrait of Duchamp as a proletarian woman is also a reminder of the enunciative power of the readymade: the presentation of one thing in the form of another. The appropriated Ben Shahn photograph speaks out of its own 'fixed' voice in order to ventriloquize other voices. The manifest authorship of the photograph is given, in another time and place, another author, offering us an image of the 'circuit of return to authorship' in surrogacy.

The circuit of return to authorship in surrogacy, then, is crucial in defending the historical significance and emancipatory potential of the readymade against the enemies of the avant-garde, both the recidivists within the avant-garde and the avant-garde's positivistic minded detractors. Moholy-Nagy and Duchamp in the 1930s stake this terrain out, developing

practices in which a non-unitary account of authorship and authorship-at-a-distance promises another account of artistic subjectivity. An artistic subjectivity that is embedded *in* prosthetic skills, strategies of doubling and the craft of reproducibility.

THE CIRCUIT OF AUTHORSHIP AND THE PROSTHETIC IMAGINATION (ATTACHED HANDS AND DETACHED HANDS)

Surrogacy is not identical to authorship-by-prosthetics, but prosthetics is certainly a form of surrogacy. Indeed, prosthetics might be construed as being the means by which surrogacy is embodied technically in art. But, as we have seen in our discussion of the readymade and the avant-garde, the technical embodiment of labour in prosthetic devices and in machines has tended to be appropriated by early avant-garde artists in the name of a dialectic of deskilling. Avant-garde artists were not at all interested in the ways that technology might extend a range of conventional skills, but in letting technology stand in for such skills. Hence the place of photography, for instance, in the avant-garde, is a history of the unambiguous and radical displacement of fine art craft; the defence of the photograph as a readymade is concerned precisely with the prosthetic *eradication* of craft-based skills. This invites a more nuanced understanding of prosthetics in art than is normally held to – the notion that authorship is prosthetic or not according to whether the artist is using or not using a piece of equipment, or operating or not operating some mechanical or technological device.

Prosthetics, rather, is the name we might give to the relations between the *attached* hand of the artist and the *attached* hands of non-studio labour (in their relations with technology) and the *detached* hand of the artist in its role as executor. The attached hand and the detached hand as they operate across the divide between artistic labour and non-artistic labour, thus, oppose each other as part of the dialectic of skill and deskilling. Consequently, the 'circuit of return to authorship' involves different relations of attachment and detachment depending on the nature of the work. For instance in the case of Moholy-Nagy's 'telephone paintings' the circuit of authorship might be represented in the following way: detached hand (the call into the factory; the reading out of the instructions), is followed by attached hand (the labour of the factory workers), followed by detached hand (Moholy-Nagy's authorial re-presentation of the enamel paintings as readymades). Equally an artist may only provide one moment of detach-

ment, so to speak, as Carl Andre did in ordering his bricks for *Equivalent VIII* (1967). After the initial call to the brickworks Andre had no further involvement in the material organization of the work. When the sculpture is shown the bricks are placed by gallery assistants on the floor following his written instructions. Prosthetics, therefore, is as much about the relationship between the artist's hand and anonymous labour as it is a description of the attachment of the hand to technology in authorship. And, as such, it is best thought of as a theory about where the artist's hands touch or do not touch the object or objects of authorship, and, therefore, about the absence or presence of the place of the attached hand of non-studio labour in this process.

The relations between the detached hand and the attached hand as they define the 'circuit of return in surrogate authorship' are at the centre of avant-garde practice from the 1920s onwards. Once the readymade enters the relations of art's production the attached hand is suddenly in a relationship of intimacy with the detached hand. This leads to a rapid opening up of the prosthetic imagination, in which the gap between meaning in art and mimetic expressivism is exulted in, and transformed into a place of rich experimentation. However, if the composite-artist, the miscegenating-artist, the surrogate-artist, the collective-artist step forward into this place as avatars of art's reskilling, the detached hand's intimacy with general social technique also channels what is the other driving force of the prosthetic imagination in this period: the equalization of technique as an expression of cultural democracy. All the expanded circuits and relations of authorship I have so far discussed cohere around one important question: if artistic authorship is a category that is not embedded in innate skill, but is the result of learning as part of collective intellect and shared labour, then, in short, anyone can be an artist. And, moreover, perhaps more pointedly, everyone will be an artist.

To this effect the critique of authorship since the 1920s has been accompanied not just by various identifications with productive workers on the part of artists, but with an openness to the democratic aspirations of amateurs and popular enthusiasts. From Duchamp through the Constructivists and Productivists, and through to the Surrealists, the avant-garde has drawn from the democratic imaginary of those who try and fail the test of professional cultural assimilation. This tradition of identification with the culturally unassimilated, indeed, runs through both modernism and the avant-garde from the 1860s through to the 1960s, and still determines the

anti-bourgeois reflexes of art today. Both traditions have drawn from the notion of the amateur as someone who in his or her failure to assimilate culturally stands outside of or athwart bourgeois cultural authority and status. But the amateur is no singular figure or force, he or she represents a number of different cultural tendencies which modernism and the avant-garde have incorporated. In this light amateurism can be split into two broad categories which largely follow the split between modernism and the avant-garde: the notion of the amateur-technican and amateur scientist – as inscribed in the vast expansion of amateur photographic practice and natural-scientific work from the 1920s – and the amateur as eccentric, 'primitive', *idiot savant*, best represented of course by the art of the insane.[23] From the 1860s to the Russian revolution modernist subjectivism favoured the latter; from the Russian revolution through to the late 1930s, the avant-garde favoured the former. This division is not strict. Surrealism's interest in automatic and collective authorship owed a major debt to mesmerism, spiritualism and the occult, just as many later modernist painters (Jackson Pollock, Mark Rothko, Franz Kline) saw themselves as manual workers of sorts, and affected a proletarian style.[24] Nevertheless, there is a clear distinction between these traditions in relation to how the labour of the amateur, in particular the amateur artist, is identified, and what this might mean for notions of artistic authorship and cultural democracy. For the avant-garde the amateur is the ally of the productive worker, insofar as his appropriation of photography for his own ends, for example, places the worker-as-amateur-photographer and amateur-photographer-as-worker at the forefront of the cultural means of production. As Dorothea Lange, who worked for the Farm Security Administration photo-archive in the 1930s, puts it: 'Documentary photography invites and needs participation by amateurs as well as by professionals. Only through the interested work of amateurs who choose themes and follow them can documentation by the camera of our age and our complex society be intimate, pervasive, and adequate.'[25] This is why the worker-photographer was central to the political imagination of the early avant-garde, perhaps more so than any other cultural or artistic figure, as was reflected in Benjamin's writing.[26] Modernist subjectivism, on the other hand, invests in the amateur as someone who fails to see what is artistically appropriate, with the result that their work produces a kind of mistranslation or mis-seeing of what is culturally approved. This might take the form, for instance, of an over-eagerness to be seen as technically skilful by replicating what are perceived

as the most technically advanced aspects of contemporary art, which results in a strange and affected concoction of effects. The amateur's inability to stabilize his object of desire (to be taken seriously as an artist) is identified metonymically, therefore, as being similar to the subjective drive in modernism to resist prevailing and professional accounts of good taste and skill. He is thereby redeemed from the disdain of academic judgement and the stigma of failing to achieve critical self-consciousness. Modernists may act as professional artists, but they perform their work as aspirational amateurs, forever mistranslating their object of desire. The amateur then is a lowly figure in different ways in these two traditions. On the one hand, for the avant-garde, he is someone who in gaining access to the modern means of cultural reproduction represents the narrowing of the skills between artist and non-artist; and on the other hand, for modernist subjectivism, he is someone who, in his exsanguinousness, is a model of resistance to professional protocol. There is an assumption, then, in the avant-garde that general social technique provides a space in which artist and non-artist, professional and amateur, come together in order to reshape the dynamics of authorship. Who is an author, and on what terms, once general social technique is in place? In modernist subjectivism, in contrast, there is an assumption that professional authorship and the authorship of the amateur will never meet, and, consequently, will always be engaged in a necessary dance of mutual exclusion. In this sense, in the avant-garde the amateur is assimilated, along with the decentred skills of the professional artist, into the sphere of general social technique. In modernist subjectivism he is identified as an exemplar of counter-cultural negation.

The identity of the amateur in modernism is thus closer to the notion of the self-taught artist, now the generally accepted term for most folk-artists ('outsider' artist being rightly thought of as socially demeaning). This is an art which is untrained, largely provincial and working-class or peasant in origins, and driven by powerful psychological and therapeutic needs. In this its self-identity and value derive from its expulsion of the forms, signs and skills of prevailing professional accounts of art. As such, the autochthonous artist is admired precisely because he or she fails or resists all accounts of dominant cultural inclusion. Indeed, the would-be 'sincerity' and psychological 'honesty' of the work provides an authentic counter to the reflexivity of high-culture. But despite the formal overlap between the modernist account of the amateur and self-taught on the grounds of their

shared 'primitivism', self-taught art in these terms is not strictly amateur at all, given its unwillingness, or inability, to enter the advanced technical relations of art. Self-taught artists are invariably naive-painters (or rather untrained artists trained in the conventions of painterly naiveté), they are not photographers, filmmakers or 'installation-artists'. This is because self-taught art calls forth, and reinforces, the retardation of the technical relations of art as the necessary means by which the authentic claims of self-taught art are to be staged. Amateur art on the other hand, because it has a notional relationship to technically advanced practice (albeit in a spirit of mistranslated copying), has a working relationship to general social technique. Self-taught art, therefore, for all its espousal of popular values, does not provide a democratic point of entry for the transformation of the relations between artist and non-artist, professional and non-professional. In its fetishization of retarded craft it is ultimately opposed to the self-development of the non-professional or occasional artist and to the development of collective intellect. This is reflected in the vast financial speculation in self-taught art (tied as it is to the fact that the value of the art is always codified through the biography of the artist-as-victim) at the expense of the art's possible place in a transformative model of culture.[27]

The amateur, then, *contra* the self-taught or naive artist, is one of the ways in which the avant-garde artist mediates the equalization of artistic technique under general social technique. The amateur, in this sense, is a new kind of artist lying in waiting, the artist who will be borne out of general social technique's erosion of the division between professional artist and non-professional artist. The amateur on the 'way up' and the professional artist on the 'way down' meet under the auspices of deskilling. In this way the amateur-as-artist is the destinal form of the artist-as-amateur. But if the amateur – as failed or dutiful aspirant artist – mediates the democratic drive of general social technique, it is the amateur's companion, the non-artist as collaborator, who determines the form that this democratic drive actually takes in the early avant-garde and after. This expands our understanding of the circuit of return to authorship in surrogacy, and collective authorship. Surrogate authorship is not simply that which returns to the author, but is the means by which the relationship between artists and non-artists and the relationship between non-artists and artists is transformed.

THE NON-ARTIST AS COLLABORATOR

The non-artist as collaborator is either the labourer whose labour is incorporated into the circuit of authorship unknowingly (as in Duchamp) or deliberately and knowingly as in Moholy-Nagy. The latter – the Constructivist model *par excellence* – can, as such, be divided between two different circuits of inclusion. Between labour which is hired and subject to executive decision (as in Moholy-Nagy's own 'telephone paintings') and labour which is directly collaborative and democratically organized. This is largely the model of Soviet Productivism, and left Constructivism in the 1920s. Thus when the Constructivist Osip Brik and others advocated in 1921 that artists should get involved in 'real practical work in production',[28] he was insisting that the circuit of authorship should be opened up to include workers as non-artistic collaborators. The objective of this inclusion being, in clear contradistinction to Gastev and the mechanists, that the worker 'must become a conscious and active participant in the creative process of producing an object'.[29] Here the non-artistic collaborator 'completes' the circuit of authorship as the artist enters production by removing the distinction between artist and worker. As the First Working Group of Constructivists puts it: 'before the Revolution – slave work; at present – the liberation of work; and after the final victory of the proletariat – the possibility of exultant work'.[30] For Alexsei Gan in *Konstruktivism* (1922), the eradication of the distinction between the factory worker and the artist was essential to the development of communism.[31]

This completion of the artist in the worker, and the worker in the artist, represents the expanded liberatory content of surrogate authorship in this period. The non-artist as collaborator becomes the figure who brings authorship out of subjectivism into collective intellect. Aesthetic thinking is made a subsumptive category rather than presumptive one. As I have argued, this is already evident in Duchamp's readymades. In Constructivism and Productivism, however, this thinking becomes more than a cognitive model of good practice, it becomes the basis for the very transformation of the social form of art and labour and therefore the *ideal horizon* of praxis. Hence if the early avant-garde has a critique of productive labour (of its instrumentalities and repetitions) it does not see aesthetic thinking as opposed to the objectivity of socialized labour. On the contrary, the critique of productive labour in avant-garde practice is

addressed – across various kinds of thinking and forms – to the restructuring of socialized labour. The circuit of return to the author in surrogate authorship, and the artistic surrogacy of the non-artist, hence, are part of a larger emancipatory circuit: the possibility of self-realization as a constitutive part of the universal release of human labour from the constraints of socialized labour. The early avant-garde's reflections on authorship, and labour in the artwork, then, are no less an account of how the complex labour of artistic labour challenges the drive to simple labour at the point of production. This is why when we look beneath the formal and ideological differences between Duchamp and Moholy-Nagy, and the Constructivist and Productivist theorists, we can see something larger historically in their work: a preoccupation with the circuits of authorship beyond the monadic author. Despite the different accounts of the circuits of authorship across the divide between artist and non-artist, artistic labour and productive labour in the early avant-garde, they provide a shared understanding of the social limits of Cartesian modernism. Modernist subjectivism's defence of artistic authorship *all the way down* has to be carried over into *technik* and socialized authorship for it to prevail, that is, for aesthetic self-transformation to be more than a disembodied defence of the 'aesthetic life' and the verities of self-taught authenticity. And it is this mode of address, with its destinal sense of the essential spectrality of the artist, that, despite the gulf in historical and social circumstances from the original avant-garde, continues to haunt contemporary art's reflections on authorship.

NOTES

1 For a discussion of the early Renaissance workshop, see Bruce Cole, *The Renaissance Artist at Work: From Pisano to Titian*, John Murray, London, 1983.

2 Cennino de'Andrea Cennini, *The Craftsmen's Handbook* ('*Il Libro dell'Arte*'), translated by Daniel V. Thompson, Dover, New York, 1960.

3 Ibid., p.16.

4 See Karen-Edis Barzman, 'Perception, Knowledge and the Theory of Disegno in Sixteenth-Century Florence', in Larry J. Feinberg, ed., *From Studio to Studiolo: Florentine Draftsmanship Under the First Medici Grand Dukes*, Allen Memorial Art Museum, Obelin College, University of Washington Press, Seattle and London, 1991.

5 Anthony Hughes, 'An Academy for Doing 1: The Accademia del Disegno, the Guilds and the Principate in Sixteenth-Century Florence', *Oxford Art Journal*, Vol. 9, No. 1, 1986, pp.3–9; and Hughes, 'An Academy for Doing 11: Academies, Status and Power in Early Modern Europe', *Oxford Art Journal*, Vol. 9, No. 2, 1986, pp.50–62.

6 This process of disattribution began in 1969. From a total of approximately 1000 works at this date, over 600 have been disattributed. The cull includes many would-be canonic works in Rembrandt's oeuvre, including *The Man With the Golden Helmet* (1650), disattributed in 1985. The initial impetus of the project was to remove from the market works in the name of Rembrandt that were painted by his students and assistants as a way of bringing some historical order to the oeuvre, and in turn, deflate the excesses of the Rembrandt industry. The outcome, however, has been less an expanded understanding within the museums of Rembrandt's model of diffuse authorship, than a reinforcement of the scarcity value of the attributed paintings.

7 See Anne Middleton Wagner, *Jean-Baptiste Carpeaux: Sculptor of the Second Empire*, Yale University Press, New Haven and London, 1986.

8 Ruth Butler, *Rodin: The Shape of Genius*, Yale University Press, New Haven and London, 1993, p.261.

9 This split in the sculpture-atelier between the apprentice-as-labourer and apprentice-as-pupil, reflects the deeper conflict within sculpture in the nineteenth century between the notion of the sculptor as *practicien* and the sculptor as 'thinker'. Most young men (and mostly young men) who entered the profession of sculptor in the nineteenth century were the sons either of sculptors or artisans. Sculptors, therefore, tended to be seen as manual labourers, as practioners, despite the view of the profession – because of its arduousness – as the most noble of artistic callings. In this light sculpture in the nineteenth century is characterized by a split mentality. On the one hand sculptors take pride in their familiarity with material process and physical labour, but at the same time define their success in terms of their executive intellectual role in the studio, their capacity to delegate work to assistants, to mere *practiciens*. See Wagner, *Jean-Baptiste Carpeaux*.

10 For a discussion of his transitional modernist status, see Rosalind E. Krauss, *Passages in Modern Sculpture*, MIT, Cambridge, Mass. and London, 1981; and Alex Potts, *The Sculptural Imagination: Figurative, Modernist, Minimalist*, Yale University Press, New Haven and London, 2000.

11 See Svetlana Alpers, *Rembrandt's Enterprise: The Studio and the Market*, Thames and Hudson, London, 1988. Alpers argues that there is no conflict between the sociability of Rembrandt's studio and his drive to individualistic painterly mastery; one invites the other. 'Rembrandt displays and extends his authority in a manner that calls authenticity into question. This despite the fact that authenticity as a marketing feature was laid down in his own practice' (p.121).

12 Duchamp, however, was familiar with Constructivist debates in the 1920s. For instance, Katherine Dreir's Société Anonyme – an organization with which Duchamp was closely involved – in 1925 published Louis Lozowick's *Modern Russian Art*, which included material on Constructivism.

13 Louis Kaplan, ed., *Laszlo Moholy-Nagy: Biographical Writings*, Duke University Press, Durham and London, 1995, p.89.

14 Alfred Kemeny, from a letter in *Das Kunstblatt* ('Comments', *Das Kunstblatt*, 8, No. 6, 1924), quoted in Kaplan, *Laszlo Moholy-Nagy*, p.69.

15 Hans Arp and El Lissitzky, *Die Kunstismen: The Isms of Art*, Eugen Rents ch, Zurich, 1925, quoted in Kaplan, *Laszlo Moholy-Nagy*, p.122.

16 Laszlo Moholy-Nagy, *Painting, Photography, Film*, trans. Janet Seligman, Lund Humphries London, 1969, p.25.

17 Laszlo Moholy-Nagy, 'Light Architecture' [1936], in *Moholy-Nagy: Documentary Monographs in Modern Art*, Richard Kostelanetz, ed., Pelican, London, 1971, p.155.

18 The place of the telephone in art's relations of production is yet to be written, just as the telephone's prosthetic identity is barely understood. One author who has recognized these omissions is Avital Ronell, in *The Telephone Book: Technology, Schizophrenia, Electric Speech*, University of Nebraska, Lincoln, 1989. She rightly recognizes that the telephone generates a kind of command-economy of meaning; the telephone rings; someone's space is invaded; questions are asked, directions are given, information confirmed, things and services ordered. The telephone 'destabilizes the identity of self and other, subject and thing, it abolishes the ordinariness of site; it undermines the authority of the Book and constantly menaces the existence of literature. It is itself unsure of its identity as object, thing, piece of equipment, perlocutionary intensity of artwork (the beginnings of telephony argue for its place as artwork); it offers itself as instrument of the destinal alarm', (p.9). The phone call that Moholy-Nagy puts in to the factory supervisor is the destinal alarm of the avant-garde, the act that – like Duchamp's *Fountain* – strips painterly modernism of its subjectivist fantasies. Interestingly, in 1923, at a time when Duchamp was friendly with the painter Charles Sheeler, Sheeler produced a surrogate portrait of himself (*Self-Portrait*) *as* a telephone.

19 El Lissitzky, 'Suprematism of World Construction', in Sophie Lissitzky-Küppers, *El Lissitzky: Life, Letters, Texts*, translated by Helene Aldwinkle and Mary Whitall, Thames and Hudson, London, 1980, p.333.

20 The use of wood in art and production, in fact, in the early years of the revolution was associated with 'counter-revolutionary' tendencies, particularly after Trotsky had identified the manipulation of metal as the foundation of scientific industrial organization. For a discussion of the artisanal and the symbolization of the hand in El Lissitzky, see John E. Bowlt, 'Manipulating Metaphors: El Lissitzky and the Crafted Hand', in Nancy Perloff and Brian Reed, eds, *Situating El Lissitzky: Vitebsk, Berlin, Moscow*, Getty Research Institute, Los Angeles, 2003.

21 David Hopkins, 'The Politics of Equivocation: Sherrie Levine, Duchamp's "Compensation Portrait" and Surrealism in the USA 1942–1945', *Oxford Art Journal*, Vol. 26, No. 1, 2003.

22 Ibid., p.57.

23 The surrogate hand is broadly that of the technician, the subjectivist hand is broadly that of the 'primitive', child and mad person. However one of the identities of the amateur that does cross the avant-garde/modernist divide is that of the collector: the person who defines their subjectivity through the ordering and arranging of collectible objects. This enunciative model of ordering knowledge 'from below' finds many sympathetic voices in the avant-garde and modernism. In the avant-garde and neo-avant-garde (Surrealism and Conceptual art) it tends to take the form of an anthropology of the unconscious and social symptom; in modernism an identification with the neurotic and repetitive-compulsive characteristics of collecting (Johns, Rauschenberg, Cage).

24 For a discussion of 'proletarian' modernist styling, see Caroline A. Jones, *Machine in the Studio*.

25 Dorothea Lange quoted in K.B. Ohrn, *Dorothea Lange and the Documentary Tradition*, Louisana State University Press, Baton Rouge 1980, p.37.

26 For example, Benjamin's 'The Author as Producer', in Burgin, ed., *Thinking Photography*.

27 For an affirmative discussion of self-taught art see Gary Alan Fine, *Everyday Genius: Self-Taught Art and the Culture of Authenticity*, University of Chicago Press, Chicago, 2004. Fine's underlying argument, essentially, is that self-authentication in art is emancipatory. Duchamp's 'ready-made urinal . . . reflects the triumph of aesthetic education and the

status-conferring power of art-world judgements' (p.2). The history of class relations and culture tells us otherwise.

28 Osip Brik, quoted in Taylor, *Art and Literature Under the Bolsheviks*, p.118.

29 Ibid., p.124.

30 First Working Group of Constructivists, quoted in Christine Lodder, *Russian Constructivism*, Yale University Press, New Haven and London, 1983, p.282, n.105.

31 Alexsei Gan, *Konstructivism*, Tver: Tverskoe izdatel'stvo, 1922, translated as 'Constructivism' in Bowlt, ed., *Russian Art of the Avant-Garde*.

SIX

SITUATIONAL AUTHORSHIP, DIFFUSE AESTHETICS AND NETWORK THEORY

Since the 1980s and the assimilation of Conceptual art as the determining framework for the critique of modernist subjectivism, the critique of the author has diversified in a number of directions. In this chapter I want to explore some of the avenues this labour has opened up, as it connects with the technological, social and political transformations over these decades. This will involve reestablishing the links between some of this work and the early avant-garde, but it will also involve bringing into view circuits of authorship which, technically and culturally, owe little to the 1920s and 1930s. This will also require us to reexamine the relations between skill and deskilling and the changing meaning of artistic-authorship-at-a-distance in the light of the growth of immaterial labour in the intervening period.

After the high-point of Conceptual art in the early 1970s, the readymade, copying without copying and the craft of reproducibility became the common technical basis and desiderata of contemporary art. Indeed, it is possible to talk about the readymade after the 1970s and the terminal crisis of American modernism, as the shared technical ground of advanced practice. This is reflected in the theoretical supersession of the theory of the readymade in the late 1970s and early 1980s by the more general category of post-conceptualism, which is simply art-terminology for the increasing congruence of artistic technique with general social technique. Post-conceptualism, in turn, became superseded by the more capacious and ambitious category of postmodernism, whose success in the academy, however, belies its usefulness as a concept of cultural and social period-ization. In this respect I prefer the term post-conceptualism for my purposes here, for, despite its narrowness, it nonetheless points in a

succinct way to the general condition of art after its assimilation into, and mediation by, Conceptual art. The readymade and the craft of reproducibility are no longer 'parasitic' on art, living on the margins of painterly modernist subjectivity, but are constitutive of the technical relations of art's production. In this light a contradiction arises at the heart of neo-avant-garde practice from Conceptual art onwards: between the general assimilation of the readymade and the craft of reproducibility into practice and the increasing deflation and dissolution of the avant-garde as a space of social transformation. As art's technical base expands, the inter-class content of its social base is constrained, as art is subject to the power of the new cultural industries and to the expanding art market. Art is now mediated by the marketing power and calendrical order of the museum. Indeed, long inured to making positive judgements about contemporary art, by the early 1970s the museum is increasingly defining itself as the 'home' of contemporary practice. Admittedly this new sense of inclusiveness is not based on free access. The post-war museum remains committed, primarily, to defending the canon of modernist painting (and the author). But the museum now exhibits the contemporary next to the recent modern without fear of loss of curatorial clarity. By the 1970s the market and museum have little problem accommodating the technological diffusion of art as a subsidiary part of art's technological spectacle. The result of this is a growing dissociation between the readymade and the craft of reproducibility and the extra-institutional sociability of their early avant-garde forms. In a period of art's assimilation into global museum display, the democratic claims of the craft of reproducibility largely accrues *to* the museum. With no social competitors the museum is seen, and views itself, as the best and most advantageous home for art's relationship to general social technique, given that museums have the resources to support and exhibit the most technically ambitious work.

The critique of authorship, and the production of expanded circuits of authorship, today, then, inevitably pass through the museum, just as the museum could be said to pass through contemporary art, in that the museum requires that contemporary art display itself in the museum if its visibility as art is to be taken seriously.[1] This places the 'circuit of return to authorship in surrogacy' and authorship-at-a-distance in a different position to the pre-Second World War avant-garde, where the critical horizons of the circuits of authorship were determined overwhelmingly by its actual or imaginary relationship to non-artistic social forces. As I have stressed in

this book, the expansion of the circuits of authorship in the early avant-garde focused on the interrelation of two primary processes: the creative transformation of labour at the point of production and the insertion of the artist into general social technique as the possible avatar of this creative transformation. In this respect, up until the period of Conceptual art it is possible to say that the avant-garde's critique of authorship was embedded in a commitment to the *mutual transformation of productive labour and artistic labour*. And this is what defines a great swathe of artistic activity under the rubric of the readymade from 1917–39, uniting many formally disparate practices. By the 1950s, however, in the wake of the fascist and Stalinist destruction of the political links between the avant-garde and labour, coupled with the aggressive post-war rise of the modern culture industries and the pacification of independent working-class culture, there is no labour theory of culture in avant-garde art to speak of. The revival of discussion on the social form of artistic labour in the 1960s, for instance, for all its commitment to the dissolution of the category of art, is divorced from the critique of the value-form. The critique of the category of art is now largely contained within a debate on sensibility and taste, as at Black Mountain College, or as a manifestation of anti-aestheticism, as in Fluxus. However, this is not to say that during and after Conceptual art there weren't artists who modelled their critique of authorship on something like a labour theory of culture derived from Constructivism, or that the relationship to the category of labour was in complete abeyance. The Argentinean group Tucumán Arde stands out here.[2] But, rather, that the critique of authorship was increasingly no longer *focused politically* on collaboration with labour, actual or imaginary, and when it was, its results were invariably torpid, as in the British organization Artist Placement Group with its social democratic conception of cultural exchange between artists and workers in the workplace. Similarly the debate on deskilling and reskilling became hypostasized as a debate on reproducibility and the mechanized image, as photography reentered neo-avant-garde discourse after a period of modernist exclusion and patronization. This, of course, was the beginning of all the multifarious work on the politics of representation.

It is in the politically deracinated space of the neo-avant-garde, therefore, that the economic and cultural power of the new museum system is able to flourish. This is because the museum is now the principal arena where the possibilities and limits of the transformation of the social form of art, and

of the legacy of the early avant-garde, are staged; the place, in fact, where the avant-garde comes to learn about its own past as much as it comes to test its current status in the world. As a result, in direct contrast to the early avant-garde, the production of art since Conceptual art has derived the internal and external relations of its social identity from a primary critique of the art *institution*. This is very different from the early avant-garde's critique of the academy and museum. Whereas the academy and museum were judged to be in a joint state of decrepitude and were thus assumed to have been surpassed in practice by revolutionary artists, in contemporary culture institutional critique has become the *frame of practice*. What art is able to do or not able to do, should or shouldn't do, what is perceived to block art's cultural role or not, is mediated by art's relationship to the museum's public and historicizing role. Now, of course, there is nothing new in art's mediation of its own conditions of possibility through an accommodation on the part of the artist to where power is seen to reside and best practice exercised. The enabling or disabling presence of the art institution has been internal to art's relations of production in Europe since the Renaissance. But under the conditions of advanced capitalism, where the art institution is increasingly a major site of art's *production*, as well as the principle centre of art's reception, art has internalized the museum as the site of its own possible emergence or disappearance. This is why the diffusion of the critique of the author and authorship-at-a-distance in the art of this period has necessarily generated kinds of composite artistic identities, such as the artist-as-archivist and artist-as-curator, other than the ones we're already familiar with from the early avant-garde; and as such, it has also generated very different kinds of circuits of authorship.

THE CRITIQUE OF AUTHORSHIP AFTER CONCEPTUAL ART

i) The Autistic Readymade

One place to begin to examine the shift in the circuits of authorship is the split in Conceptual art between the formal critique of authorship (as in Joseph Kosuth) and the general commitment to a notion of expanded authorship (as in Art & Language). This is because it is here – at the point where the different kinds of sociability of the old avant-garde are long dispersed, and the reality of the new culture industries incontrovertibly present – that the different versions of the critique of authorship in post-

conceptualism are laid down. As such it is possible to see how this split has come to play itself out in post-conceptualism as a set of distinct critical positions.

When, in *Second Investigation* in 1969, Kosuth treated his assistants as employees in a series of works which involved the artist purchasing advertizing space in various international newspapers, he incorporated these geographically distant collaborators into the circuit of surrogate authorship strictly as wage labourers.[3] That is, these employees from various international galleries were delegated to instigate the work – the purchasing of space – as a part of their contracted labour. There was no, or at most minimal, contact between Kosuth and these assistants, no process of consultation and negotiation. Unlike Moholy-Nagy's 'telephone paintings' the exchange between artist and non-artist provided no actual or imaginary revaluation of the non-artist *upwards*. What preoccupied Kosuth, rather, was how his singularity as an artist might be pursued without recourse to the first person *language* of the artistic self. In this his executive delegation of labour didn't get much beyond a smartened up version of modernist autonomy, but without all the fussy tropes of subjectivism.

The rejection of this formalistic narrowing of the critique of authorship is, precisely, what characterizes Art & Language's reinforcement of the research model of authorship and Warhol's early performative non-linearity. The social relations of an expanded, decentred authorship are placed above that of the formal critique of the author. Yet, when Conceptual art collapsed it was Kosuth's model that fitted the times all the more easily. The limited social possibilities for expanded authorship meant that the formal critique of authorship offered the line of least resistance for those who followed afterwards. Indeed, in a world that was eager to throw off the revolutionary rhetorics of the recent past, this critique of authorship appeared to possess the right kind of stoicism and anti-modernist rigour. It is no surprise, therefore, that from the mid–1970s to the late 1980s the critique of authorship took a largely Kosuthian turn, as the emergent intertextual model of authorship channelled the deconstruction of authorship into a formal account of the author as recontextualist and appropriationist of image and text. Most of the work produced under the auspices of post-structuralist theory in the 1980s shares the Kosuthian perspective, insofar as it reroutes the decentred return to the author in forms of surrogate authorship into a picturesque notion of authorship as a kind of *aristocratic autism*. Sherrie Levine and Richard Prince are perhaps the

best representatives of these moves. A Kosuthian submission to the surrogate as factotum (the photographic readymade) is transposed into the realms of a post-humanist derogation of originality and authenticity. The dialectic of skill and deskilling is narrowed to a debate on copying as the end-of-art, or at least as the end of the artist as the autonomous maker of meanings. This leaves the circuit of authorship as a closed loop, in which the return to authorship in surrogacy (Levine's reproduction of a Walker Evans portrait of a female sharecropper, for example) is delivered as a sign of the death of meaningful artistic labour. One of the reasons that the Kosuthian model of surrogate authorship became so successful for a younger generation in the late 1970s and early 1980s is that it appeared to rewrite the language of the readymade for the newly emergent world of the simulacrum and mediafication of experience. As a consequence the last thing on the minds of artists working through the critique of authorship in conditions of apparent social closure was the desire to build new models of artistic sociability. Sociability seemed irredeemably otiose. The result was that much of the debate on authorship in this period floundered in the realm of a theory of the image and of epistemology, reproducing, ironically, a Cartesian model of consciousness – the only secure knowledge we have of the world is through our own private subjective experience – the very thing which the critique of authorship in Conceptual art actually set out to undermine.

One model of authorship through this period, though, which offered a counter to the Kosuthian reading of Conceptual art was situational aesthetics.[4] Situational aesthetics is what happens to the sociability of expanded authorship when Conceptual art rejects both aristocratic autism and the 'return' to the studio in the mid–1970s, and moves into a socially interventionist mode. In this it can claim to keep the question of expanded authorship an open and living issue in a period where theories of the image tended to dominate theories of art's social agency. On the one hand it owes something to a research-based notion of authorship inherited from Conceptual art, and, on the other, to the extension of the non-artistic subjects of authorship beyond art's relationship to productive labour. In these terms situational aesthetics is where the critique of authorship emerges in response to the demise of the labour theory of culture in the avant-garde and the general rise of institutional critique. In essence it is the place where the readymade, copying without copying, the craft of reproducibility, and the return to authorship in surrogacy are rearticulated through a theory of

art as *communicative action*, redefining the social agency of the avant-garde as it comes to terms with its political and cultural deracination.

ii) The Haptic Readymade

A key social force of these changes was the women's movement, because it was women artists and writers who had perhaps the greatest stake at the time in pulling the critique of authorship out of its crisis of sociability. The women's movement brought the circuits of art's authorship back into alignment with cultural and social division. In this period one work that represents the situational turn at its most perspicacious is Mary Kelly's *Postpartum Document* (1973–9), which bridges the craft of reproducibility and surrogacy in order to generate a new sociability from the old expanded circuits of authorship of Conceptual art. The authorial passage outwards is not to the labourer as non-artistic collaborator, or to the artistic assistant as fabricator, but to her own child as a 'collaborator'. Over a six-year period *Postpartum Document* records, in a sequence of panels containing texts and readymades taken from her home, Kelly's formative relationship with her newly born son. But included in this primary dialogue with her son is also a dialogue with two absent fathers: her relationship with the child's biological father and her relationship with her psychoanalytical 'father', Jacques Lacan, whose reflections on the formation of the subject, and Kelly's reflections on his reflections, are incorporated into the texts. The circuit of authorship is based on the interaction of three voices of authority (mother, father and 'meta-father') which represent different, but overlapping, sets of interests in the mother's 'authoring' of the child's development and identity.[5] In this way the situational character of the work derives from the insertion of the author into a complex and predetermined set of social relationships which, in turn, establish the boundary and conditions of authorship. The author is voiced by the relationships in which the work is embedded. Hence, in *Postpartum Document* the relations between mother–son/son–father/mother–father/mother–meta-father/father–mother/son–meta-father, and so on, provide a discursive framework through which the voice of the artist emerges.

In the mid–1970s this opening up of the circuits of authorship to the social and familial relations in which the self is intersubjectively embedded was important for a second generation of feminist artists. By engaging with sexual and familial relations which had been overwhelmingly bypassed in

the early avant-garde, female-centred circuits of authorship incorporated forms of intimacy that collaboration with productive labour tended to exclude. This allowed, at the point of the split between the formal critique of the author and a commitment to expanded authorship, another kind of labour to enter the circuits of authorship: *domestic* labour. Kelly's 'collaboration' with her son is, first and foremost, a symbolic enactment of her own labour as a mother and wife. As such there is a direct convergence between Kelly's representation of her own labour as a mother in bringing up her child and the labour performed in the production of the work during its six-year incubation. The time-scale of the work's production is brought into conjunction with the time-scales of domestic labour involved in the production of the primary material for the art. In this way Kelly's model of situational aesthetics establishes another kind of embodiment through the readymade other than that involved in strictly surrogate circuits of authorship. In selecting objects and tokens from her child's upbringing the enunciative character of the readymade becomes expressly biographic. The readymade enters the work on the basis of its psychographic and narratological value. This encourages a haptic possession of the readymade quite different from the Constructivist tradition. The incorporated readymade becomes the embodiment of those things the author has *touched and loved*, in this instance the child's drawings and other possessions. The result is that the readymade's circuit of production and consumption is overdetermined by another circuit of exchange: the exchange of the commodity as a token of love; just as the object that is not the product of exchange (the child's drawings for example), overrules the logic of the commodity. This haptic incorporation of the readymade became highly influential in post-Conceptual practice as a generation of women artists set out to rearticulate both copying without copying and the craft of reproducibility from within the realm of sexual difference and women's labour and experience. As a consequence, in a period when detachment from the incorporated object had become the dominant sign of masculine radicality (as for instance in Carl Andre's *Equivalent VIII*), the authorial relations to the readymade in much of this work by women tends to favour signs of hand-to-object attachment rather than hand-to-object detachment. The enunciative power of the readymade is opened up to its affective qualities. This is why the situational aesthetics of Kelly are certainly closer to late Duchampian practice than to what we know as analytic Conceptual art.

iii) The Institution as Readymade

Another model of situational authorship, equally influential during the late 1970s and 1980s, places the relational content of situational aesthetics within the framework of the institution itself, in particular the museum. If in Kelly authorship emerges out of a predetermined set of relationships based on the practices of a non-localizable institution (the family) in this model the predetermined relationships of expanded authorship derive from the workings of the life of discrete institutions themselves. Indeed, this type of practice involves the artist or artists actually working in a given institution in order to reflect on its functions, and, as such, the artist or artists are invariably interactive with those who are employed by the institution or pass through it. In this way the internal and external relations of the institution become the enunciative framework of the work, mirroring the way that sociology and anthropology conduct its fieldwork. But there is an important distinction between these situational art practices and sociology or anthropology proper. The resultant research is not removed from the confines of the institution in order to find an external reflective form (as in the publication of research, for example), but incorporated into the life and architecture of the institution as an exhibition or event. The development of the work is inseparable from the author or authors' presence in the institution as a director or site manager of the institution as a space for the manifestation of the work. In this respect the author or authors treat the institution (its internal/external architecture, internal objects, internal power relations) as a series of large-scale ready-mades that can be manipulated, extracted, deconstructed and renarrativized.[6]

This version of situational practice can be said to be both institutional-specific and interventionist. In the 1980s these practices became, not surprisingly, the dominant model of expanded authorship in post-conceptualism's turn to institutional critique. Michael Asher, Andrea Fraser, Dan Graham, Renée Green, Carole Condé and Karl Beveridge, Fred Wilson and Hans Haacke have all adopted versions of this model. However it is Hans Haacke's work that I want to focus on here, for it is Haacke, above all else, who has come to develop perhaps the most ambitious model of expanded authorship as communicative practice after Conceptual art, and as such represents a key transformative model of situational aesthetics in the neo-avant-garde's dissociation from the labour theory of culture.

Haacke's work is grounded in what the artist perceives to be the internal conflicts, suppressed histories and ideological aporias of a given institution, which then provide the research material for his investigations. The outcome of these investigations may take the form of photograph and text or paintings, photographs and text, text and event, but it is the constellational relationship between the elements that provides a structure for the work. Obviously the targeted institutions are not always amenable to these investigations and then projects are abandoned, for it is central to Haacke's practice that the work is staged in the institution of its origin. There is, thus, an inbuilt testing of the limits of liberal democracy to these projects given that the institutions approached tend neither to want to be seen to reject the work outright for fear of appearing repressive and intolerant, but nor do they really want to give the artist free access to their archives, work practices and employees. This means that when Haacke's projects are accepted there is a forced accommodation between artist and institution based on a kind of artistic equivalent to a prenuptial agreement, which, invariably, produces an awkward or uncomfortable compromise between the two parties. Indeed, this fraught and challenging process of negotiation is what constitutes the collaborative process of the work for Haacke, as for example his exhibition at the Tate Gallery in 1984, installed at the height of the Saatchis' patronage of modern art in Britain (before Charles Saatchi diversified into building an autonomous collection of contemporary work himself). The exhibition almost didn't take place, after the Saatchi brothers objected to Haacke's desire to expose on the walls of the gallery the full extent of their financial involvement in the dealings of the Tate's purchasing committee. Haacke had to agree to certain restrictions if the work was to continue; which he did. This conflict of interests is very much representative of Haacke's situational practice: what is embarrassing or sensitive to an institution is brought into the public realm in order to renarrativize or reframe the self-image of the institution 'from below'. In this way, what tends to drive Haacke's interventions into galleries and museums is a desire to 'narrow' the gap between claims to liberal neutrality of the modern art institution – its claims to represent the best without favour – and its increasing subjection to (undemocratic) corporate and other external financial interests. In this sense Haacke's conception of situational practice derives from a classical left social-democratic model of the counter-public sphere, developed most persuasively from the 1960s onwards in the German Federal Republic, in the

writing, in particular, of Alexander Kluge and Jürgen Habermas.[7] Public institutions such as museums are held in public trust as centres of free intellectual and creative exchange. But when they are left to negotiate with private capital in order to survive as institutions, the erosion of this trust begins, weakening their socially participatory role and educative functions.

Haacke has presented his work, therefore, very much as a model of collaboration within the institution that flows in the other direction to that of art's increasing spectacularization at the point of consumption. In a dialogue with Pierre Bourdieu in 1995 he argues that the artist must create a 'productive provocation' that can 'trigger a public debate'.[8] But as the corporate pressure on museums has increased through the 1990s and the new century, Haacke has had even less room to manoeuvre inside the museum's portals. This has led him to increase his work with non-artistic institutions. One of the most compelling of these collaborations was with the administration of the Reichstag building in Berlin in 2000, *Der Bevölkerung* (*To The Population*). He asked a number of members of the new unified German parliament, some of whose constituencies had been affected by violent physical attacks and firebombings against immigrants, to personally go and collect a half kilo bag of soil from their election districts and bring it into the Reichstag and deposit it collectively in a specially designated public area. Some of the collected soil contained traces of the blood of the victims of violence and charred debris from the fires. The soil was then watered on a regular basis. The outcome, over a period of weeks and months, was an extraordinary profusion and tangle of wild flowers and weeds, which had grown from seeds that had been unknowingly transported in the soil. An image of free miscegenation and hybridity took root inside the newly formed parliament, whose last 'democratic' incarnation had been destroyed by the barbarous exultation of purity: fascism's nationalist mythos of 'blood and soil'.[9] As a model of collective surrogate authorship this work remains distinct from the main body of Haacke's practice. But it does point to what lies at the heart of his notion of expanded authorship: the skills of the artist lie in his or her capacity to produce, through collaborative activity, counter-symbolic events and forms from out of a confrontation with, or manipulation of, a network of institutionally articulated signs and practices. And clearly this is what attracts Bourdieu – a writer who is indebted, unusually for French intellectuals of his generation, to the German left-social democratic tradition – to Haacke's practice. Haacke's work represents 'a kind of

avant-garde of that which could be the action of intellectuals. It could serve as a critical analyzer of the moment of transmission of knowledge in relation to the moment of the conception and of the research itself. Everything makes me think that intellectuals are not all concerned about the moment of the *performance*.'[10] As such Bourdieu imagines Haacke's work as an exemplary model of expanded collaborative authorship in which intellectuals, writers, artists, theatre people, communication specialists, technicians, contribute to a collective intellect that has the power to 'mobilize a force equivalent to the symbolic forces' of capital.[11] This sort of reading may subject Haacke's work to a political agency it cannot withstand. Haacke's circuits of authorship are as locked into the limited channels of social-democratic cultural exchange as any other practice under advanced capitalism. Yet Bourdieu is right on one level: situational aesthetics in this form allows art to incorporate a reflection on relations of power and a wide variety of intellectual and cultural skills into the expanded circuits of authorship in ways that challenge, at key or sensitive points, the way that the capitalist public sphere circulates images and frames its own histories and cultural self-identity. As Bourdieu was to say in *Firing Back: Against the Tyranny of the Market 2* (2003) art's participation in this collective intellect can give '*visible and sensible* form to the *invisible but scientifically predictable* consequences of political measures inspired by neo-liberal ideology'.[12] Nevertheless, this is not to be confused with counter-hegemonic practice, as there was a tendency to do with this kind of art in the 1980s.[13] Kosuth and Art & Language and others are at least commendably realistic about the political limitations of this form. Anti-institutional critique can just as easily end up supporting the good image of the institution rather than underwriting progressive social forces. But despite this, it can function as a counter-symbolic 'best practice' in richly counterfactual ways. In this respect Haacke's work has provided a model of counter-symbolic practice that has become a successful template for expanded authorship both inside and outside of the museum in the 1990s and beyond. For it continues to draw on expanded authorship as a place of collaborative learning and agency: authorship is shown to be, no more no less, *what happens when some people join other people, at a given time in a given location, to share their skills in order to produce a work of symbolic value which is judged to be meaningful by those who experience it*. This is a long way from the early avant-garde's confrontation and exchange with productive labour — as in the work of other situational artists it is symbolic exchange which frames

the circuits of authorship – yet, nevertheless, it offers a sociable research space in which the model of expanded authorship can find and develop new forms of agency. And this, precisely, is why post-conceptualism has been able to reproduce and diversify itself.

NETWORK THEORY AND DISTRIBUTIVE INTELLIGENCE

What Haacke's model systematizes within situational aesthetics is the idea of expanded authorship as an open and transformative network. The artwork is presented as an interrelational, collaborative, discursive and non-linear entity. In this way the internal complexities of the artwork are judged to be equal to the internal complexities of the object of research. This notion of the discursive artwork as a non-linear network is an idea that, perhaps more than any other, continues to shape post-conceptual practice after Haacke. In fact in the wake of situational aesthetics this kind of thinking now dominates the imaginary horizons of art's expanded circuits of authorship across art's expanded technical domain. The idea of the artwork-as-network-in-process, of course, is not specific to situational aesthetics: the expanded circuits of authorship of the early avant-garde operate unambiguously in this way as an exchange across boundaries; but it is not an image that the avant-garde had access to, or could have access to, or indeed would have found fruitful even if it did. On the contrary, the artwork-as-network is derived primarily from the growth of post–1960s telecommunications, developments in the neurological sciences and the rise of the biosciences.

We have already discussed the importance of the network to recent reductionist neurological accounts of the brain. The notion of consciousness as a distributive system of parallel processors clears out the idea that there is some Cartesian centre of action to all our neurological activity. Consciousness is a system of overlapping, multiple vectors. Non-linearity is also crucial to digital theory and the new (quantum) molecular biology. The network functions as a way of describing a given system as open and interactive with other systems and as such both stable and unstable. Thus, just as digital theory thinks of the Internet as a giant multitude of systems embedded and interactive with other systems, the new molecular biology talks about the eco-networks of physical life in terms of systems of causal reciprocity.[14] Biological order is conceived as distributed over multiply parallel and mutually dependent systems, and not as the result of uniquely

predetermined molecular patterns. Even the simplest cell exhibits con-siderable adaptive plasticity.[15] Indeed, it is the adaptive plasticity of systems down to the smallest unit or cell that structures the use of the network in computer science, the neurosciences and biosciences. The constitutive elements of a given system are co-extensive and interactive with the larger environment – system – in which they are embedded.

These feedback models have not been transferred wholesale to art, just as the network in digital theory is not used in the same way and towards the same ends as the network in the neurosciences and biosciences. Yet the presence of the non-linear, system-embedded network in all kinds of thinking and practice in art after post-conceptualism is unmistakable, and therefore needs to be addressed seriously.

This rise in network thinking in art is the result of three primary factors that cross and inform each other: 1) the continuing demise of the 'expressive' (Cartesian) model of artistic production; 2) the increasing enculturalization of art as a non-studio-based socialized practice; and 3) the weakening of a model of revolutionary critique of the hierarchies of art derived from the early avant-garde, Marxism and the labour theory of culture. However, on the basis of the latter this is not to say that network theory is what happens to post-conceptual art after its revolutionary traditions have been dispersed and assimilated. Network theory is not *in and of itself* a conservative and adaptive move. Network theory un-doubtedly contributes to the problematization of the unity of the artwork on all kinds of levels, bringing new post-Cartesian content to the circuits of authorship, just as it provides a focus for connectivity and social exchange in a culture that is increasingly monologic at its centres of power. Nevertheless, as the concept of the network passes from the sciences into art it suffers from the same generality and diffusion, as it does when the concept passes from the natural sciences to the social sciences. Network theory has a specific range of meanings in the natural sciences which are grounded in a materialist account of the genesis and reproduc-tion and interaction of living systems. In the social sciences, however, and more directly in cultural theory, this model of causal reciprocity has become a banal account of symbiosis.[16] In this sense much of its thinking is feebly identitary, in which the absence of network thinking in a given context stands for the loss or crisis of shared meanings. As such its model of social interaction is internally unstructured, indifferent as it is to any realist causal model of cultural and social division. This is also the problem

with complexity theory, which network theory broadly borrows from. Both are essentially integrative models of explanation, and therefore have a diminished sense of the necessity of linking political action and cultural transformation with negation and the need sometimes for the *breakdown* of networks and the construction of asocial identities.[17] The dissolution of division and asymmetry in the name of mutuality, therefore, has made network theory amenable to all kinds of social interests and social forces in art which privilege 'connection' and 'interaction' and the creation of 'ecological niches' over and above anything resembling a critique of the value-form. Transferred to art these models of reciprocity have largely dovetailed with a post-avant-gardist model of artistic production.

At the level of art's relationship to the institution this has generated an unprecedented reordering of the collaborative, collegiate and interactive content of art after post-conceptualism. Whereas notions of dynamic interactivity between systems (montage) and constitutive mutuality (inter-textuality) were specific to post-conceptual practice and its refusal to accept the unitary stability of the artwork (as in Kelly and Haacke), this model of connectivity has now grown to incorporate the sites of art's distribution and production themselves, opening out a conception of diffusion in the artwork into a notion of the diffuse museum. As an open and non-linear network the artwork is embedded in another open and non-linear network (the institutions of art and their others). The outcome is that the idea of the art institution as a staging area for a confrontation with, and interrogation of, art's social form – as something determined by the embodiment of fixed capital and social capital in actual buildings – now becomes, if not marginalized, then at least certainly weakened, as art's circuits of authorship appear to push beyond and bypass the art institution altogether. One of the immediate consequences of this is the demise of the anti-institutional critique as an *institutional practice*, reflected in Haacke's own move away from the museum-based installation.

An early theorization of these new technical conditions is outlined in the work of the US group the Critical Art Ensemble (CAE), who have done much to pull digital theory and the new biosciences into cultural alignment for art.[18] In the early 1990s the group were one of the first to develop a network theory of the artwork based on the communicative flows of the new digital technologies and cell mutation. Close in form and ideology to much other emerging telematic theory,[19] they stressed that computer interactivity moved the notion of artistic discursivity and collaboration

beyond that of the institution-as-readymade. The construction of a counter-public domain through collaboration with bourgeois institutions seemed a waste of time and energy, when a far more effective and extensive counter-public domain could be constructed on the Internet. The temporal and dynamic form of the Internet meant that interactivity and non-linearity were actually built into a system of collaboration and exchange which its participants had some control over. As the group declared: 'All who participate in the network also participate in the interpretation and mutation of the textual stream.'[20] The notion of collaborative authorship, therefore, as a continuously mutating stream of text and image, shifts the temporal focus of situational practice as communicative practice. Artistic production and artistic intervention are identified with the electronic circulation and continuous transformation of image and text rather than with the arrangement of elements within fixed modes of exhibition. As a result the very notion of artistic site and art's situatedness changes. Rather than producing a counter-symbolic order through disrupting or reframing the modes of display of the bourgeois art museum, the digital artist uses the channels of capital's electronic exchange to disrupt and subvert the flow of the capitalist sensorium itself. '[T]he hacker and the cultural worker should blend' together.[21] The very notion of what situational practice might mean becomes opened up to scrutiny: in a world of global digital access addressing a political constituency in one place specifically as a localized *art audience* – albeit an internally differentiated one – delimits the possibilities of network distribution and thinking. In this way the idea of the network for the Critical Art Ensemble becomes the site of art's electronic portability, allowing the exhibition value of the technologically transmitted text and image to have multiple and diverse points of entry and use. The expanded circuits of authorship, accordingly, become subject not just to the displacement of the author into collaborative practice as an externally bounded form of group practice, but also into the multifarious and open-ended dynamics of electronic exchange. Since the mid–1990s telematic theorists of digital practice have tended to talk about the new temporal possibilities of digital authorship in which the collective intellect is identified with the multiple points of entry to and use of the Internet. As the founder of the US net-art group Rhizome.org, Mark Tribe declares: 'we're trying to create a many-to-many communication environment.'[22] This approach can be divided into two significant areas: first, the new technology is seen as a recombinant form of

artistic production all the way down – artistic labour becomes the continuous immaterial reorganization of the readymade (the labour of others) on screen – and as such a powerful democratizer of artistic practice; second, and relatedly, the fundamental condition of digital practice as a multiple-entry, non-linear flow of text and image successfully dissolves the division of producer and consumer in ways that the early avant-garde barely broached. The renewed utopian remit of the expanded circuits of authorship under digital technology, then, is unmistakable. Contemporary writing on networking and digital practices – as for example the writing of Nicolas Bourriaud – now talk of a new cultural economy of art, in which the 'productive consumer' becomes an increasing reality.

A COMMUNISM OF (DIFFUSE) FORMS?

Bourriaud's version of network theory owes a direct debt to the Critical Art Ensemble's bio-computational model of authorship: in the realm of electronic flow artists' relationship to the readymade is constitutive of art practice. Artists no longer compose their works, but 'programme' them. In this, previous artworks are no longer things to be cited or surpassed, but congeries of signs to be inhabited and manipulated, and, once these signs enter the realm of electronic space, a continuous means of generating other works and activities. The artwork, then, functions as a temporary nodal point in a larger flow or network of art's productive relations. Artists become 'tenants of culture' and 'specialized workers of cultural reappropriation'.[23] 'The producer is only a *transmitter* for the following producer, and each artist from now on evolves in a network of contiguous forms that dovetail endlessly.'[24] Or as the Critical Art Ensemble insist: the recombinant artist is first and foremost a plagiarist. 'The plagiarist sees all objects as equal, and thereby horizontalizes the place of phenomena. All texts become potentially usable and reusable.'[25] But for Bourriaud and the Critical Art Ensemble the plagiarist is not a cognate of Kosuth's and Levine's formal critique of the author. The plagiarist, rather, restores the productive drift of meaning, in that the reinscription of the readymade, in the spirit of Duchamp, is first and foremost a transformative, enunciative act. Bourriaud asks: 'Are we heading toward a culture that would do away with copyright in favor of a policy allowing free access to works, a sort of blueprint for a communism of forms?'[26]

In this respect, Bourriaud's and the Critical Art Ensemble's version of post-Conceptual practice seeks to make alliance with the sociable legacy of expanded authorship in opposition to both the integrative conception of the network in complexity theory and the nihilistic Situationist turn in the formal critique of the author. 'Plagiarism', CAE say, 'progresses beyond nihilism.'[27] In this, for all their work's antipathy to Marx and the labour theory of culture, they still retain some dialectical movement in their categories. The recycling and appropriation of images and forms provide a space of critical habitation *within* the informational economy, reconnecting the model of communicative action in post-conceptualism to a productive account of counter-symbolic art practice. In emphasizing the reflexive moment in copying without copying, both Bourriaud and the Critical Art Ensemble are rightly keen to distance the practices of reinscription and deinscription from the notion of counter-symbolic practice as merely parasitic on capitalist forms. The recycling and appropriation of images and texts involves a continuous process of negotiation with the dominant culture as a way of keeping open the channels of democracy. Each ensemble of appropriated images and text is a way of introducing other use-values into the 'closed' circuits of the social. Their version of recombinant practice, as such, has much in common with other, and more sophisticated, accounts of recombinant practice explored in cultural theory in the 1980s and 1990s – for example Greg Ulmer's theory of *euretics* and Tom Cohen's theory of *mnemotechnics*.

As with Bourriaud and the Critical Art Ensemble, neither of these theories has an explicit relationship to the labour theory of culture. Their conceptions of recombination are essentially textual and do not cross the boundaries of artistic labour and productive labour. But nevertheless *euretics* and *mnemotechnics* invoke a model of 'proactive mimesis', in which the enunciative functions of the readymade and copying without copying are defended as transformative acts, and as such underline the convergence of recombinant practice with network thinking across a number of practices and disciplines. As Ulmer argues, as a theory of the 'braiding' of discourses, *euretics* 'replaces the temporality of hermeneutics (the detective narrative, the search for truth by puzzling through the enigma of riddles) with the temporality of invention'.[28] In other words, recombinant forms possess the capacity to break, distress and displace dominant historicist networks of explanation, by insisting, in the spirit of Walter Benjamin, on the essentially denaturalizing function of symbolic recontextualization. Cohen's theory of

mnemotechnics defends something similar. The narrative and informational networks of the capitalist sensorium create various historicist, ocular and humanist blockages. It is the job of *mnemotechnics* to produce other 'representational networks'[29] in which the recombinant production of forms produces 'alternate models of reference, causality, the historical and the "event"'.[30] This becomes the basis, not of a 'wanton aestheticism',[31] or a form of linguistic play, but a transfiguration of the epistemological management of reference and the historical event. Indeed, the epistemological becomes the political. In an explicit debt to Benjamin, *mnemotechnics* depends on blasting an 'image from the delusive mimetic continuum into an allegorical moment of crisis'.[32]

THE AUTHOR AS CURATOR
(OR THE INTERNALIZATION OF CURATORSHIP AS AUTHORSHIP)

On this basis, the extension of the readymade into the textual and *mnemetechnical* flow of the Internet is held to bring a new plasticity – adaptive plasticity – to the recombinant techniques of expanded authorship. Because the recombinant digital practices are fundamentally mutable, the production of forms can be built up and transformed from readymade elements without any loss of continuity between these elements. This leads to a sense that the author's immaterial reorganization of the electronic readymade is closer to a process of continuous and emergent manipulation than it is to the cut-and-paste operations of montage past. Immersion in digital flow produces a heightened sense of formal continuity between elements. As a result the recombinant facility of the artist becomes close to that of the curator: that is, the artist, essentially, re-narrates readymade elements by reorganizing them into new unities.

This idea of the artist-as-curator is certainly not new to post–1960s practice. The expansion of the circuits of authorship into the archival connects Surrealism to Conceptual art to post-conceptualism. Thus, Hans Haacke's presence in the museum, for instance, is not just that of the researcher, but that of someone who sees his job as reorganizing the relationship between the art object, the exhibition space and the conditions of spectatorship, as curators are (ideally) trained to do. But in digital work archival practice becomes heightened; and this is what Cohen means by *mnemotechnique* being central to the generation of other 'representational networks'. In the world of the 'informational economy' the archival

recovery of the readymade constitutes the plastic flow of artistic produc-
tion. Accordingly the author's relationship to the readymade is one that
necessitates sorting, categorizing and genealogical exploration before re-
narrativization, reinscription and disinscription can begin. Consequently
these shifts have had a profound effect on the circuits of artistic authorship
as the dissolution of the category of art has come to be identified with a
form of archival rewriting: *the interpretative re-narrativization of extant works of
art converges with the re-narrativization of the readymade in the electronic flow of
production.* It might be construed that Moholy-Nagy 'curated' the surrogate
production of his five enamel paintings after they arrived from the factory;
just as it is clear from the historical record that he always took an active role
in the organization of how his work was seen in his exhibitions. But he did
not consider artistic authorship as a kind *of* curating, or curating *as* a kind
authorship, because, at the time, the democratic content of the expanded
circuits of authorship lay outside of this internal management of the
category of art itself. However, this convergence between artistic-produc-
tion-as-curating and curating-as-a-form-of-artistic-production is precisely
what has happened to the identity of the artist as a consequence of network
theory and the electronic plasticity of digital practice. The making of new
unities from the organization of works and textual components in an
exhibition space is seen now, epistemologically, as little different from the
production of new unities through the appropriation and manipulation and
re-narrativization of readymade elements on-line. Thus, if the early avant-
garde imagined a convergence between the deskilling of artistic labour and
the deskilling of productive labour on the grounds that both might
constitute the basis for the reskilled technical domain of a post-capitalist
system, the digital neo-avant-garde imagines reskilling in the terms of a
convergence between art's electronic production and its display and
distribution. The artist becomes a curator and the curator becomes an
artist not in order to advance the democratization of the social form of art,
but as a democratization of the circumscribed professional relations
between artists and those who seek professionally to represent art and
distribute it.

A curious thing has happened, then, to the circuits of artistic authorship
in the wake of network theory and digital practice. The museum may have
been largely bypassed as the physical site of critique for digital post-
Conceptual practices, but museum practice – the organization, selection,
narrativization and re-narrativization of extant materials – has become the

modus operandi of art's production. Why? How is it possible that today one of the composite artistic identities most admired is that of the *artist-curator* (rather than the artist-technician, the artist-educator, the artist-worker)? In this respect, in what ways is the dialectic of skill, deskilling and reskilling being played out here? Is it a temporary phase or does it represent a moment of general transformation within art's relationship to general social technique?

'DEMOCRATIC' CONVERGENCE

The convergence between the artist and curator has echoes of the early avant-garde's assimilation of the non-artist. But of course in this instance the incorporated labour is not proletarian, although the labour of most curators is certainly poorly paid. So, something else must be at play here other than the identification of artistic labour with its deskilled others as a critique of the distinction between artistic labour and non-artistic labour. Indeed, in contrast to the early avant-garde, the convergence here between artist and curator is an intra-professional identification between the labour of the artist and the labour of the curator, meaning that no direct transference from the dominant to the dominated occurs between the different parties. There is no emancipatory point of identification that links artist and non-artist. In this respect the process of identification must be based on a recognition of changes internal to artistic labour and non-artistic labour, and not simply on the perceived identification between artistic labour and non-artistic labour. Thinking of yourself as a curator as an artist, in other words, is a response to how the image of your demanualized labour is shared by your professional collaborator. There is no loss in status, therefore, in identifying with what you know to be freely equalized in your practice: productive artistic labour and interpretative labour. This makes the unity between artist and curator the expression of a historically specific kind of convergence between artistic and non-artistic skills as part of the wider interpenetration of artistic and general social technique: the convergence, that is, in the era of the 'informational' economy and immaterial labour, between waged labour and communicational practices and affective skills.[33] Increasingly in certain sectors of the economy labour is interwoven with cultural knowledge and advanced communicative skills (particularly in the area of sales where many of the new 'informational' jobs have been created). Indeed, even certain forms of material and manual

labour have become infused with 'cultural values' such as teamwork and 'creative exchange'. For some writers these changes reflect the increase in 'non-value' determinate values in labour, allowing us to talk about a 'new economy' in which some of the subjective and aesthetic judgements customarily associated with artistic practice are brought to the workplace. The extent of these changes is open to question, and as such presently represents the area of greatest dispute within the critique of political economy: to what extent does the rise of immaterial labour transform how value is produced and measured?[34] How much of this new 'creative ecology' in the workplace is vastly overstated? I will look at these issues in detail in the next chapter, but for now it is important to recognize that in certain sectors management has without doubt remodelled labour practices on cultural values associated with artistic labour (non-hierachical collaboration, flexibility of response, trust-based exchange, and non-linear processuality). This has produced in various sectors of the digitalized 'new economy' a heightened sense that certain forms of immaterial labour are culturally embedded, as much as they are the outcome of capitalist competition. It is into this emergent space of affective labour skills, therefore, that the professional convergence between artist and curator has appeared. Yet, this has happened not because the majority of artists now think of themselves as immaterial *workers*, although some like the Critical Art Ensemble clearly do, or aspire to. Rather, as a result of the increasing continuity between what artists do and the skills possessed by immaterial workers, artist and curator now stand in a relationship of cultural *affinity*. This leaves the identity of the artist-curator in an interesting position: the artist reappropriates what has been appropriated from him or her (deskilled artistic skill) in the name of an expanded democratic exchange.

As an intra-professional dialogue the convergence between artist and curator represents a *displaced* democratization of the circuits of art's authorship. By incorporating the critique of the art institution into art's relations of production through the assimilation of the idea of the artist-as-curator, the gap between primary artistic skills and secondary interpretative skills is short-circuited, allowing auto-curation and curating-as-authorship to converge as a *common practice*. What post-conceptual artists do technically and what curators do technically – the organization, manipulation and re-narrativization of readymade components – become interchangeable. This not only blurs artistic decisions and administrative and interpretative

decisions, but allows the circuit of artistic concepts to begin outside of what is judged to be artistic practice, transforming the entry points where artistic production begins. As one curator-artist has argued recently, by shifting the traditional balance of power between artists and curators along these lines, 'the role of the artist or curator has the possibility to augment or replace existing decision-making structures or to develop new ones.'[35] 'I think it will come about that instead of one curator to thirty artists there should be one artist to thirty curators. This idea surely makes sense when an artist has an idea which requires a huge amount of resources, energy, time, specialisation and research.'[36] Such expansion of authorial boundaries may seem ponderous and unwieldy, but nevertheless this kind of thinking has begun to produce a 'democratic' challenge from below in the museum as its curators come under the influence of these new conditions of authorship. The late-modern museum may be in the pay of corporate masters and thereby subject to banal and oppressive hierarchies of taste, just as it may be beholden to traditional notions of the author, but as self-modernizing institutions museums are also subject to the *demands of artistic production*. If artists present themselves to the museum as curators, then, irrespective of corporate requirements and the hierarchies of taste, the museum cannot but accommodate the work on the work's own terms, for otherwise there appears an unbearable gap in legitimacy between what contemporary artists do and what the contemporary museum claims to be doing: bringing to attention what is of the moment. Indeed, anxiety about this gap in legitimacy is what has defined the emergence of the modern museum since the Second World War. But now, as the critique of the museum is built into the production of art, and more art circumvents the museum at the point of distribution, the museum must, above all else, *be equal to its own demise*. That is, it must be equal to its own critique at the point of display and production if it is to remain in a position to call itself a modern museum of modern *art* at all, and not just a place of modern antiquarian interest.

This is why museums have become increasingly committed to the idea of themselves as sites of artistic production and as *devolved* sites of display in a network of sites of display, for a commitment to the museum as a site of fluid production and dissemination is one way of resolving the problem of the museum as a site of cultural domination in a culture of digital flow. The museum is revealed to be a place where values and judgements are not just imposed, but produced in collaboration with artists, who *have no investment in*

the museum. This produces a dual ideological functionality to museums as they enter 'network' culture. On the one hand museums are still largely managed as staging areas for the contemplative engagement with authentic and canonic works, and as such are still thought of by those who run them as 'counter-institutions to the factory' and the classroom.[37] But with the convergence of artistic auto-curation and curatorship as authorship, increasingly those who work and produce ideas in them, and those, such as artists, who demand a different kind of engagement from them, think of them as possible research stations and sociable public forums. Consequently there has been much discussion recently about the new museum as a discursive, dynamic or multifunctional structure.[38] As one museum curator has argued, the new museum is both 'a production site and . . . a distribution channel',[39] by which art 'ventures out into our surrounding reality'.[40] The future of the museum lies in its development as a major point of distribution for projects and collaborations outwards into other networks of display and the social world. As such the new museum will operate a bit like a major film studio does: financing, supporting and promoting artists in a multitude of different ways and across a multitude of different sites. As the curator Joshua Decter insists, summing up these new prospects, the new museum will 'need to develop strategies that explode the museum into another space so that the insulated institution splinters into a plethora of situations and contexts, touching a broader, more diverse range of constituencies and challenging disciplinary Balkanization'.[41] The museum is caught on the horns of a dilemma: it cannot just catch up and exhibit work that is profoundly antithetical to the idea of the museum, or conversely, retreat to a world of humanist pieties; it must intervene, and establish a stake in the new culture. This is why many museums are now engaged on joint ventures with artists in non-artistic contexts, and why many museums are now developing their own digital facilities. The conjunction between artist and curator, then, is not the only process of cultural convergence taking place. There is also evidence, as post-conceptualism moves into the area of digital practice, of a wider cultural convergence occurring between artist and curator and the museum itself. Whereas artist and curator talk about a democratic dialogue inside the circuits of authorship, the museum now talks about wanting to bring this dialogue into the museum. What this actually means in relation to an engagement with issues of social and cultural division remains painfully limited, but something no doubt has shifted in the boundaries of the old

bourgeois culture, or rather, in terms of how the old bourgeois culture wants to be seen.

The conflation of artist and curator inside the walls of the museum, the rise of non-artistic sites of art's production and display attached to the museum's name, and the incorporation of the critique of the museum into the museum's process of modernization, represent the artistic alignment of the museum with its critics. Museums may be constituted as privatized fiefdoms, and at the high-end of their exhibition programmes they may continue to reflect the conventional judgements of art history, but, through the actions of their curators and the demands of artists, they also remain places of critical rendezvous and exchange. It is hard to tell, therefore, at what point the critique of the art institution is now able to find its target, when the museum is able to provide its own auto-critique. But this is exactly the point about these conditions of convergence; and precisely why Hans Haacke and defenders of the anti-institutional critique find little room for their confrontational strategies these days. The radical network theory of telematicists and digitalists, the blurring of identity of artist and curator through the transference of skills under general social technique, are in perfect harmony with the re-modernization of capitalist culture and the institutions of capital, as they reconstruct themselves under the new cultural economy's images of flexibility and non-linearity.[42] The craft of reproducibility, the immaterial labour of curating and non-hierachical management meet in free and open exchange; and, as such, at these points of exchange they can all see something of themselves in each other, and, therefore, all believe themselves closer to one another than they first dare assume. The outcome of this is that the relations of production of the new art and the new museum, despite their real opposition, actually dissolve into each other, as the reciprocal relations of network thinking inescapably draw them into a common bond. Because the museum can become part of network thinking, art can re-enter the museum on the understanding that the institution is one part of a wider web of connections; the face-on critique of the institution becomes harder to realize. Nevertheless, this would seem to fly in the face of conventional wisdom on the new corporate museum. What the new corporate museum has engineered since the 1980s, it is argued, is the very the opposite of this mutuality: the post-historical narrowing of the museum as a place of intellectual exchange and counter-symbolic work. In her extensive survey of the new museum, *Privatising Culture*,[43] Chin-tao Wu broadly follows this

line, by linking the neo-liberal attack on what Bourdieu calls the 'left-hand' of the state (those 'spending ministries', such as labour, education, public housing and health which represent the trace of past class struggles) to the increased entry of private capital into artistic support structures across Western culture. That is, the extended privatization of culture under the neo-liberal onslaught represents a further erosion of the 'social state'. And symptomatic of this is the ease with which institutions and individuals are prepared to take the corporate shilling, from Fay Weldon's willingness to allow a product placement in one of her novels, to Chris Ofili and other artists being commissioned by Absolut Vodka to produce a work that includes references to their product.

Now although Wu rightly condemns the explicit conservative and regulatory cultural agenda of the new corporate museum – as evidence of capital's deepening cultural parasitism – under the new corporatization of high culture the museum is still able, as I have demonstrated, to secure a place for the self-modernizing interests of the new middle class. This is why, alongside the insidious integration of business values into the support system and modes of public display of the art world, there has emerged a section of the new middle-class cultural administration that defines its self-identity not through the idea of the museum as a place of historical record, generic creativity or humanist affirmation, but as a 'research forum', 'post-exhibition arena', 'exchange network', etc.; and therefore as no less a legitimate or effective space than any other cultural site for counter-symbolic and counter-cultural work. We don't need to recognize the obvious counter-hegemonic limitations of this position, or its debt to the post-Althusserian critique of the institution-as-unitary-expression-of-capital, to realize that at the same time as capital moves on the museum – repossesses it for its dominant ideological work as the neo-liberal counter-revolution has done as a whole – the centrigual, consensual force of the museum is in continual conflict with its post-Second World War commit-ment to the contemporary and to the critique of art as such. And this is the modern museum's recurring contradiction: the museum can exclude ideologically, corporatize meaning, police the canon as much as it likes – in the interests, of course, of what is 'best' in the culture – but it cannot shut its doors to the destabilizing strategies and effects that most modern art brings through its portals, no more so now when so many artists think of the museum as simply a 'staging' area for their practice and not the place where meaning is secured and managed. My point, then, is that the social-

democratic place of the museum in the culture – defended variously from the left by Haacke, Kluge and Negt, Habermas and Bourdieu – may have been eroded, but this has not in any way severed the relationship between art and its modes of negation, or its democratic horizons of presentation and engagement. Similarly, it would be wrong to fetishize the statism of the older social-democratic model, as if the museum was any less attached from 1945–75 to conservative notions of authorship and fluctuations of the market, despite the general absence during that period of sponsors' logos from its hoardings. The increased penetration of private capital into the domain of high culture, then, is precisely the *operational* space under which art continues to define its critical autonomy; and therefore, the boundary-space in which art as social praxis continues to be forged.

PROSTHETIC OMNIPOTENCE

Network theory is an attempt to solve the problem of art's social form in late capitalist culture, where the remnants of the old forms of cultural production (medium specificity, artisanal-based object making, the division between high culture and popular culture) are in retreat, and where the transformative social programmes of the early avant-garde are, it is believed, no longer viable. In developing the model of the interconnected web out of digital theory and the new biosciences, network theory, therefore, has become the new hegemon, precisely because it appears to provide an image of art's internal and external fluidity and interconnection in a world of wider artistic hybridities, cultural multiplicities and interactive exchanges. Under these conditions the circuits of art's expanded authorship have been subject to a symbolic remodelling (and reembedding). The passage of authorship across the artistic and non-artistic is no longer a passage into and across social and cultural division (artistic labour/productive labour, productive labour/immaterial labour, simple labour/complex labour, copying/copying without copying), but into a communicative framework in which instant reciprocity and recall and the fluidity of semiotic and formal boundaries determine the progressive horizons of artistic agency. The mediation of division is subsumed under the model of 'interactive dialogue'. Yet, this is not to say that network theory is just another theory of artistic hybridity and cultural multiplicity, and therefore does not possess a theory of conflict and division. The writing of Bourriaud and the Critical Art Ensemble belie this, as I have emphasized. But for all

their stress on the production of alternate spaces of reference and historicization, as theories of counter-symbolic production they share with almost all network theory a systematic derogation of place and the hand, and as such mistakenly identify the liberation of the image from its original productive context with the liberation from labour on things. (One immediately needs to recall the title of one of Bourriaud's books: *Post-Production.*) The result represents one of the fundamental problems of digital practice and telematics as they are subsumed under network theory: the vast inflation of the democratization of art in the name of digital practice's perceived liberatory semiotic and virtual effects, at the expense of relations between the digital and the manual.

I talked earlier about subjective omnipotence in modernism. We might talk in a similar fashion about the *prosthetic omnipotence* of digital and recombinant theory: the fact that the radical displacement of the hand into the pure realm of technical facility is taken to be an unchallengeable emancipatory outcome of digitalization and radical plagiarism. The questioning of this ideological inflation is rare in network theory precisely because digital practice and telematics do not want to be slowed down by considerations of the haptic body. The result is that the craft of reproducibility in the epoch of art's technological dissolution and global transmission is made to do the kind of work it was never able to do, even at the height of the avant-garde's revolutionary investment in the mechanical reproduction of the image: the instant global distribution of art. This leaves us with an important consideration: in what sense are the new circuits of artistic authorship in all their autonomy compatible with the old avant-garde's emphasis on the interconnection between corporeality and reproducibility? Do they break with this legacy? Indeed, are the new circuits of authorship compatible with those forms of complex labour that the avant-garde saw in art as a source of critique of the value-form?

THE RECALCITRANT HAND

The circuits of authorship in recombinant digital practice and telematics bring into focus some of the problems faced by the early avant-garde's assimilation of the craft of reproducibility and authorship-at-a-distance. In response to the equalization of labour, and the convergence of artistic technique and general social technique, art expands its technical conception of authorship. But in what ways is the transformative agency of the hand

present in these processes? Where is their evidence of the hand's relation-
ship to artistic form *all the way down*? This is why Duchamp, El Lissitzky and
Moholoy-Nagy all addressed the importance of the artisanal hand in
keeping the heteronomy of general social technique at bay, after initially
identifying the 'disappearance' of the authorial hand with the emancipation
of art from its artisanal and humanist constraints. Digital theorists and
telematicists are certainly not defenders of the autonomization of artistic
labour. In fact many digital theorists talk about the necessity for the artistic
humanization of technology, just as they also talk about the place of the
hand in the plastic mutability of the electronic image.[44] But this is a
'humanization' framed by weak, post-human forms of interactivity be-
tween body and machine, given the priority that digital practice gives to the
spatial autonomy of the 'eye' as the dominant function of electronic
authorship. The tendency in digital authorship towards free-floating
recombinancy takes over from the embodied presence of expanded
authorship in specific and interactive locations. There is a greater accep-
tance, therefore, as authorship-at-a-distance becomes the primary mode of
computer-based practice, of the hand's *disappearance* into the prosthetic and
machinic. Of course, the expressive hand in art is not recoverable as a
unitary craft practice. As I have repeatedly argued, the craft of reprodu-
cibility removes the conventional link between artisanal craft and author-
ship; and digital practice extends this into the realms of the virtual. But
virtuality is not in itself congruent with the liberation of technique.
Virtuality is also the place where artistic subjectivity also gets *lost*, that
is, the place where the fluidity of technical response in recombinancy
confuses facility with meaning, and immediate access with democratiza-
tion. This is why in digital theory and telematics the relationship between
artistic technique and general social technique tends to get presented as a
question of *expanded facility*, rather than as a reflection on facility itself. The
avant-garde dialectic of skill and deskilling is suspended in a fetishization of
'computer skills'. This is due to the fact that digital authorship is largely
reliant on machinic inventiveness to 'compose' the flow of images and text,
which inevitably results in the inflated role of the detached hand and body.
Surrogate authorship in the early avant-garde, in contrast – given its direct
relationship to productive labour – was always embodied in a conflicted
exchange between artistic skill and non-artistic skill, allowing forms of
artistic and non-artistic immateriality and artistic and non-artistic materi-
ality to intersect and play off each other. The craft of reproducibility in

Duchamp, El Lissitzky and Moholy-Nagy was not monologically directed to the production of a flow of images and text as information. Rather, the conjoining of the detached hand and the attached hand was always concerned with staging a critique of technology from inside technology. In the world of the omnipotent digital image, however, this interrelationality between technology and its critique, materiality and immateriality, the body and the virtual, has been eroded as the prosthetic hand is now assumed to carry all before it. This is why recombinant theory, even in its most 'productivist' form, as in Bourriaud and the Critical Art Ensemble, is so insistent on its disembodied, post-productivist status. In the world of instantaneous communication, immediacy of interaction and immediacy of appropriation overwrites the emancipatory potential of technology's *failure*.

The problem then for digital authorship is one that faced the avant-garde: critical embodiment. Where is the presence of the emancipatory totipotentiality of the hand in digital and telematic forms of prosthetic and surrogate authorship; and, as such, in what ways is the positivization of technical facility in digital and telematic practice identifiable with artistic autonomy and the emancipation of labour?

Some of the most pertinent theoretical work on this question lies, in fact, in the area of telerobotics (the manipulation of objects electronically at a distance). Telerobotics is one branch of telematics and digital theory which has learnt the most from the anti-computational school of Artificial Intelligence and cognitive science, and therefore has a sceptical relationship to the fetishization of detached forms of intelligence. Theorists and practioners in this area – given that they're actually involved in *building* things – tend to possess a greater understanding of the importance of real-time embodiment in the construction of a convincing virtual machine, and as such have little sympathy for the reactionary notion that machine-intelligence is in itself progressive and liberatory. Accordingly, telerobotics is a valuable resource from within the wider community of cognitive science and Artificial Intelligence in thinking through the aporias of recombinant digital practice.

The central technical problem confronted by the science of telerobotics is: in what ways might the electronic manipulation of objects at a distance be a pleasurable and engaging experience for the user? Can telepresent objects stand in for our direct interaction with things and be *convincing*? These are significant questions because informational space does not so much bring what is far and near into close and instantaneous proximity as

actually do the opposite: destroy the metric relations of time and space. We live in, and belong to, metric space, the space of daily bodily interaction, giving us a sense of repleteness and continuity with things as we move through the world. This is why, as Albert Borgman suggests, 'information in cyberspace fails to have the suppleness and life that the semantic plenum of reality supplies to natural and cultural information and to the presence of real things and persons.'[45] Consequently, this gap in repleteness is a major problem for telerobotics as it is for digital representation, and, as such, represents the intellectual driving problem for this science. How is it possible to generate forms of telepresence in which the subject's hand movements and judgements are *continuous* with the prosthetic technology? In the current forms of telepresent technology available on the internet the user is overwhelmingly aware of acting-at-a-distance. This produces, inevitably, a physically inert and awkward experience for the user. Too often the movement of the hand-at-distance feels slow and clunky. What this reflects is that digital and telepresent technologies are actually parasitic on our bodies' richer and more complex involvement in metric space, and our haptic manipulation of objects. Digital technology may stretch the plenum of metrical space but our interaction with this expansion is always pre-embodied by our familiarity with what is proximate to us. This concretizes a more general problem with the way digital practice is usually theorized: our sensory and cognitive engagement with the world is not primarily through our representations of the world, but through our interaction with things that are available to our touch and other senses. This is why 'world knowledge', as I outlined in my discussion of the experience of the blind Conceptual artist, is not just a representational activity. As Gareth Evans writes: 'The very idea of a perceivable, objective, spatial world brings with it the idea of the subject as being *in* the world, with the course of his perceptions due to his changing position in the world and to the more or less stable way the world is. *The idea that there is an objective world and the idea that the subject is somewhere cannot be separated* [my emphasis], and where he is is given by what he can perceive.'[46] In other words, knowledge is not located inside our heads and causally connected to the world by way of our senses, but connected through our motor and haptic location as embodied subjects. The point is not that representations do not provide knowledge of the world, but that our representations of the world are not tested simply through reflection on our mental states. When we want to test these representations we do not gaze or reflect on these states

of consciousness, but on the way our representations work or fail to work as we move through the world. And this is no different for the blind person as it is for the sighted person. Our conception of ourselves as producers of representations, on this basis, then, is thoroughly anti-Cartesian. Knowledge is not a property of abstract mind, but of the mind-body through its motor-intentional and labouring modes. 'We [cannot]' as Evans puts it, be 'Idealists about ourselves',[47] because it is impossible to imagine ourselves free of embodied praxis. It is the separation of knowledge from agency and place, therefore, that always puts conventional computational-based AI and digital practice at a disadvantage. As the computer scientists John Canny and Eric Paulos put it: 'From an epistemological point of view, we may be convinced by the light and sound of the virtual world, but we will not be satisfied by our interactions with it. The experience of being in the world is much more than merely observing it.'[48] And it is this dissatisfaction with digital representation as an embodied experience that drives telerobotics' desire to move beyond AI's 'bedridden' pre-history and the world of 'digital representation' itself.

The immediate practical prospects of telerobotics, however, are not what concern me here. Rather, what interests me about this new generation of computer scientists (and some digital theorists) is the critical profile of their anti-Cartesian research programme, the fact that the development of the relations between *technik* and human corporeality are explored here without the customary post-human rhetoric. For, in searching for a realistic increment in human–machine interaction, this kind of research programme stresses the qualitatively determinate presence of human embodiment *in* electronic practice. This, naturally, has implications for the expanded circuits of artistic authorship. By emphasizing the qualitative transformation of human–machine interaction the relations between reproducibility and corporeality become reinstated as a renewed source of artistic *autonomy* within the sphere of digital authorship and telematics. The idea of artists 'humanizing' technology is far too vague and technically feeble a concept, then, to cover this demand for autonomy, because strictly speaking artists do not humanize technology at all. Rather, technological relations have to be broken, cajoled, manipulated, in order to render them amenable for authorship and non-instrumental uses. This means shifting the debate on reproducibility and corporeality beyond simple notions of machine–body hybridity, as if machines and humans have a history of greeting each other on equal terms, a view which has tended to underwrite the cultural

optimism of digitalization and network theory's emergence.[49] By empha-
sizing machine–body embodiment as a productive site of exchange and
tension between the attached hand and detached hand, the body and the
virtual, machines become not so much technical extensions of authorship –
of heightened technical facility in the positivistic imaginary of digital culture
– but tools of subjective transformation. Consequently machine–body
embodiment challenges some of the present (idealist) Cartesian contain-
ments of network theory and digital practice. For this embodiment moves
the emphasis in telematics and digital practice away from recombinant
representation to the production of forms of counter-symbolic networking
in which immersive positioning and reciprocal interaction across the orders
of materiality and immateriality play a reflective and determining role,
rather than simply a formal and navigational one. In this the dialectic of
subjectivity and technology in social *technik* is restored, and the question of
art's critical relationship to immaterial practice in an 'informational econ-
omy' reinserted into the broader debate on labour and value.

NOTES

1 For a discussion of the assimilation of the museum into the relations of the production
 of contemporary art, see Philip Fisher, *Making and Effacing Art: Modern American Art in the
 Culture of Museums*, Harvard University Press, Cambridge, Mass. and London, 1991.

2 In the 1960s the group documented the conditions of sugar-plantation workers in the
 northern Tucamán province of Argentina. The group emphasized the need for the
 production and display of their work to remain within non-art contexts.

3 For a discussion of Kosuth and collaborative practice, see Charles Green, *The Third
 Hand: Collaboration in Art From Conceptualism To Postmodernism*, University of Minnesota,
 Minneapolis, 2001.

4 For a discussion of situational aesthetics, see Claude Gintz, 'Michael Asher and The
 Transformation of "Situational Aesthetics"', *October*, No. 66, Fall 1993.

5 For an extended reflection on the work, along with the work's complete reproduction,
 see Mary Kelly, *Postpartum Document*, University of California Press, Berkeley, Los
 Angeles and London, 1999.

6 In this light this model of situational practice owes something to Michel de Certeau's
 notion of the flâneur's imaginative re-symbolization and re-narrativization of urban
 space; the making *improper* of the proper. See de Certeau, *The Practice of Everyday Life*,
 University of California Press, Berkeley, Los Angeles and London, 1984.

7 See Alexander Kluge and Oskar Negt, *Öffentlichkeit und Erfahrung: Zur Organisationsanalyse
 von bürgerlicher and proletarischer Öffentlichkeit*, Suhrkamp, Frankfurt/Main, 1972; and Jürgen
 Habermas, *The Theory of Communicative Action, Vol. 1: Reason and the Rationalization of Society*,
 trans. Thomas McCarthy, Beacon Press, Boston, 1984.

8 Pierre Bourdieu and Hans Haacke, *Free Exchange*, Polity Press, Oxford, 1995, pp.21 and
 22.

9 The title of the work, *Der Bevölkerung* (*To The Population*) forms a large neon sign amongst the weeds and flowers. The phrase is borrowed from Brecht: 'In these times, the one who says *Bevölkerung* instead of *Volk* [. . .] already does not support many lies' (*Writing the Truth: Five Difficulties*) (1934/35), and in this represents an answer to the old and still visible sign on front of the Reichstag, 'Dem Deutsche Volk', which was so venally corrupted and manipulated by the Nazis. See, *Hans Haacke*, Phaidon Press, London, 2004.

10 Bourdieu and Haacke, *Free Exchange*, p.108.

11 Ibid., pp.107–8.

12 Pierre Bourdieu, *Firing Back: Against the Tyranny of the Market 2*, translated by Loïc Wacquant, Verso, London, 2003, p.25.

13 Situational practices and a theory of the counter-hegemonic tended to go hand in hand in the 1980s. The shift to institutional critique in the neo-avant-garde reflects a wider set of political reorientations on the left. Institutional critique becomes the frame or staging area for a nodal conception of politics, in which counter-symbolic struggle is identified with a multiplicity of fronts. Anti-institutional critique was a key mediator, then, of the enculturalization of politics, and a focus for the rise of identity politics in the 1980s.

14 'Wherever we see life, we see networks.' Capra, *The Hidden Connections*, p.8.

15 The cell is in a constant dynamic state (that is, it is not dictated by an internal 'gene-script'). For a critique of preformation and defence of Aristotelian epigenesis (dynamic, developmental interaction), see Lenny Moss, *What Genes Can't Do*, MIT, Cambridge, Mass. and London, 2003. See also Johnjoe McFadden, *Quantum Evolution: Life in the Multiverse*, Flamingo, London, 2000.

16 See Capra, *The Hidden Connections*.

17 This is the fundamental weakness of Niklas Luhmann's work, who uses a bioscientific account of autopoesis (self-development) as a system-model for art. See Niklas Luhmann, *Art as a Social System*.

18 Critical Art Ensemble, *The Electronic Disturbance*, Automedia, Brooklyn, 1994.

19 For example in the journal of electronic arts, *Leonardo*.

20 Critical Art Ensemble, *The Electronic Disturbance*, p.96.

21 Ibid., p.138.

22 Mark Tribe, in Sarah Cook, Beryl Graham and Sarah Martin, eds, *Curating New Media: Third BALTIC International Seminar, 10–12 May 2001*, Baltic Gallery, Newcastle-Upon-Tyne, 2002, p.145. See also Julian Stallabrass, *Internet Art: The On-line Clash of Art and Commerce*, Tate Publishing, London, 2003.

23 Nicolas Bourriaud, *Postproduction*, Lukas and Sternberg, New York, 2002, p.18 and p.19. See also *Esthétique relationelle*, Les presses du réel, Dijon, 2001.

24 Ibid., p.34.

25 Critical Art Ensemble, *The Electronic Disturbance*, p.88.

26 Bourriaud, *Postproduction*, p.29.

27 Critical Art Ensemble, *The Electronic Disturbance*, p.90. For a nihilistic defence of plagiarism, see Stewart Home, *Neoism, Plagiarism and Praxis*, AK Press, Edinburgh and San Francisco, 1995.

28 Greg Ulmer, *Teletheory: Grammatology in the Age of Video*, Routledge, London and New York, 1989, p.138 and p.131.

29 Tom Cohen, *Ideology and Inscription*, Cambridge University Press, Cambridge, 1998, p.14.

30 Ibid., p.104.

31 Ibid., p.20.

32 Ibid., p.40.

33 See, for example, Andreas Wittel, 'Culture, labour and subjectivity: for a political economy "from below"', *Capital and Class: Creative Industries: Production, Consumption and Resistance*, eds, Jim Shorthouse and Gerry Strange, No. 84, Winter 2004.

34 Toni Negri of course leads the way (see Chapter 7). See also Luc Boltanski and Eve Chiapello, *The New Spirit of Capitalism*, and Eve Chiapello, 'The "Artistic Critique" of Management and Capitalism: Evolution and Co-optation', in Roberts and Wright, eds, *Third Text* No. 71.

35 Gavin Wade, 'QRU', in Wade, ed., *Curating in the 21st Century*, p.19.

36 Ibid., p.20.

37 Fisher, *Making and Effacing Art*, p.29.

38 For an overview of the new museum, see Noever, ed., *The Discursive Museum*.

39 Maria Lind, 'Learning from art and artists', in Wade, ed., *Curating in the 21st Century*, p.88.

40 Ibid., p.100.

41 Joshua Decter, 'Synergy Museum', in Noever, ed., *The Discursive Museum*, p.87.

42 See, for instance, Paul du Gay and Michael Pryke, eds, *Cultural Economy: Cultural Analysis and Commercial Life*, Sage, London, 2002.

43 Chin-tao Wu, *Privatising Culture: Corporate Art Intervention since the 1980s*, Verso, London and New York, 2002.

44 See for example, the work of historian Frank Popper, one of the doyennes of contemporary digital and telematic practice, interviewed by Joseph Nechvatal, 'Origins of Virtualism: An Interview with Frank Popper', *Art Journal*, Spring 2004, pp.63–7.

45 Albert Borgmann, 'Information, Nearness, and Farness', Ken Goldberg, ed., *The Robot in the Garden: Telerobotics in the Age of the Internet*, MIT, Cambridge, Mass. and London, 2001, p.100.

46 Gareth Evans, *Varieties of Reference*, John McDowell, ed., Oxford University Press, Oxford, 1982, p.222.

47 Ibid., p.256.

48 John Canny and Eric Paulos, 'Tele-Embodiment and Shattered Presence: Reconstructing the Body for On-line Interaction', in Goldberg, ed., *The Robot in the Garden*, p.277.

49 See for example, Donna J. Haraway, 'A Cyborg Manifesto: Science, Technology and Socialist Feminism in the Late Twentieth Century' (1985), in *Simians, Cyborgs and Women: The Reinvention of Nature*, Free Association Books, London, 1991. In a reversal of the old Cartesianism of mind-body philosophy, Haraway talks of machines as intimate extensions of ourselves. 'The machine is us, our processes, an aspect of embodiment. We can be responsible for machines; *they* do not dominate or threaten us' (p.180). This seems to be exactly the opposite of the truth: our prosthetic intimacy with machines is precisely the outcome of machinic domination. This does not mean that we should not or cannot be intimate with machines, but rather that this intimacy is only worth calling intimacy when it becomes an extension of authorial and embodied autonomy, and as such this is only *generalizable* when such domination is called into question at the level of productive labour. The polymorphousness of Haraway's 'hybrids of machine and organism' (p.150) operate beyond the law of value.

ART, IMMATERIAL LABOUR
AND THE CRITIQUE OF VALUE

As we have seen in the last chapter the development of digital practices appears to have rapidly transformed the landscape of culture and labour practices. The old co-ordinates between labour and 'culture', it is argued, no longer apply. With the rise of immaterial labour the management of many workplaces now relies on cultural values such as teamworking and creative exchange as a constitutive part of the labour process. Indeed, in some digital-based 'creative industries' the conventional attributes of 'artistic critique' (non-hierachical interaction, processual integrity) are foregrounded as part of a flat-management system. As two analysts of this emergent system have argued, this 'new cultural economy [is] char-acterised by highly fluid and informally organised networks of economic relations; different working patterns and forms of exchange that are thoroughly embedded in a range of non-capitalist values and meanings; and an alternative work–life nexus'.[1] Even if the authors are referring here to a number of 'show-case' businesses in the new creative industries, the general implication is nonetheless clear: the would-be enculturalization of labour introduces 'non-economic' motivations into production, signalling the blurring of 'labour' and 'life'. But, despite the attractiveness of this notion of a new cultural commons at the centre of production, these so-called cultural values are not new to capitalism. In fact, capitalist reproduc-tion is predicated on co-operation and non-hierachical interaction at all levels of productive and non-productive labour. Capitalism would not function *at all* if every interaction and exchange were a monetary and instrumental one. Similarly, at the heart of the deskilling of labour, workers have always found compensatory use-values in the worst and most banal of

jobs (something that Braverman doesn't discuss). This is because the working class, as a class whose labour is based on co-operation, is embedded in mutual structures of support, irrespective of the social inclinations and political affiliations of specific individuals. Consequently the co-operative relations of labour-power is always a cultural issue. But, admittedly, this is not strictly what the authors mean by enculturalization. All labour is embedded culturally at some level, but the new economy's enculturalization of labour provides something qualitatively different from shared class interests and compensatory use-values: a real space of autonomous exchange within the heteronomy of the workplace. And, of course, this represents the key transfigurative claim of recent writing on immaterial labour derived from the autonomist political tradition, to which much of the work on the new cultural economy is so clearly indebted. It is the convergence of the structural co-operative power of workers with the immaterial realities of the new workplace that has, it is claimed, expanded workers' autonomy, weakening the disciplinary regime of surplus value-extraction. But is this actually autonomy? Is it generalizable? And does it represent an actual weakening of the disciplinary regime of extraction?

MARXISM, THE CRITIQUE OF THE VALUE-FORM AND ANTI-TECHNISM

There is a significant, if broken, political tradition of critique of the value-form in Marxism. This centres on the question of technology and the labour process, in contrast to orthodox Marxism (Engels, Lenin, Stalin, [some] Trotsky, Kautsky and Mao) where technology is treated in a largely unexamined and neutral fashion and conflated with the labour process.[2] For orthodox Marxism, although technology is manifested in different modes of production, far from assimilating the effects of the social structures, in the end it ultimately transcends them. This is pure technism, and, not surprisingly, in the work of a number of these writers it is given a humanist gloss: technological development is fundamentally a human practice. In Kautsky for example, 'the extension of our knowledge of nature enables us to advance technologically and to improve our human activity in terms of the production of life.'[3] Orthodox Marxist defences of this technism may have largely disappeared, but this technological evolutionism has been the great social democratic mantra (on the left as much as the right) for over a hundred years; and it still, in many ways, represents the very heart of political common sense. Indeed, Bolshevism itself did not

escape this 'common sense', even if humanist technism was suppressed in the name of revolutionary technism. From 1917–21 Lenin saw Marxism, broadly, as an ideology of proletarian training. The factory was run as a place of collective discipline and organization. This is Lenin's factory-schooling; hence the leadership's enthusiasm for Taylorism. '*Unquestioning submission* to a single will is absolutely necessary for the success of labour processes that are based on large scale industrial machinery.'[4] Trotsky's productivism was no less technicist. In *The Problems of Everyday Life*, he argues that the aim of revolutionaries should be not to dismantle Fordism, but to separate Fordism from Ford and to socialize it.[5] Mao also argued that the productive forces were transcendent of the social relations of production, and, like Kautsky and others, talked in evolutionist terms of the 'backward' or 'advanced' nature of the productive forces.[6]

Opposition to this tradition has been fitful and fragmentary. In the early Soviet Union it lay mainly with the Productivist and Constructivist theorists and artists (Arvatov, El Lissitzky, Rodchenko) who, as I have outlined, all tried in their various ways to keep alive the debate on the labour process and the emancipation of labour. They all attempted to link the possibility of creative autonomy (and aesthetic discourse) to general social technique and the relations of production. For a short while, as a result, there was a rich and highly motivated culture of engagement with art, technology and the labour process. In the area of politics and political philosophy, however, anti-technism is far rarer in this period. Rosa Luxemburg attacked Lenin's celebration of factory-schooling, and rejected the notion of a technocratic continuum linking capitalism to socialism.[7] In *Marxism and Philosophy* (1927) Karl Korsch adopted a similar line by emphasizing that Marxism represents a critique of *all* forms of bourgeois practice and consciousness.[8] Similarly Gramsci believed that the anti-technism of classical German idealism was closer to the critical position of Marx, than the then orthodox materialism of the social democratic evolutionists.[9] But at no point do these disparate critiques of orthodoxy add up to anything like a critique of technology. This is because there is little understanding in this period, even amongst those Marxists who were most familiar with *Capital* as a critique *of* political economy and not a radical treatise on economics, of Marx's analysis of capitalist production as a theory of value-in-process. It is only in those writers who emerged from a cultural and Hegelian background, such as Lukács and Benjamin, that a substantive critique of technism begins to emerge, although Lukács does

not fulfil the promise of his early anti-technist work as his writing moves closer to Stalinist orthodoxy. Indeed, it is Benjamin and Benjamin alone who provides the most coherent anti-technist position of the period. As a philosophic critic of Second International evolutionary orthodoxy, a sympathetic reader of German Idealism, and first-hand interlocutor of the Russian avant-garde, he was well placed to confront the dominant instrumental interpretations of technology. And he does this in an unprecedented way: by splitting Marx's critique of the value-form *off* from post-Marx Marxism as a tradition of Communist Party politics and historiography. In a speculative leap beyond the positivism and function-alism of the Party, the critique of the value-form becomes communism-*as*-practice, and not – as for its detractors – an abstruse technical theory that stands in the way of building socialism here-and-now. For Benjamin, technology is not an ensemble of tools and machines which humans employ and manipulate, Kautsky-like, towards given ends on the basis of improving and expanding the productive forces, but the means by which, on the basis of collective proletarian intervention, the relations of produc-tion can be prised open to non-instrumental use-values and as such opened up to the forces of creative autonomy. In other words, the critique of the techniques employed by capitalist enterprises cannot be separated from the social forms in which they are embedded. In this Benjamin's writing takes the form, unusual for readers of Marx in this period, of seeing technology as the means by which the intellectual attributes, skills and senses of humans are extended and expanded. And he does this by refusing, as in Marxist orthodoxy, to split the realm of art, aesthetics and the senses from technology and new forms of production. Production and art – as in the Left Productivist tradition – stand to reshape each other. But in a world where technism continues to rule – even in the early Soviet Union – this reconfiguration is limited and suppressed. The disciplinary rule of value at the point of production makes it impossible to redirect *technik*. Yet Benjamin realizes, on the basis of his experience of the Soviet avant-garde, that this reconfiguration has some room for development in the realm of art, where, as we have seen, the value-form does not operate freely. Thus, Benjamin's commitment to bringing art and new forms of production together lies in the speculative adaptation of technologies. The use of new technologies in production and the entertainment industry are grounded in their alienated conditions of development and reproduction; in avant-garde art, however, these same technologies are able to establish

new modes of interaction and self-identity. This is the meaning of the author as producer: art is not a model of Cartesian reflection *on* the world, but is itself a mode of production in which the reproduction of the real enters real living relations.[10] By establishing new identities and new relations between humans in the realm of aesthetic-thinking the non-heteronomous transformation of the relations of production are able to be played out prefiguratively in cultural form. As such, with this notion of art as a realm of production – of the production of affect, and new subjectivities – technology opens up the self to new experiences and perception. As Esther Leslie argues, 'cultural production and cultural reception [become] forms of training. The rehearsal in culture of new modes of social relations becomes the precondition for the general over-powering of conformism in its cultural and political guises.'[11] In this way, as a training-ground, culture is the space of experimentation between technology and humans. In the second version of the 'Artwork' essay Benjamin refers to this as a form of *second technik* that possesses an affinity with play, in contrast to *first technik* – the realm of technism – which is connected to semblance, identity and unilinearity.[12] In a reversal of Romanticism, playfulness is associated with non-determinate human/machine interaction.

Benjamin's work on *technik* shattered the technicist misunderstanding of Marxist orthodoxy, thereby releasing Marx from the burden of his economist and historicist advocates. But of course, if Marx's conception of value-in-process here is released from the bunkers of grim orthodoxy, the possibility of a new phenomenology of *Capital*, and the labour theory of culture were still-born. Benjamin's writing largely went the same way as the avant-garde: it was lost from view until recirculated in the late 1960s and 1970s.

However, one area of theoretical practice which does emerge during this period, which has significant overlaps with Benjamin's understanding of *technik*, is Italian autonomism. As in Benjamin, Marx is recovered as a theorist of value-in-process. In Raniero Panzieri, for example, anti-techn-ism is presented not as a struggle between the rational content of technology and the misuses of technology under capitalism, but as a struggle over the subordination of production to the social forces of the working class. Working-class power proposes a political rupture in the uses of technology given that machinery is the basis of the dominance of one class over another: the 'working-class overthrow of the system is a negation

of the entire organization in which capitalist development is expressed – and first and foremost of technology as it is linked to productivity.'[13] The overcoming of the technical division of labour, then, signifies the achievement of the dominance of social forces over the realm of production, and therefore represents a refusal to accept the notion of technological neutrality.[14] Autonomist Marxism, though, pays little attention to the aesthetic content of the social regulation of the labour process, reproducing the split between aesthetic-thinking and general social technique that Benjamin was so conscious of avoiding. Italian autonomism may have a theory of machines, but it also has an attenuated sense of what machines and hands might do after the machines have stopped.

Yet if autonomism was important in recovering Marx's theory of value-in-process in the late 1960s, it was the anti-technism of the Frankfurt School and post-Marxist communists that dominated thinking on technology during the Cold War: both identify anti-technism with a critique of technological rationality. The result is that the critique of technism is split from the speculative realm of *second technik* on the basis that under advanced capitalism, the anti-technism of *second technik* is utterly assimilated into the cultural industry. Experiments in the realm of art's relations of production have either become a boon to the spectacle or to the art market, just as the prospect of the social regulation of the labour process is politically foreclosed. For Adorno, in particular, what is at stake in this period of the political crisis of the critique of the value-form, therefore, is not so much the preemptive labour of interaction between technology and humans but the preemptive labour of the discrete, autonomous artwork itself.[15] This is because the autonomous work of art, in its transformation of artistic subjectivity *all the way down*, provides a model of emancipated labour *all the way down*. As a result, the redemptive significance of the artwork rises in Adorno in proportion to the demise of its social function. Yet, Adorno's understanding of autonomy here is not a conservative defence of the artisanal, but, more concretely, a defence of the kind of labour secured and demanded by the autonomous artwork. By identifying the non-instrumental use-values of artistic labour (attention to artistic process, non-linear structure, and the aleatory) with autonomy, the mimetic demands of artistic labour and interpretation are foregrounded. If anti-technism is to be truly transformative it must be grounded in forms of attention and interaction which visibly, and coherently, break with instrumental forms of attention and interaction. Anti-technism gets shifted in

Adorno, then, on to those forms of labour that are deemed to truly count in the resistance and negation of the dominant heteronomous functions of technology: the free and heterogeneous practices and modes of attention of artistic practice. In this sense, there is a general move 'inwards' in the debate on technological relations during this period towards a culturalist engagement with technology and the commodity form, and away from the political critique of the relations of production. This is reflected at the political level in the revisionism of a number of post-Marx anti-technists, such as Carlos Castoriadis.[16] Castoriadis places Marx himself in the technist tradition, confusing – as post-structuralism was later to do – Marx's defence of the Enlightenment with scientism. The assault on capitalism, he argues, must be an onslaught on technology and scientific rationality itself. The outcome of this position is that there is little sense in speaking about the contradiction between productive forces and relations of production. Class struggle, the development of the productive forces, and value-in-process are treated as separate processes, as they are in the Frankfurt School.

Recent post-autonomist work on technism and the value-form draws from both the autonomists and the Frankfurt School. This would seem to represent a blatant contradiction. However, what unites these very different traditions is something that neither the Frankfurt School nor autonomist theory experienced in any consistent form in the 1960s: a growing sense of the internal limits of living labour in the face of the perceived demise of full-time waged labour under the 'new economy'. In this way the political critique of the value-form, and the aesthetic critique of the value-form in Adorno, opposed as they are, find a kind of exchange in an emphasis on the connection between the 'demise' of waged labour and the emergence (or possibility) of self-directed activity.

In the 1980s this exchange was at its most explicit in André Gorz's writing. For Gorz the crisis of valorization in contemporary capitalism and the rise in automated labour and decrease in full-time waged labour produces an irreversible decline not just in labour skills, but in labour as a source of social identity for workers. Workers continue to labour, but their labour is increasingly irrelevant to their individual and collective identity: hence the weakening of collective class identities since the 1970s. As such he stresses that the link between capitalism's diminishing capacity to reinvest profits in production and the contraction of living labour leads to a system of production in which work is no longer the affective centre of

workers' lives. Indeed, in an absolutization of Braverman's deskilling thesis, he argues that the socialization of labour now, for the majority of workers, involves no direct contact between themselves and physical matter. The elimination of workers' individual craft knowledge across all sectors is now almost complete. Marx of course foresaw the nature of work becoming largely irrelevant to the worker under the socialization and equalization of labour. But for Gorz, Marx was unable to see how this would develop into a general disaffection from work in a world of part-time waged labour. On this basis Gorz argues that under a system in which full-time waged labour is in decline absolutely, there is greater scope for autonomous activity amongst workers, and consequently a greater awareness on their part of the social form of labour. With the rise in unemployment and routinized part-time work there emerges the struggle for work-sharing and the abolition of waged work itself. In fact these disparate struggles converge to form a new revolutionary social subject in the place of the traditional (faded) working-class subject: the disaffected 'non-worker'. Because the disaffected non-worker has no material stake in the system, he or she is better placed to establish the critical lead of autonomous activity and production ('creating, giving, learning, establishing with others non-market, non-hierachic' relations).[17] Non-waged labour and self-determined activity are linked under aesthetic transformation or *poesis*. And this, Gorz suggests, can attract mass support. 'Reduction in the time and importance we give to alienated work is within our reach.'[18]

The weakening of workers' identification with labour constitutes a real problem for political praxis; just as Braverman outlined, capitalism produces a structural delinking of labour and sensuous skill. Similarly the identification between non-waged labour and self-determined activity opens out the debate on value again to the aesthetic content of working autonomy. Gorz's work fits within a tradition of aesthetic critique of the socialization of labour. However, the exit from the sphere of wage labour cannot be a solution to the process of labour's decomposition, for, irrespective of the qualititative content of abstract labour under deskilling, the sphere of waged labour is where the majority of workers find themselves, and where use-values continue to be produced. Indeed, Gorz's speculations about the contraction of waged labour are deeply flawed, skewing his whole model. In the early 1980s Gorz predicted that unemployment would reach levels of 30–50 per cent in 2000 in the advanced economies; yet despite digitalization, robotization and the contraction of full-time employment, waged labour on a

global scale has grown enormously since the 1970s. This is due to the fact that mechanization does not lead to an automatic decrease in labour-power. In reality the opposite applies: living labour is freed to expand into other non-automated sectors, because the value-creating part of capital (labour-power) has to be reproduced and secured. Gorz's predictions, therefore, are based on a fallacious reading of deskilling: deskilling does not prepare workers for an exit from waged labour, but, on the contrary, actually expands waged labour. As Daniel Bensaïd puts it, Gorz 'draws the falsely innovative conclusion that contestation of capitalist exploitation has now been relocated outside of the enterprise'.[19] But is this falsely *innovative*? Gorz's position is largely a Bakuninist response to the rise of automation, immaterial labour and the crisis of valorization. Like Gorz, Bakunin believed that the revolutionary subject that would overthrow capitalism would come from the margins, such as peasants and the lumpen proletariat, those not trapped in waged labour; and, therefore, that emancipation would come through the emancipation *from* work and not through waged work. But if Bensaïd misses the historical connection he is nevertheless, correct: there is nothing to assume that the generation of workers' autonomy can be secured any more easily outside of labour as inside labour; indeed, outside of labour all the old problems of the inflation of aesthetic ideology apply. Under the guise of 'embracing the cause of the worst-off, this ideology of non-work, centred on the primacy of individual sovereignty, is actually the new guise of a utopia of the distraught middle classes . . . for whom "real life" begins outside work'.[20] This is why Adorno's defence of art's autonomy through self-directed artistic labour never became a model of social praxis, for fear of obliterating its specific class-location. The autonomy of the artwork is a model *of* emancipated labour, not the model through which the emancipation of labour will be accomplished.

The emancipation of labour through labour is, precisely, the passage through the value-form and not around it, for it is the transformation of the social form of labour that will produce the generalizable conditions of labour's emancipation. Outside of the enterprise, non-hierachic, non-waged labour can only produce communitarian use-values; it cannot produce autonomous ones. That is, if the working class stands in opposition to its own intellect, which has been stripped from the labour process, it needs to recognize itself again in the labour process in order to recover its collective intellect. It can only do this by repossessing its subjectivity in labour.

NEGRI'S AUTONOMISM

The repossession of subjectivity in labour is the key area which distinguishes autonomist and post-autonomist writing from both the Frankfurt school and from the Bakuninite–Gorz tradition. Since the 1960s autonomist writing has stressed the constitutive creativity of workers *in* the labour process (their powers of resistance, their collectivity) as distinct from their general subjugation to the technical division of labour. Waged and unwaged workers are not merely passive victims of technological change, but active agents who are in a position to contest the control of capital at the point of production. One strategy is refusal (understood as sabotage or slowing down); another is reappropriation in which labour's 'invention power' is used to reclaim or détourn machinery and work practices for subversive ends.[21] But with the generalized defeat of labour in the 1980s and 1990s and the rise of anti-union laws globally, this model of immanent resistance was put on the defensive; indeed, it is the very crisis of this notion of immanent resistance that precipitated the revival of Bakuninite-type thinking in Gorz and others: with the generalized disaffection from work immanent resistance seemed superfluous. But Gorz's writing on value largely precedes the massive extension in the 1990s of immaterial labour, in which the extension and recomposition of waged labour has been shaped, in certain sectors, by a growth in intellectual labour. This extension has not dealienated nor deroutinized labour, but, as we have already discussed, certain 'cultural values' have, nevertheless, entered the production process transforming the deskilled 'skill-base' of labour. This has provided a revival of autonomist thinking in which the long-term picture of workers' immanent resistance is foregrounded over and above any chronology of workers' defeats, as in the writing of Antonio Negri. Negri, of course, is well known for his debt to autonomist thinking;[22] in the 1990s, however, autonomist theory's model of immanent resistance is transformed in his writing into a post-autonomist system. In this respect, in *Empire* (2001), co-written with Michael Hardt, he situates a model of autonomist resistance within the techno-cultural dynamics of the new global economy. As a result he and Hardt broaden and synthesize the other major theoretical component of Italian autonomist Marxism: that creative resistance is generalizable across *all* sectors of labour, and not just within the factory, given that all wage labourers are subject to the same alienated rule of the commodity. In this way Negri's and Hardt's model of resistance

uses the metaphor of the network in order to propose that the disciplinary nature of the commodity is of a different order today than in Marx's day. The directly coercive effects of Marx's competitive capitalism and the monopoly capitalism of the Frankfurt School have dissolved into a society in which the heteronomous 'free choices' of the market are internalized as freedom and personal growth. But for Negri and Hardt, with the diffusion of power into all elements of life, the obverse is produced: a diffuse plurality of subjectivities and points of resistance. Indeed, as the commodity form envelops and penetrates all areas of social life, these points of resistance proliferate. 'Resistances are no longer marginal [that is pursued by advanced workers in the factory and office], but active in the center of society that opens up in networks.'[23] The task of the left, then, is to contribute to the production of other subjectivities that will contest the regime of homogenization across all sectors. But this task is not identifiable with postmodernism. By defending resistance as multiple and nodal they are not, they claim, interested in defending difference as the sole preserve of truth. On the contrary, under the new forms of enculturalization heterogeneity and difference are perfectly compatible, indeed, absolutely coeval with, the cultural logic of capital. Rather, a pluralizing and nodal model of resistance must contest capital on its own universalizing grounds. The local is constructed not in opposition to the universal, but speaks *through* the universal. That is, each struggle, although rooted in contingent circumstances can, as a result of 'network-culture', leap immediately to the global level and to abstract universality. This destroys, according to Negri and Hardt, the traditional 'horizontality' of struggles at the point of production, whose effects are usually distributed outwards through a chain of localized, subsidiary activity. In 'network-culture' struggles do not just connect horizontally, but vertically, insofar as the exchange of information is propelled instantly into the centre of 'Empire'. On this basis the immanent condition of resistance is given a primary identity for fear of reinstating a hierarchy of conflicts: there are no struggles outside of the plane of immanence, because there is no utopian leap to the other outside of immanent struggle.

This is where Negri and Hardt depart from Marx's and Braverman's insistence on deskilling and the separation of workers' intellect from labour, and ally themselves with Castoriadis and the break with value-theory. Under the new economy techno-scientific processes have, they argue, produced a qualitative transformation in the character of workers'

immanent struggles. While the mass worker of Fordism and post-Fordism was only able to sabotage (and sometimes stop) the assembly line, today socialized labour in the digital-based enterprise is able to appropriate the new technologies for subversive and constructive ends both inside and outside the workplace. As a result general intellect (collective social intelligence) is realized through workers' extended access to the possible counter-usage of technologies. In previous periods workers' tools were related to specific manual tasks embedded in various craft-traditions, limiting the exchange of skills, today computers represent a universal tool in the hands of workers, through which many diverse operations and procedures pass. In this sense the increasing immateriality of labour releases those aspects of productive labour delimited or degraded by Fordism: human contact (affect) and creative interaction. This is because, Negri and Hardt assert, the co-operative aspects of immaterial labour are not imposed externally through the discipline of the workshop, but are internal to the labour process itself: production takes the form of 'cooperative interactivity through linguistic, communicational and affective networks'.[24] The outcome of this is that the production of value is increasingly hard to measure as productive labour converges with affective labour. Echoing Manuel Castells and many others, Hardt and Negri talk about informational production and deterritorialized production.[25]

One of the central problems of autonomist thinking, exacerbated steeply in Negri and Hardt, is the positivization of the negative power of labour. The emphasis on resistance internal to the labour process and the creativity of labour allows the labour process to float free of capital. By insisting on worker autonomy the existence and reproduction of labour *within* the capitalist enterprise is weakened. Hence, the very concept of a newly minted workers' creativity downgrades the structural and long-term realities of deskilling both external and internal to immaterial labour. Thus by insisting on the immanent creativity of labour *Empire* suffers from an undialectical binarism, in which labour is opposed to the categories of capital, and capital to the categories of labour. 'The power of each side does not appear to penetrate each other', as John Holloway puts it.[26] This leads to the underestimation of the way that labour exists – and is contained within – capitalist forms. This is why the concept of immaterial labour so easily dominates their account. There is no recognition that immaterial labour represents only an emergent fraction of labour on a global scale; and, therefore, the idea that we now live in a world in which value is (or is

becoming) immeasurable is a fantasy.[27] Moreover, as a potential site of worker autonomy, immaterial labour suffers from the same old constraints as material labour. Skills may be transferable through the universal tool of the computer, but at the point of labour they are subject to a similar discipline: the technical division of labour.[28] The information revolution has been integral to a corporate offensive against the working class; informational skills have been quickly routinized and exposed to the same movement from complex labour to simple labour as in manual labour. In this Negri and Hardt actually obliterate the real distinction between different kinds of labour by letting slip the specific place of immaterial labour in the relations between productive labour and unproductive labour. There is no breakdown of the labour process in *Empire* in relation to occupation and skill. Negri and Hardt's account of labour is particularly weak, therefore, where they claim the new economy has somehow escaped the discipline of the value-form. As a result we need to examine in more detail what we mean by convergence in relation to both artistic labour and productive labour.

When Marx talked about the equalization of labour-values within and across various sectors in manufacturing he was referring to the tendency for machinery to strip out the heterogeneities of individual craft labour; the specific skills of the labourer were taken up into and reproduced by technology. Consequently equalization – simplification and interchange-ability – occurs once labour is subject to the law of value, and as such is structurally constitutive of the labour process. This is why deskilling is not the oppressive outcome of mismanagement but the immanent logic of the value-form. The rise of the computer, therefore, as a universal tool of production and the labour process, continues this logic, producing an intensification of this process of equalization: deskilled skills are now interchangeable across vastly different kinds of production processes. Furthermore, unlike the machines of competitive and monopoly capital-ism, the computer not only produces a convergence between different forms of productive labour and between productive labour and non-productive labour, but between artistic labour and non-productive labour. And this, precisely, is what Negri and Hardt and theorists of the new cultural economy mean about computerization producing a qualitative transformation of the labour process: the heterogeneities of concrete labour are subject to even further reduction and equalization. Convergence is what happens, then, when general social technique is diffused through-

out the system, establishing a technical link between determinate (instrumental) labour and non-determinate (creative) labour. But, Negri and Hardt and the new cultural economy theorists are wrong to suggest that, on this basis, we are entering a period of creative 'mass intellect'. This is because connections and similarities do not amount to a qualitative transformation. You cannot simultaneously have a theory of deskilling (equalization) and the *creative* interchangeability of labour. This suggests that productive and non-productive labour are now embedded in a dialectic of skilling and deskilling similar to that of the neo-avant-garde; the discipline of the technical division of labour on the shop-floor and in the office simply disappears. Under the rule of the technical division of labour the convergence of skills, therefore, can only be formal rather than substantive. General social technique remains subordinate to general intellect's separation from the labour process; the introduction of 'cultural values' into the immaterial labour of the majority does not change this. Significantly, then, despite the distance Negri and Hardt have supposedly travelled from vulgar Marxism, this position is strikingly close to that of Sohn-Rethel's notion of the 'scientification' (*Verwissenschaftlichung*) of production: the forces of production are essentially neutral and, as such, available for worker self-management. But instead of the restructuring of the management of machines in the workshop supplying this potential for self-management, it is now the immaterial forces of production that offer this potential. However, Negri and Hardt take a step further, that Sohn-Rehel and others would never have dreamed of: immaterial production has an anti-capitalist character itself, thereby divorcing the new economy's network of 'affective relations' from the real subsumption of labour.

Yet, if Negri and Hardt are overly optimistic in linking immaterial labour with the expansion of general intellect, they are right to think of the convergence between productive labour and non-determinate labour as a site of the repoliticization of political economy and culture. With the advance of technology and science into production, the socialization of value-creating labour takes forms very different from those under Fordism. And this essentially is what links Gorz and Negri and Hardt despite their antipathetic approaches to the rise of immaterial labour. Both writers generate useful (contradictory) materials for understanding how the new socialized forms of labour *re-pose* the problem of *second technik* under new conditions. This is because despite the tendency to inflate the rise of immaterial labour in Negri and the failure to address the social significance

of immaterial labour in Gorz, both authors have produced a model of emancipated labour in which the problems of labour and *technik*, anti-technism and 'aesthetic critique', are brought back into political and cultural alignment. By insisting on the crisis of waged labour within the new forms of immateriality and technical diffusion, aesthetic critique and the critique of the value-form are reconnected. Indeed, as techno-scientific processes have come to increasingly dominate, the processes of capital accumulation struggles over techno-scientific use-values have become a common and pressing point of unity between activists, scientists and artists, necessitating new kinds of artistic/non-artistic alliance. This is reflected in the expansion of collaborative ventures beyond the familiar terms of recombinancy and the convergence between immaterial artistic artistic and non-productive labour, what we might call a 'new constructivism'.

THE NEW CONSTRUCTIVISM AND THE POST-VISUAL

These new practices find their expression into two directions, which loosely follow the historical split between non-professional cultural practice and the neo-avant-garde. First, with the extensive overcoming of restrictions in technical and cultural expertise amongst activists and amateurs using new technologies, there has been a huge expansion in the technological literacy of non-artistic producers. Lomography – or the Lomo-International – the global Mass-Observation-type photography movement is a good example of this, as is the rise of Indymedia and other independent image-gathering agencies.[29] Techniques and strategies once associated with the neo-avant-garde have passed into the oppositional media of the new social movements and popular consciousness. And second, with the increasing emergence of artists working with scientists (eco-scientists, computer scientists/programmers, engineers), technicians and activists, the neo-avant-garde dialectic of skill–deskilling–reskilling is employed to transform art into *artistically invisible* social practices. Here the direct production and recovery of use-values becomes the task of the art, replaying the Constructivist and Productivist legacy as an activist 'united front' of artists, non-artists, scientists and technicians, as in the work of Peter Fend, and groups such as Superflex and AAA.Corps. Superflex, for instance, favours working on projects that are directly and practically beneficial to a group, community or client. In a defence of this new

constructivism, Stephen Wright has written: 'What is more unusual, and far more interesting, is when artists don't do art; or at any rate, when they don't claim that whatever it is they are doing is, in fact, art.'[30] Indeed by not pursuing post-conceptualism-as-art, this work, he contests, actually 'live[s] up to art's promises'. That is, it refuses the melancholic disposition of those institution-focused practices which, irrespective of their critique of the institution, end up legitimating the institution. Wright bases his defence of the new constructivism on Duchamp's theory of the reciprocal readymade: the inversion of the art object into a functional object (Duchamp had famously quipped about wanting to transform a Rembrandt into an ironing board).[31] Following this logic Wright argues for the symbolic and critical potential of recycling artistic skills and competences into the general symbolic economy of everyday life, as opposed to recycling the real into art and then art into the real. The circuit of artistic authorship refuses to return to the institution or its representatives, deliberately foreclosing the conventional forms of artistic mediation. As Wright puts it, echoing the Critical Art Ensemble, this type of work produces a 'low coefficient of artistic visibility'.

Another practice of low artistic visibility is that advocated by the artist-curator Gavin Wade, which he refers to as a QRU or Quick Response Unit. In a similar fashion to Superflex, Wade talks about linking art to the location and solution of specific material and social problems. 'Let's find a way to combine activities that lead towards solving identifiable proble-matics, whether they be personal relationships, public crimes, architectural crimes, ecological disasters, war, increasing efficiency of businesses, com-munities, education, incarceration, living and working environments, entire cities and other social structures.'[32] In this the art is opened up to the contingencies of social interventionism and the demands of the collabora-tive plan and consultancy. Or more accurately, social interventionism *becomes* the collaborative plan and consultative process. The '*Newspaper of the Engaged Creative Platform/Newspaper of the New Creative Platform*' based in Berlin and St Petersburg, has also adopted a similar 'new constructivist' programme.[33] Only in this instance, the artistic 'invisibility' is framed by an explicit revolutionary politics, derived principally from the post-Soviet Russian context. Publishing polemics and essays from artists and artist-theorists and critics, the Newspaper calls for a new politicized and interventionist culture which bridges art and the critique of political economy. 'As in the era of workers' autonomy, today's intellectual and

artistic vanguard must reclaim the factories of the cultural industry' (Dimitry Vilensky).[34] 'When the energy and force of the many enters into a union with the intellectual sharpness and conviction of the firmest, coming together in the form of democratically organized mass working-class organizations with precise political programs – we shall finally prevail' (Vladislav Sofromov-Antomoni).[35] This explicit politicization of *second technik* admittedly remains fairly marginal within the 'new constructivism', but nevertheless it points to one of the unifying aspects in these works' reappropriation of technical use-values: the projection of the skill–des-killing dialectic within the neo-avant-garde into the framework of the *post-visual*. The post-visual, or better still *anti-visualization*, is essentially what happens at the formal level to art when artistic technique and immaterial labour converge as intellectual labour. Art is diffused into an ensemble of non-artistic intellectual skills and competences. However, this is not to say that such artists are no longer interested in working with images, representations, or symbols. But, in contrast to the counter-symbolic model of post-conceptual network theory, the détourned image and text is not at the centre of artistic praxis in this model. On the contrary, artistic skill is radically decoupled from the residual pictorialism of the post-war neo-avant-garde in favour of collaborative research-based projects which are not in any primary sense – as in Wright's formulation – defendable or explainable as *art*. This means that artistic technique and general social technique mutually dissolve into non-artistic practices.

In these terms the anti-visualization model represents an extreme post-autonomization of authorship in a period of general post-autonomization in art. In asserting the non-artistic character of the artistic plan or practice the question of artistic form as a focalized problem for artistic judgement and interpretation is removed. This break up of the focal integrity of the artwork, of course, has been at the centre of practice since Conceptual art. After Conceptual art, art has found numerous ways to eradicate its traditional material forms. But here defocalization is different, it is emphatic: there is no evidence of art *work* – practices that are designated as artistic – only the temporary or permanent residues of various artistically derived shared competences and skills which have become indistinguishable from non-artistic competences and skills. Superflex, for instance, in one project built a water pump, as an NGO might, in an African village. As Wright acknowledges, in its artistic invisibility, this work is uninterested in producing and sustaining an art spectator.

POST-AUTONOMY?

But can art be truly invisible here? In fact, do post-autonomous artists truly want their art to be invisible as art? And, is invisibility a worthwhile or progressive attribute, even if artists believe it be so? The drive to post-autonomy, as we have seen in our discussion of the early readymade, was subverted or made bathetic by avant-garde artists' unwillingness to give up the transformative functions of the hand as a critique of productive labour. An art of triumphant automatization or functionality was believed to render itself too formally pliant and ideologically submissive in the face of general social technique. This is why Duchamp, El Lissitzky and Moholy-Nagy all developed critical theories or responses to the supersession of *la patte*. As such they saw the presence of the hand in broader terms: as the site of 'aesthetic thinking' that presented a kind of sovereign disruption of heteronomous labour. Hence, it is crucial for Duchamp, El Lissitzky and Moholy-Nagy that the artwork retained its identity *as* art simultaneously as it produced a critique *of* art. The transference of art into general social technique and, thereby, into scientific, technological or political practice, merely submitted art to the heteronomous forces it appropriated. This is why the 'hand' became a pressing issue for avant-garde art in the mid–1920s as the new mass reproductive technologies were subject to extensive capitalist development. Submitting wholeheartedly to general social technique meant eventually submitting art to the technical division of labour. Retaining the sovereignty of the (totipotentiality of the) hand, in contrast, was a way of retaining the sovereignty of aesthetic thinking as a form of labour qualitatively different to that of heteronomous labour. Consequently, it meant producing a spectator who might then be in a position to recognize the difference between artistic (autonomous) labour and heteronomous labour. For it is on the basis of recognizing this difference that the negation of labour by those who labour might proceed.

To dissolve artistic labour completely into non-artistic labour is to render this distinction opaque, and therefore to give the appearance that the dissolution of artistic labour into non-artistic labour is somehow a plausible critical programme, despite the discipline of the value-form. Recycling the real into the symbolic economy of real might obviate the problem of art's institutional mediation as art, but it does not address the more fundamental problem about best practice. How are cultural and artistic practices to exemplify their own non-identity or autonomy in order

to render heteronomous practices problematic? If art is made invisible as art how is art able to sustain what differentiates itself from heteronomous labour: its freedom from the value-form? In this way, art's relative freedom from the value-form is a more persuasive way of defining art's autonomy, rather than the more familiar notion that autonomy is the name for art's purported transcendence from social determination. However, this does not mean that 'aesthetic thinking' in its sovereign powers is superior as a form of reason to other forms of reason. The defence of the part that 'aesthetic thinking' is able to play in the emancipation of labour is not because of the superiority of the 'creative imagination' or any other Romantic shibboleth. Rather, its success derives from the fact that aesthetic reason, because it is irreducible to deductive logic, forces non-aesthetic reason to reflect on its own conditions of possibility. Aesthetic reason does not solve the problems that non-aesthetic reason can solve, but, rather, confronts non-aesthetic practices with their aporias.[36] It subverts non-aesthetic reason, it does not replace it. Accordingly 'aesthetics' is not in itself an emancipatory discourse, because aesthetic reason as a critique of non-aesthetic reason is constituted through the non-aesthetic. This is why the 'aesthetic thinking' immanent to Marx's critique of the value-form is more persuasive than the occasional hypostasization of 'art' in Marx's writing. As Henri Lefebvre notes, at certain points Marx is reluctant to subject art to the law of becoming (world law). 'He often accepts that when the economic, the political and their alienations come to an end they will be superseded by art, or by the realm of ethics. We do not wish to exempt art and the moral sphere from world law.'[37] The contradiction between aesthetic reason and non-aesthetic reason, consequently, cannot be resolved under a system in which non-aesthetic reason is subordinate to the value-form. Aesthetic reason and non-aesthetic reason need to be reconfigured under non-heteronomous conditions of value. But if, in the final analysis this is a revolutionary question, it is always possible for art to bring aesthetic reason and non-aesthetic reason – as Benjamin's concept of *second technik* acknowledges – into some kind of temporary critical alliance. The avant-garde and the neo-avant-garde have always done this. There is no liberatory content in avant-garde practice without the actual or imaginary submission of art to non-aesthetic reason. But one of the consequences of this submission is that aesthetic reason's critique of non-aesthetic reason is easily dissipated and politically inoculated.

This invites the key question that has affected all ambitious art after the

readymade and after conventional forms of modernist autonomy: *how do artists produce use-values, that signify as art, without limiting what might be made in the name of art?* To criticize the assumptions of post-autonomous thinking, then, is not to foreclose on the 'circuits of authorship' in the name of some earlier version of the avant-garde, or celebrate some comforting notion of artisticness we are already familiar with. The anti-visual extension of art is a powerful and compelling way of producing models of practice that do not rely on the pictorial (or non-pictorial) art historical precedents, driving the skill–deskilling–reskilling dialectic into new areas. But, if the modes of attention and access to knowledge being produced here are indistinguishable from non-artistic modes of attention, then there is always the threat of the nihilism of nomination returning to render art as an undifferentiated form of non-aesthetic reason. There is always the threat of art becoming domesticated as social technique. Post-autonomy, therefore, presents a Janus-face to art under the value-form: it seeks a social form for art that bypasses the museum's deathly mediation of the circuits of authorship, but on the other hand, in trying to speed up art's social integration by passing it off as non-artistically mediated social practice, it reinforces the tyranny of commodified immediacy and instrumental ends. In a reversal of Adorno's notion of the autonomous artwork as absolute commodity, the artwork as commodity disappears absolutely into the flow of all other commodities. How might a workable concept of autonomy, then, reside in the post-autonomous flows and networks of immateriality?

INTERNAL COMPLEXITY/ATTENUATED COMPLEXITY

If 'fast thinking' is the result of the vast penetration of the commodity form and the development of telecommuncations since then 1960s, then the 'fast artwork' is its conceptual and network corollary. Indeed 'fast thinking' and the 'fast artwork' are brought into conjunction by the speed of the readymade. The succinctness of Duchamp's *blague* is achieved, precisely, at the expense of the fastidiousness of Cubist painting. However, if the fast artwork was a liberation from dull craft, it was also as I have explained, a nominative nightmare, in which the release of art from mimetic expressivism was confused with the Beauty of the Spontaneous Idea. The Beauty of the Spontaneous Idea (BSI) is what happens to art once it derives value from the absolute separation of general social technique from the hand. This is why in the wake of digitalization, telematics and network theory, the

BSI has become a constitutive problem for practice. In response to the diffusion of vast amounts of decontextualized signs and units of information, informational capitalist culture encourages a process of knowledge exchange and accumulation based on the free association of BSIs. There is little time within the sphere of general intellect to organize and sort information into coherent narratives and contexts, resulting in information-compression and the vertical 'stacking' and superimposition of concepts and images.[38] This is why recombinant aesthetics have become so acceptable and familiar within post-conceptualism: because the requirements of information integration are forbiddingly high – and appear to derive from a discredited model of creativity – the trials and errors of conjunction are preferred over long-term organic construction. But, without reflexive integration, recombinant practices become no different from the heteronomous flux of the capitalist sensorium they seek to 'intervene' in. Immateriality, then, is confronted by its own destructive process of deskilling: attention deficiency syndrome, or a privileging of conjunction over connectedness. To say that the conditions of production of contemporary art reflect and encourage this attention deficiency is not to say, however, that what art requires in order for structural and aesthetic coherence to be secured is a return to pre-modernist organicism or a modernist model of contemplation. But, rather, that reflection on the expanded circuits of authorship of contemporary art requires us to address the skill–deskilling–reskilling dialectic from inside the temporality of network-culture.

Beyond the museum, in a state of digital immediacy, or anti-visual convergence, the artwork exchanges discrete internality for the 'cognitive spread' of a diffuse externality. The apprehension of 'internal complexity' (immediate absorption) is sacrificed for 'attenuated complexity' (temporal involvement). The question which needs asking, therefore, is whether internal complexity is the magic ingredient of autonomy; does attenuated complexity irredeemably weaken art's autonomy? Is autonomy, in fact, only able to be constituted as a category through a focalized attentiveness to the internal relations of discrete forms? Aesthetic conservatives who love internal complexity would no doubt say yes; aesthetic radicals, who have historically tended to favour attenuated complexity, would say no. Thierry de Duve, for instance, defends a version of the former. *Kant After Duchamp* is essentially a critique of attenuated complexity in the name of good, sound, solid, internal complexity. But is the distinction between internal

complexity and attenuated complexity actually a coherent way of approaching the problem? Is it appropriate to think of 'good' aesthetic complexity lying in forms of internal complexity, and 'bad' anti-aesthetic complexity lying in forms of attenuated complexity? De Duve and others would like us to think so. But the problem with this opposition is that complexity, internal or otherwise, cannot be a normative criteria of value in art. Works that reject or fail the test of complexity on either count can be just as compelling as works of art that do pass the test (Duchamp's *Fountain* is an obvious example). Thus in wanting to distinguish between bad complexity and good complexity, there is no set of criteria that will stabilize value on the basis of this distinction. And this is why, once we demand good internal complexity from a work of art as a response to attenuated, stacked or cognitively thin complexity we get into all kinds of problems. Because after copying without copying, after the craft of reproducibility, after Conceptual art, after post-conceptualism, after anti-visualization, the insistence on internal complexity, in fact, betrays art to certain expectations about what art should be: namely that it should not be too diffuse, too temporal, too non-visual, too intellectual (or too anti-intellectual). In other words, internal complexity doesn't actually do what it claims it wants to do: bring the 'wayward' dialectic of skill and deskilling into line. Rather, it wants to define 'quality' on the basis of what it knows already, in order to dissolve what it takes to be the wanton, unworkable and destructive extremes of negation in art. How, then, might autonomy-as-a-commitment-to-complexity exist in the space of post-autonomous practice, particularly amongst anti-visual practices that converge art with social technique? Under what basis is the judgement of art as a 'diffuse ensemble of competences and skills' to take place?

This, I would argue, is only answerable on the basis of a re-radicalization of Adorno's understanding that autonomy is not a thing or set of formal conditions but a critical expression of the *relations between aesthetic reason and non-aesthetic reason*. Autonomy is not to be found *in* internal complexity, because to do so is to identify the production of good art solely with aesthetic reason. As we have seen, art is not simply the product of aesthetic reason; it is the product of the interrelations of aesthetic reason and non-aesthetic reason, and consequently the demands of internal complexity will also be embedded in art's relations to attenuated complexity. Therefore it is better to speak of the production of internal complexity and attenuated complexity as *co-extensive* moments in advanced art, and autonomy, as such,

as the moment when their interrelationship produces a reflective experience in the spectator which can be described – and described by others – as de-temporalizing: as 'aesthetic' rather than 'non-aesthetic'. We know our de-temporalizing experience of art as an autonomous activity can just as easily be embedded in our temporal involvement with a set of activities or processes as in modes of absorption in front of discrete works, so there is nothing to suggest that forms of attenuated complexity in art cannot continue to produce experiences we can identify as art. The diffusion of art into the plan, consultancy or research-programme, therefore, is not the final nihilistic version of the readymade as a nominative act. It is, rather, the attenuated space where new (internally complex) experiences of art might be constituted. In this way the immateriality of artistic skills are secured.

NOTES

1 Shorthouse and Strange, 'The new cultural economy, the artist and the social configuration of autonomy', p.48.

2 For a discussion of this orthodox tradition and its counter-tradition, see Monika Reinfelder, 'Introduction: Breaking the Spell of Technism', in Phil Slater, ed., *Outlines of a Critique of Technology*, Ink Links, London and Atlantic Highlands, New Jersey, 1980.

3 Karl Kautsky, *Die Materialistische Geschichtsauffassung* (1927), translated as *The Materialist Conception of History*, edited by John Kautsky, Yale University Press, New Haven and London, 1988.

4 V.I. Lenin, 'Immediate Tasks of the Soviet Government', *Collected Works*, Vol. 27, Progress Publishers, Moscow, 1972, pp.235–77.

5 Leon Trotsky, *The Problems of Everyday Life, and Other Writings on Culture and Science*, Path Finder Press, New York, 1973.

6 Mao Tse-Tung, *Four Essays on Philosophy*, Foreign Languages Press, Peking, 1968.

7 Rosa Luxemburg, *The Russian Revolution*, University of Michigan Press, Ann Arbor, 1961.

8 Karl Korsch, *Marxism and Philosophy*, trans. Fred Halliday, New Left Books, London, 1970.

9 Antonio Gramsci, *Selections from Prison Notebooks*, ed. and trans. Quintin Hoare and Geoffrey Nowell-Smith, Lawrence and Wishart, London, 1971.

10 Benjamin, 'The Author as Producer'.

11 Esther Leslie, *Walter Benjamin: Overpowering Conformism*, Pluto Press, London, 2000, p.xi.

12 Walter Benjamin, 'Das Kunstwerk im Zeitalter seiner technischen Reproduzierbarkeit,' ('Zweite Fassung'), *Gesammelter Schriften*, Vol. VII.I, Rolf Tiedemann and Herman Schweppenhäuser, eds, Suhrkamp, Frankfurt am Main, 1991, pp.350-84. Discussion of 'first *technik*/second *technik*' is omitted from the third version, translated as 'The Work of Art in the Age of Mechanical Reproduction,' in *Illuminations*, Fontana, London, 1973, pp.219–53. For an analysis of the second version see Esther Leslie, *Walter Benjamin: Overpowering Conformism*, pp.130–67.

13 Raniero Panzieri, 'The Capitalist Use of Machinery: Marx Versus the "Objectivists"', in Slater, ed., *Outlines of a Critique of Technology*, p.60.

14 One of the reasons there has been no machine-wrecking by workers in the twentieth century is precisely because of technology's perceived neutrality. The inner value-form of production is presented abstractly as universally valid in terms of the rationality and efficiency of technology. In this way machinery and technology appear to be the primary subject and agent of capitalist development.

15 Adorno, *Aesthetic Theory*.

16 Carlos Castoriadis, *Political and Social Writings, Vol. 2*, University of Minnesota Press, Minneapolis, 1988.

17 André Gorz, *Paths to Paradise: On The Liberation From Work*, Pluto Press, London, 1985, p.107. The theorization of the disaffection from work had been in place in French Marxism from the late 1950s. See also Henri Lefebvre, *Critique of Everyday Life, Vol. 2: Foundations for a Sociology of the Everyday* (1961), trans. John Moore, Verso, London and New York, 2002: 'for the worker, work and life outside work have sunk to the same lack of interest' (p.69) and Lefebvre, *Everyday Life in the Modern World* (1967), trans. Sacha Rabinovitch, Athlone Press, London, 2000: 'the "values" that were formerly attached to work, trade and quality in creative activity are disintegrating' (p.53).

18 Gorz, *Paths to Paradise*, p.102.

19 Daniel Bensaïd, *Marx For Our Times: Adventures and Misadventures of a Critique*, trans. Gregory Elliott, Verso, London and New York, 2002, p.187.

20 Ibid. p.192.

21 For an analysis of the place of these strategies in autonomist writing, see Nick Witherford, 'Circles and Circuits of Struggle in High-Technology Capitalism', in Davis, Hirschl and Stack, eds, *Cutting Edge: Technology, Information, Capitalism and Social Revolution*. For a defence of similar kinds of strategies in cultural theory see Michel de Certeau, *The Practices of Everyday Life*.

22 Antonio Negri, *The Politics of Subversion: A Manifesto for the Twenty-first Century*, trans. James Newell, Polity Press, Oxford, 1989.

23 Michael Hardt and Toni Negri, *Empire*, Harvard University Press, Cambridge, Mass. and London, 2001, p.25.

24 Ibid., p.294.

25 Manuel Castells, *The Information Age: Economy, Culture and Society*, Vol. 1, Blackwell, Oxford, 1996.

26 John Holloway, 'Going in the Wrong Direction; Or Mephistopheles – Not Saint Francis of Assisi', *Historical Materialism*, Vol. 10, Issue 1, 2002, p.88.

27 See Pete Green, 'The Passage from Imperialism to Empire: Commentary on *Empire* by Michael Hardt and Antonio Negri', *Historical Materialism*, Vol. 10, Issue 1, 2002.

28 For an insightful critique of Negri's failure to subject immaterial labour to the real subsumption of labour, see the Aufheben Collective, 'Keep on Smiling: Questions on Immaterial Labour' *Aufheben*, No. 14, 2006, pp.23–44.

29 For a discussion of Lomography, see John Roberts, 'The Logics of Deflation: the Avant-Garde, Lomography, and the Fate of the Photographic Snapshot', *Cabinet*, Issue No. 8, Fall 2002.

30 Stephen Wright, 'The Future of the Reciprocal Readymade (The Use-value of Art)', pamphlet accompanying exhibition of the same name, March 17–April 17 2004, Apex Art, New York, not paginated.

31 'Reciprocal Readymade = Use a Rembrandt as an ironing-board', Duchamp, *The Essential Writings of Marcel Duchamp*, p.32.

32 Gavin Wade, 'QRU', in Wade, ed., *Curating in the 21st Century*, p.26.

33 The newspaper has switched between these two titles; it is also now known as *Chto delat?*

34 Dimitry Vilensky, '9 Points for Initiating a Discussion on the Subject of History', *Newspaper of the New Engaged Creative Platform*, Issue (Emancipation From/Of Labour) No. 3, 2004.

35 Vladislav Sofromov-Antomoni, 'Love and Politics', *Newspaper of the New Engaged Creative Platform*, Issue No. 5, 2004.

36 See Christophe Menke, *The Sovereignty of Art: Aesthetic Negativity in Adorno and Derrida*, trans. Neil Solomon, MIT, Cambridge, Mass. and London, 1998.

37 Lefebvre, *Critique of Everyday Life, Volume 2*, p.185.

38 I borrow the concept of 'stacking' from Thomas Hylland Eriksen,*Tyranny of the Moment: Fast and Slow Time in the Information Age*, Pluto Press, London, 2001. In 1975 in the UK 35,000 books were published. In 2000, 107,000. The same pattern emerges on a global scale. In 1985 the total use of telecommunications in the world (telephone, fax, data transmission) amounted to 15 billion minutes. In 2000 it was 95 billion and rapidly rising, just as the number of websites have grown from 3 million in 1994 to over 72 million in 2000 and rising.

REPRODUCIBILITY AND THE HAND

Under general social technique the function of the hand in productive labour and art is routinized, or deskilled. However this deskilling is not the same across art and productive labour. In productive labour deskilling is structural and systematic; in art it is grounded in the expansion of artistic skill into intellectual and immaterial labour. This means that the erosion of traditional artisanal skills in art is not equivalent to the erosion of artistic skills *per se*. A displacement and reorientation takes place in which artistic skill becomes subject to two substantive and interrelated processes: the making of art is identifiable *with* its conceptualization; and the execution of this conceptualization – the transformation of intellectual process into material form – is no longer determined by the artist as sole author. The making of art is opened up to authorship-at-a-distance and surrogacy. Consequently, the artist may continue to speak in the 'first person', but this is not identifiable in any strict sense with first person expression (with the expressive motility of handcraft). But, if the hand is fundamentally displaced from the making of art, handcraft reenters the circuits of authorship through the continuing 'autonomy effect' of art: the attempt by artists to distinguish art from general social technique through the physical intervention in, and manipulation of, technical processes, on the basis that what separates artistic labour from productive labour is its access to the subjective transformation of materials *all the way down*. Art that opposes this or weakens its claims, loses its identity as art. This is why the surrogate model of authorship in modernism and the avant-garde – as in Moholy-Nagy's factory-ordered enamel paintings – has always been qualified by the presence of the artist's hand, for fear of giving art over

to the heteronomous content of general social technique, to the abstract and executive processes of other hands. The dialectic of skill and deskilling after the readymade, then, is a history of the *mutual displacement* of general social technique by the hand and the hand by general social technique, down to the anti-visual social practices of today. In this respect the residual link between the expressive hand – or the laying on of hands so to speak – and artistic autonomy defines the critical conditions under which art and general social technique mediate each other under the capitalist value-form. The technical contents of general social technique are subject to the technical division of labour: that is the prevailing conditions of techno-logical reproducibility are the result of capitalist competition between enterprises. This means that although art is not subject directly to the technical division of labour (to efficiency, speed-up times), the instru-mental and heteronomous functions of general social technique under the value-form are none the less brought to bear on art's relations with technology. The connection between artistic autonomy and the hand, therefore, is that cognitive and material space where art's relationship to the heteronomous functions of technology is negotiated and challenged. For without the return of the processes of authorship-at-a-distance and surrogacy to the artist or artists, art dissolves itself *into* general social technique and the heteronomous. But the challenge of artistic autonomy is not a challenge to general social technique as such. Without the penetration of general social technique into art, without art's objective deskilling, art is pulled back into the socially constrained realm of artisanal skill. Hence artistic skill and deskilling remain dialectically entwined on the basis of the mutual penetration of artistic autonomy (the hand) and general social technique – dialectically entwined that is, until, artistic subjectivity all the way down, or the totipotentiality of the artistic hand, is released into, and transformative of, productive labour. The dialectical interpenetration of the artistic hand and general social technique is the ground, therefore, for a deeper interpenetration: the emancipatory transformation of general social technique by productive labour, and as such, the dissolution of the division between intellectual labour and manual labour. Avant-garde art after Duchamp is not only the history of this dialectic, but also, stealthily, imperturbably, the continuing call of this emancipation.

BIBLIOGRAPHY

Adorno, Theodor W., *Aesthetic Theory*, trans. C. Lernhardt, Routledge and Kegan Paul, London, 1984.

————, *Aesthetic Theory*, trans. Robert Hullot-Kentor, Athlone Press, London, 1997.

Alpers, Svetlana, *Rembrandt's Enterprise: The Studio and the Market*, Thames and Hudson, London, 1988.

Antliff, Alan, *Anarchist Modernism: Art, Politics, and the First American Avant-Garde*, University of Chicago Press, Chicago and London, 2001.

Arvatov, Boris, *Kunst und Produktion*, Karl Hanser Verlag, Munich, 1972.

Art & Language (Terry Atkinson), 'From an Art & Language Point of View', *Art-Language*, Vol. 1, No. 2, February 1970.

Aufheben Collective, 'Keep on Smiling: Questions on Immaterial Labour', *Aufheben*, 14, 2006.

Babbage, Charles, *On the Economy of Machinery and Manufacture* (1832), Indypublish, New York, 2002.

Barthes, Roland, 'Theory of the Text' (1973), trans. Ian McLeod, in *Untying the Text: a Poststructuralist Reader*, Robert Young, ed., Routledge and Kegan Paul, London, 1981.

Baudrillard, Jean, *In the Shadow of the Silent Majorities . . . or The End of the Social*, trans. Paul Foss, Paul Patton and John Johnston, Semiotext(e), New York, 1983.

Benjamin, Walter, 'The Work of Art In the Age of Mechanical Reproduction', in *Illuminations*, Fontana, London, 1973.

————, 'The Author as Producer', in Victor Burgin, ed., *Thinking Photography*, Macmillan, London, 1981.

Bensaïd, Daniel, *Marx For Our Times: Adventures and Misadventures of a Critique*, trans. Gregory Elliott, Verso, London and New York, 2002.

Bergson, Henri, *Laughter: An Essay on the Meaning of the Comic* (1900), trans. Cloudesly Brereton and Fred Rothwell, Green Integer Books, Copenhagen and Los Angeles, 1999.

Bhaskar, Roy, *The Possibility of Naturalism: A Philosophical Critique of the Contemporary Human Sciences*, Harvester Press, Brighton, 1979.

Boltanski, Luc and Chiapello, Eve, *The New Spirit of Capitalism*, Verso, London and New York, 2005.

Bourdieu, Pierre and Haacke, Hans, *Free Exchange*, Polity Press, Oxford, 1995.

Bourdieu, Pierre, *Firing Back: Against the Tyranny of the Market 2*, trans. Loïc Wacquant, Verso, London and New York, 2003.

Bourriaud, Nicolas, *Esthétique relationelle*, Les presses du réel, Dijon, 2001.

——————, *Postproduction*, Lukas and Sternberg, New York, 2002.

Bowlt, John E., 'Manipulating Metaphors: El Lissitzky and the Crafted Hand', in Nancy Perloff and Brian Reed, eds, *Situating El Lissitzky: Vitebsk, Berlin, Moscow*, Getty Research Institute, Los Angeles, 2003.

Buchloh, Benjamin, H., 'One-Dimensional Art: 1956–1966', in Annette Michaelson, ed., *October Files 2: Andy Warhol*, MIT, Cambridge, Mass. and London, 2001.

Bürger, Peter, *The Theory of the Avant-Garde* (1974), University of Minnesota Press, Minneapolis, 1984.

Butler, Ruth, *Rodin: The Shape of Genius*, Yale University Press, New Haven and London, 1993.

Braverman, Harry, *Labor and Monopoly Capital: The Degradation of Work in the Twentieth Century*, Monthly Review Press, New York, 1998.

Caffentzis, C. George, 'Why Machines Cannot Create Value; or Marx's Theory of Machines', in Jim Davis, Thomas Hirsch, Michael Stack, eds, *Cutting Edge: Technology, Information Capitalism and Social Revolution*, Verso, London and New York, 1997.

Capra, Fritjof, *The Hidden Connections: A Science for Sustainable Living*, Flamingo, London, 2003.

Castells, Manuel, *The Information Age: Economy, Culture and Society*, Vol. 1, Blackwell, Oxford, 1996.

Castoriadis, Carlos, *Political and Social Writings*, Vol. 2, University of Minnesota Press, Minneapolis, 1988.

Cennini, Cennino d'Andrea Cennini, *The Craftsman's Handbook*, trans. Daniel V. Thompson, Jr, Dover, New York, 1954.

Chiapello, Eve, 'The "Artistic Critique" of Management and Capitalism: Evolution and Co-optation', in John Roberts and Stephen Wright, eds, *Third Text*: special issue on 'Collaboration', No. 71, Vol. 18, Issue No. 6, Nov–Dec, 2004.

Churchland, Paul M., *The Engine of Reason, the Seat of the Soul: A Philosophical Journey into the Brain*, MIT, Cambridge, Mass. and London, 1995.

Churchland, Paul M., and Churchland, Patricia S., 'Could a Machine Think?', in Paul M. Churchland and Patricia S. Churchland, *On the Contrary: Critical Essays, 1987–1997*, MIT, Cambridge, Mass. and London, 1998.

Connor, Steven, *Dumbstruck: A Cultural History of Ventriloquism*, Oxford University Press, Oxford, 2000.

Cohen, Shelia, 'A Labour Process to Nowhere?', *New Left Review*, No. 165, Sept/Oct, 1987.

Cohen, Tom, *Ideology and Inscription: 'Cultural Studies' After Benjamin, De Man, and Bakhtin*, Cambridge University Press, Cambridge, 1998.

Cole, Bruce, *The Renaissance Artist at Work: From Pisano to Titian*, John Murray, London, 1983.

Cook, Sarah, Beryl Graham and Sarah Martin eds, *Curating New Media*, Baltic, Newcastle-Upon-Tyne, 2002.

Corn, Wanda M., *The Great American Thing: Modern Art and National Identity, 1915–1935*, University of California Press, Berkeley, Los Angeles, London, 1999.

Crane, Hart, *The Bridge* (1930), commentaries by Waldo Frank and Thomas A. Volger, Liveright, New York and London, 1992.

Critical Art Ensemble, *The Electronic Disturbance*, Automedia, Brooklyn, 1994.

Danto, Arthur C., *The Transfiguration of the Commonplace: A Philosophy of Art*, Harvard University Press, Cambridge, Mass. and London, 1981.

Davies, Paul, *The Last Three Minutes: Conjectures About the Ultimate Fate of the Universe*, Basic Books, New York, 1994.

Davis, Jim, Thomas, Hirschl and Michael, Stack eds, *Cutting Edge: Technology, Information, Capitalism and Social Revolution*, Verso, London and New York, 1997.

Debord, Guy, *The Society of the Spectacle*, Black and Red, Detroit, 1977.

De Certeau, Michel, *The Practice of Everyday Life*, University of California Press, Berkeley, Los Angeles and London, 1984.

Decter, Joshua, 'Synergy Museum', in Peter Noever, ed., *The Discursive Museum*, MAK and Hatje Cantz Publishers, 2001.

de Duve, Thierry, *Kant After Duchamp*, MIT, Cambridge, Mass. and London, 1996.

Dennett, Daniel, *Kinds of Minds: Toward an Understanding of Consciousness*, Basic Books, New York, 1996.

————— *Brain Children: Essays on Designing Minds*, MIT, Cambridge, Mass. and London, 1998.

—————, *Freedom Evolves*, Allen Lane, London, 2003.

Descartes, René, *Discourse on Method and Meditations*, trans. Laurence J. Lafleur, Liberal Arts Press, Indianapolis and New York, 1960.

—————, *Philosophical Writings*, a selection trans. and ed., Elizabeth Anscombe and Peter Thomas Geach, Open University Press/Thomas Nelson Publishers, London, 1970.

Dickie, George, *Art and Value*, Blackwell, Oxford, 2001.

Dijkstra, Bram, *Cubism, Stieglitz, and the Early Poetry of William Carlos Williams: The Hieroglyphics of a New Speech*, Princeton University Press, Princeton, 1969.

Dreyfus, Hubert, *What Computers (Still) Can't Do*, MIT, Cambridge, Mass. and London, 1972.

Duchamp, Marcel, *The Essential Writings of Marcel Duchamp*, Michael Sanouillet and Elmer Peterson, eds, Thames and Hudson, London, 1975.

Du Gay, Paul, and Michael Pryke, eds, *Cultural Economy: Cultural Analysis and Commercial Life*, Sage, London, 2002.

Elson, Diane, 'The Value Theory of Labour', in Diane Elson, ed., *Value: The*

Representations of Labour in Capitalism, CSE Books, London and Humanities Press, Atlantic Highlands, New Jersey, 1979.

Engels, Frederick, *The Dialectics of Nature*, Lawrence and Wishart, London, 1940.

Eriksen, Thomas Hylland, *Tyranny of the Moment: Fast and Slow Time in the Information Age*, Pluto Press, London, 2001.

Evans, Gareth, *Varieties of Reference*, John McDowell, ed., Oxford University Press, Oxford, 1982.

Feinberg, Larry J., with an essay by Karen-Edis Barzman, *From Studio to Studiolo: Florentine Draftsmanship Under the First Medici Grand Dukes*, Allen Memorial Art Museum, Oberlin College, Seattle and London, 1991.

Fine, Gary Alan, *Everyday Genius: Self-Taught Art and the Culture of Authenticity*, University of Chicago Press, Chicago, 2004.

Fisher, Philip, *Making and Effacing Art: Modern American Art in the Culture of Museums*, Harvard University Press, Cambridge, Mass. and London, 1991.

Fülöp-Miller, René, *The Mind and Face of Bolshevism: An Examination of Cultural Life in Soviet Russia*, trans. F.S. Flint and D.F. Tait, G.P. Putnam's and Sons, London and New York, 1927.

Gamboni, Dario, *The Destruction of Art: Iconoclasms and Vandalism since the French Revolution*, Reaktion, London, 1997.

Gan, Alexsei, *Konstructivism*, Tver: Tverskoe izdatel'stvo (1922), translated as 'Constructivism', in John E. Bowlt, ed. and trans., *Russian Art of the Avant-Garde: Theory and Criticism, 1902–1934*, Thames and Hudson, London, 1988.

Gintz, Claude, 'Michael Asher and the Transformation of "Situational Aesthetics"', *October*, No. 66, Fall, 1993.

Goldberg, Ken, ed., *The Robot in the Garden: Telerobotics in the Age of the Internet*, MIT, Cambridge, Mass. and London, 2001.

Gorz, André, *Farewell to the Working Class: An Essay on Post-Industrial Socialism*, trans. Michael Sonescher, Pluto Press, London, 1982.

————, *Paths to Paradise: On the Liberation from Work*, trans. Malcolm Imrie, Pluto Press, London, 1985.

Gramsci, Antonio, *Selections from Prison Notebooks*, ed. and trans., Quintin Hoare and Geoffrey Nowell-Smith, Lawrence and Wishart, London, 1971.

Green, Charles, *The Third Hand: Collaboration in Art From Conceptualism To Post-modernism*, University of Minnesota, Minneapolis, 2001.

Green, Peter, 'The Passage from Imperialism to Empire: Commentary on *Empire* by Michael Hardt and Antonio Negri', *Historical Materialism*, Vol. 10, Issue 1, 2002.

Grogan, Emmett, *Ringolevio*, Rebel Inc. Press, Edinburgh, 1999.

Haacke, Hans, *Hans Haacke*, Phaidon Press, London, 2004.

Habermas, Jürgen, *The Theory of Communicative Action, Vol. 1: Reason and the Rationalization of Society*, trans. Thomas McCarthy, Beacon Press, Boston, 1984.

Hacks, Peter, *Schöne Wirtschaft. Ästhetisch-ökonommische Fragmente*, Nautilus, Hamburg, 1996.

Hamilton, Patrick, *The West Pier*, Constable, London, 1953.

Haraway, Donna J., 'A Cyborg Manifesto: Science, Technology and Socialist

Feminism in the Late Twentieth Century' (1985), in *Simians, Cyborgs and Women: The Reinvention of Nature*, Free Association Books, London, 1991.

Hardt, Michael, and Toni Negri *Empire*, Harvard University Press, Cambridge, Mass. and London, 2001.

Harris, John, *On Cloning*, Routledge, London and New York, 2004.

Harvey, David, *The Limits To Capital*, Blackwell, Oxford, 1982.

Heller, Morton A., ed., *Touch, Representation and Blindness*, Oxford University Press, Oxford, 2000.

Holloway, John, 'Going in the Wrong Direction; Or Mephistopheles – Not Saint Francis of Assisi', *Historical Materialism*, Vol. 10, Issue 1, 2002.

Hopkins, David, 'The Politics of Equivocation: Sherrie Levine, Duchamp's "Compensation Portrait" and Surrealism in the USA 1942–1945', *Oxford Art Journal*, Vol. 26, No. 1, 2003.

Home, Stewart, *Neoism, Plagiarism and Praxis*, AK Press, Edinburgh and San Francisco, 1995.

Hull, John M., *Touching the Rock: An Experience of Blindness*, Vintage, New York, 2000.

Iversen, Margaret, 'Ready Made, Found Object, Photograph', *Art Journal*, Vol. 63, No. 2, Summer 2004.

Johnson, B.S., *The Unfortunates*, Panther Books in association with Secker and Warburg, London, 1969.

Jones, Caroline A., *Machine in the Studio: Constructing the Post-war American Artist*, University of Chicago Press, Chicago, 1996.

Joselit, David, *Infinite Regress: Marcel Duchamp 1910–1941*, MIT, Cambridge, Mass. and London, 1998.

Kaplan, Louis, *Laszlo Moholy-Nagy: Biographical Writings*, Duke University Press, Durham and London, 1995.

Kautsky, Karl, *Die Materialistische Geschichtsauffassung* (1927), translated as *The Materialist Conception of History*, John Kautsky, ed., Yale University Press, New Haven and London, 1988.

Kelly, Mary, *Postpartum Document*, University of California Press, Berkeley, Los Angeles, 1999.

Kluge, Alexander and Negt, Oskar, *Öffentlichkeit und Erfahrung: Zur Organisationsanalyse von bürgerlicher and proletarischer Öffentlichkeit*, Suhrhamp, Frankfurt/Main, 1972.

Korsch, Karl, *Marxism and Philosophy*, trans. Fred Halliday, New Left Books, London, 1970.

Kosuth, Joseph, 'Art After Philosophy', in *Art After Philosophy and After: Collected Writings, 1966–1990*, Gabriele Guerico, ed., MIT, Cambridge Mass. and London, 1991.

Krauss, Rosalind E., *Passages in Modern Sculpture*, MIT, Cambridge, Mass. and London, 1981.

————, 'The Motivation of the Sign', in William Rubin, ed., *Picasso and Braque: A Symposium*, Museum of Modern Art, New York, 1992.

Kuh, Katherine, 'Interview with Marcel Duchamp', in *The Artist's Voice: Talks with Seventeen Artists*, Harper and Row, London, 1962.

Lefebvre, Henri, *Critique of Everyday Life, Vol. 2: Foundations for a Sociology of the Everyday* (1961), trans. John Moore, Verso, London and New York, 2002.

——, *Everyday Life in the Modern World* (1967), trans. Sacha Rabinovitch, Athlone Press, London, 2000.

Lenin, V.I., 'Immediate Tasks of the Soviet Government', in *Collected Works*, Vol. 27, Progress Publishers, Moscow, 1972.

Leslie, Esther, *Walter Benjamin: Overpowering Conformism*, Pluto Press, London, 2000.

Lind, Maria, 'Learning from art and artist', in Gavin Wade, ed., *Curating in the 21st Century*, New Art Gallery, Walsall/University of Wolverhampton, Walsall and Wolverhampton, 2000.

Lissitzky, El, 'Suprematism of World Construction', in Sophie Lissitzky-Küppers, *El Lissitzky: Life, Letters, Texts*, trans. Helene Aldwinkle and Mary Whitall, Thames and Hudson, London, 1980.

Locke, John, *An Essay Concerning Human Understanding*, ed. John W. Yolton, Everyman, London and Rutland, Vermont, 1993.

Lodder, Christine, *Russian Constructivism*, Yale University Press, New Haven and London, 1983.

Luhmann, Niklas, *Art as a Social System*, Stanford University Press, Stanford, California, 2000.

Luxemburg, Rosa, *The Russian Revolution*, University of Michigan Press, Ann Arbor, 1961.

Maharaj, Sarat, ' "A Master of Veracity, a Crystalline Transubstantiation": Typo-translating the Green Box', in Martha Buskirk and Mignon Nixon, eds, *The Duchamp Effect: Essays, Interviews, Round Table*, MIT, Cambridge, Mass. and London, 1996.

Margolin, Victor, *The Struggle For Utopia: Rodchenko, Lissitzky, Moholy-Nagy 1917–1946*, University of Chicago, Chicago, 1997.

Marx, Karl, *Theories of Surplus-Value*, Vol. 1, Lawrence and Wishart, London, 1969.

——, *Capital*, Vol. 2, Lawrence and Wishart, London, 1970.

——, *Capital*, Vol. 3, Lawrence and Wishart, London, 1972.

Masbeck, Joseph, *Marcel Duchamp in Perspective*, Prentice Hall, New Jersey, 1975.

McFadden, Johnjoe, *Quantum Evolution: Life in the Multiverse*, Flamingo, London, 2000.

McGinn, Colin, *The Problem of Consciousness: Essays Towards a Resolution*, Blackwell, Oxford, 1991.

Menke, Christophe, *The Sovereignty of Art: Aesthetic Negativity in Adorno and Derrida*, trans. Neil Solomon, MIT, Cambridge, Mass. and London, 1998.

Mészáros, Istvan, *Beyond Capital: Towards a Theory of Transition*, Merlin Press, London, 1995.

Moholy-Nagy, Laszlo, *Painting, Photography, Film*, trans. Janet Seligman, MIT, Cambridge, Mass and London, 1969.

——, 'Light Architecture', (1936), in Richard Kostelanetz, ed., *Moholy-Nagy: Documentary Monographs in Modern Art*, Pelican, London, 1971.

Moss, Lenny, *What Genes Can't Do*, MIT, Cambridge, Mass. and London, 2003.

Murray, Patrick, 'Marx's "Truly Social" Labour Theory of Value, Part 1, Abstract Labour in Marxian Value Theory', *Historical Materialism*, No. 6, Summer 2000.

————, 'Reply to Geert Reuten', *Historical Materialism*, Vol. 10, Issue 1, Spring 2002.

Nagel, Thomas, 'What is it like to be a bat?' in *Mortal Questions*, Cambridge University Press, Cambridge, 1979.

Nechvatal, Joseph, 'Origins of Virtualism: An Interview with Frank Popper', *Art Journal*, Spring 2004.

Negri, Antonio, *The Politics of Subversion: A Manifesto for the Twenty-first Century*, trans. James Newell, Polity Press, Oxford, 1989.

Nesbit, Molly, 'Ready-Made Originals: The Duchamp Model', *October*, No. 37, Summer 1986.

————, *Their Common Sense*, Blackdog, London, 2000.

Newspaper of the Engaged Creative Platform/Newspaper of the New Creative Platform, Berlin and St Petersburg.

Niedecker, Lorine, *Collected Works*, ed. Jenny Penberthy, University of California Press, Berkeley, Los Angeles, London, 2002.

Noever, Peter, ed., *The Discursive Museum*, MAK and Hatje Cantz Publishers, 2001.

Oppen, George, *New Collected Poems*, ed. Michael Davidson, Carcanet, Manchester, 2003.

Ohrn, K.B., *Dorothea Lange and the Documentary Tradition*, Louisiana State University Press, Baton Rouge, 1980.

Panzieri, Raniero, 'The Capitalist Use of Machinery: Marx Versus the "Objectivists"', in Phil Slater, ed., *Outlines of a Critique of Technology*, Ink Links, London and Atlantic Highlands, New Jersey, 1980.

Parmelin, Héléne, *Art Anti-Art: Anartism Explored*, Marion Boyars, London, 1977.

Pinker, Stephen, *How The Mind Works*, Penguin, London, 1997.

Potts, Alex, *The Sculptural Imagination: Figurative, Modernist, Minimalist*, Yale University Press, New Haven and London, 2000.

Putnam, Hilary, 'Brains in a Vat', in *Reason, Truth, and History*, Cambridge University Press, Cambridge, 1981.

Rée, Jonathan, *I See a Voice: Language, Deafness and the Senses*, HarperCollins, London, 1999.

Reinfelder, Monika, 'Introduction: Breaking the Spell of Technism', in Phil Slater, ed., *Outlines of a Critique of Technology*, Ink Links, London and Atlantic Highlands, New Jersey, 1980.

Remington, Thomas F., *Building Socialism in Bolshevik Russia: Ideology and Industrial Organization 1917–1921*, University of Pittsburgh Press, Pittsburgh and London, 1984.

Richter, Hans, *Dada: Art and Anti-Art*, Thames and Hudson, London, 1997.

Roberts, John and Stephen Wright eds, 'Art and Collaboration', a special issue of *Third Text*, No. 71, Vol. 18, Issue 6, November 2004.

Ronell, Avital, *The Telephone Book: Technology, Schizophrenia, Electric Speech*, University of Nebraska Press, Lincoln, 1989.

Rubin, I.I., *Ocherki poteoril stoimosti marksa*, Moskva: Gosdarstvennoe Izdatel 'stvo, 3rd Edition, 1928, translated as *Essays on Marx's Theory of Value*, Black and Red, Detroit, 1972.

Schwartz, Hillel, *The Culture of the Copy: Striking Likenesses, Unreasonable Fascimiles*, Zone Books, New York, 1996.

Scroggins, Mark, *Louis Zukofsky and the Poetry of Knowledge*, University of Alabama Press, Tuscaloosa and London, 1998.

Shorthouse, Jim and Gerard Strange 'The new cultural economy, the artist and the social configuration of autonomy', in Jim Shorthouse and Gerry Strange, eds, *Capital and Class: Creative Industries: Production, Consumption and Resistance*, No. 84, Winter 2004.

Sohn-Rethel, Alfred, *Intellectual and Manual Labour: A Critique of Epistemology*, Macmillan, London, 1978.

Smith, Gary, ed., *Benjamin: Philosophy, History, Aesthetics*, University of Chicago Press, Chicago, 1989.

Stallabrass, Julian, *Internet Art: The On-line Clash of Art and Commerce*, Tate Publishing, London, 2003.

Tallis, Raymond, *The Hand: A Philosophical Inquiry Into Human Being*, Edinburgh University Press, Edinburgh, 2003.

Taylor, Brandon, *Art and Literature Under The Bolsheviks, Vol. 1: The Crisis of Renewal 1917–1924*, Pluto Press, London, 1991.

Taylor, Frederick, *The Principles of Scientific Management* (1911), Harper Bros, New York, 1947.

Thompson, Michael, *Rubbish Theory: the Creation and Distribution of Value*, Oxford University Press, Oxford, 1979.

Thompson, Paul, *The Nature of Work: An Introduction to Debates on the Labour Process*, Macmillan, London, 1983.

Tomkins, Calvin, *The Bride and the Bachelors: Five Masters of the Avant-Garde*, Viking Press, New York, 1968.

Trotsky, Leon, *The Problems of Everyday Life, and Other Writings on Culture and Science*, Path Finder Press, New York, 1973.

Tse-Tung, Mao, *Four Essays on Philosophy*, Foreign Languages Press, Peking, 1968.

Ulmer, Greg, *Teletheory: Grammatology in the Age of Video*, Routledge, London and New York, 1989.

Virilio, Paul, *The Aesthetics of Disappearance*, trans. Philip Beitchman, Semiotext(e), New York, 1991.

Voloshinov, Valentin, *Marxism and the Philosophy of Language*, Harvard University Press, Cambridge, Mass. and London, 1986.

Wade, Gavin, ed., *Curating in the 21st Century*, The New Art Gallery Walsall and the University of Wolverhampton, 2000.

Wagner, Anne Middleton, *Jean-Baptiste Carpeaux: Sculptor of the Second Empire*, Yale University Press, New Haven and London, 1986.

Weiss, Jeffrey, *The Popular Culture of Modern Art: Picasso, Duchamp, and Avant-Gardism*, Yale University Press, New Haven and London, 1994.

Williams, William Carlos, *In the American Grain* (1925), W.W. Norton and Company, Norfolk, Conn. 1956.

————, *Autobiography*, Random, New York, 1951.

Witherford, Nick, 'Circles and Circuits of Struggle in High-Technology Capitalism', in Jim Davis, Thomas Hirschl and Michael Stack, eds, *Cutting Edge: Technology, Information, Capitalism and Social Revolution*, Verso, London and New York, 1997.

Wittel, Andreas, 'Culture, Labour and Subjectivity: For a political economy "from below"', in Jim Shorthouse and Gerry Strange, eds, *Capital and Class: Creative Industries: Production, Consumption and Resistance*, No. 84, Winter 2004.

Woolfson, Charles, *The Labour Theory of Culture: Re-examination of Engels' Theory of Human Origins*, Routledge and Kegan Paul, London, 1982.

Wright, Stephen, 'Le dés-oeuvrement de l'art', in *Les Valeurs de l'art: Entre Marché et Institutions, Mouvements*, No. 17, Septembre/Octobre, 2001.

————, 'The Future of the Reciprocal Readymade (The Use-value of Art)', pamphlet accompanying exhibition of the same name, March 17–April 17, 2004, Apex Art, New York.

Wu, Chin-tao, *Privatising Culture: Corporate Art Intervention since the 1980s*, Verso, London, 2002.

Žižek, Slavoj, *The Ticklish Subject: the Absent Centre of Political Ideology*, Verso, London and New York, 1999.

Zukovsky, Louis, *55 Poems*, Press of J.A. Decker, Prairie City, 1941.

————, *'A'*, Johns Hopkins University Press, Baltimore and London, 1978.

————, 'An Objective' (1930/31), *Prepositions +: The Collected Critical Essays*, Wesleyan University Press, Hanover, New England, 2000.

————, *A Useful Art: Essays and Radio Scripts on American Design*, edited with an introduction by Kenneth Sherwood, afterword by John Taggart, Wesleyan University Press, Hanover, New England, 2003.

INDEX